Dr Claribel & Miss Etta

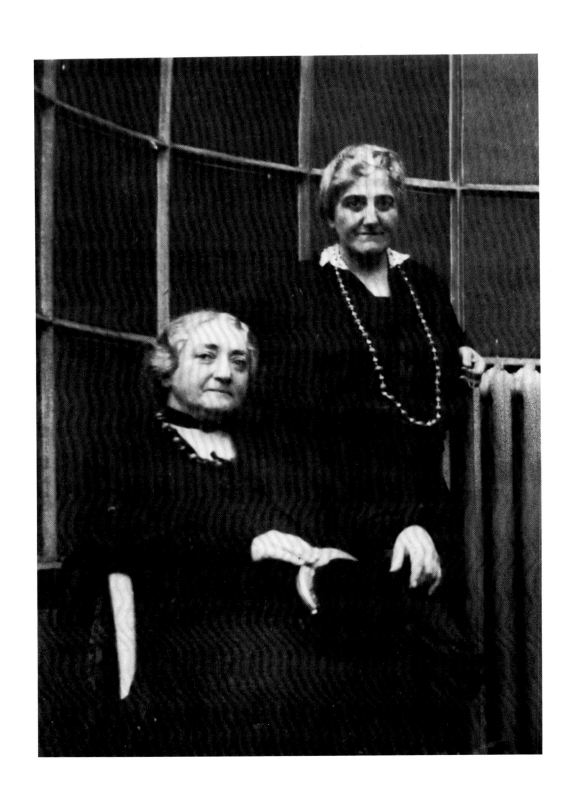

Dr Claribel & Miss Etta

Brenda Richardson

with the assistance of

William C. Ameringer
Audrey Frantz
Faith M. Holland
L. Carol Murray
Gertrude Rosenthal

THE CONE COLLECTION
OF THE BALTIMORE MUSEUM OF ART

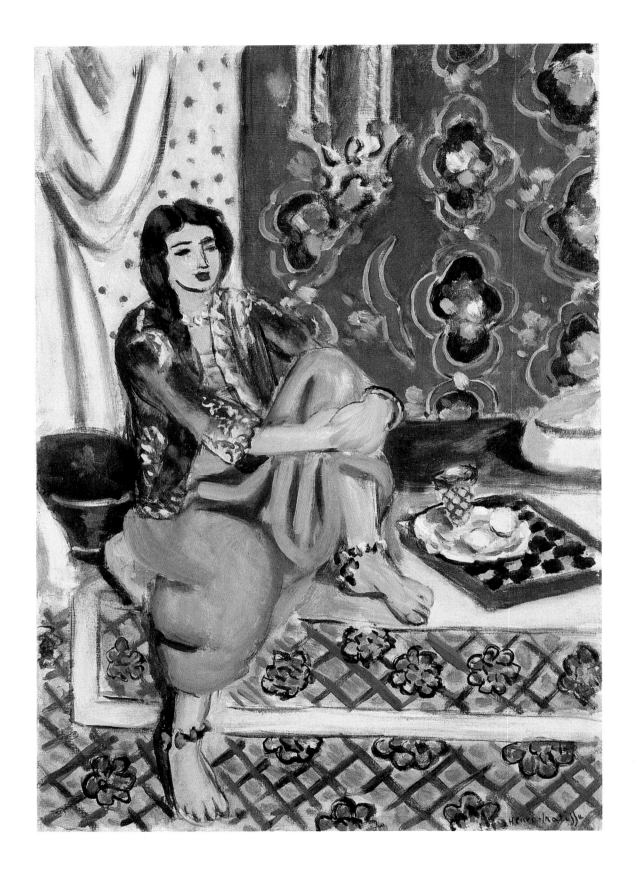

Henri Matisse. *Seated Odalisque, Left Knee Bent, Ornamental Background and Checkerboard.* (1928). Oil on canvas. BMA 1950.255.

Dedicated, with profound admiration, to

GERTRUDE ROSENTHAL and ADELYN BREESKIN

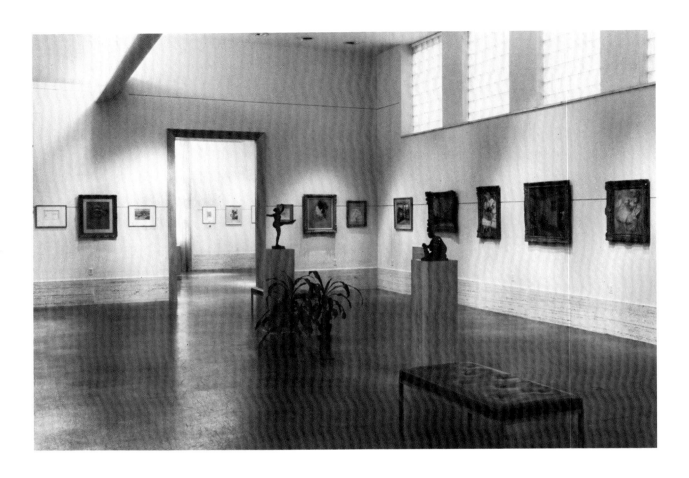

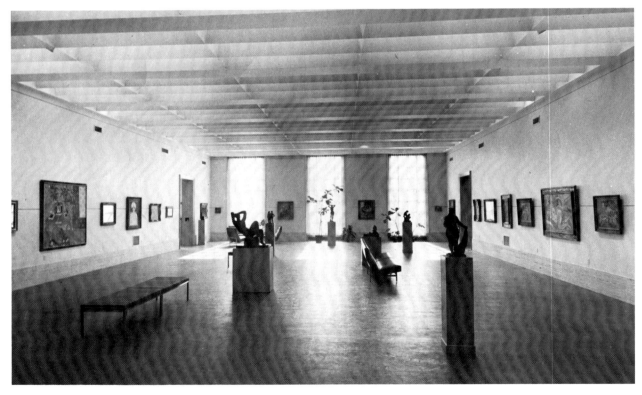

Cone Wing, 1957

8

Foreword

The Cone Collection came to The Baltimore Museum of Art by bequest of Etta Cone in 1950, and was dedicated in its Cone-endowed new wing on February 23, 1957. In the succeeding years The Cone Collection, with its incomparable holdings of work by Henri Matisse and major examples by Picasso, Cézanne, Gauguin, van Gogh, Renoir, and other masters of early twentieth-century French art, has drawn admiring visitors from around the world. The Baltimore Museum of Art, known as a "collection of collections" for the grandeur of its inheritance from early Baltimore collector-patrons, was immeasurably enriched by this bequest of approximately 3,000 items acquired over a fifty-year period by Dr. Claribel and Miss Etta Cone. Although the collection's painting, sculpture, and graphic work by Matisse and Picasso are internationally renowned and thus most closely identified with the Cone sisters and the Baltimore Museum, the collection also includes several important works by American artists (and countless lesser known works by regional artists), hundreds of prints and drawings, illustrated books, a large group of textiles (ranging from Coptic fragments to Middle Eastern silks), eighteenth and nineteenth-century jewelry, furniture and other decorative arts, Oriental rugs, objects of African art and adornment, Japanese prints, and antique ivories and bronzes. With the Cone bequest also came to the Museum the Cone sisters' archives (including correspondence, miscellaneous personal papers, newspaper clippings, and surviving diaries and account books) and their personal library numbering 1,250 volumes. The Cone Collection thus represents not only one of the most extraordinary art holdings in any museum in the world, but also constitutes a unique resource for students and scholars of modern art and culture.

Etta and Claribel Cone together formed one of the world's preeminent collections of modern art at a time when modern art was not widely collected, and when there were few patrons of the avant-garde. Although it is this collection of art by the modern masters for which the Cone sisters are remembered, Etta and Claribel were also compulsive buyers in the tradition of upper-class ladies of Victorian-era America. They traveled the world, and as they traveled they acquired antiques, curios, and objets d'art of every description. Contemporary photographs of their rooms at The Marlborough in Baltimore reveal a profusion of fabrics, furniture, pictures, and objects—a three-dimensional "collector's cabinet." Although the quality and scope of their art collection clearly set them apart from others of their time and class, nonetheless the cluttered, heavily-adorned decor in which they lived

is characteristic of the period (photographs of the apartments of Gertrude Stein and Alice B. Toklas, and of Michael and Sarah Stein, for instance, reveal a parallel look).

Textiles form an important aspect of The Cone Collection. Adèle Coulin Weibel, former Curator Emeritus of Textiles and Near Eastern Art at The Detroit Institute of Arts, wrote of these materials in 1950: "With the exception of a few well chosen Coptic and Egypto-Islamic roundels and borders of wool and silk tapestry, the collection is devoted to textile art from the Renaissance to the nineteenth century. . . . Dr. Claribel Cone amassed silks and velvets sparkling with silver and gold and the colorful embroideries of many peoples of the Old World. Miss Etta Cone built up a collection of delicate laces and related embroideries from Italy, France and Flanders." The collection includes brocades and velvets from Italy and Spain, mostly eighteenth-century; several Polish cavaliers' sashes in woven silk, including one rare signed piece; Persian woven silks, including several small fragments of gold and silver cloth; exquisite embroidered Kashmir shawls; saris, headcloths, and boxes lavishly embroidered in silk and metal threads from Mughal India; folk embroideries from Bokhara and Turkey, and from Tunisia, Algeria, Morocco, Rhodes and the Greek islands, Transylvania, Hungary, and Czechoslovakia; fine *punto rosso* of central and northern Italy; examples of *point de France*, needle-made laces of Alençon and Argentan; rare Russian bobbin laces and beautifully designed Milan lace. The Cones also bought Oriental rugs, shopping in both Paris and Baltimore, and acquired wall hangings, tapestries, and draperies in great quantity.

Much of what the Cones bought was acquired for domestic and personal use rather than as a part of an art collection. Adelyn Breeskin, a former director of the Baltimore Museum and instrumental in arranging for The Cone Collection to come to the Museum, has recalled seeing the Cone sisters at concerts in Baltimore when she was still in her teens: "Dr. Claribel was dressed very picturesquely. She made a handsome figure with her hair fixed in a psyche knot held by silver skewers from India. Her outer wrap was often either a burnoose from North Africa or a very handsome shawl from India. And her jewelry was splendid— large pieces of French paste from the eighteenth century or else near-eastern." Thus the jewelry bought by the Cones, like many of the textiles, was acquired for personal adornment. As Marvin C. Ross, former curator of Baltimore's Walters Art Gallery, has noted, most of the collection's jewelry is eighteenth-century with beautifully handcrafted settings featuring pastes imitating precious and semiprecious stones. There is a great variety of design in the jewelry collected, representing sophisticated European craftsmanship as well as peasant jewelry from around the world; there are fifteen Hindu necklaces in gold, set with precious and semiprecious stones, and decorated with beautiful Jaipur enamel work. There are more than forty items in coral, which was Claribel's special love, and dozens of items in amber, which was Etta's passion.

The furniture bought by the Cone sisters paralleled their other decorative interests. Although they purchased almost all of their furniture as "Renaissance," in fact most of their pieces are pastiches of the nineteenth and early twentieth centuries. The Cones also bought a few works of classical antiquity (ivories and bronzes, mostly domestic pieces) and at least one work of Egyptian sculpture identified by Claribel as her favorite piece in the entire collection. On August 18, 1927, she wrote Etta from Lausanne: " . . . I have a cat—and nothing that M. [Matisse] does can approximate in quality, in virility, in majesty and charm— the life-like quality of my cat. I wish I knew the artist who created this thing of beauty—or

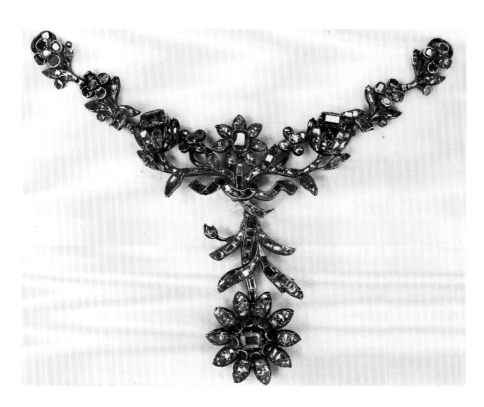

French. Center part of a *Necklace*. (ca. 1750).
Silver set with green and red stones and brilliants. BMA 1950.552.12.

African, Zaire, Kongo. *Cup*. (late 19th century).
Wood. BMA 1950.388.

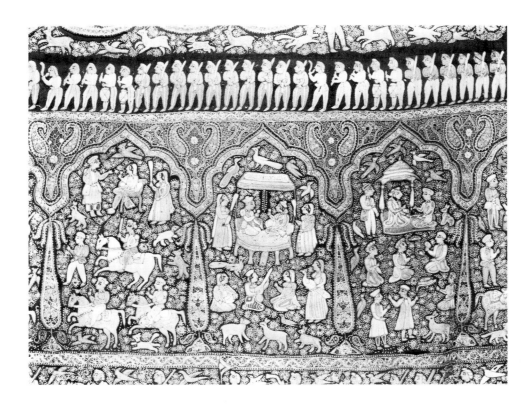

Indian. Detail of *Delhi Shawl*. (19th century). Cotton. Cone, T-NE 3.49.

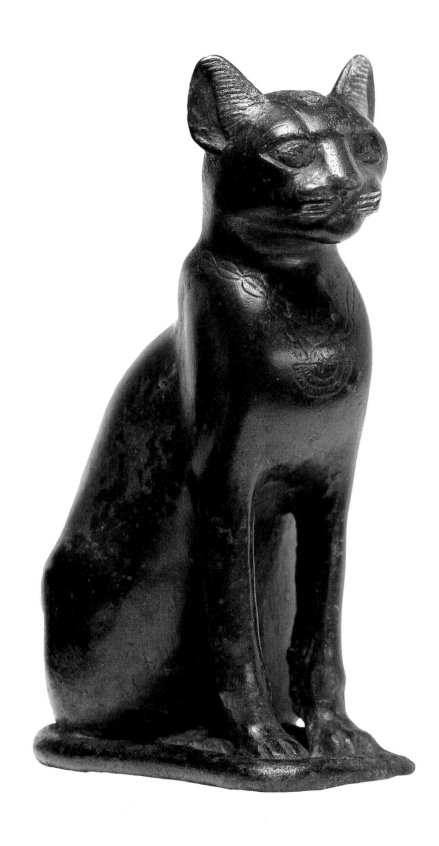

Egyptian. *Seated Cat*. Saitic Period (7th–4th century B.C.). Bronze. BMA 1950.405.

I wish I knew the name of the man whose soul inhabited it. . . . " The cat, an authentic Egyptian bronze reliquary of the Saitic Period, was bought by Claribel from the Lausanne dealer Paul Vallotton, through the great dealer in Egyptian art, Dikran Kalekian. Claribel was thrilled when Kalekian confirmed that the bronze was 3500 years old, and from the time of Ramses II, and she was convinced that "The person whose soul it contains must have been an artist—or something divine."

No doubt under the influence of Henri Matisse, whose interest in "primitive" art is well documented, Etta and Claribel also collected several pieces of African art. While artists of the period were fascinated by African art for its originality of form and power of expressive content, the Cone sisters were more attracted to miniaturized pieces as decoration or adornment. In fact, a number of their African pieces are items of jewelry, such as four nineteenth-century ivory bracelets, and necklaces of amber, ivory, metal, and quartz. An ivory trumpet from the same period is elaborately decorated with geometric patterns that suggest a form of ideographic communication found commonly in Zaire. There is an exquisite wooden goblet bearing evidence of many years of formal palm-wine drinking among the Kongo people of Zaire, and from the Bembe of Zaire comes a miniature figure of a hunter carrying a rifle and a blade. Although a small part of The Cone Collection, these African objects are important as a representation of early collecting of "negro-art" materials, before the field was complicated by a profusion of forgeries. The Cones bought their African art in Paris in the 1920's. Claribel Cone's account book for the summer of 1925 notes that at least one work of African sculpture was acquired directly from the collection of Gertrude Stein, and at a very generous price (cited in francs): "Paid Sallie [Stein] Sunday last—for Gertrude's objects—5000 Picasso bronze masque / 3000 negro sculpture (figure) . . . " [July 9, 1925]. And on June 29, 1925, in the same account book, Claribel notes " . . . [Etta and I went to] Paul Guillaume 59 rue de la Boetie Paris . . . saw negro-art. . . . "

* * *

In 1934 Etta Cone published *The Cone Collection of Baltimore—Maryland: Catalogue of Paintings—Drawings—Sculpture of the Nineteenth and Twentieth Centuries*, a large volume of black-and-white illustrations, with a Foreword by George Boas, "dedicated to the memory of Dr. Claribel Cone by her sister Etta Cone." The book's frontispiece was a portrait drawing of Claribel done by Matisse at Etta's request as a special memorial to her older sister who died in 1929. The book, itself conceived by Etta as a memorial to Claribel, was organized and published on Etta's behalf by Siegfried Rosengart, a Cone cousin who operated an important art gallery in Lucerne, Switzerland. Together Etta and Rosengart selected the works to be illustrated. The book was printed in a limited edition and has been out of print for many decades. In 1955 the Museum published a *Handbook of the Cone Collection*, with numerous illustrations and with a selected listing of paintings, sculpture, and drawings in the collection. This volume was revised and reprinted in 1967. Both editions have been out of print for over a decade. In 1981 the Museum's staff and Trustees identified as the highest priority a publication on The Cone Collection, as well as a later more thorough cataloguing of the collection primarily for use by specialists. Realizing that such publication projects

would require major funding, the Museum obtained the support of the National Endowment for the Arts through the enthusiastic assistance of Livingston L. Biddle, Jr. An additional generous subsidy was provided by the Andrew W. Mellon Foundation for support of publication research related to the collections. Without the NEA and Mellon funds, the book could not have been published in its present scope. Most important, Professor Edward T. Cone of Princeton, New Jersey, nephew of Etta and Claribel, committed his support to the Museum's publication program and contributed generously to assure realization of a substantive work on The Cone Collection. Professor Cone's open and sympathetic interest in the publication has been warmly demonstrated throughout the many months of the book's preparation.

In June 1983 William C. Ameringer came to the Museum as Assistant Curator of Painting and Sculpture to work with Brenda Richardson, Assistant Director for Art and Curator of Painting and Sculpture, on this substantive research and documentation project. He investigated issues of provenance on the works in the collection and coordinated recataloguing of the paintings, sculpture, and unique works on paper (including conservation examination and new photography). He also traveled both in this country and abroad to compile oral histories from Cone relatives and acquaintances. As research progressed, it was evident that the biographical facts of the Cone sisters' lives and the unique personalities of Etta and Claribel were inextricably interwoven with the nature of the collection. The way in which the collection was built, when and why each object was added, proved to be a direct reflection of these two fascinating women and the era in which they lived. Brenda Richardson read all the correspondence and journals in the Museum's Cone Archives; reviewed materials relative to the Leo and Gertrude Stein circle, with which the Cones were intimately involved; and obtained copies of the Cone materials deposited with the Stein archives at Yale University. The final manuscript was written by Brenda Richardson, who studied the lives of the Cone sisters with the same dedication and sensitivity that she brought to the objects in the collection. Ann Allston Boyce, Faith M. Holland, and Dr. Gertrude Rosenthal provided essential editorial and research assistance in the course of the manuscript's preparation. Audrey Frantz expertly supervised every detail of the book's production and Priscilla Little keyboarded the manuscript. The book's elegant design reflects the sensitive artistry of Alex and Caroline Castro of Baltimore's Hollowpress.

Without any question, The Cone Collection became a part of the permanent collection of The Baltimore Museum of Art through the extraordinary skill, grace, and professionalism of Adelyn D. Breeskin. Acquainted with the Cones for a lifetime, it was she who ultimately persuaded Etta Cone that it was Baltimore's Museum that must become home to this very personal collection. Mrs. Breeskin did not accomplish this coup in the absence of competition. The Cone Collection was internationally known by 1940, and loan requests for works of Matisse were routinely addressed to Etta Cone from around the world throughout the 1930's and 1940's. Museum directors and curators were frequent guests at The Marlborough. Etta welcomed visitors who wished to view this collection of ever-increasing fame; there was no comparable gathering of the work of Matisse accessible anywhere in America, and specialists, including many artists, made their pilgrimage to Baltimore to study The Cone Collection. Etta was always eager to extend herself as hostess and to conduct guided tours through the rooms of the joint apartments complete with anecdotal narration about each object. In later years she often telephoned the Museum to invite either Mrs. Breeskin or Dr. Rosenthal,

Chief Curator, to assist her with these visitors by assuming guide duties, but invariably once a visit was begun Etta would join the group and take up her personal role as hostess in order to relish more fully her visitor's response. Trude Rosenthal recalls with particular pleasure her presence at a visit to Etta Cone's by Daniel-Henry Kahnweiler (the great and early Paris dealer in Picasso's work), at which Etta and Kahnweiler affectionately recalled Paris in the 1920's. Etta was especially animated during this visit, and graciously stood her ground in response to Kahnweiler's gentle inquiry about why The Cone Collection did not include any of Picasso's Cubist works: "Why did he do it?" Etta retorted, adding that she simply could not understand Picasso and Cubism.

On April 17, 1934, Etta wrote Gertrude Stein that " . . . Many museum directors have been here this winter & many of them were thrilled to find the bronze & portrait of you in this collection. I always apologize for the Vallotton portrait for it is not you valuable as [it] is" [Yale]. Etta could not have been unaware of the primary motive in the visits of these "many museum directors," whose interest was spurred by professional obligation as well as by love of art. In particular, Alfred H. Barr, Jr. courted Etta Cone on behalf of The Museum of Modern Art, New York; he is reliably reported to have argued that The Cone Collection was too good for Baltimore and should instead be in New York at his own museum. And Barr was not alone. The Philadelphia Museum of Art also sought the collection and Philadelphia's curator Henry Clifford was a frequent Cone guest. The San Francisco Museum of Art kept in close touch with Etta Cone, as did Boston's Museum of Fine Arts, the Brooklyn Museum, The Art Institute of Chicago, the Cleveland Museum of Art, Harvard's Fogg Art Museum, and both the Phillips and the National Gallery of Art in Washington, D.C.

Given Alfred Barr's devotion to the work of Matisse and his credentials as the foremost scholar of Matisse's art—and of course the prestige of The Museum of Modern Art even in its formative years—it is almost certain that Etta Cone gave serious consideration to Barr's persistent interest in obtaining the collection for New York. In the end, Etta settled on The Baltimore Museum of Art as the repository for the collection. In this decision, she must have been positively impressed by Adelyn Breeskin's demonstrated friendship and obvious commitment and sensitivity to the collection. In addition, of course, she was ultimately deferring to her beloved Sister Claribel.

Claribel Cone died in Lausanne, Switzerland in September 1929. On April 25, 1929, while in Greensboro, North Carolina, she had drawn up her Last Will and Testament, bequeathing to her sister Etta her "entire Art Collection, consisting of . . . all Pictures, Oil Paintings, Water Colors, Lithographs, Colored Aquatints, Etchings, Prints, Drawings, Engravings, Photographs, Piper Prints . . . also all of my Laces, Shawls, Fabrics, Draperies, Portieres, Embroideries and other textiles; also all of my Bric-a-brac, Bronzes, Marbles, Sculptures, Curios and all other Objets d'Art; also all of my Antique Furniture and other antiques." She then bequeathed to Etta "a full and unrestricted power of appointment" under the following precatory language:

It is my desire in respect to the above Art Collection that in so far as is possible, or practicable, the same be kept intact as one individual collection. It is my suggestion, but not a direction or obligation upon my said Sister, Etta Cone, that in the event the spirit of appreciation for modern art in Baltimore becomes improved, and if the Baltimore

Museum of Art should be interested in my said Collection and desire to be named as appointee hereunder to receive said collection after the death of my said sister, Etta Cone, that said Baltimore Museum of Art be favorably considered by her as the institution to ultimately receive said Collection.

My second preference for an appointee would be the Metropolitan Museum of Art, of the City of New York.

But I name these two names as suggestions merely and leave it in the absolute judgment and discretion of my sister, Etta Cone, to be exercised by her in accordance with conditions that may arise hereafter as to whom she shall appoint to receive this collection under the power herein granted.

Claribel's caveat regarding the need for improvement in Baltimore's "spirit of appreciation for modern art" unknowingly set the stage for Barr's attempt to woo the collection away from an allegedly unappreciative Baltimore.

In fact, the Cones' view of Baltimore as a backward, provincial city with little tolerance for modern art or social progress is a leitmotif of their correspondence over several decades. On January 10, 1910, Etta Cone wrote Gertrude Stein about Baltimore's reaction to Stein's *Three Lives*: " . . . they think Melanctha indecent—aren't they a baby lot—in many other ways too" [Yale], and on February 11, 1910, Etta mentioned to Gertrude Stein, " . . . philanthropy & women suffrage—questions that have put old Baltimore in a state of real turmoil" [Yale]. Claribel, writing to Etta from Munich in 1910, reported " . . . how I hate those cramped, narrow, crowded, high-above civilization–lonely (lonely) rooms on Eutaw Place . . ." [letter from Claribel Cone to Etta Cone, July 8, 1910, Munich]. Claribel's notebooks from 1925 underline the contrast she perceived between her own interest in modern art and that of her fellow Baltimoreans: " . . . Read Mencken's article (Balto Evening Sun Sat–June 30 1925) As he sees it, New critics as absurd as new Painters they celebrate . . . " [Claribel Cone notes, July 12, 1925]. A letter to Etta Cone from Michael Stein also reflects an awareness of Baltimore's cultural conservatism in the 1920's: " . . . Then a young San Francisco composer [Mr. Cowell] showed up and we were very much impressed with his work. He brings entirely new and rich effects out of the piano. . . . He goes back to New York on the 30th and is to play at Carnegie Hall on February 4–I guess he would shock Baltimore as he uses his forearm and fists part of the time or I would ask you to do something for him there . . . " [letter from Michael Stein to Etta Cone, December 17, 1923, Paris].

No matter how far from the Baltimore sensibility Claribel and Etta may have felt themselves to be, they were nonetheless fundamentally devoted to their native city. They were both extremely active in civic, cultural, and philanthropic activities in Baltimore, and virtually all of their lifelong associations were with friends and relatives from Baltimore. They were figures of recognized prominence—if no little bemusement—within the community and their collections were acknowledged to be of enormous significance even from a relatively early date. Baltimore's *Sun*, on November 22, 1929, ran a lead news story, an extensive feature story on the collections, and an editorial after Claribel's will had been made public:

The possibility that the widely-known art collection of the late Dr. Claribel Cone, Baltimore scientist and art connoisseur, eventually will pass as a unit into the keeping of the new

Municipal Museum of Art, together with a fund of $100,000 for housing, preserving and maintaining the collection, was learned yesterday.

Under the terms of Dr. Cone's will, filed late yesterday, the large accumulation of paintings, chiefly by famous leaders and representatives of the post-impressionist and modern schools, of textiles, *objets d'art*, furniture, etc., may be acquired by the museum after the death of Dr. Cone's sister, Miss Etta Cone, or in the latter's lifetime if this should be her wish. It is suggested, however, that this may be done if "the spirit of appreciation of modern art in Baltimore becomes improved."

Determination of this last, as in fact, of all other related matters, is in the hands of the sister, in whose keeping the collection is left ["Cone Art Unit May Pass to City Museum," *The Sun*, Baltimore, November 22, 1929, p. 30].

The long and detailed feature story (on page 13 of the same edition) lauding the Cones and their collections was signed by *The Sun*'s astute and informed art critic A. D. Emmart, who presumably also wrote the editorial:

By far the most important contribution which the Baltimore art community has visioned in many years is that which becomes possible under the will of Dr. Claribel Cone. . . .

Doctor Cone's doubts about the city's cultural zeal can be understood by anyone who realizes, for example, how few in the city even knew of the notable collections which she and her equally devoted sister had painstakingly assembled, or, knowing, realized how enormous a part of Baltimore's total art resources they amount to.

The ultimate bestowal of these works—in certain phases of truly national importance—upon the Museum depends definitely on Miss Etta Cone's conviction that the community deserves them and wishes them. How that can be evidenced is something about which the community in general and the Museum in particular should promptly bestir themselves. We are wisely required to prove our worth before we are given this spirited stimulus toward our artistic renaissance ["The Cone Collection," *The Sun*, Baltimore, November 22, 1929, editorial page].

For 1929 this represents a remarkably enlightened public position and must have offered both solace and encouragement to Etta at a time of intense grief over the loss of her sister. Her conviction must have grown in intervening years. In 1932 Gertrude Stein gave to Etta one of the original annotated typescripts of *Two Women*, Stein's word portrait of the Cone sisters, in memory of Claribel. Etta acknowledged the gift: "I was very much moved at your remembering my sister as you did, and I shall Catalogue your manuscript among her other art books which eventually go to a museum—no doubt the Museum of Baltimore. I thank you profoundly for this generous tribute to my sister's memory . . . " [letter from Etta Cone to Gertrude Stein, September 14, 1932, Paris (Yale)]. While Etta was definitive in her 1932 judgment that the collections would go to "a museum," she was not yet firmly convinced that it would be to Baltimore's. In a 1944 article on the collection (*Art in America*, October 1944), John Rewald called it an "open secret" that the Cone collection would end up at the Baltimore Museum, but it was not until 1947 that Mrs. Breeskin was given assurances by Cone attorneys that Etta had decided to make her will in favor of the bequest of the collection to the Museum. Etta Cone drew her Last Will and Testament on May 18, 1949, and she died

on August 31, 1949. Her own collection, that of her sister Dr. Claribel, and the much smaller holdings of youngest brother Frederic were designated as a single unit to come to The Baltimore Museum of Art.

<p style="text-align:center">* * *</p>

Because of the pride and pleasure with which this Museum houses The Cone Collection and preserves it for future generations, it is an extraordinary privilege to bring this publication to realization. No single individual has been more involved with the collection and with this publication than Dr. Gertrude Rosenthal who continues in active service to the Museum as Chief Curator Emeritus. She enthusiastically shared with Brenda Richardson and Will Ameringer not only her memories of Etta Cone but, more significantly, her extraordinary sensitivity to the objects collected by the Cones, which she so lovingly and conscientiously attended during her long curatorial tenure at the Museum. Her contribution to the final manuscript of the present publication was invaluable and is warmly appreciated.

Adelyn Breeskin generously acceded to requests for interviews during the manuscript's preparation, as did Siegfried Rosengart and his daughter Angela Rosengart of Lucerne, Switzerland. Mr. Rosengart was extremely helpful in reconstructing the chronology and method of Etta Cone's collecting during her last two decades when she depended on his assistance. Cone relatives Edward T. Cone (Princeton, New Jersey) and Ellen B. Hirschland (New York) also readily granted Will Ameringer's requests for interviews on the subject of their aunts. Edward Cone generously took the present opportunity to contribute from his personal collection certain Claribel Cone papers to the Museum's Cone Archives. We are also extremely grateful to the staff in charge of the Gertrude Stein Collection of the Yale Collection of American Literature in the Yale University Library: Dr. David Schoonover, Curator of American Literature; Patricia Howell, Reference Librarian; and Marjorie Wynne, Research Librarian, Beinecke Rare Book and Manuscript Library. Access to Cone-related materials in the Stein papers at Yale was essential to the preparation of this publication.

The Cone Collection stands on its own as a gathering of masterworks by some of the most significant artists of the twentieth century. As such, these works of art require no historical context; their beauty and authority communicate independently of history or biography. However, as two separate collections formed by Etta Cone and Claribel Cone and then merged into one to come to The Baltimore Museum of Art, these individual objects elicit our interest as both personal and sociocultural reflections of their collectors. The collections and the collectors mirror one another. In the present text Etta and Claribel Cone come to life and assume a dimensionality that can only enrich our already appreciative viewing of the art objects they acquired in the course of fifty years. For this illustrious and expanded vision of The Cone Collection we are deeply grateful to our author, Brenda Richardson.

<div style="text-align:right">

ARNOLD L. LEHMAN
Director

</div>

Henri Matisse. *Festival of Flowers.* (1922). Oil on canvas. BMA 1950.240.

Two Women
Gertrude Stein

Accompanied by photographs of
The Marlborough Apartments

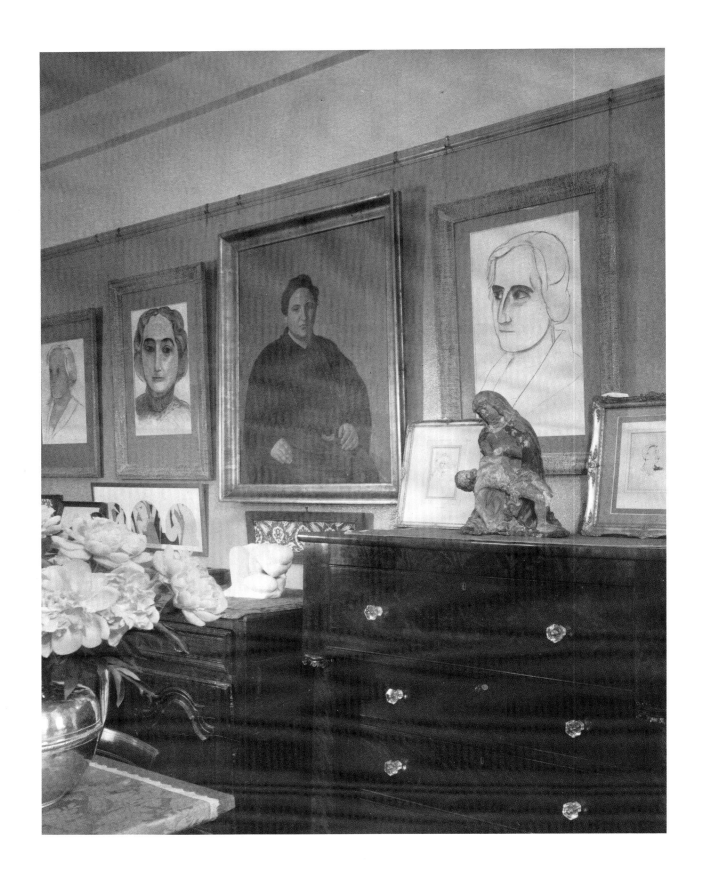

There are often two of them, both women. There were two of them, two women. There were two of them, both women. There were two of them. They were both women. There were two women and they were sisters. They both went on living. They were very often together then when they were living. They were very often not together when they were living. One was the elder and one was the younger. They always knew this thing, they always knew that one was the elder and one was the younger. They were both living and they both went on living. They were together and they were then both living. They were then both going on living. They were not together and they were both living then and they both went on living then. They sometimes were together, they sometimes were not together. One was older and one was younger.

When they were together they said to each other that they were together and that each one of them was being living then and was going on then being living. When they were together they called each other sister. When they were together they knew they were together. When they were together, they were together and they were not changing then, they were together then.

There were two of them, they were both women, they were sisters, they were together and they were being living then and they were going on being living then and they were knowing then that they were together. They were not together and they were living then and they were each of them going on being living then and they were knowing then that they were not together.

Each of them were being living. Each of them were going on being living. Each of them was one of the two of them. One of them was older. One of them was younger. They were sometimes together. They were sometimes not together. The younger called the older sister Martha. The older called the younger Ada. They each one knew that the other one needed being one being living. They each one knew that the other one was going on being living. They each one knew that that one needed to be one being living. They each one knew that that one was going on being living. The younger knew that the older was going on being living. The older did not know that the younger was going on being living. The older knew that the younger would be going on living. They both were going on being living. They were both needing being one being living.

They were together and they spoke of each other as their sister. Each one was certain that the other one was a sister. They were together and they were both then being living.

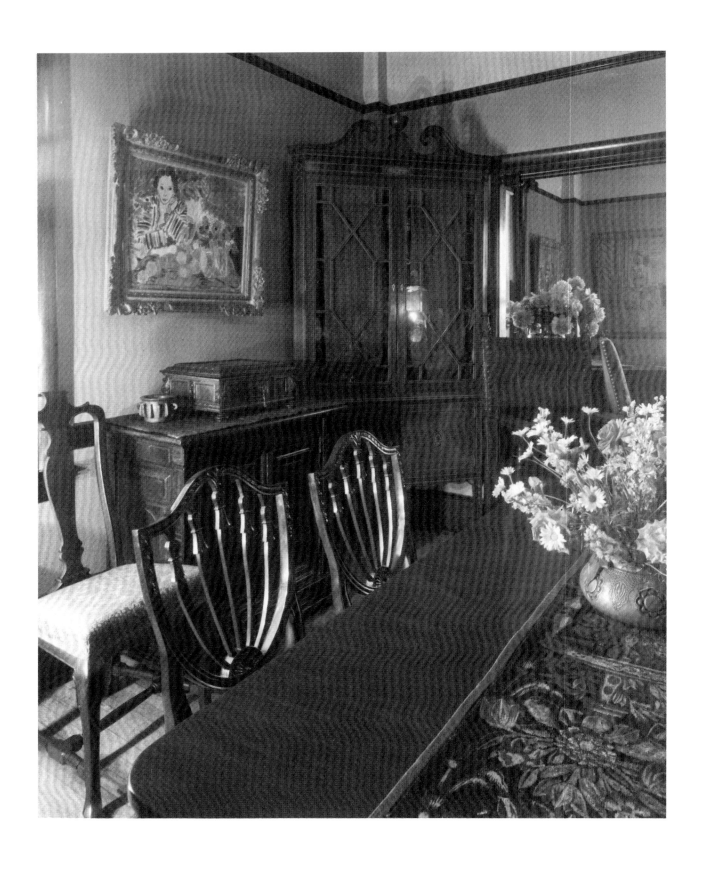

The younger one called the older sister Martha. The older called the younger Ada. They were together and they were then both of them going on being living.

The older one was more something than the younger one. The younger one was not so much something as the older one. The older one was more something than the younger one. The younger one was receiving everything in being one going on being living. The older one was more something than the younger one. The older one was going on being living, the older one was telling about this thing about being more something than the younger one. The older one was telling about this thing about the younger one being more something than any other one. The younger one was telling about being more something than any other one. The younger one was not telling about the older one being more something than any other one. The younger one was telling about both of them being more something than any other one.

They were together and they knew it then, knew that they were together. They were not together and they knew it then, knew that they were not together. They both went on being living. Later they were not together. They knew it then both of them that they were not then together. Later then they were together. They knew it then, both of them, that they were then together.

They did some things. The elder did some things. The older one went on being living. She did some things. She went on being living. She did this thing, she went on being living. She did some things. She did go on being living. She was more something than any other one. She did some things. She went on being living. She did this thing, she went on being living.

The younger one did some things. She was receiving some things more than any other one. She went on receiving them. She went on being living. She received this thing, she went on being living. She had this thing more than any other one, receiving going on being living. She received this thing, she went on being living. She received going on being living. She received this more than any other one. She went on being living. She was receiving this thing, she was receiving it more than any other one. She was receiving it some from her sister Martha, she received it more from every one. She received this thing, she received going on being living.

They were together and they knew that then, the two of them, both of them knew it then, knew that they were together. They were not together and they knew it then, both of them knew it then, each one of the two of them knew it then, knew that they were not together then.

There were others connected with them, connected with each of them, connected with both of them. There were some connected with both of them. There had been a father and there had been a mother and there were brothers and quite enough of them. They each of them had certainly duties toward these connected with them. They had, each one of them, what they wanted, Martha when she wanted it, Ada when she was going to want it. They had brothers and a mother and a father. They were quite rich, all of them. They were sometimes together, the two of them, they were sometimes traveling. They were sometimes alone together then. They knew it then. They were sometimes not alone together then. They knew that then. They were, the two of them, ones traveling and they were then ones buying some things and they were then ones living in a way and they were then ones sometimes

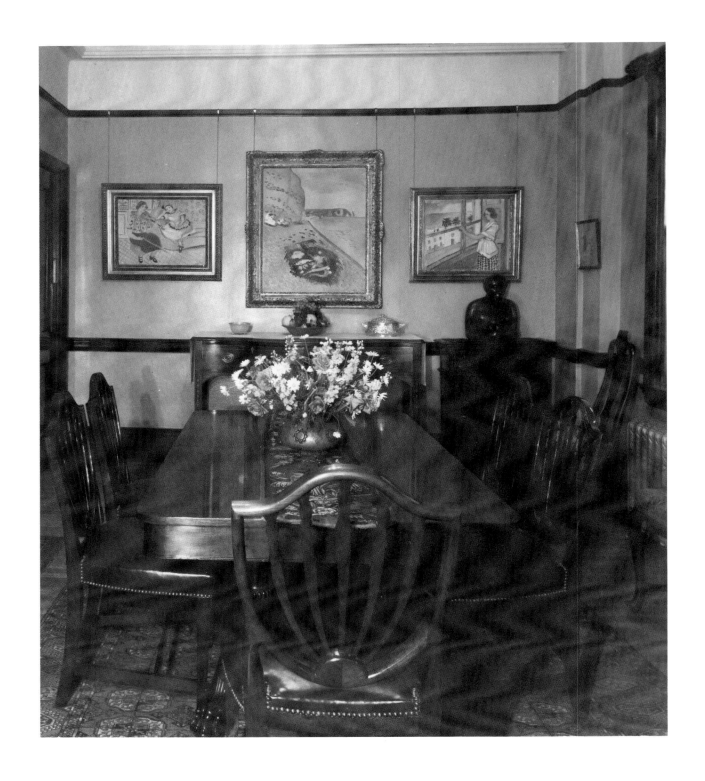

living in another way. They were very different the one from the other of them. They were certainly very different.

They each of them knew some who were knowing them. They each of them pleased some who were knowing them. They each of them were pleased by some who were knowing them. They were large women, both of them, anybody could see them. They were large women either of them. Very many saw them. Very many saw each one of them. Some saw them. Really not very many saw them, saw both of them. They were large women. Really not very many saw both of them. And that was a natural thing. There were two of them. They were together and they knew it then. They were not together and they knew it then. They were both large women and they were very different the one from the other of them, very different, and one, Ada, was younger and called her sister, sister Martha, and one, Martha was older and called her sister Ada.

There were two of them. They were each one of them rich. They each one of them had what they wanted, Martha when she was wanting, Ada when she was going to be wanting. And they both had not what they were wanting. The older Martha because she was not wanting it and the younger Ada because she could not come to want it. They both of them were spending money that they had and they were both of them very different one from the other of them. They were both of them doing what they were doing that is to say Martha was doing what she was doing that is to say she was not changing in doing what she was doing, that is to say she was going on and that was something that she was saying was a curious thing, that she was doing what she was doing and not changing and not doing that thing. Ada was doing what she was doing that is to say she needed to be doing what she was doing, that is to say she was having what she was having to do and she was doing what she was doing, that is to say she was doing what she was doing and any one could be certain that she was doing what she would be doing, that is to say she was doing what she would be coming to be doing and certainly then sister Martha was with her then and certainly then Ada was not doing that thing, certainly then Ada was doing something, certainly then she had something to do and certainly then she was doing something and certainly then her sister Martha was not then changing and certainly then they were rich ones and buying things and living in a way and sometimes then they were living in another way and buying some things and sometimes then they were not together and then they did not know it then that they were not any longer traveling together. They were each of them rich then. There were some whom they pleased then, each one of them, that is to say there were some who knew each one of them, there were some who knew both of them. There were two of them, they were sisters. There was an older one and she pleased some and she was interesting to some and some pleased her. There was a younger one and she was pleasing some and she was feeling something about this thing and feeling something about some pleasing her some. There were two of them, they were sisters, they were large women, they were rich, they were very different one from the other one, they had brothers enough of them, the older one had what she wanted when she wanted it, that is to say she did not have what she wanted because she did not want it. The younger had what she wanted when she was coming to want it, that is to say she did not have what she wanted as she could not come to want it. They were living together in a way and then they were living together in another way and then they were not living together.

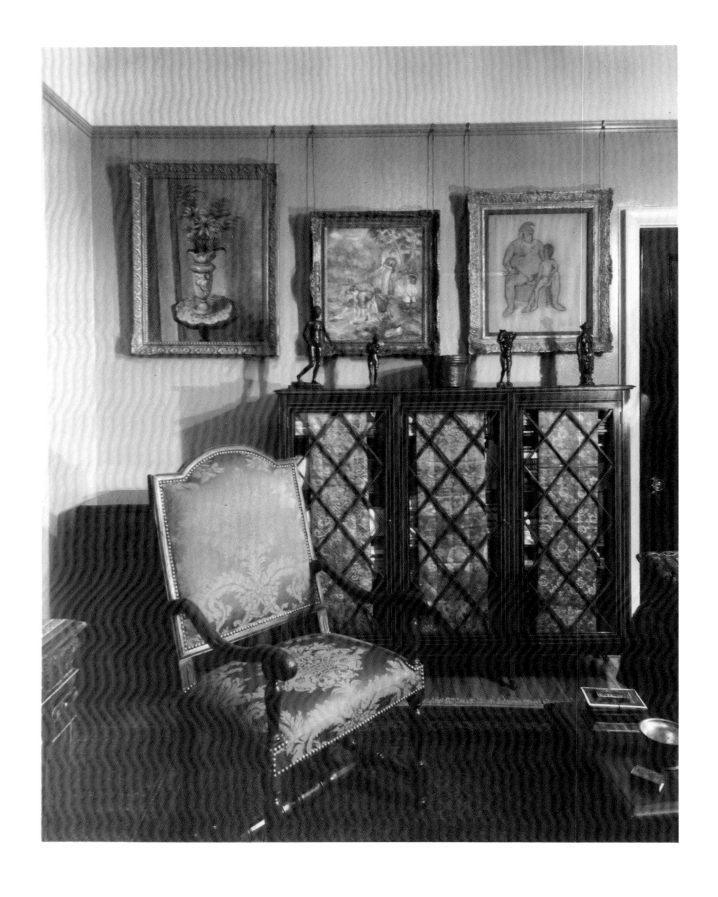

The older one was one who did with distinction telling about being one being living. She was one who was being living. She was one telling about this thing and many people were not listening. She was telling about this thing about being one being living, telling about this thing with some distinction and some were knowing this thing were knowing that she was telling this thing, telling about being living and telling it with distinction and they were not listening, were not listening to her telling about this thing, telling about being living, telling with distinction about being living. She was one being living and she was telling about this thing telling about it very often, beginning and going on then and certainly very many then were not listening.

The younger one was one being living and she was telling about this thing, telling again and again about this thing about being living and she was telling this thing and some were listening, certainly some were listening, and she was telling again and again about being one being living and certainly some were listening and certainly she did this thing again and again, she told about being one being living and certainly anybody might not be going on being listening and certainly some were listening and certainly some went on listening. And certainly sometime not any one was really listening, certainly some time pretty nearly not any one was really listening and certainly sometime she was to herself not telling about this thing not telling about being living and certainly in a way she was always telling about this thing telling about being living and certainly then in a way the older one was listening, and certainly then in a way not any one was listening.

The older one went on living, the younger went on living, they both went on living. The older one went on living. Certainly she went on living and certainly some were enjoying this thing enjoying that she was going on living, some who were not then listening, some who certainly would not be listening and she certainly would be telling and telling with distinction of being one being living. Some were certainly enjoying this thing that she was one being living. Anybody could be pleasant with this thing that she was being living. Mostly every one could not be listening to her telling this thing telling of being one being living and certainly all of living in her was being one telling with distinction of being one being living. She was being living, any one could remember this thing, any one could be pleasant in this thing, some could be tired of this thing, not really tired of this thing, any one could be pleasant with this thing, some were very pleasant in this thing in her being one being living.

The younger one was one being living, any one could be tired of this thing of this one being one being living, any one could come to be tired of this thing of this one being one being living. Any one could be careful of this thing of this one going on being living, almost any one could be pretty careful of this thing of this one being one being living. This one was one being one being living. Very many were quite careful of this thing of this one being one being living.

These two were being ones who were being living. They had been for some time ones being living. They had been living each one of them, they were living, each one of them, they were going on living each one of them. They were, each one of them, being living, they had been being living, they were going on being living. Each of them was a different one from the other one in having been living, in being living, in going on being living.

The older was one and any one could know this thing for certainly if she was not such a one she was not anything and every one knew she was something, the older one was one

29

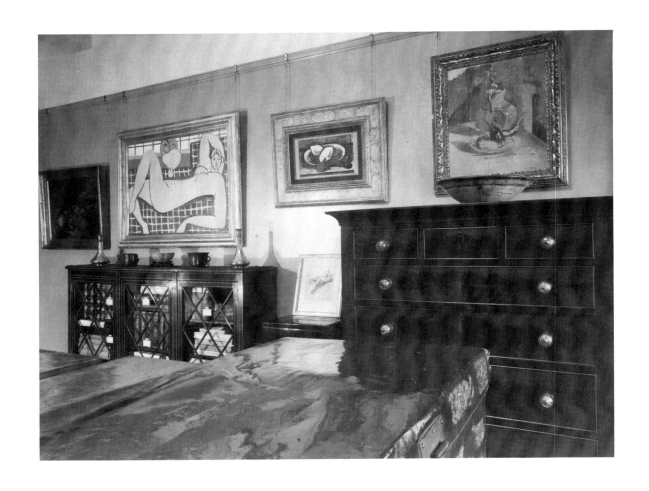

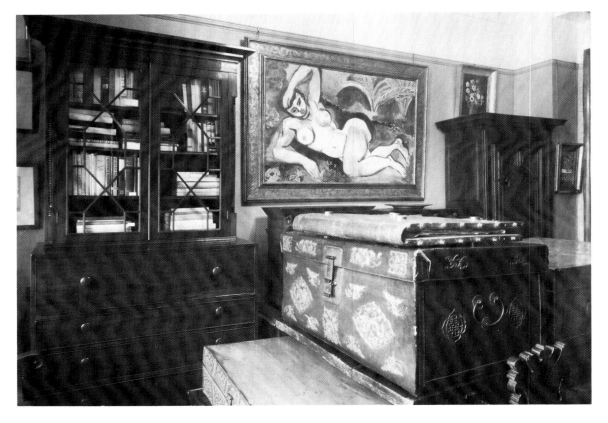

who had distinction and certainly she said that she did not do anything to be any one and certainly she did everything and certainly not anything was anything and would not be anything if she were not one having distinction. And certainly she was one having distinction and certainly some were interested in this thing and certainly she was doing nothing and certainly she was doing everything and certainly very many were very tired of this thing of her not doing anything, of her doing something, and certainly any one could know she was a person of distinction. She certainly did not do anything, that is to say she certainly never had done anything. She certainly did anything, that is to say she certainly was always going on doing something. She told about such a thing, she told about going on doing something, she told about never having done anything. She certainly never had done anything. She certainly was always really going on doing something.

She was a person of some distinction. She was not ever changing in this thing. She was not ever changing in anything. She was not changing in being one being living. She was not changing in being one not having done anything. She was not changing in being one going on doing something. She was not changing about anything. She was not changing in telling about this thing. She was not changing and certainly any one could come to be certain of this thing. She was certain of this thing, any one could be certain of this thing, any one could come to hear her be certain of this thing. She was a person of distinction. She was not changing in this thing. She had not ever done anything. She was not changing in this thing. She was going on in doing something. She was not changing in this thing. She was needing that any one was knowing any of these things. She was always needing this thing needing that any one was knowing any of these things, was knowing that she was not changing, that she had distinction, that she had not done anything, that she was going on doing something. She was needing that any one was knowing some of these things. Some were knowing some of these things, she needed that thing. Certainly her sister knew some of these things and certainly in a way that was not any satisfaction, certainly that was in a way considerable satisfaction, and certainly there was in a way considerable satisfaction in their being two being living who were, the one sister Martha and the other Ada, considerable satisfaction to almost any one. They talked to each other about some things, they did not talk to each other about everything and certainly they both were needing this thing that some one was knowing that they were being ones being living and not being then two of them, being then each of them.

The older, sister Martha, talked some and certainly she wanted to hear talking, and certainly some do want to talk some and want to hear talking and it is about something, something which they have not ever been doing and certainly some of such of them will not in any way really be doing any such thing, not in any way really be doing anything of any such thing. The older, sister Martha certainly was willing, was needing to be willing to be talking, to be listening to talking about something and certainly she would not ever in any way be doing anything of any such thing. Certainly she was one, if she had been one who was more of the kind she was in being living would have been needing to be really doing some such thing again and again. And certainly she was not ever really doing anything of any such thing and that was because she was one not needing to be willing to be doing any such thing and she was one needing to be telling and listening to telling about doing such a thing. Certainly she was one quite completely needing to be telling and to be listening to

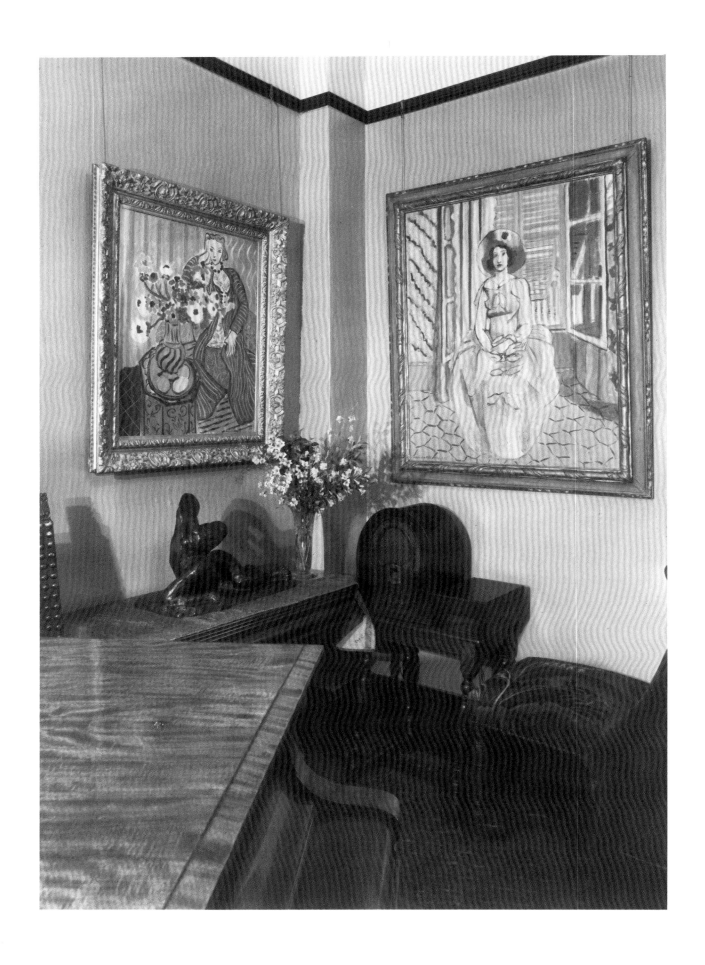

telling about doing some such thing. Certainly she was not one ever needing to be willing to be in any way doing any such thing. And this would be puzzling if it were not completely a certain thing and it is completely this thing. She was one being one of a kind of them that when they are that kind of them are ones completely needing to be doing some thing, some one thing. She was of that kind of them. She was of a kind of them and that kind of them when they are that kind of them are ones needing to be willing to be doing, really doing one thing and she was of that kind of them and she was not needing to be willing to be doing that thing. She was of a kind of them and some of that kind of them are ones needing to be telling and to be listening to telling about doing a thing and she was of that kind of them and more and more she was completely needing to be listening and to be telling and to be asking and to be answering about doing that thing. There are some and they are of this kind of them and they certainly are not telling or not talking about this thing, are not listening, are not asking, are not needing to be willing to be hearing, to be telling anything about any such a thing. Sister Martha then was of a kind of them of ones being existing.

Ada, the younger, certainly was of a kind of them of a kind being existing. She was one certainly hearing, certainly talking, she and sister Martha certainly were listening and were talking and about something they certainly were needing to be willing to be talking about and listening about. Ada, the younger, was one not willing to be needing to be doing that thing and certainly she was completely needing doing that thing and certainly she was not ever completely needing to be willing to be doing that thing. And this then was soon not completely interesting to any one but her sister Martha who certainly was interested in any such thing.

Ada, the younger, was one being living and certainly she was one being living in needing anything that was in her being living to be being living. She certainly was using anything in being living. That is to say she needed to be one being living and certainly she was needing to be using anything that could be something being living for her to be one being living. That is she was one needing being one being living, that is she was one needing to be one going on being living. She certainly was needing this thing, needing being one going on being living, and she was one not easily feeding to be one going on being living. Feeding on being living to be one going on being living was a thing that she was not easily doing. She certainly was needing to be one going on being living. She certainly was not one easily being living to be one going on being living. She certainly was needing to be one going on being living. She certainly was not easily feeding on being living, on anything being living, she certainly was needing being one going on being living. She was feeding some on something being living, on somethings being existing, on being living being existing and she was going on being living. She was needing going on being living. She did go on being living.

She was sometimes together with sister Martha, she was sometimes not together with her. She was one being living. She was needing going on being living. She was going on being living.

Any one being living can be one having been something. Not any one, some being living, can be one having been something. Some being living have been one being something. Certainly having been doing something and then not doing that thing and having been something and certainly then being something is something that has been making a living that is almost a family living in some one. Certainly sister Martha and Ada had been ones

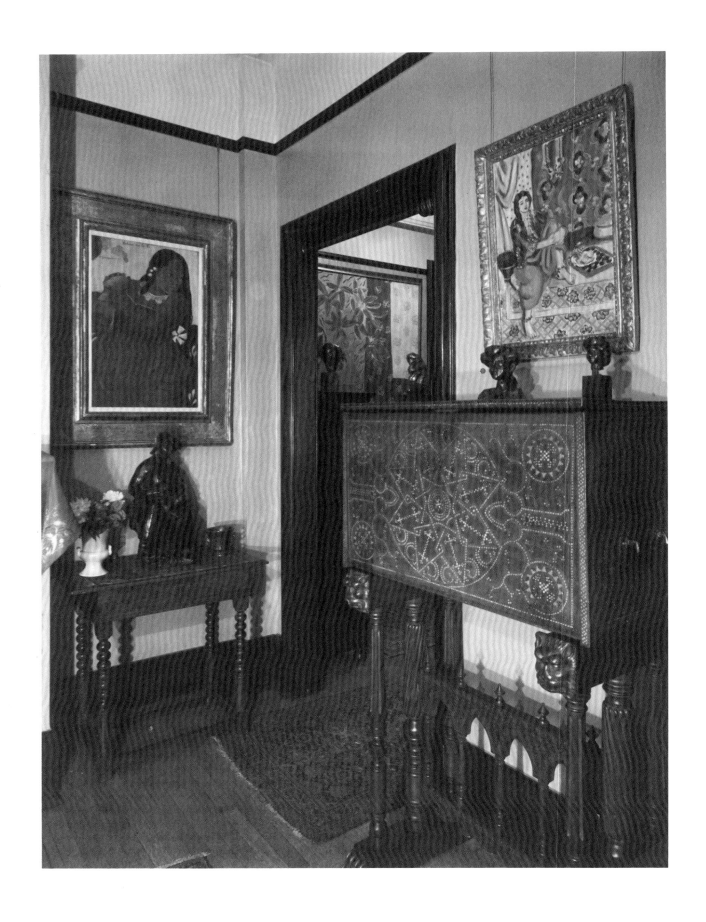

having family living and certainly they were ones having family living and certainly they were ones going to be having family living and certainly family living is something that is not existing in a family living together in any daily living. And certainly each one of them, each one of the two of them were living and had been living and certainly very many were certain of this thing and certainly such a family living was a thing to be remembering and certainly some could be certain that such a family living made any one have a finer feeling, and sometimes some one was quite certain that fine feeling was not then existing and certainly this thing was interesting to sister Martha and not convincing and certainly this thing was not interesting to Ada and sister Martha was not repeating this thing any too often and Ada was quite certain of any such thing, of fine feeling in a way being existing and sister Martha was pretty nearly certain of some such thing.

They were both of them certain that there was some connection between loving and listening between liking and listening and certainly some listened to each one of them and certainly there were some who were listening and liking the one to whom they were listening and certainly there were some who were listening and some having some tender feeling for the one to whom they were listening.

The older one, sister Martha, was one in a way needing that there should be some connection between liking and listening between liking her and listening to her and she was not in any way suffering in this thing, through this thing, she was not suffering for certainly some were listening and really then listening being existing certainly something was then being existing, listening was being existing, and certainly in a way there being some connection between liking and listening something was certainly in a way being existing. The older one then was one being living in something being existing and listening being existing, something was being existing, and there being some connection between liking and listening, certainly something was being existing.

The younger one was certain that there was completely a connection between tender feeling and listening, between liking and listening and she certainly was completely suffering in this thing, suffering from this thing. She was completely suffering and there certainly was connection between tender feeling and listening and liking and listening. She was almost completely suffering and certainly some were listening, quite a number were quite listening and certainly there is some connection between tender feeling and listening, and liking and listening. She had been suffering and she was suffering in there being a connection between tender feeling and listening, and between liking and listening. Quite a number were listening, certainly, quite a number were listening and in a way she was quite certain of this thing, quite certain that quite a number were listening and she was quite certain, she was completely certain that there was connection between listening and tender feeling, and listening and liking. She certainly had been, she certainly was going on suffering from this thing, she certainly was suffering in this thing. She was certain that some were listening and she went on being certain of this thing that quite a number were listening and certainly quite a number were listening to her and certainly that was going on being existing. She certainly was suffering in this thing in their being existing a connection between listening and liking and listening and tender feeling.

They were together and they were very often then not together. Certainly each one of them was sometimes then not with any other one. That is to say the older one was sometimes

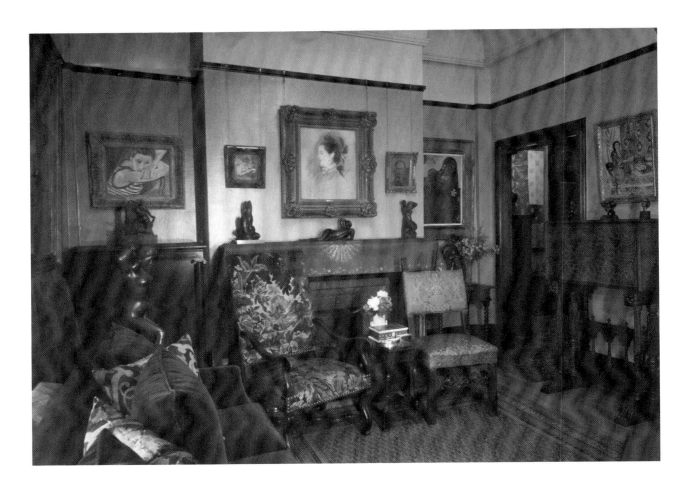

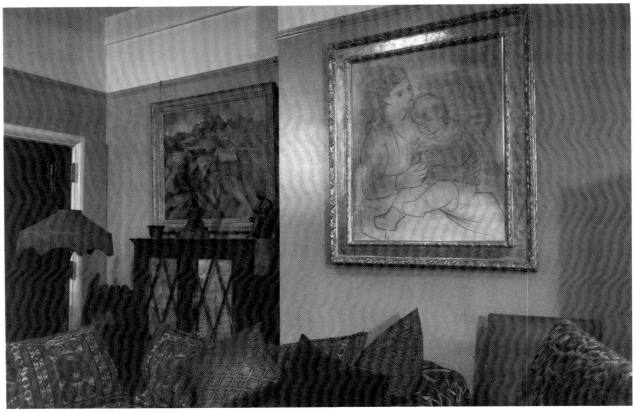

then not with any other one, she was very often not with any one and always then some one, some were in a way doing something and certainly then were meeting this one who was then being living. This one the older one in a way was very often not with any one. She was quite often not with any one. She certainly was not needing this thing. She certainly was not certain that she was not needing this thing. She was being living and certainly then very often she was not with any one.

She was not needing anything and she was needing being living and she was needing anything that she was needing for this thing for being living. She could be needing very much for this thing for being living. She was having something to be doing this thing to be being living, she was using a good deal for this thing for being living and in a way she was not needing anything and she was needing to be living and she was using quite enough for this thing for being living.

She was using some for this thing, for being living, that is to say if not any one were living she would not be living and really then she was not using them very much, she was not using any one very much, she was using them and really she was not needing that they should be any one. She was not using women and men and not at all children to be one being living. She was not using any one of any of them. She was needing being living and a good deal was being existing in this thing, she was not using very much of anything for this thing, a good deal had to be existing for this thing.

She was very often not with any one, quite often not with any one and she was being living and enough had to be being existing for this thing, quite a good deal had to be existing for this thing. She was one not needing to be very often with not any one. She was one not needing anything, not needing any one, she was one needing, pretty well needing being living and she was one needing that enough things be existing and in a way she was not using any of them anything being existing.

The younger one was sometimes not with any one and certainly this was not what this one was needing she certainly was needing being with some one and certainly she was sometimes with her sister Martha and in a way she was not ever really needing this thing needing being with the older one. She certainly was needing that the older one, that sister Martha had been and was being existing. She the younger one was certainly needing using something and some one and very often any one and certainly very often she was not doing this thing she was not using anything she was not using any one and certainly then she was with some one for she was one who certainly was needing going on being living. She certainly was needing that she was going on being living and certainly she was completely needing for this thing to be using some to be using some things and certainly sometimes she was almost completely not using anything not using any one and certainly then she was still with some one, still with something for certainly she was one going on being living.

Certainly each one of them were ones that might have been better looking, might have been very good-looking when they were younger ones and this had not been, they had not been as good looking when they were younger ones as they were when they were older ones neither the one nor the other of them. They were quite good looking when they were older ones, they were quite big enough then for this thing for being good looking and quite old enough then for being good looking, they were big then and old enough then and they certainly were quite good looking then. When they were older ones they were ones saying

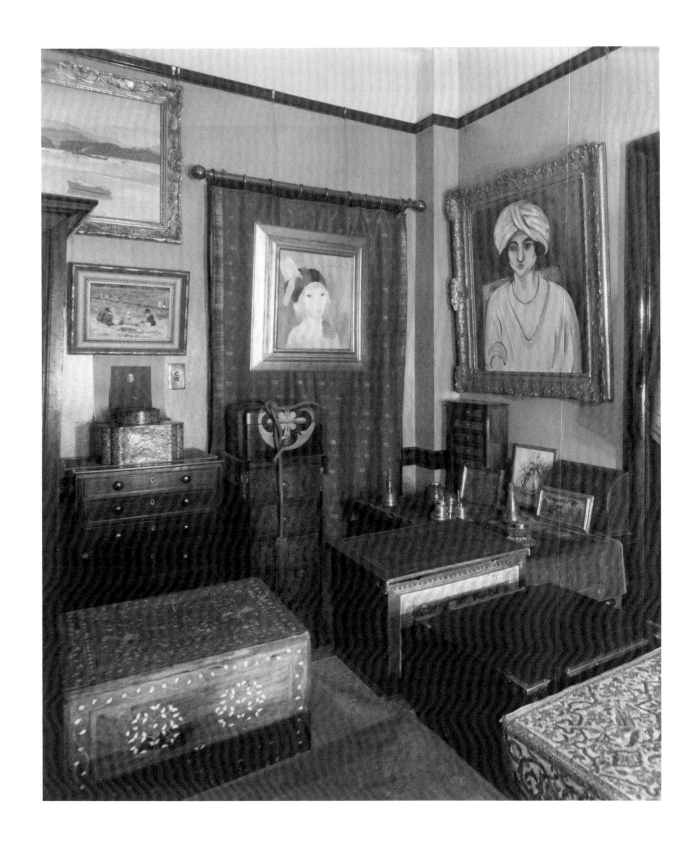

again and again and again, and some one always was listening, what they had had as pretty nearly feeling when they were younger ones. When they were younger ones they certainly were feeling some thing and certainly then they were not ever completely saying that thing saying what they were feeling and they were certainly not then saying it again and again and they certainly were then not completely feeling that thing the thing they were later in being older ones saying completely and again and again and again. They were, each one of them, saying something when they were young ones and saying it again and again and they were feeling that thing and they were really feeling something and more and more they were ones completely feeling that thing and completely saying it again and again and again and again and again. They were, each one of them completely feeling a different thing from the other one of them and completely saying that completely different thing. Each one of them was completely saying a complete thing and saying it again and again and again and again and again and again and again.

Martha was quite young once and that was never of any interest to herself or any one. She did some things then, that was a natural thing. She was not ever completely interested in having done any of them. She was quite young then a completely young one and not any one then was very proud of this thing that she was a young one then. Some one may have been then a little proud of this thing that she was a young one then, it was not an interesting thing her being, her having been a young one.

She had been a quite young one, there were many others in the family then, some being very young ones then some being a little older ones then, there were always many others in the family and that was certainly a thing that was quite interesting.

Martha then was not any longer such a quite young one. She certainly then was doing something. Any one could then have been proud of that thing that she was certainly then doing something. Enough were then proud of that thing that she was doing something. She was interested enough in that thing that she was doing something. All her life then, all the rest of her living, she was doing that thing she was interested enough in doing that thing, some were proud enough of that thing that she was doing that thing. And certainly she was interested enough in doing that thing and certainly what she had done and was doing was not in any way completely interesting and it was almost completely interesting as being something that she had been all her living doing and finding interesting to be one being doing that thing. So then Martha was not any longer quite a young one and certainly then there were a good many of them and they were all of them being ones any one could be remembering as being in the family living. There were many of them and all of them were proud enough and interested enough in this thing and certainly Martha was one of them and certainly not any one of them was completely anything excepting that any one of them and all of them were being living.

Martha was then one being living. She was then not such a young one, she was almost then an older one and certainly then she was being living and so were all of them and so was any one of them. Certainly any one of them might have it come that something would stop in going on and then that one would not be any longer living. Certainly this could, certainly this did happen to some of them and certainly then all of them were remembering this thing that something could be stopping in them and they would then not be being living. And this could sometime happen to Martha and she could sometimes be remembering to

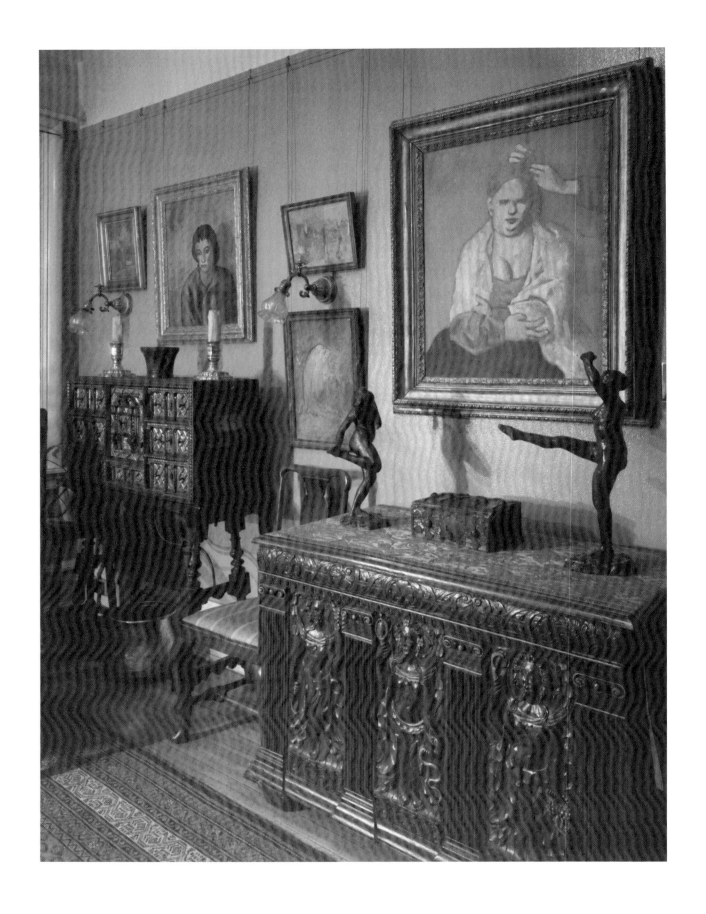

think about this thing and this then was not an interesting thing as happening to any one of them, it was an interesting thing as being something happening to each of them and certainly it was not a thing going to happen to each of them but it was as such an interesting thing to Martha and as such she was completely remembering it and certainly she was almost remembering that perhaps it would not be happening to herself ever and certainly it could be happening to herself.

Ada the younger one was always completely remembering such a thing could be happening to herself, she was always completely remembering this thing. She was always completely remembering that there were very many of them. She was not always completely remembering that this thing could be happening to every one of them. She was very often remembering this thing that that could be happening to all of them, she was always completely remembering that it could be happening to herself, she was not ever completely remembering that that thing could be happening to any one of them, she was remembering this thing after it had happened to one of them and she was completely remembering this thing after it had happened to another one of them, and she completely remembered this thing after it had happened to another one of them. Certainly this thing did not happen to her in her being living and certainly she completely remembered all her being living that it would happen to her in her being living.

She had been a young one a quite young one and this had been completely enough interesting to her then so that she was completely certain that having been a quite young one was a thing that any one could be remembering. She had been a completely young one and certainly then she had been then not doing anything and certainly she completely remembered this thing and some other ones could remember this thing. Even her sister Martha could remember this thing and certainly she did not remember this thing. Certainly some did remember this thing. Ada was then not such a quite young one and certainly then she did not do anything and certainly then it was an important thing to any of them that she was then being one who was one remembering that each one was being living then and needing this thing needing being living. She was one then who was not completely interested in that thing in herself then, in being one being living, she was certainly then being completely interested in being one going on being living. She always went on being living.

Surely Ada would like to have been one going on living and she was remembering that she had been going on living and she was remembering that she had been liking going to be enjoying something then. She certainly, then when she had been going on being living, she had been certain that she could be coming to be enjoying something that sometime she would be having. She certainly was needing then to be going to be enjoying something. She certainly was then going to be enjoying some one and she certainly knew this thing then and could tell any one this thing then that she would be enjoying some one and certainly then she was going on being living.

She certainly could remember this thing, in a way she could remember anything, and certainly in a way she did remember everything. She always could remember that she would enjoy some, that she would enjoy somethings. She always did remember that she had been going on being living. She always could remember this thing. She always did remember this thing. She always could remember that she would enjoy some, that she could enjoy some things, that she needed this thing to be one going on being living and she always could

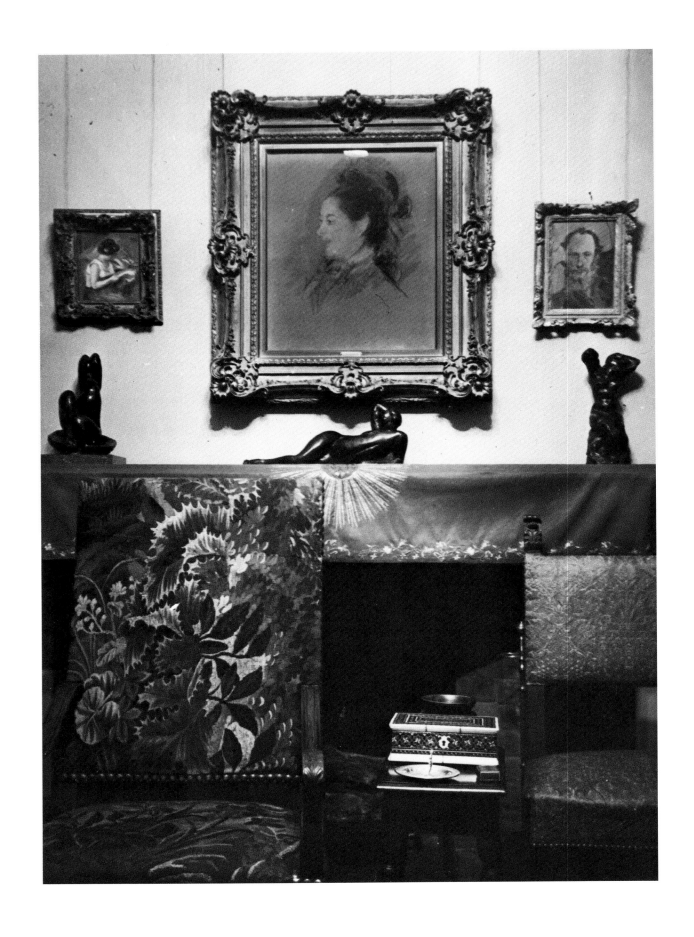

remember that she had always been going on being living. She could remember everything. She was remembering everything. She was remembering that she had been going on being living. She remembered that she could enjoy some, that she could enjoy somethings, that she had needed this to be one going on being living. She could remember everything. She did remember everything. She remembered again and again that she had gone on being living. She remembered again and again that she could remember this thing that she could remember, that she did remember that she had gone on being living. She did remember this thing. She remembered some other things. She remembered everything. She remembered that anything might happen and that certainly she was not needing that thing that anything was happening. She remembered and remembered it again and again that not any one was remembering any such thing that anything might be happening and that she was completely remembering this thing. She remembered this thing and she remembered that she had been going on being living.

She was not, to every one, remembering everything, and certainly she did remember this thing, she did remember that, to some, she did not remember everything, she did remember that some did not remember everything, that they did not remember that she could remember everything. She could certainly not forget this thing that some did not remember everything.

She certainly was one needing going on being living. She certainly was being living. She certainly had been going on being living. She certainly was going on being living. She certainly went on being living. She certainly remembered everything of this thing of going on being living. She certainly remembered everything. She certainly remembered about some remembering everything. She certainly remembered about some not remembering anything. She certainly could remember everything. She certainly remembered again and again this thing remembered that she could remember everything.

She was younger than her sister. Her sister was older. She called her sister, sister Martha, her sister called her Ada. When they were together they were each one of them certainly being living, the older was then certainly being living, she was knowing that thing, her sister was knowing that thing, the younger was then going on being living, the younger then knew that thing, the older one then knew that thing.

They were together and they were both being living then. They were not together and they were both being living then. The older was being living then. The younger was going on being living then.

The younger one was always remembering that they were both being living. The older was not ever forgetting that they were both being living. The younger was knowing that the older was being living, was knowing that she herself was needing going on being living. The older was knowing that the younger was going on being living, that she was needing this thing, she was knowing that she herself was being living.

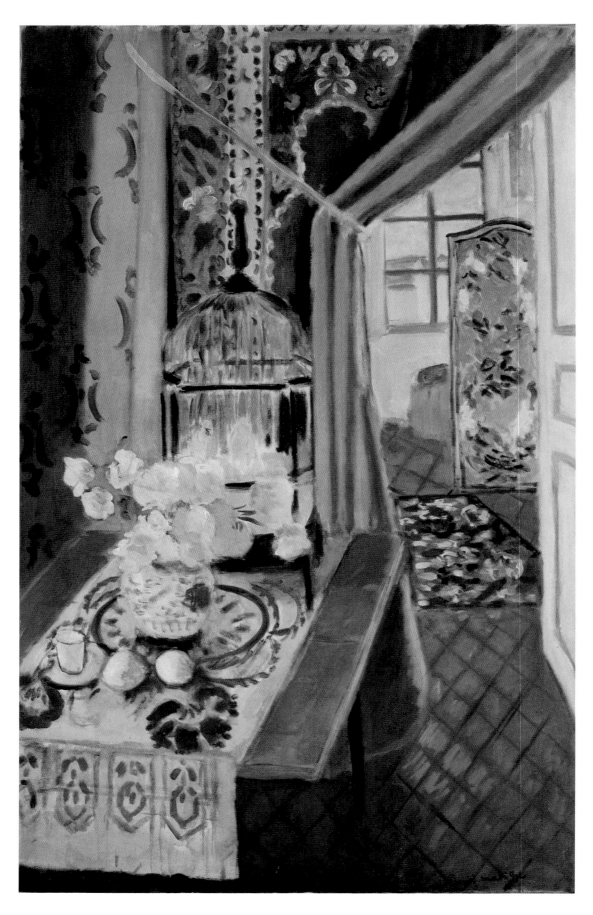

Henri Matisse. *Interior, Flowers and Parakeets*. (1924). Oil on canvas. BMA 1950.252.

Dr. Claribel and Miss Etta

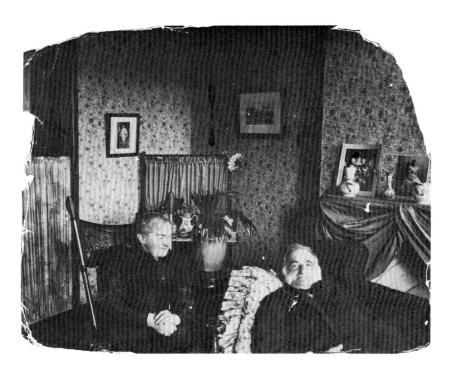

Helen and Herman Cone, 1607 Eutaw Place, Baltimore, ca. 1895.

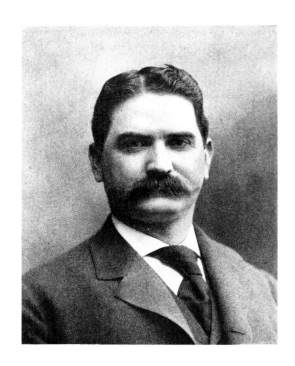

Brother Moses Cone, 1857–1908

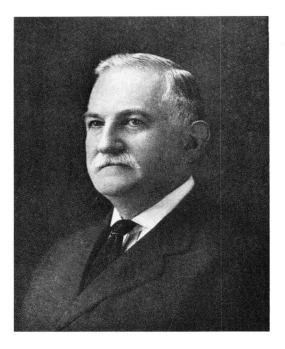

Brother Ceasar Cone, 1859–1917

There were two of them, they were sisters, they were large women,
they were rich, they were very different one from the other one....

Gertrude Stein
Two Women

I.

The psychodynamics of Dr. Claribel and Miss Etta Cone, spinster sisters from Baltimore who in the early decades of the twentieth century together formed one of the premiere modern art collections in America, eluded even the astute literary voyeurism of Gertrude Stein. In Stein's "word portrait" of the Cone sisters, written between 1908 and 1912 and first published in 1925, she grappled in her characteristic style, based on highly structured repetition, to define the personalities of the sisters but captured them only in opaque outlines. If her word portrait fails to communicate much detail about either sister, it nonetheless conveys significant truths about Claribel and Etta, and especially about a sibling relationship that was apparently of special fascination to Stein.

"There had been a father and there had been a mother and there were brothers and quite enough of them." Father Herman was born a Kahn in Altenstadt, Germany in 1828. He emigrated to America in 1846 and joined his married sister in Richmond, Virginia. At some point the family name was translated to Cone. Herman worked as a dry goods peddler in the southern states and by 1855 assumed co-ownership with an Adler cousin of a grocery store in Jonesboro, Tennessee. In 1856 he married Helen Guggenheimer of Natural Bridge, Virginia, and over the next twenty years they had thirteen children, ten boys and three girls. Moses, the eldest, was born in 1857 and Frederic, the youngest, in 1878. Albert, born in 1886, died in infancy, and Monroe, the fourth child, died in 1891 before his thirtieth birthday. The eldest daughter, Carrie, was born in 1861; married in Baltimore in 1883 to Moses Long, she eventually established her own family household in North Carolina. Claribel, the fifth child (born November 14, 1864), Etta, the ninth child (born November 30, 1870), and Frederic, the thirteenth, never married and eventually maintained a joint household in Baltimore under Miss Etta's management.[1]

Having lived through the Civil War with apparently minimal disruption, in 1871 Herman sold his half share in the Jonesboro grocery store and moved with his wife and eight children, including seven-year-old Claribel and infant Etta, to Baltimore where he bought a house on Lanvale Street in Bolton Hill and opened a wholesale grocery store. In 1878 the business

was renamed H. Cone & Sons, reflecting the active involvement of eldest sons Moses and Ceasar (born 1859), who worked as "drummers" throughout the south for their father's business. By 1880 the family moved to a more spacious and elegant brownstone at 1607 Eutaw Place, a then fashionable residential district, and participated in the social life of a large German-Jewish community, including numerous Guggenheimer relatives as well as Bachrachs, Franks, Gutmans, and Bambergers. The Cones were members of the neighborhood congregation and Helen Cone attended weekly services, but religion was not a central part of the family life. In May of 1882, with Moses in charge of the family business and Carrie smoothly managing the family household, Helen and Herman Cone departed for a four-month European trip to visit German relatives and to make the "Grand Tour." The business prospered and in 1890 H. Cone & Sons was dissolved, with Herman Cone's profits loaned to Moses and Ceasar who in turn founded Cone Export and Commission Company based in New York City. Within a few years the Cone brothers had become owner-operators of many small southern cotton mills, the base of what would become an enormously successful financial empire. In 1893 the company established a main office in Greensboro, North Carolina, and expanded with construction of the Proximity Manufacturing Company (cotton mills), the White Oak Mills (the largest denim manufacturing plant in the world), and the Proximity Print Works (printing mattress ticking, indigo drills, and khakis). The Cone Mills, known as a "community" rather than as a company and recognized as a leader in employee welfare, operate to the present day (though, since 1984, no longer under Cone family control). Herman Cone, suffering from heart trouble, retired when his business was dissolved; the family was supported from that time by Moses and Ceasar through the success of Cone Export. Herman died in 1897 and Helen in 1902.

"They always knew this thing, they always knew that one was the elder and one was the younger.... Each of them was one of the two of them.... The younger called the older sister Martha [Claribel]. The older called the younger Ada [Etta]." In a remarkably telling transposition, Gertrude Stein assigned the fictional name Martha to Claribel, having used the same name (Martha) to represent herself in the 1906–1908 fictionalized autobiographical work, *The Making of Americans*. For Etta she adopted the name Ada, having previously assigned the name Ada to represent her life companion, Alice B. Toklas, in her earlier word portrait of Alice. Stein's original autograph manuscript (at Yale) is inscribed on the inside cover "Cone Sisters" and dated both "1908–1912" and "1910–1912."[2] The manuscript includes extensive working notes by the author, all of which reveal more about the Cone sisters than anything Stein allowed into the typed and published versions:

> Go on with their lives and their duties and their [worth?]. Go on with how one of them is more something than the other one, and how each one of them thinks it of themselves and the other one. Claribel [as?] Etta, Etta [as?] Claribel. Both [as?] the Cone family.

> Tell about the others connected with them, their duties and how they did them, what effect they had when they were traveling, how they quarreled, how they spent money, how they each had what they wanted, Bertha [Martha] when she wanted it, Ada when she was going to want it. Stinginess, buying scarfs. [Handling?] things, patting hair, a little crazy, dress-making scenes, friends of each. Pleasing anybody. Etta and no [faith no worth?]. [Widow?] and [marry?] again. sex in both.

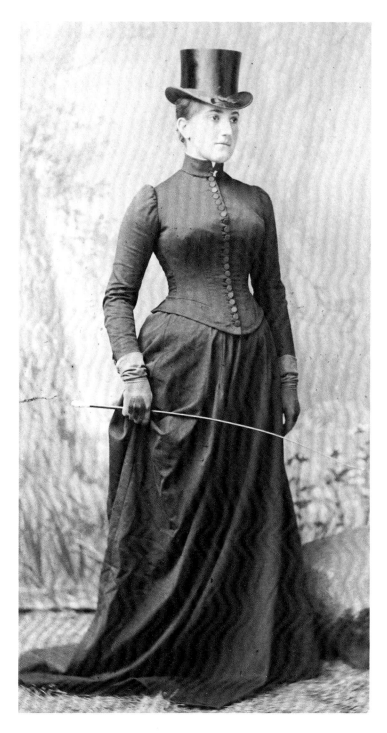

Etta Cone, ca. 1890 (age 20?).

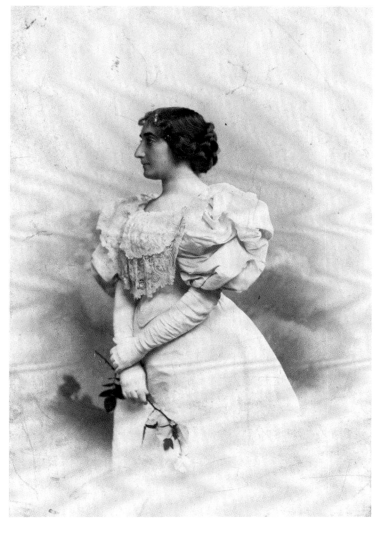

Claribel Cone, ca. 1883 (age 19?).

Complete description of the two, each one of them, life history. Etta family father and mother, Ida, house, Saturday evening, Hetty, Claribel, Sidney, Clarence, Hortense, etc. Amy, Carrie Gutman. Claribel, career, [Mrs. Lud?], etc. and the young man, reading, Flxner, sex, germans, bon marche, boxes, science, photographs, Etta, [Brother?] [Mosey?].

Go on about Ada. The younger Ada.

Describe Ada the whole [family?] youth Ida, brother, art, flattery, family, lady etc.

Go on with lives and family lives and family quarrels.

Go on with their lives.

Go on with their lives and their needs for young womanhood [one?]. How being old is saying what you used to feel.

Go on with each one of them young and older and old and other people. and then a short narrative of how much money they had and what they did with it, to whom they left it. their family and their relations the number of brothers and sisters they had how they liked them and how their mother and father died and how they died and how they were afraid of heart complaint and how ~~Claribel~~ Bertha [Martha] had it and ~~Etta~~ Ada didn't.

Go on with Etta's private life and then a little more of both of them and [sumery?] and so end.

It is apparent in Stein's choice of naming that she intended to draw parallels between Gertrude/Claribel/Martha and Alice/Etta/Ada. Certainly Stein's writings reveal an acute and persistent interest in dependency relationships, whether familial, marital, or sexual, and it would appear that she observed similarities between the interpersonal relations of herself and Alice, and those of Claribel and Etta, despite what might seem to be overriding differences. (In using the same name Ada for both Alice Toklas and Etta Cone, Gertrude Stein may have been archly clueing her readers to a possible intimate relationship between herself and Etta.) Gertrude/Claribel/Martha was the elder, the professional, the accomplished, the admired, the dominant; Alice/Etta/Ada was the younger, the housekeeper, the helpmate, the oft-overlooked, the subservient. Alice devoted her life to the person and career of Gertrude; Etta, though adopting a more literally independent lifestyle, demonstrated a lasting devotion to her sister that reflected an equally powerful psychological dominion by the elder Claribel. Gertrude and Claribel both aspired to the medical profession (a still unconventional career for women in their time, even though in the 1890's there were 4,500 practicing female physicians in the United States); Alice and Etta were routinely educated, sustained a lifelong interest in music, and were admirable domestic managers and agreeable hostesses. Gertrude and Claribel were lionized for their brilliance and daring eccentricity ("Everybody delighted in Doctor Claribel," wrote Gertrude Stein in her *Autobiography of Alice B. Toklas*); Alice and Etta kept the company primarily of women ("the wives of geniuses," said Stein condescendingly in *The Autobiography*) and saw to the daily comforts of their more charismatic companions. In Paris in the early years of the century Gertrude and Claribel were at the center of discussions about art and ideas; Alice and Etta heard about hats, cosmetics, and dogs. It was only in their years alone, after the deaths of Gertrude and Claribel, that Alice and Etta, each in her own way, attained independence and individual prominence and asserted their own feelings and views though both continued to avow dependence on their

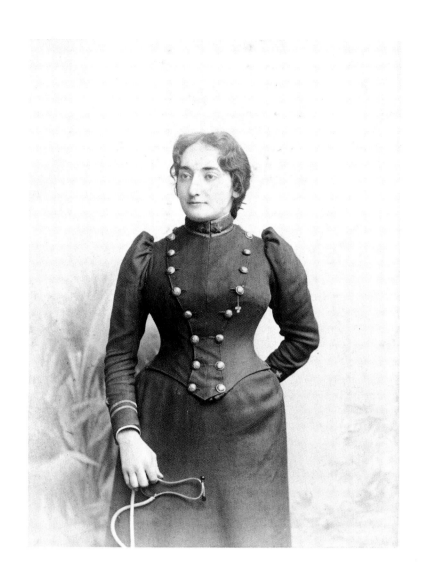

Claribel Cone, ca. 1891–1892 (age 27–28), as resident at Philadelphia Hospital.

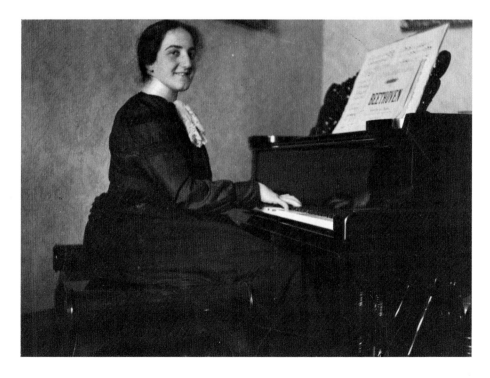

Etta Cone, early 1900's (age early 30's).

much-mourned companions. Even three years after Claribel's death, Etta wrote Gertrude Stein, "Life continues very empty without her [Sister Claribel], but I am trying to carry on as she would have wished done" [letter from Etta Cone to Gertrude Stein, September 14, 1932, Paris (Yale)].

The nature of the sibling relationship between Claribel and Etta was set from a very early date. Claribel, six years senior, was an independent child devoted to books. She resisted domestic duties, and never took to socializing. All of the Cone children attended Baltimore public schools, and Claribel graduated from Western Female High School in 1883; in the fall of 1886 she enrolled at the Woman's Medical College of Baltimore. In the summer of 1886, perhaps in a last effort to divert her from her intended goal, Herman Cone escorted Claribel on a trip to Munich, in a country that would become virtually a second home to Claribel in later years. The Woman's Medical College had been founded in 1882, the first in the south to accept women and only the fifth school in the country where women could study medicine. Neither Claribel nor Gertrude Stein were activists in the then nascent women's rights movement, and it is impossible to know precisely how or why Claribel decided to pursue a medical career. Claribel graduated first in her class in 1890 and that summer did postgraduate work in gynecology at The Johns Hopkins Medical School. She then went on to Philadelphia where she did postgraduate work at the Woman's Medical College of Pennsylvania and at the University of Pennsylvania between 1890 and 1891, and won a residency at the Philadelphia Hospital (known as Blockley Hospital), where she worked in 1891 and 1892, staying in close contact with her family all the while. She was aware of the 1892 arrival in Baltimore of Leo and Gertrude Stein (born 1872 and 1874) who were sent to live with Bachrach relatives after the death of their parents in California. The Steins joined the same social circle common to the Cones, and the families would have had fairly frequent contact. Claribel returned to Baltimore in 1893, committed to medical research and teaching rather than to a clinical practice. She moved back into the family home on Eutaw Place where Etta was now efficiently in charge of household affairs. Between 1893 and 1895 Claribel held the position of Lecturer on Hygiene at the Woman's Medical College and from 1895 to 1910 (with significant periods away from Baltimore for either personal or professional reasons) served as Professor of Pathology at the College and as pathologist at the Good Samaritan Hospital. In 1900–1901 she held the prestigious position of President of the Woman's Medical College of Baltimore. During these same years she continued postgraduate studies and research at The Johns Hopkins Medical School, specializing in pathology and working under the renowned Professors William H. Welch (1893–1903), William Osler (1903–1904), and Simon Flexner (1907–1910). From 1903 to 1906 she also did research in pathology at the Senckenberg Pathology Institute in Frankfurt-am-Main, studying with Professors Karl Weigert and Eugen Albrecht, Director of the Institute. According to a curriculum vitae in Claribel's handwriting and a typed transcription probably prepared at the time by Etta, and dating from about 1910–1911, she " . . . worked in Pasteur Institute—summer of 1904—and in other Institutions for periods too short to mention during residence abroad (1903–1907). . . . "

As the only daughter not married or otherwise committed, Etta, upon graduation from Western Female High School in 1887, assumed the role of caring for parents, brothers, sisters-in-law, and nieces and nephews. Moses and his wife Bertha lived at the Eutaw Place house and must have been an even more dominant presence than either parent or the busy

Claribel. Etta rarely traveled away from home except to visit Sister Carrie in Asheville, North Carolina, and the several brothers in Greensboro who managed the Cone Mills there. She participated in an active social and cultural scene in Baltimore and, after the arrival of the Steins, apparently spent considerable time in the company of the reputedly very magnetic Leo Stein who was already devoted to art and aesthetic ideas. It may have been under Leo's influence that Etta took advantage of lecture programs, concerts, and recitals sponsored by The Peabody Institute (opened to the public in 1866), fine arts exhibitions sponsored by various local arts clubs and at the Peabody art gallery (after 1879), and the collections at the William T. Walters private gallery (intermittently open to the public in about 1876). Young people in the Cone circle met and talked in a group called the Sociables, and there were several other social clubs typical of the period that sponsored a wide range of private cultural activities.

In 1892 Leo Stein entered Harvard University, and in 1893 sister Gertrude Stein followed him to Cambridge to enroll at Radcliffe College where Professor William James became a pivotal influence. It was on James's recommendation that Gertrude Stein enrolled as a first-year medical student at Johns Hopkins in Baltimore in 1897, immediately following her graduation from Radcliffe. In these same years Dr. Claribel Cone was still involved in special research at Hopkins, and Claribel and Gertrude shared the trolley ride from their homes to the end of the line on Broadway, where they walked together the several blocks to the hospital buildings where they worked and studied each day. Both were physically imposing women and both were active talkers. They were apparently a remarked presence in the neighborhood. Gertrude Rosenthal reports that Saidie A. May—many years later to be a major art collector herself and the source of an important collection of primarily European art of the 1930's and 1940's given to The Baltimore Museum of Art—remembered sitting as a young girl on her family's front stoop in East Baltimore and watching Claribel Cone and Gertrude Stein walk past each day, a pair of women already known as daring individualists within the Baltimore community. For Saidie May, whose personal eccentricity would eventually rival that of the older women and whose influence in the contemporary art world would be almost as significant, the image of Dr. Cone and Miss Stein confidently passing by must have been memorable indeed. It is reported that Gertrude was impressed with Dr. Claribel's story-telling abilities—stories that would be broken off at the end of one day's walk and taken up again the next. For her part, Dr. Claribel must have been impressed with the young Gertrude (ten years her junior), whom she invited to lecture to a Baltimore women's group. This speech, representing one of Stein's earliest public literary endeavors, was titled "The Value of a College Education for Women."

Throughout these years Claribel hosted open houses at Eutaw Place for her friends and colleagues, which included Gertrude and Leo Stein on occasion. These Saturday evenings were notable enough to have been reported in a Baltimore newspaper account of the day: "Dr. Cone's Saturday night parties, which she kept up for many years, came as near to forming a salon as anything that this city has ever known. To them came clever people in every walk of life—musicians, artists, writers, scientists—and the discussions which ensued sparkled with wit and wisdom."[3] Leo and Gertrude Stein, living together in a house on Biddle Street managed by a German housekeeper, also occasionally had friends in for social evenings focused on art and books. Gertrude and Leo later established in their Paris home at 27, rue

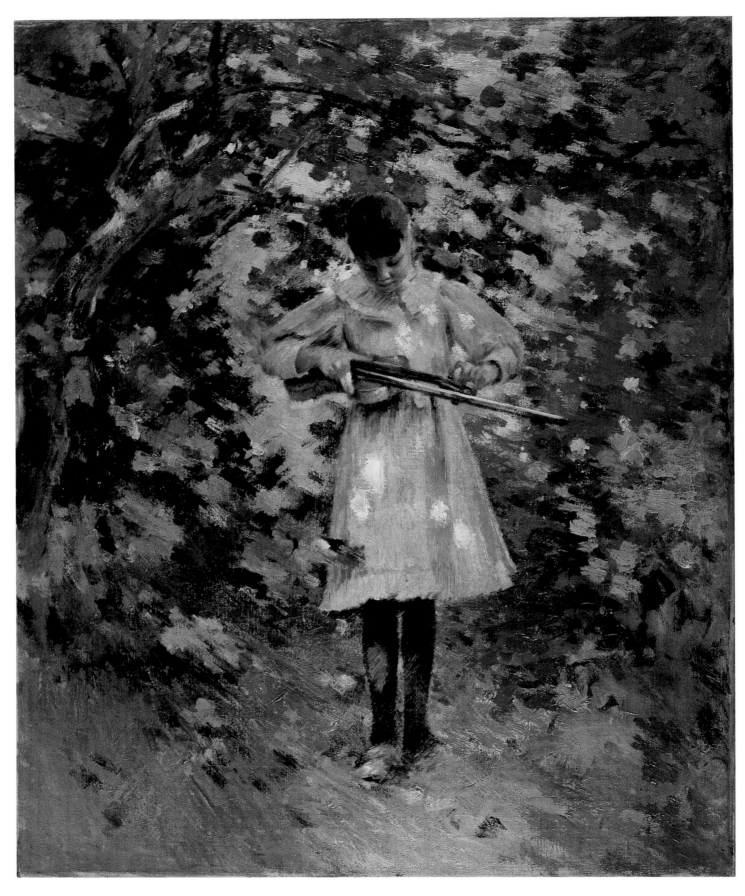

Theodore Robinson. *The Young Violinist*. (late 1880's). Oil on canvas. BMA 1950.290.

de Fleurus their own weekly Saturday evening salons, attended over the course of several decades by hundreds of artists, writers, critics, American soldiers, and the merely curious. (In Paris at the same time older brother Michael Stein and his wife Sarah also held Saturday evening salons, independent of Gertrude's a few blocks away, and it was often to the elder Steins in the rue Madame that the Cones would go, rather than to Gertrude's, as their notebooks attest.) Despite this exposure to art and aesthetics, principally deriving from Leo Stein in these early years of the century, neither Etta nor Claribel demonstrated any particular interest in collecting. Leo brought back from a trip to the Orient a large group of Japanese prints, which the Cone sisters saw, and Gertrude surrounded herself with books of every description. The Steins traveled to Europe in the summers, and Leo was especially involved with the art of Renaissance Italy.

In 1898, some months after the death of Herman Cone, Brother Moses had given Etta $300 when she expressed her wish to buy something to brighten the Eutaw Place parlor. Etta traveled to New York with sister-in-law Bertha, and together they visited the exhibition of paintings from the estate of Theodore Robinson, scheduled to be auctioned at public sale on March 24, 1898. There is no evidence to explain either how Etta knew about the sale or, for that matter, what attracted her to Robinson's work.[4] She indicated her preferences among the works on exhibition, and authorized a bidder "to get as many for the money as possible." Back in Baltimore a few days later, she was informed by Bertha (still in New York) that the $300 had bought five Robinson paintings: *Mother and Child* of the mid-1880's, *The Young Violinist* of the late 1880's, *In the Grove*, ca. 1888, *The Watering Place*, 1891, and *A Lock*. All were modest in size, and each depicted a figure subject in a closely circumscribed landscape setting. Robinson was certainly not unknown at the time of his death in 1896. His work had many admirers, had been widely shown, and was acknowledged as central to the movement identified as American Impressionism. Although generally viewed as an American student of the work of French Impressionist Claude Monet (from 1888 to 1892 he lived and worked in Giverny, near the French master), his work often seems more indebted to that of the Barbizon master Corot, about whom Robinson wrote an admiring article published posthumously. Given the lively art conversations in the Cone-Stein circles, it is not impossible that the name of Robinson would have been raised, especially in the context of discussions about the then current subject of French Impressionism and its influence. The Robinson paintings bought by Etta in 1898 foretell, at least in subject matter, the direction the later Cone Collection would take. Although painted with the sun-drenched palette and dappled touch of Impressionism, the subjects are realistically rendered and sentimentally portrayed. *The Young Violinist* speaks to Etta's love of music and is not so far removed from musician subjects painted by Matisse and acquired by the Cones in the 1920's. Similarly, several Cone Matisses of young women in domestic interiors reveal a contextual sensibility not unrelated to that of the Robinsons.

However Etta came to Robinson's work, she was in 1898 reaching out to something beyond her direct experience, to what was then the still exotic and generally unaccepted world of contemporary art. Nonetheless, by selecting the traditional subjects she did, she managed to retain an appropriate degree of propriety essential to her self-respect as a well-bred maiden lady of the upper classes of Jewish society. For the rest of her life Etta would be challenged in a way that Claribel apparently never was—perhaps in part because of the

confidence engendered from her status as the elder—by internal conflicts between propriety and eccentricity. Invariably, she selected art works that retained traditional subject matter even when that very traditionalism seemed to subvert the artist's formal invention. Attracted to modernism, her personal taste was narrowly circumscribed by her essentially Victorian upbringing and forever constrained her capacity to embrace anything beyond relatively realistic figure and landscape subjects. For a lifetime she rejected abstraction, expressionism, and any extreme distortion from representation. It is clear that Etta knew who the moderns were; it is equally clear that she did not fully grasp why they were modern or precisely what was modern about their work. She definitively knew what she liked, and what she liked altered very little over the course of years. She did not buy paintings for their formal innovation; she demonstrated little understanding or appreciation of line, form, color, composition. In 1898 she bought five Theodore Robinsons to decorate her family home, and for the next fifty years she bought the work of some of the most radical artists of the twentieth century—albeit not always their most radical statements—essentially for the same reason, to decorate her family home. This premise is in some way fundamental to understanding Etta and hence The Cone Collection. Years later Etta noted, with more than a trace of defensiveness, "But remember, the Cone Collection began before that. The first pictures were the Theodore Robinsons that I bought for my parents' house in 1898."[5] It is significant to note that Etta's pride in The Cone Collection drew little distinction between the modernism of Robinson and that of Matisse, and that she was sharply conscious of her own role in initiating the collection. She was not a critic with the eye and mind of Gertrude Stein, nor a dilettante with the brilliant theoretical bent of Leo Stein. She was a passionate collector who wanted to be surrounded by beautiful things she liked.

"They always knew this thing, they always knew that one was the elder and one was the younger." The Cone senior brothers and sisters were addressed formally as Brother Moses or Sister Carrie, while the juniors were addressed without the formal Brother or Sister title. Helen Cone's correspondence uses these terms of address when referring to the children; Edward T. Cone's 1973 memoir confirms this Cone family formality. Thus, throughout their life together, as Gertrude Stein softly notes, *"The younger called the older sister Martha [Claribel]. The older called the younger Ada [Etta]."* Etta's letters and diaries consistently refer to Sister Claribel or abbreviated as Sis C. Herman Cone left a modest inheritance for his wife and for each son and daughter upon his death in 1897. The elder Cone brothers gave their shares to their two unmarried sisters, each of whom thus had a private annual income of about $2,400 (equivalent to approximately $30,000 in today's dollars, a substantial personal annuity at the turn of the century). Travel for well-to-do unmarried young ladies was not uncommon in 1900. Additional travel impetus for the Cones might have derived from Leo Stein's residence in Florence at that time, which must have been a subject of conversational interest to the Baltimore social circle he left.

On May 10, 1901, Etta, thirty years old, left for her first trip to Europe in the company of her cousin Hortense Guggenheimer and their friend Harriet F. Clark. Leo met the three women when their ship docked at Naples and was a constant companion and consummate tour guide over the next three weeks as they visited Naples, Pompeii, Sorrento, Capri, Rome, Orvieto, Florence, Pisa, and Lucca. Etta's diary of the trip is filled with the enthusiasm of discovery as she recounts the museums, churches, palaces, and gardens they visited on

their tour. The entries are fascinating narratives, naming sites and artists and sometimes specific works of art of special interest, interspersed with notes about shopping, dining, and mail:

> After breakfast at about 10 A.M. Leo came by and took us to the Ufizzi Gallery. Here we saw many beautiful Botticelli's, Ghirlandajo's, Andrea del Sarto, Titian etc etc. The "Madonna with child & two angels" of Fra Lippo Lippi interested me keenly, as it is so beautiful & the story of the Madonna of this picture being the nun whom Lippi married & whose son the great Filippino Lippi is, added charm to this. I found myself sitting often for thirty minutes before either Andrea del Sarto's "Madonna of the Harpies" or one of the Madonna's of Botticelli . . . [Monday, June 3, 1901, Florence].

> Went to the Ufizzi Gallery for our second visit & was as charmed as the first day. Saw today Botticelli's "Birth of Venus" which is so aptly described by both Grant Allen & Baedeker, both of whom are my daily companions in the galleries. Spent my time over my pets here, having added a large canvas of "The birth of Christ" by "Van der Goes" an old Dutch painter of 14 or 15th cen. Titian's Venus, supposed to have been done for Count Urbino for his wife, is very attractive but hasn't the charm that Titian's "Artless Love" that we saw at The Borghese Gallery in Rome. Leo came home to lunch with us & after I had my rest, we went with Leo to call on Mrs. Houghton who proved a most attractive English woman who is an antique collector. We bought several pieces of her, but found the 14th, 15th & 16th century things too rare for our purses . . . [Tuesday, June 4, 1901, Florence].

> Made our third visit to the Ufizzi and as usual had Leo in his own leisurely way flitting (I should rather say creeping) from one to the other of us, each one of us delighted to welcome this wonderful brain. It is marvellous to me to find him absolutely well grounded in every possible field of thought. We stood & admired the glorious sculptures in the Piazza Signoria. . . . The Palazza Vecchio is on this square & here is the scene of Savanorola's execution. We had quite some trouble in buying a few buttons in these shops until at last we found a store devoted to every kind of button made . . . [Wednesday, June 5, 1901, Florence].

> . . . we walked up to the old Cathedral [in Lucca] which is a delight. The place was built in 12th century & remodelled in 15th. A most beautiful tomb of a young woman who died of cholera in the 15th cen. is in this church. Leo explained much of architectural construction to us, of how the arches are constructed, of what a flying buttress consists etc. [Saturday, June 15, 1901, Pisa-Lucca-Florence].

Page after page is written in this style, every line filled with Etta's inked notes of the day's activities and a jumble of her impressions overflowing into the narrow margins of the sheets. Her handwriting suggests the speed with which she was documenting her experience. This is not the travel diary of a casual tourist. Despite occasional afternoon respites to shop for gifts, Etta and her friends devoted virtually every waking hour to art. Theirs was not an obligatory stop at the Uffizi to visit known masterpieces; rather, they returned day after day to spend hours with the painting and sculpture that offered such revelation and excitement.

In these pages too Etta reveals her awe of Leo Stein, for his "charming talk," "wonderful brain," "valuable suggestions," "master-like way." Etta always considered Leo Stein "her teacher" and she later insisted "that it was Leo, and not Gertrude, who had developed the real eye for modern art and hence had contributed significantly to her own education."[6] Leo

encapsulated many of his ideas in his 1927 book *The A-B-C of Aesthetics* (there were three copies of this book in the Cones' personal library, including one copy heavily annotated by Claribel). These ideas, both in book form and as communicated in conversation and in correspondence with friends, are a recasting of the formalism of Roger Fry and Clive Bell. The formalist approach to painting, particularly as promulgated by Leo Stein, emphasized with virtual exclusivity the physical properties of paint and canvas and the internal relationships of these primary elements. Subject matter was scarcely raised as an issue. Even in early correspondence with Mabel Weeks, a friend from Baltimore days (who lived in New York), Leo conveyed this formalist bias perceptively and with conviction:

> . . . To make the subject clear requires a discussion of the qualities of the men of '70 of whom the Big Four and Puvis de Chavannes are the great men and the inspirers in the main of the vital art of today. The Big Four are Manet, Renoir, Degas and Cezanne.
>
> Of these Manet is the painter par excellence. . . . in sheer power of handling he has perhaps not had his equal in modern times. . . .
>
> Renoir was the colorist of the group. . . . he had the gift of color as no one perhaps since Rubens except perhaps Fragonard has had it. . . .
>
> Degas . . . is the most distinctively intellectual. . . . He is incomparably the greatest master of composition of our time. . . .
>
> Fourth comes Cezanne and here again is great mind, a perfect concentration, and great control. Cezanne's essential problem is mass and he has succeeded in rendering mass with a vital intensity that is unparalleled in the whole history of painting . . . [letter from Leo Stein to Mabel Weeks, ca. 1905, Paris].[7]

> . . . the thing that Matisse has as his dominant character is clarity . . . for me his color & form result in a total expression for which clarity is the best term. Michael Angelo & Cezanne are so far as I know the great masters of Volume. . . . The difference between an apple of Cezanne & a nude of Michael Angelo lies mainly in the complexity of organization . . . [letter from Leo Stein to Mabel Weeks, February 15, 1910, Paris (Yale)].

There is certainly not a hint in Leo Stein's aesthetic that one essential difference between a Cézanne apple and a Michelangelo nude is that one is an apple and one a nude—a distinction that would prove crucial to Etta Cone at least and, though perhaps to a lesser extent, to Claribel Cone as well. Leo Stein was no amateur at formal analysis, no matter the derivation from Fry or Bell, and his writings reveal an extraordinary eye and mind at work when looking at pictures. In Etta's understanding and application of the Stein aesthetic theory, she could embrace the pure values of the formalism Leo had taught her to esteem without sacrificing the comforts of familiar subject matter. She somehow came to believe that formal properties served only as a kind of "camouflage" for the subject matter that interested her. Throughout her early diary notes she expresses the appeal of subject matter, often recounting the "story" or anecdotal history of a picture (essentially the iconography of sentiment) as central to her appreciation. Both Etta and Claribel spoke publicly about modern art in their later years; surviving lecture notes from each are filled with references to Fry, Bell, and Leo Stein, and to the concepts of line, form, and color, despite the fact that the talks were illustrated with landscapes, still lifes, and domestic interiors in which subject matter was far more dominant than form.

Leo Stein, rue de Fleurus, Paris.

Gertrude Stein, Luxembourg Gardens, Paris, early 1900's.

After Leo left the group the "three lonely maids" traveled on, visiting Siena, Padua, Venice, Innsbruck, Munich (where they spent time with Etta's relatives, the Rosengarts), Dresden, Berlin, Cologne, Frankfurt, Hamburg, Heidelberg, Zurich, Lucerne, Interlaken, Lausanne, Geneva, and finally at the end of August arriving in Paris where, Etta's diary notes, ". . . found to our amazement that Leo & Gertrude had arrived one hour before us. Of course we talked a lot . . . " [Thursday, August 29, 1901, Geneva Paris]. Paris quickly restored Etta after the rigors of such extended travel:

> . . . We then went to the Louvre where I had a perfectly delicious time. Giorgione's "Concert" & Mona Lisa are glorious, not to speak of Leonardi di Vinci's "Madonna of the Rocks" & his "Madonna, St Anne & Infant Jesus" In fact the whole place is so redolent of glorious warm color & form that I actually felt enthused once more and forgot any fatigue I had . . . [Saturday, August 31, 1901, Paris].

> . . . Our afternoon was spent in talk & enjoying Gertrudes charming Japanese prints [Sunday, September 1, 1901, Paris].

> Took it easy as usual and made our start to the "Galleries Lafayette" where we made several purchases. Next to the Bon Marche where also spent money. Our morning was well nigh gone, so we came to the hotel, met the others & had lunch after which I went off with Gertrude in search of Japanese prints. Found them, book plates perfectly irresistible. Gertrude & I spent greater part of afternoon around this fascinating neighborhood . . . [Monday, September 2, 1901, Paris].

Their days were filled with shopping, with visits to dressmakers, seeing friends, the Louvre, the Pantheon with "the beautiful wall frescoes of Puvis de Chavanne" [Thursday, September 5, 1901, Paris], buying Japanese prints (which "the girls" would admire in their rooms after dinner), lunching with "the crew" (which often included Gertrude Stein and friends), and sleeping late (". . . Got up at 1 P.M. when Gertrude came in with her enthusiasm over her French literature . . . " [Wednesday, September 4, 1901, Paris]; "Arose late & Gertrude came in most inopportunely to my room . . . " [Tuesday, September 10, 1901, Paris]). Etta's handwriting in the diary entries has, in the course of the trip, grown increasingly rushed; sentences are breathlessly abbreviated with frequent instances of almost illegible words; and entries tend to be simple recitations of activities without additional comment. Her days are sometimes so filled that she retires exhausted without making her diary entries and then on a later date attempts to recreate previous activities. Although most of the entries describe exposure to old master art, Etta did see some of the moderns:

> . . . Also saw the earliest school of so called impressionist painters Monet, Manet & others. Back to hotel & immediately after lunch I was delighted when Gertrude suggested going to dressmakers with me. She was quite amused & interested in the funny conglomeration of french people there. . . . On we went . . . into the interesting art stores on the Rue Laffitte. One man asked me 150 francs for a little Barye bronze plaque, but at another place I got the same thing for 30. Gertrude & I then took a carriage—had a most interesting drive in the Bois [Friday, September 13, 1901, Paris].

Despite Paris days filled with more social activities (friends, theatre, opera, shopping) than had characterized the intense art-filled days under Leo's tutelage in Italy, Etta's voracious

Kitagawa Utamaro. *Courtesan and Attendant*. Color woodblock print. BMA 1950.12.729B.

appetite for art in every form still dominated her time. One day at the Louvre she shared the morning with Hortense and Gertrude looking at "... the great Greek frieze of the Parthenon & then to the Renaissance gallery to see The Slave of Michael Angelo & some other glories," and then continued on alone in the afternoon with no diminution of energy or enthusiasm:

> ... I wandered around upstairs in the Louvre all alone. It was delightful to linger over the great cases of magnificent old french china & on to the rooms of the greek discoveries. The old Greek tiles with figures of animals for the facades of buildings were delightful & reminded me of Fred's puzzle blocks. The large marble column with bulls heads, hundreds of which supported the triforium of the building, was a glory. Wandered on among the curios & modern 18th, 19th cen french pictures & had a splendid time . . . [Saturday, September 14, 1901, Paris].

In her last week in Paris Etta is in a frenzy of shopping for gifts. On September 16 "Hortense & I cabbed the whole morning away in search of antiquities & found one piece for Aunt Clara & Uncle Isaac. . . . I went on a hat hunt & found one nice grey one for myself at Mme Girot, Boulevard Housman 19. Ordered one also for Sister Claribel. . . ." On September 17 " . . . stopped by the milliner Lacroix 101 Rue Petits Champs & liked the hat she was making for me for Sister C. . . ." On the same day she notes that she has spent more money than she intended on Japanese prints, " . . . however I've got the fever bad & couldn't help it. . . ." On September 18 she writes of her delight in finding a shop filled with " . . . Nice old ivories & bronzes & iron work . . . an old Amati violin . . . besides a magnificent collection of old porcelains, the most beautiful being Italian & Spanish." Later the same day " . . . the whole crew of us including Mr. Schaffner went off to Hayashi's to see his Japanese prints. He has the finest collection in the world. It was a delight & my enthusiasm for Japanese prints grew & grew. . . . " On September 19 she went with Hortense and Gertrude to the dressmaker where her "suit promised well" and then wandered "up the Rue de la Paix & saw the most exquisite jewels I have ever seen in my life," and then "in search of antiquities & Gertrude of Japanese prints & books." Etta finished the afternoon alone by returning to the Louvre "to see the Japanese & Chinese collection of pottery. It was simply delightful & the prints were most attractive. Some good Harunobo's, Hiroushigi, Hakousai's, Outamara's etc etc. It was nice to wander through this vast collection of charming bric-a brac all alone, for there was no one else in the gallery . . . " [Thursday, September 19, 1901, Paris]. Throughout the diary entries Etta's most frequent descriptive adjectives are "delightful," "attractive," and "glorious." Despite what was obviously a growing sophistication about Japanese prints and an apparent ability to make certain qualitative distinctions, she nonetheless summarized the Louvre's oriental material as a "vast collection of charming bric-a brac."

In the Paris diary entries Leo's name appears periodically, in contrast to an almost daily entry citing Gertrude. On September 17 Etta reports that after dinner she "walked home with Leo and had a great talk from Leo on the value of life in one European city & how to regard art" and on September 20 she "met the girls & Leo at the Gallery." While her diary records talk *from* Leo, it records more frequent talk *with* Gertrude, and the latter often hints at more intimate kinds of conversation and a much more personal relationship: " . . . Talked

with Gertrude on her pet subject of Human intercourse of the sexes. She is surely interesting. . . . Back to the hotel & read some of 'Red Pottage.' Later Gertrude came in and we had a writing bee" [Sunday, September 15, 1901, Paris]. Entries often suggest Etta's pleasure at Gertrude's approval: " . . . Gertrude says I'm improving . . . " [Saturday, September 14, 1901, Paris]; " . . . Gertrude & Hortense went with me to Girot's to pass judgment on a hat for me. Gertrude liked it, so I ordered it . . . " [Friday, September 20, 1901, Paris]. Always, Gertrude and Leo take center stage: " . . . After dinner at the Gare l'Orient near the hotel we had lots of fun at the table & as usual I made my breaks. Leo & Gertrude are great fun. Gertrude & I went back to hotel. I started my job of packing. Hortense & Leo came back & I sandwiched in talk while packing my miserable antiquities" [Saturday, September 21, 1901, Paris].

The morning of September 24 Leo saw Etta and Hortense ("Clark" was staying on in Paris) off at the depot for their trip across the English Channel. Once satisfactorily ensconced in their rooms at the Victoria in London, Etta reports that she " . . . Had a nice long interesting talk with Hortense on Leo, Gertrude & Europe" [Tuesday, September 24, 1901, Paris-London]. They visited the National Gallery, The British Museum, the Wallace Collection, and the Tate Collection: " . . . saw my first Burn Jones, also 2 Rosetti's, many Millais . . . " [Tuesday, October 1, 1901, London]. Etta and Hortense also toured the famous London parks and monuments, went to the theatre, and of course shopped. Although they spent time with friends and Cone relatives who happened to be in London, Etta reports several evenings when she dined alone in her hotel room. London seems to have been a disappointment after the excitement and discovery of Paris.

Arrangements had been made for Gertrude Stein to return to America with Etta and Hortense, and the three met at Southampton on October 2, 1901, and steamed for home. Etta's diary the first day out declares the trip "Uneventful in every sense of the word . . . " [Thursday, October 3, 1901, Ocean-Lahn]. These shipboard entries are extremely brief, with no mention of her cabin companions except to note that she read "until the girls turned in when so did I" [Sunday, October 6, 1901, Ocean]. A gloomy Etta notes the foggy weather and the monotony of the return voyage, and her longing to be home: "Took life easy & cheered inwardly with happy thoughts of soon being at home . . . " [Friday, October 4, 1901, Ocean-Lahn], and " . . . I fear that I am not in a sociable mood. I want awfully to get home" [Monday, October 7, 1901, Ocean Lahn]. The very next day the diary reveals an abrupt and extreme mood swing in a final, curious ocean entry:

> Clear beautiful day which I spent mostly
> below in a most beautiful state of mind,
> but one which brought out the most ex-
> quisite qualities of Gertrude. My vanity
> [Tuesday, October 8, 1901, Ocean].

The underlined emphasis is Etta's and is the only such underlining in the entire journal. The two words "My vanity" at the end of the entry are broken off abruptly, without punctuation, and appear to have been inked at a different time than the rest of the lines in the entry. It is difficult to construe this passage as other than an oblique reference to some kind of emotional attachment on Etta's part to Gertrude, an interpretation which is only fortified by

her apparently later attribution of these feelings to her "vanity." It is known that by this time Gertrude Stein had already met the two women (May Bookstaver and Mable Haynes) with whom she was involved in a romantic triangle, with herself as the divisive love interest. Much of what is known about the Stein-Bookstaver romance is derived from *Q. E. D.*, a novella written by Stein in 1903. From what can be established, historians have concluded that the most intense months of the romance must have been during 1901–1903, concurrent with this period of friendship between Gertrude and Etta. Many of the events and locales of the novella correspond in time and place to Gertrude Stein's activities in these years. The novella's opening scene is set on a shipboard crossing to Europe (an ocean voyage never taken in life by Stein, Bookstaver, and Haynes), where Adele (Stein) and Helen (Bookstaver), a tall "American version of the English handsome girl," first discover their mutual attraction and make contact in secrecy from Helen's companion, Mable Neathe (Haynes). The novella, which describes the course of the affair in detail which would certainly have been considered explicit in 1903, is only thinly veiled autobiography and seems to interweave facts of the Stein/Bookstaver/Haynes affair with other unrelated incidents from Stein's life at the time. While the specifics of the shipboard scene need not have been drawn from life, of course, it seems likely that Stein may have drawn on her memory of the 1901 crossing with Etta and Hortense as the source for certain of the fictionalized details in the novella's opening scene.[8]

One can only speculate about the degree of candor that might have been shared by two women at the turn of the century on such a perilous subject. It is conceivable that Gertrude's Paris talk with Etta "on her pet subject of Human intercourse of the sexes" was more directed than Etta could absorb; it is also possible that Gertrude's exchanges with Etta, in frequent companionable privacy, though intended to be confessional in nature, were falsely (or accurately?) interpreted by an impressionable Etta as expressions of romantic intimacy ("My vanity"). In any case, October 8 is Etta's last ocean entry in the diary, and "My vanity" the final words. Uncharacteristically, there is no comment on the remainder of the voyage (the locale "Ocean" is inked in for the October 9 and 10 entries, but nothing else) nor any comment on the much anticipated homecoming. Etta's 1901 travel diary, so complete in every other respect, breaks off with this exceedingly curious entry about Gertrude.

Dr. Claribel and Miss Etta Cone and dozens of other educated, unmarried women, singly or in pairs, who appeared in the Cone-Stein circle from the 1880's through the 1940's were not unique. As Carl Degler has documented in *At Odds*, "The highest proportion of women who never married for any period between 1835 and the present [1980] were those born between 1860 and 1880. The proportions ranged between 10.0 and 11.1 per cent."[9] Despite these record proportions of unmarried women at the end of the nineteenth century, "the decision to remain single was not an easy one" and "being single or an 'old maid' was hardly an honorable status." It was "an age of domesticity" in which the place of the unmarried woman was "anomalous." The Cone sisters were given the still unusual opportunity of a high school education and, in Claribel's case, college (medical school) and postgraduate study.[10] For the single woman of the middle or upper classes who did not embark on a career the most common alternatives were housekeeping for the family and an active leisure life of pastimes such as music, needlework, and teaching or social welfare activities. Only in recent years has there been considerable investigation into "the emotional dimension of

the life of the single woman of the late 19th century." What has come to light is evidence of extremely common sororial relationships, among both married and unmarried women, that could be "warm, intense, and satisfying."

> Single women often lived together, experiencing privately, if not publicly, a relationship with another adult that was quite similar to that of marriage between two members of the opposite sex. Mary Grew made that precise comparison when she responded to a letter of condolence upon the death of her lifelong friend and companion, Margaret Burleigh, in 1892: "Your words respecting my beloved friend touch me deeply. Evidently . . . you comprehend and appreciate as few persons do . . . the nature of the relation which existed, which exists, between her and myself. . . . To me it seems to have been a closer union than that of most marriages" [At Odds].

Such relationships were sometimes sexual and sometimes not, but in either case they seem to have been of an emotional intensity and subtlety more accepted among women of the nineteenth century than of the present. Like the Cone sisters, too, "some single women [in the nineteenth century] found their emotional outlets in their brothers." One diarist in 1813 wrote "that I can never love anybody better than my Brothers. I have no expectation of ever finding their equal in worth and attraction. . . . " These comments are remarkably close to Etta's response to her niece's inquiry about why she had never married: "Because I never met a man who was the equal of Brother Moses."[11]

The extent of naiveté on the part of Etta and Claribel is difficult to judge, despite hundreds of pages of extant correspondence. Etta's nieces and nephews were of the impression that their aunt was a woman of delicate sensibilities who expressed dismay at nudity in art and once professed incredulity that there could have been "something *between* Gertrude and Alice."[12] It is likely that such apparent naiveté on Etta's part was an affectation of style; according to Gertrude Rosenthal and Edward Cone, it was not uncommon for Etta to smile sweetly and adopt the pose of the demure maiden lady when it suited her purposes. At least in correspondence with Gertrude Stein, whom Etta obviously viewed as a sympathetic confidante, she revealed numerous instances of intimate involvements:

> . . . my attractive little nurse calls me Goliath, & she's my David. She's got a bad case on me & she is most powerfully attractive to me . . . [letter from Etta Cone to Gertrude Stein, October 6, 1906, Frankfurt (Yale)].

> . . . Has my successor [Alice B. Toklas] done her duty by my place what she usurped & does she your typewriting & takes she care of that nice Mikey man [Michael Stein]. I am sometimes envious, but guess I am greedy, cause so far this trip has not been all a bad stunt . . . [letter from Etta Cone to Gertrude Stein, February 6, 1907, Cairo (Yale)].

> . . . I am desolee as my congenial companion [Nora Kaufman] feels she ought not to leave her parents this summer. I hope I shall overcome her qualms [letter from Etta Cone to Gertrude Stein, January 25, 1923, Baltimore (Yale)].

In 1907 Etta first mentions to Gertrude Stein her love for Ida Gutman, a passion that continued at least through 1908. It is no doubt to this relationship that Stein referred in her working notes to the manuscript of *Two Women* ("Describe Ada the whole [family?], youth Ida . . . " and "Etta family father and mother, Ida, house. . . . "). In these same manuscript notes Stein reminds herself to write about "sex in both" Etta and Claribel, but did not do

so in the final text. From the context of Etta's letters, it would seem that she struggled to overcome her attraction for Ida, even shunning residence in Baltimore in order to avoid further emotional entanglement:

> . . . I love Ida just as hard as ever & don't want to live in Balt. <u>Cones</u> <u>never</u> <u>change</u> [letter from Etta Cone to Gertrude Stein, December 4 (?), 1907, Greensboro (Yale)].

> . . . Ida too is still my pet adoration & my heart still beats hot when her letters come so what are you going to do—advise me to go to Balto & get a surfeit—no I'm coming to Italy & get weened again . . . [letter from Etta Cone to Gertrude Stein, January 7, 1908, Greensboro (Yale)].

> . . . Of course Hortense is the light of Balto. to me for though sad to say I loves Ida as much as ever, I see very little of her, for the poor thing is so walled in with an excited household & when she gets out, she goes by her lonesome to the park & needs to be alone to get her poise & thats how it stands between Ida & me . . . [letter from Etta Cone to Gertrude Stein, April 14, 1908, Baltimore (Yale)].

It is not credible that Etta would have written in this vein to Gertrude Stein had the two women not shared sympathetic conversation on the subject of intimate female attachments, possibly their own for one another included. (In contrast, there is nothing in the exchange of correspondence between the sisters Claribel and Etta to suggest that Etta similarly bared her soul to her family companion.) While not an intellectual, Etta was by all evidence a bright and sensitive woman. Through the Steins both Etta and Claribel were exposed to a culture of extreme bohemian character: "The sexual ambiguities of the Stein circle were apparent. . . . Both Gertrude and Leo, it appears, were tolerant about the unorthodox sexual habits of the expatriates who visited their studio."[13] One of the books often recommended by both Gertrude and Leo Stein was *Sex and Character* by the Viennese psychologist Otto Weininger (who committed suicide in 1903). While apparently both antifeminist and anti-Semitic, Weininger's book postulated a character analysis based on bisexuality and took an enlightened though simplistic view of homosexuality to which Stein subscribed at least in part. She forwarded a copy of Weininger's book to one friend with the comment that it exactly embodied her own views.[14] Stein, perhaps adopting Weininger's view that genius was the exclusive domain of men (and sex and procreation that of women), attributed her own genius to "maleness": "Pablo & Matisse have a maleness that belongs to genius. Moi aussi perhaps."[15] Although Etta and Claribel, along with many others of their single and married women friends, maintained close sororial relationships that were not necessarily sensual in nature, it is hardly possible that Etta failed to grasp the explicit nature of the relationship between Gertrude and Alice or that of other same-sex relationships in the Stein circle. Between 1913 and 1939 Etta shared much of her time with Nora Kaufman, including nine trips together to Europe. Kaufman was initially employed by Etta as a private duty nurse but their relationship quickly blossomed into a close friendship. Etta and Nora privately adopted the nicknames "Cutie" and "Mac" (like Gertrude and Alice, who shared the nicknames "Lovey" and "Pussy" privately and in public) and were identified as inseparable companions, traveling and attending social functions as a pair. When they traveled with Claribel, Etta and Nora shared a double room and Claribel took an adjoining single room (hotel room

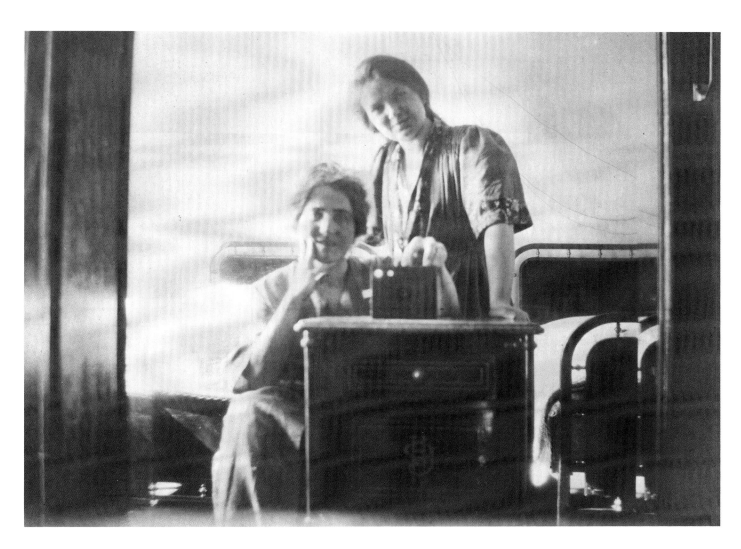

Etta Cone and Nora Kaufman, 1913.

numbers are carefully annotated in Claribel's account books of the 1920's, always indicating which room was occupied by "Etta & Miss K" and which by herself, and the price differential between the double and the single).[16]

Certainly Etta and Claribel were indulgent of the intermingling of wives and mistresses in the lives of the artists of the circle (though Etta insisted on referring to Picasso's mistress Fernande Olivier as "Madame Picasso" even when she was made aware of the non-marital status of the relationship). The Cones always considered Matisse a "gentleman painter" despite their awareness of his unconventional marital history (an illegitimate child, divorce, model-mistresses). In one letter discussing a particular Bonnard painting in which the sisters were interested, Claribel elaborated to Etta:

> . . . I forgot to tell you that the Bonnard woman with the red ribbons and roses Mr. V. [Paul Vallotton] called Bonnard's "wife"–but I "did not know he was married"–then Mr. V. substituted the correct (which was not the "correct") term. But if Bessie and Frank can talk with the son (Paul) about forbidden subjects–why can I not call a spade a spade–a mistress "a Mistress" in talking with the father–but I didn't–. . . . By the way– Mrs. V. yesterday evening told me a spicy but proper–quite proper–story of a flirtation Felix Vallotton had with a beautiful American girl of about 26 shortly before his death. . . . It was at the dinner table and frankly this harmless (?) little flirtation made him (Felix) more interesting than–"than ever" I was about to say–"his pictures do" is better. "Oh," I put in "all artists have their flirtations . . . " [letter from Claribel Cone to Etta Cone, August 20, 1927, Lausanne].

Throughout Claribel's letters to Etta there appear occasional references to taboo subjects such as syphilis or "Oscar Wilde's psycho-pathy sexualis," and to the morals of the day:

> . . . I am not quite sure but that the play ["Mrs. Warren's Profession"] is a bit too "intime"–shall we say naughty–for Mike [Michael Stein] to see–. . . . the play has not been allowed on the English stage but there is considerable talk of having it given there now–since according to the Herald article Bernard Shaw is tame and moral next to the flapper conversations which take place these days– . . . [letter from Claribel Cone to Etta Cone, September 10, 1924, Paris].

Comments like these in Claribel's letters, usually with an incidental reference to the subject's delicacy or with a warning to Etta not to repeat the story (" . . . And here I am telling you– but of course it will not go further–than Miss Kaufmann– . . . " from the August 20, 1927 letter), serve as reminders that the manners and mores of the 1920's, even in Europe, were still ostensibly prudish, an era when George Bernard Shaw's "Mrs. Warren's Profession," a play first published in 1898, "has not been allowed on the English stage." From this societal perspective, it would seem that Claribel and Etta, if not exactly free of inhibitions, were at the least more sophisticated and indulgent than most of their generation. Of course Claribel Cone was a medical doctor and, until the First World War, was engaged in her profession at an internationally respected level. As such, she had access to some of the finest medical minds of her day and was introduced to advanced medical thought on many fronts (including psychoanalysis). It is not surprising, therefore, that Claribel should take a relatively temperate view of topics that might seem shocking to more sheltered ladies of her time.

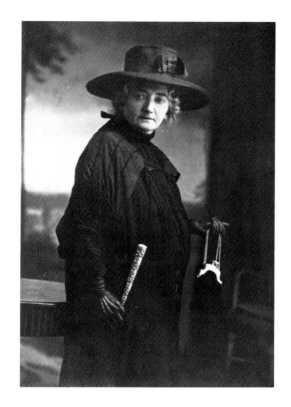

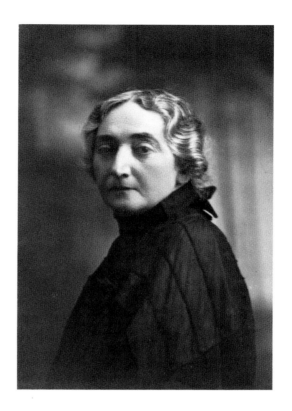

Claribel Cone, ca. 1915–1916 (age 51–52), Munich. Claribel Cone, ca. 1915–1916 (age 51–52), Munich.

Claribel Cone, 1909 (age 45).

Claribel's private life is more veiled than Etta's, in large part because she led a much more independent and isolated life. From August 1914 until the spring of 1921 (throughout World War I) Claribel lived in Munich and was essentially incommunicado from 1917 until the end of her stay there. For much of the rest of her life she lived in Germany and traveled throughout Europe, often alone, and actually spent much less time in the company of Etta and family than is generally assumed. Decades of correspondence with Etta reiterate, over and over, in letter after letter, her "mania for living alone," a theme which is so consistent and so often repeated that an analytical reader might question its psychological roots.

> Do you know as to Oberammergau—I do not want a companion—I want to enjoy the performance—I want to feel the reality of it—and I do not wish to have my thoughts distracted by the conversation of some uncongenial or half congenial person. I enjoy the Wagner operas now because I learned to know them when alone. The only reason you wish me to have a companion is because you fear some unknown danger for me—and I do not fear—hence to be alone at times is a luxury. . . . Miss Octavia Bates said to me once—Doctor after you have once travelled alone you will never travel again with a companion. Miss Octavia Bates has no sister. But I must say dear Etta that I should certainly never find it necessary to take a companion but of my own choosing—whatever that reason for choosing may be . . . [letter from Claribel Cone to Etta Cone, June 30, 1906, Frankfurt].

> . . . Now why did I deprive myself of a pleasant companion when I might have had agreeable company all the way!—Throughout life—that is what I do—and have been doing—there is something subtle—and indefinable—that impels me to be alone—it interests me—to send people whom I might like away from me— . . . [letter from Claribel Cone to Etta Cone, August 25, 1910, Weimar].

> . . . That is another reason I think that I am so comfortable on being alone this summer. I feel though I have a right to my idiosyncracies—without any explanation whatsoever to anybody—and that is right. . . . I am not lonely—I am not unhappy. . . . this all does not mean that the right companion would not be agreeable to me—it only means in the absence of the right companion—I do not mind being alone—for I am not alone . . . [letter from Claribel Cone to Etta Cone, September 8, 1910, Paris].

> . . . on the whole I find things so much more satisfactory than people—people are interesting but you cannot live with them as satisfactorily as with things—things are soothing—if they are works of art—most people are over-stimulating . . . [letter from Claribel Cone to Etta Cone, March 16, 1920, Munich].

There is no clear understanding of why Claribel made the seemingly irrational decision to stay in Germany throughout the war. Her life there must have been one of some deprivation and risk, despite letters which cite the continuation of daily activities like work and study with medical colleagues, concerts, plays, and operas, visiting with friends, and shopping for antiques. From her correspondence it is clear that she maintained an extraordinarily busy social life, joining one friend or colleague after another for tea almost every day. Her letters throughout 1910, in particular, fairly burble with her love of Germany and reports of her happiness. Her life in Munich during the war—except for occasional references to shortages of consumer goods—does not appear to have been markedly different from her life before the war. Toward the end of her wartime stay in Germany her letters seem defensive about

the possibility that she might be viewed hostilely by Americans for her association with the enemy, and yet she never offered any persuasive rationale, either personal or professional, to support her wartime residence in Munich. From 1916 until her actual departure in 1921 she wrote of making arrangements to leave Germany and repeatedly put forth only the flimsiest of reasons for not doing so (studies, no time to pack, weather, strikes, long lines for passage permits). Certainly there is nothing in Claribel's correspondence, either during the war or at any other time, even to hint at any personal intimate relationship or binding emotional ties to another individual. Claribel apparently was a lively, independent professional woman who chose to live alone, finding more stimulating companionship among "things" and in the world at large than she could find in any single human bond.

Most observers of the time noted that it was Claribel Cone, not Etta, who was closest to Gertrude Stein, and Stein's writings confirm her identification with the older sister as well as her considerable admiration: *"The older one was more something than the younger one. The younger one was not so much something as the older one.... The elder did some things.... She was more something than any other one.... every one knew she was something, the older one was one who had distinction.... She was a person of some distinction. She was not ever changing in this thing."* In a 1932 letter to Etta, Gertrude Stein was still remembering her closeness to Claribel: " . . . we are now getting ready a volume of operas and plays. I often think of Claribel in connection with all this, I know how much she would have delighted in the books and in the proofs my poor Etta I do understand how lonely you are without her, she was so tremendously real direct and alive, I was very fond of her, my dear a great deal of affection for you . . . " [letter from Gertrude Stein to Etta Cone, February 15, 1932, Paris]. It may have been Claribel's greater "directness" of style, in contrast to Etta's more modest and self-effacing persona, which led Gertrude and others to conclude that Claribel was the Cone sister of "distinction." The sisters too were conscious of deep psychological differences that set them apart. For her part, Claribel frequently lectured Etta in letters about her tendency to be "too nice" and allow friends, relatives, and acquaintances to take advantage of her; Claribel was particularly sensitive to Etta's assumed responsibilities toward the family (" . . . I am so glad that you are enjoying your work and that Bertha is beginning to recognize your loneliness—it looks like loveliness doesn't it? it might be!—and to appreciate your sacrifice— . . . " [letter from Claribel Cone to Etta Cone, July 5, 1910, Frankfurt]). Etta in return warned Claribel against the temptations of flattery: " . . . Really I don't blame you for liking people . . . to think well of you, and that is not at all what I criticize.—it is that you let such commonplace people—people beneath you flatter and make much of you. When you are too superior to them for their opinion to be worthwhile . . . " [letter from Etta Cone to Claribel Cone, June 11, 1911, Blowing Rock, North Carolina]. While Claribel was traveling in Europe and sending home reports of social adventures and exciting encounters, Etta was in Blowing Rock with the family of Brother Moses (who died in December 1908), grieving and suffering deep depression and serious self-doubt:

> . . . This is a melancholy sort of an existence, but it is my own doing for I cannot think of anything I would rather do. . . . My teeth are very comfortable I am glad to say. I hope my mind will get so too . . . [letter from Etta Cone to Claribel Cone, June 18, 1911, Blowing Rock, North Carolina].

. . . Now I do hope to hear from you and all about your doings. Would that heaven had made me a little different. I cannot change alas! . . . [letter from Etta Cone to Claribel Cone, June 25, 1911, Blowing Rock, North Carolina].

Your dear letter from Frankfurt with its details of your doings gave me much pleasure. It makes me very sad indeed to realize that while I am deeply interested in the things you write of, I have lost courage and feel that it is a useless spending of energy to get all the information etc that one does in travelling around. I actually have not the energy either mental or physical. . . . Do continue to have a good time. You are a very fortunate makeup. I am a desperate one and would like to go to sleep & not awaken . . . [letter from Etta Cone to Claribel Cone, July 16, 1911, Blowing Rock, North Carolina].

Again, Gertrude Stein's working notes to *Two Women* provide further clues about the sisters' relationship: "Tell about . . . their duties and how they did them, what effect they had when they were traveling, how they quarreled, how they spent money. . . . Stinginess, buying scarfs, [Handling?] things, patting hair, a little crazy, dress-making scenes, friends of each. . . ." When they were apart, the sisters' correspondence reveals a genuinely tender devotion and concern. Each was always eager to see the other after a separation. In one of Claribel's 1913 notebooks she reports that she went to the station to meet Etta and Miss Kaufman, "after arranging Etta's room to give pleasure" [July 28, 1913]. Several account book entries itemize the purchase of "flowers for Etta" on such occasions. On the other hand, when they were together there were evident tensions (obviously observed by Stein, who wanted to report "how they quarreled") and the irritations familiar to siblings. In one entry Claribel notes with some impatience Etta's failure to perform a requested service: "Etta 'did not bring letters' to my room after supper—note this—she 'had no room in bags'– Etta has or has not space according to the one desiring space. These things are purely a personal equation with Etta" [October 21, 1913]. Whatever the truth of their individual and shared personal lives, the Cone sisters—Claribel of "a very fortunate makeup" and Etta "a desperate one"—would join together in the 1920's to build the art collection by which they are remembered.

II.

Etta did not immediately follow through on her newfound passion for collecting, which on the 1901 trip was still confined to "antiquities" and a few Japanese prints. Claribel was at the height of her professional involvement and Etta went back to her duties as house and family manager. After Helen Cone's death in December of 1902 Etta's time was given over to sorting out family affairs and packing for storage some of her parents' furnishings and personal belongings. In Etta's account book for 1903–1905 appears a list headed "Things to be done in Balto [Baltimore]": "Pay storage Oct 1 & $15 per mo every 6 mos beginning May 1 1903. . . . [Pay] Drovers Mar 20, 1903. . . . Estate paid C C. $15.00 & E. C. $35 cash for coats / C C owes E. C 11.25 for Aunt Clara table May 7, 03. . . . " Clearly the first three months of 1903 were devoted to settling estate matters and clearing the house on Eutaw Place. The account book also itemizes contributions for "Jewish Publication," "Maccabeans," "kindergarten," "Suburban Club," "½ Insurances," "Subscription Masters in Art," and "Daughters in Israel," all dating between September 1903 and May 1904. Etta was carefully maintaining her civic obligations, her social responsibilities, her cultural interests, and her share of estate expenses. Although records are vague, it would seem that the family home on Eutaw Place was in fact sold in 1903 and the base of Cone domestic operations moved nearby to brother Sydney's home at 2326 Eutaw Place.

On May 9, 1903, Etta and Claribel, with their cousin Aimee Guggenheimer, set off from New York for Europe once again. Claribel had not been to Europe since her 1886 trip to Munich with her father when she was only twenty-two; Etta must have felt an old hand in view of her extended visit in 1901. Docking at Naples, the three visited Sorrento, Amalfi, Capri, Paestum, and Pompeii before moving on to Rome, Assisi, Perugia, and Florence. Etta's 1903 diary, while not nearly as detailed and expansive as her 1901 trip diary, nonetheless reports her pleasure at sharing Italy's art treasures with Aimee and Sister Claribel:

> . . . to the Uffizzi. I felt perfectly happy to be among all these great old masters again. Walked through & simply pointed out the great ones to Sister Claribel. . . . Among my letters last night was one from Gertrude asking me to be with her in Rome for July . . . [Monday, June 8, 1903, Florence].

> . . . took omnibus for the Santa Maria del Carmine. Enjoyed the Massaccio's here enormously. Began to feel the enormous difference in tactile values between Filippino Lippi's & Masolino's in the same chapel here . . . [Thursday, June 18, 1903, Florence].

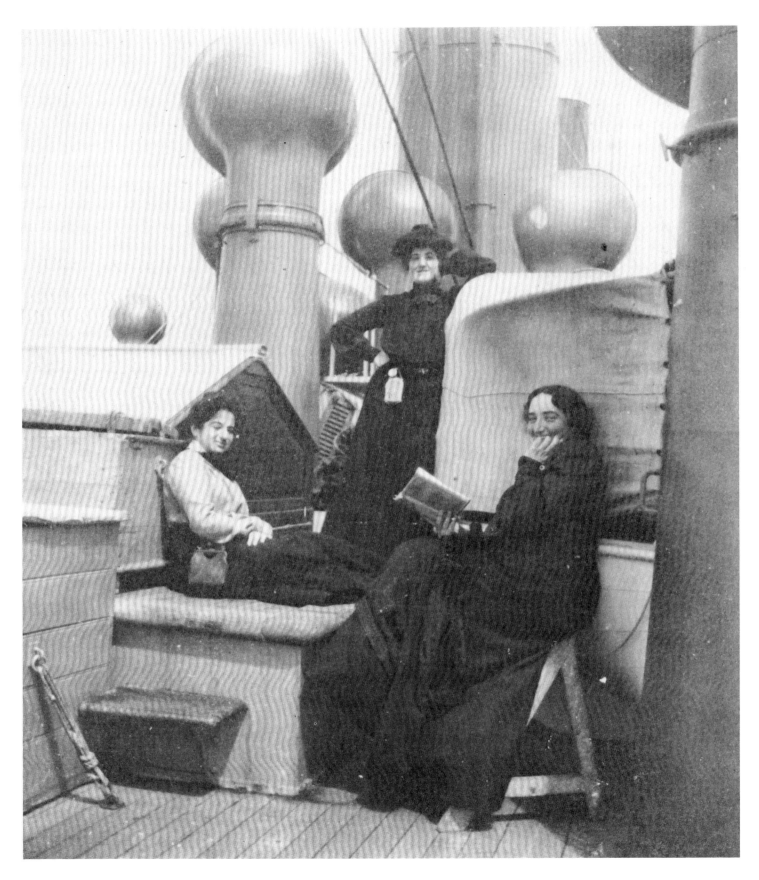

Aimee Guggenheimer, Etta Cone, and Claribel Cone, aboard ship, May 1903.

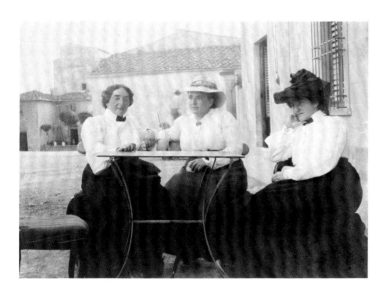

Claribel Cone, Gertrude Stein, and Etta Cone,
Settignano/Fiesole, June 26, 1903.

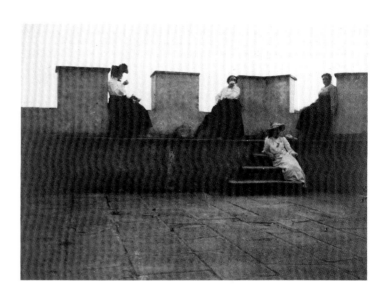

Etta Cone, Claribel Cone, Alice Houghton, and Gertrude Stein,
Certosa, June 29, 1903.

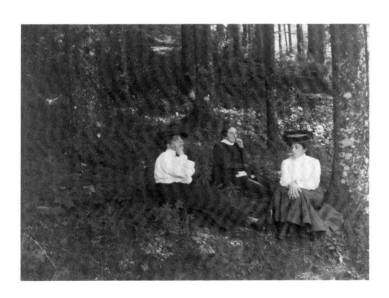

Etta Cone, Claribel Cone, and Aimee Guggenheimer,
Vallombrosa, July 2, 1903.

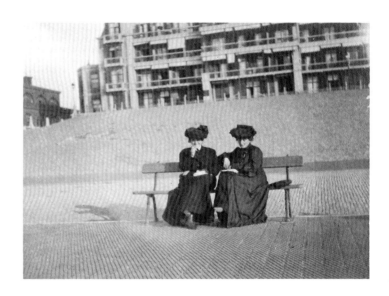

Etta and Claribel Cone,
Scheveningen (Holland), August 27–30, 1903.

Etta's diary entries do not reveal Claribel's reactions to what they saw, and Claribel did not herself keep a diary (some years later, in appealing to Etta to retain all of the letters she was writing her, Claribel noted that since she did not keep a diary, there were only her letters to remind her of her daily thoughts and activities). For her part, Etta was committed to deepening her understanding of the Italian masters whose work she had discovered two years before. Day after day she returned to the Uffizi "with Berenson in hand" and sat in the galleries reading in an effort to connect what she saw with what the esteemed art historian had written and thereby to refine her own perceptions:

> After a late start went to the Uffizzi where I found myself working out the influence one old master had on the other. For instance I worked up from Giotto, who influenced Gaddi, who influenced Lorenzo Monaco who taught Fra Angelico, who was influenced by Massaccio, who taught[?] Baldovinetti was a follower of Domenico Veneziano, who was a follower of Massaccio & Donatello. Ghirlandaijo was a pupil of Baldovinetti, who also influenced Cosimo Roselli. Pier Cosimo was a follower of this latter. Michael Angelo was the pupil of Ghirlandaijo & he (Angelo) influenced nearly all after him . . . [Sunday, June 21, 1903, Florence].

Until June 21 the tone of the diary entries is relatively sedate, even dull, with a litany of art works, sites, and castles visited along the route. That evening they went to the depot to meet Gertrude who immediately went off alone to dine with the Berensons. Later, back at the hotel writing letters, Etta reports, " . . . had just settled in bed reading French to Aimee when Gertrude came in. We talked until 1.30 P.M. [sic]. It's great having Gertrude here" [Sunday, June 21, 1903, Florence]. For the next eleven days the four women engaged in lively camaraderie from morning until night, and there is a distinct personality alteration evident in Etta's entries as her tone becomes animated, effusive, and at times almost playful.

> . . . We all met & went to Mellini's for dinner after which we walked up to the Michael Angelo Piazza & back. It was great & Gertrude was in fine humor & we had a good talk on me & my future life [Monday, June 22, 1903, Florence].

> . . . [Gertrude and I] had a beautiful time with the Michael Angelo's room in the San Lorenzo. Gertrude found a strong likeness between Michael's "Night" & me & we had a good time . . . [Tuesday, June 23, 1903, Florence].

> . . . [Etta, Aimee, Gertrude, and Claribel] proceeded to walk to Fiesole & it was a magnificent walk. Heard nightingale's for the first time. It was superb. Had a table d'hote dinner at Fiesole & all got drunk. Took a cab from Fiesole back to the hotel, & sat up as usual talking over the situation. Gertrude is great fun [Friday, June 26, 1903, Florence].

> . . . We went to Gertrude's place Mellini's for supper & walked out onto the Cascine afterwards. Gertrude & I had a fine talk & she almost worked me up to the pitch of going to Rome with her but I was able to resist . . . [Tuesday, June 30, 1903, Florence].

> . . . After lunch, we rested and later I went out, bought cold lunch & we four walked near to San Miniato & off into the country. Finally, after most stunning views of Florence we settled on a lovely hill (private) & amid cypresses & lovely moonlight we ate our supper. Had ices at the Michael Angelo piazza & walked back to hotel. Gertrude is so nice [Wednesday, July 1, 1903, Florence].

Etta Cone diary, Florence, 1903.

Etta Cone account book, 1906.

Jacques Lipchitz. *Gertrude Stein*. (1920). Bronze. BMA 1950.396.

. . . The woods [at Vallombrosa] were gorgeous & the scenery all about most ideal. Gertrude was at her best & we were all happy. . . . We went into the woods, overlooking a wonderful valley of pines, cypresses & chestnuts. Ate our lunch & afterwards Gertrude & I lay there & smoked while Sis C & Aimee went through the buildings with the little director. Aimee, Gertrude & I then left Sis C to rest & we took a walk along the most beautiful road. Were sad when we had to wend our way to the depot, for it meant leaving Gertrude [who was going on to Rome] . . . [Thursday, July 2, 1903, Florence, Vallombrosa, Florence].

Etta in 1903 showed herself to be as touchingly responsive to Gertrude's approbation as she had been in 1901:

. . . Aimee & I went first to the San Lorenzo to the Medici Chapel, for a last hour of joy with my favorite Michael Angelo's. Gertrude has put me down in history for a suggestion I made as to why a "woman lost in the art of sculpture—too many housekeeping fronts of the body" . . . [Sunday, July 5, 1903, Florence].

Etta was no doubt recalling her pleasant exchange with Gertrude as she stood a few days later with Aimee in front of Michelangelo's Medici tomb sculpture with its male figure of "Day" and female figure of "Night," the latter with its heavily musculatured body and pronounced bosom. It was the "strong likeness" between this figure of "Night" and Etta that Gertrude had remarked during their June 23 visit to the Medici Chapel. Presumably Stein had been amused by Etta's clever suggestion that women were rarely the sculptor's subject because of the greater degree of difficulty in sculpting the female anatomy! The trip continued—to Pisa, Bologna, Ravenna ("After breakfast we did churches all morning. Some had nice bits of old Roman mosaic and bits of marble left, but as a rule they were too much restored in the modern tawdry fashion . . . " [Thursday, July 9, 1903, Ravenna]), Venice, Bellagio, Lucerne, Munich, Nuremberg, Rothenburg, Frankfurt, Cologne, Amsterdam, Haarlem, and The Hague. Entries are sparse after mid-July, noting train trips and degree of satisfaction with various hotels, and many pages are blank. On August 30 in The Hague the diary is broken off although the trip continued on to Antwerp, Brussels, Paris, and London (Etta's separate account book records each day's expenses). Whatever Etta's involvement with Gertrude Stein may have been, the diary makes very clear the extent to which Gertrude's magnetism, energy, and humor acted as catalyst for the group of women. Other contemporary sources confirm Stein's remarkable charisma even in early years. From her Radcliffe and Hopkins days, she was "remembered . . . for jolliness and infectious vitality,"[17] and one friend, after traveling with Leo and Gertrude Stein in the summer of 1900, wrote to Gertrude, " . . . I could get more out of one day in London with you, than all five weeks by myself. . . . "[18] At least as far as Etta was concerned in 1903, without Gertrude the drinking, the smoking, the picnics, the laughter, the stimulating talks about pictures and life, and the late nights either did not happen or no longer seemed sufficiently interesting to be recorded.

At the end of the European tour in September 1903 Etta returned to the United States (dividing her time between Baltimore and North Carolina) to resume her life with the families of brothers Moses and Sydney, and Claribel went directly to Frankfurt and the Senckenberg Institute. Letters written over the next few years indicate Claribel's success at the Institute:

... my work is not yet done. Albrecht says he will abridge it for me and translate the article for the Festschrift. ... He says he wants the work very much—and that he has more belief in it than I have—I am most terribly flattered by his praise—especially as he is so awfully critical as a rule. ... then we again read over some of the 300 pages together—which by the way you helped to write—... [letter from Claribel Cone to Etta Cone, December 2, 1906, Frankfurt].[19]

After Dr. Albrecht's death, Claribel wrote Etta of her pride in hearing confirmation of her mentor's acknowledgment:

... I have just had a delightful hour ... with Mrs. Oppenheim—Albrecht's friend—. ... She told me of Albrecht's fondness for me and of his pride in my work. ... —it is a curious thing—Mrs. Oppenheim said to me the thing I always said of Albrecht. He reminded her of Christ and we are both Jewesses ... [letter from Claribel Cone to Etta Cone, July 5, 1910, Frankfurt].

... I am still pleased at my conquest over Mrs. Oppenheim—it proves to me that Albrecht's intent was real—of course I knew this but one always wants further proof and evidence. ... I cannot hear from too many people of Albrecht's interest in me—for it is one of the most flattering and charming things that has ever happened to me in my life—to be approved of as woman and as worker by one of the most talented yet critical and learned men in the world for all acknowledge that Albrecht was truly remarkable ... [letter from Claribel Cone to Etta Cone, July 7, 1910, Munich].

Claribel's letters throughout this period are filled with references to medical doctors, but usually in a social context. Only very occasionally does she pass along to Etta news of her professional life. One letter is particularly interesting for its medical news:

... The German papers are full of ["the great Ehrlich's"] discovery for the cure of syphilis—that is a disease we do not usually speak of in polite society—but scientifically it is correct—I suppose it has also been mentioned in the American papers—it is a wonderful discovery—. ... But I think it is the concensus of opinion [in] the Scientific world—that Ehrlich is the greatest living man in his line of special scientific research and that is serum-therapy—and Ehrlich is a Jew and not a baptized Jew ... [letter from Claribel Cone to Etta Cone, August 31, 1910, Weimar].

Frequent references in Claribel's letters suggest a high degree of consciousness about Jewish versus gentile. She often identifies individuals as Jews or as "non-gentiles," and a few letters report conversations on "the subject of the Jew." Although passing remarks indicate that Claribel at least was regularly reading both German and English-language newspapers, there is surprisingly little notice in either sister's correspondence of world events or issues of the day. All the more notable, then, to find one letter in which Claribel notes the outcome of the Leopold-Loeb trial:

... Did you see the result of the case against the Leopold-Lobe boy murderers? Prison for life! That is bad. Of course they were morons—so is every other criminal who commits such—and less brutal crimes—but more the reason why they should be put to death—as an example to other morons! ... [letter from Claribel Cone to Etta Cone, September 13, 1924, Paris].

On June 1904, after only eight months at home, Etta again sailed for Europe. She would not return to the United States until the summer of 1907, over three years later. She crossed to Italy with Gertrude Stein, who would not again return to America for thirty years, until her 1934 lecture tour. From Frankfurt Sister Claribel wrote Etta her reassurance that she would be "on hand in Milan—at the appointed time will make you feel less shaky at this end of the line," and extended her good wishes for the crossing:

> . . . with a warm atmosphere about me I am capable of nothing but the expression of warm affection and good wishes for your ocean trip—I sincerely hope that it may be a happy comfortable one—that the captain and the passengers will be "nice" and that you may enjoy it to the utmost—also Gertrude (This may be taken in both ways) . . . [letter from Claribel Cone to Etta Cone, May 30, 1904, Frankfurt].

There is no travel diary from Etta for the 1904 trip, but her account books indicate that she and Gertrude arrived at Genoa on June 25, 1904, and almost immediately purchased tickets for Florence. Although Leo Stein was living in Florence, Etta's accounts suggest that she, Gertrude, and Claribel were together at the hotel Helvetia: on July 6 Etta notes payment of the hotel bill together with "Laundry bills C.C. G.S. E.C." Both Cone sisters were meticulous record-keepers; at least when they traveled they kept daily expense records, noting the date, the item, and the amount. Art purchases appear in extant account books in chronological sequence without any indication that such items differ either in type or magnitude from the purchase of fruit or a visit to the Uffizi. Although the Cones were comfortably wealthy, their letters are filled with expressions of concern about spending too much money. Each sister managed her own finances, as is clear from both diaries and account books, and when they were together there was careful itemization of which expenditure belonged to which sister. In recognition of their separate identities, and as a product of their spending so much time apart, they frequently bought duplicates of certain items (books, in particular, but also sculpture and prints), one for each. When they began to buy works of art, there was always a decision made as to which sister was buying which work. This seems to have been as much a financial decision as an aesthetic one. In a year when Etta, for instance, chose to stay at a more extravagant hotel in Florence, she would note that the indulgence would reduce her monies available for the purchase of art. In other words, the sisters considered their annuities as separate financial resources, independent of one another, to be budgeted according to the personal needs and wishes of each.

Claribel, in particular, was a compulsive list-maker. Her notebooks are little more than detailed itemizations of things to do on a daily basis ("The Day's Work")—letters to be written, books read or to be read, monies to be counted (in francs, lire, dollars, marks, each consigned to a separate purse), lingerie to be marked (they ordered quantities of silk stockings each year, monogrammed and marked in color-coded numerical sequence, a new color for each year to keep track of how old the stockings were), leather goods to be selected from a group sent on "approbation," lists of trunks identified as to the contents of each drawer, and pages covered with specific exchange rate calculations. When the Cones gave a dinner party, Claribel's notebook includes a sketch of the seating arrangement. When Etta paid one of Claribel's bills at Liberty's, Claribel noted the date, the item, the amount, and

81

when she repaid the debt. When they went to an art exhibition, Claribel noted how much they paid for admission and, if they were given a complimentary catalogue by the dealer, what its value was. During their travels together they used a kitty system and that was so noted: "Etta pd [for lunch] from common purse . . . " [Claribel Cone notebook, June 29, 1925] or " . . . Etta & I shared expenses as usual . . . " [Claribel Cone notebook, July 16, 1925]. The notebooks are fascinating for their revelation of the sisters' interdependence; when they are together, diary entries by one almost always interweave activities of the other. Indeed, in Claribel's notes from the 1920's her scrawled, abbreviated narratives eerily twine the two sisters' activities in a way which often makes it difficult to distinguish one from the other.

Without a travel diary for the 1904 trip, it is possible only to trace the sisters' movements from city to city through Etta's 1903–1906 account book. Summarizing her expenses for this period, which she notes as applying to both E. C. and C. C., Etta reports that between June 25 and November 9, 1904, they had been in Italy, Austria, Germany, France, and Germany again. There are few clues in the account book to their daily activities; since Gertrude and Leo always spent summers in Italy, it is unlikely that the Cones saw them in Paris, although they apparently saw Michael and Sarah Stein (on October 3, the account book notes that Etta and Claribel took Allan Stein, the son of the latter Steins, to the Paris zoo). For whatever reason, Etta decided to stay in Europe through the winter of 1904–1905; with her parents dead and the Eutaw Place house apparently sold, there was little need of her domestic assistance at home and presumably she found it more appealing to share her sister's lively activity abroad. From November 1904 until March 1905 both sisters stayed in Germany, Claribel continuing her work in Frankfurt and Etta traveling between Munich and Frankfurt. By April 1905 the Cones' European summer odyssey had begun, with most of their time from May through August spent in Florence. By September 13 Etta and Claribel were in Paris and Etta at least would stay in Paris from the end of October 1905 until the end of April 1906, a six-month period which would prove formative to The Cone Collection. Claribel returned to Frankfurt to continue her work at the Senckenberg Institute in the fall of 1905.

It was in the course of these months that Etta maintained her closest and most sustained relationship with the Stein family, Gertrude and Leo as well as Michael and Sarah. In the fall of 1905 Etta volunteered to type the manuscript of Gertrude Stein's *Three Lives*, as Stein herself recounts in *The Autobiography of Alice B. Toklas*:

> Gertrude Stein tried to copy Three Lives on the typewriter but it was no use, it made her nervous, so Etta Cone came to the rescue. The Miss Etta Cones as Pablo Picasso used to call her and her sister. Etta Cone was a Baltimore connection of Gertrude Stein's and she was spending a winter in Paris. She was rather lonesome and she was rather interested. . . .
>
> Etta Cone offered to typewrite Three Lives and she began. Baltimore is famous for the delicate sensibilities and conscientiousness of its inhabitants. It suddenly occurred to Gertrude Stein that she had not told Etta Cone to read the manuscript before beginning to typewrite it. She went to see her and there indeed was Etta Cone faithfully copying the manuscript letter by letter so that she might not by any indiscretion become conscious of the meaning. Permission to read the text having been given the typewriting went on.[20]

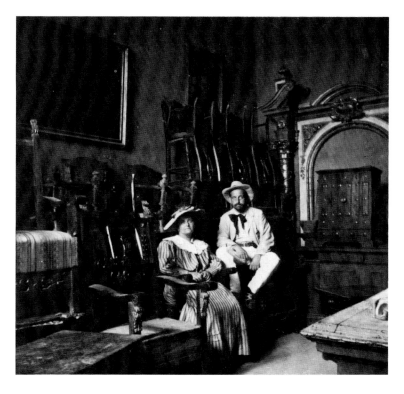

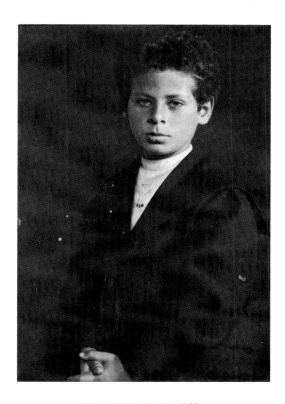

Sarah and Michael Stein, Florence, Summer 1905(?).

Allan Stein, Paris, 1903.

Leo, Gertrude, and Michael Stein, rue de Fleurus, Paris, ca. 1905(?).

The indisputably patronizing tone of Stein's recollection of Etta Cone must be seen from the perspective of 1932 when Stein wrote *The Autobiography*. The friendship between Gertrude and Etta had severely deteriorated by the thirties and on the subject of *Three Lives* there was particular sensitivity. In the summer of 1924 Gertrude, in need of money, offered the original manuscript of *Three Lives* for sale to Etta:

> I want to tell you something a propos of the thing you mentioned in connection with the autographed Three Lives selling for $13. It seems that the latest passion of the art collectors in America is the buying of manuscripts ever since Quinn made such a success with Conrad and Ulysses manuscripts that he bought through the editors of the transatlantic. Some one has suggested my selling the manuscript of Three Lives for a thousand dollars. I don't suppose that you want to pay any such price for a manuscript but since you had a connection with that manuscript I want to tell you about it before I consider doing anything. I think its kind of foolish but I wouldnt want you to think that I would sell it to any one else without telling you about it first. a bientot Gtude [letter from Gertrude Stein to Etta Cone, June 22, 1924, Paris, hand-delivered to Etta at the Hotel Lutetia, Paris (Yale)].

There was a tradition of the Cones extending financial assistance to Gertrude Stein: in the early years of their friendship both Etta and Claribel loaned money to Stein with some regularity, and in the 1920's the Cones routinely bought from the Stein art collection and from the household (several pieces of furniture were acquired in this way), usually through the mediation of Michael Stein. Whatever Gertrude's financial need, it must have come as a blow to Etta to have her friend offer for sale the manuscript to which she had repeatedly expressed specific emotional attachment. She was explicit in her possessive claim to *Three Lives*: " . . . Sorry I am not type writing your new book! I feel that 'Three Lives' is partly mine . . . " [letter from Etta Cone to Gertrude Stein, January 14, 1911, Baltimore (Yale)]. Etta clearly drew the line at buying back what she viewed as in some sense being hers to begin with. Her response was cool and no doubt calculated to injure (in its stated preference for a Renoir painting over Gertrude's manuscript):

> . . . I do indeed appreciate your kind thought of me in realizing my personal pride and interest in your "Three Lives." I simply have to face the truth and that is, that I am seriously considering putting all I can spare of what I have left of my income into a Renoir painting . . . [letter from Etta Cone to Gertrude Stein, June 23, 1924, Paris (Yale)].

Despite Etta's firm declination, a few weeks later Michael Stein was still hoping to promote the manuscript sale to her: " . . . I was going to keep the letter to show to Etta when she comes back and thus try to work her for MSS of the 3 lives; but if you need it I'll mail it to you . . . " [letter from Michael Stein to Gertrude Stein, August 26, (1924?), Paris].[21]

This was not the only instance in which the Steins tried to raise money through the sale of art works to the Cones. The Steins demonstrated a keen awareness of the Cones' financial resources, and conducted a virtual conspiracy to obtain funds from Etta and Claribel. While there was no doubt a sincere friendship between the Steins and the Cones—and for their part the Cones never attributed anything but the purest motives to Michael and Sarah Stein,

for whom they felt the highest regard and affection throughout their lives—correspondence between Michael and Gertrude Stein suggests a profit motive as a powerful ingredient of the relationship with the Cones throughout the 1920's:

> . . . The Cones came last night & Sally at once got busy for Gertrude. She has sold 9000 francs worth without the Favre pictures. Pretty swifty as Allan would say. I also spoke to them about the Laurencin and they seemed interested . . . [letter from Michael Stein to Alice B. Toklas, June 6, 1925, Paris (Yale)].

> . . . The Laurencin is sold for 10.000 and they are going to look at the Favres next week . . . [letter from Michael Stein to Gertrude Stein, June 14, 1925, Paris (Yale)].

> . . . The Favres are sold for 2000 fr altogether–21.000– . . . [letter from Michael Stein to Gertrude Stein, June 16, 1925, Paris (Yale)].

> . . . Etta has been under the weather & could not go to the bank; but is going day after tomorrow and I will deposit $2000 at Morgan for you . . . [letter from Michael Stein to Gertrude Stein, July 20, 1926 (Yale)].

> . . . While in Lausanne Claribel became quite intimate with Valloton the picture dealer who is a brother of Felix and on that account it was possible to interest her in the portrait and I think she will take it for 10.000. Where is it? Is there any way I can get it? . . . [letter from Michael Stein to "My Dear Folks," undated (Yale)].

> . . . We had the Cones out to supper and the Picasso is practically sold; but not decided to which Cone as yet . . . [letter from Michael Stein to Gertrude Stein, 1929? (Yale)].

> . . . I am practically sure that Etta is not prepared for any big deal this year; but shall try to pull off a small one . . . [letter from Michael Stein to Gertrude Stein, 1930? (Yale)].

> . . . Etta came a few days ago with a nurse (Miss Bowman) and a young nephew (Harold Cone). She is not awfully well and not interested in buying this year . . . [letter from Michael Stein to Gertrude Stein, 1932? (Yale)].

This evolution in the relationship between Gertrude and Etta—from their intimacy of 1901 to the business negotiations of the 1920's—is reflected in the tone of Stein's 1932 *Autobiography*. From this perspective, Gertrude's portrait of Etta as drawn in the *Autobiography* cannot be seen as a reliable mirror of the women's relationship in 1905. Also by 1932, of course, Alice B. Toklas had been with Gertrude Stein for twenty-five years. Alice and Etta were not especially fond of one another; retrospectively recalling their first meeting, Alice wrote: "Gertrude took me in Florence to lunch with Dr. Claribel and Miss Etta Cone, whom she had known first in Baltimore and then in Paris. Dr. Claribel was handsome and distinguished, Miss Etta not at all so. She and I disagreed about who should pay the lunch bill."[22] For her part, Etta viewed Alice as her "successor" and with some envy, as she had written Gertrude in 1907; Alice in turn was known to be extremely possessive and intolerant of Gertrude's earlier liaisons. Once Alice became a fixture of Stein's life, the Cones felt the strain in their friendship with Gertrude, as Claribel wrote Etta in 1910:

> . . . I do not expect to enjoy Paris so much. . . . Gertrude alone would have been alright– and I suppose Miss Tacklos thrown in–now Gertrude wonders why I don't like Miss T.– (I do like her–but she does not interest me)–Gertrude wonders why I do not appreciate (?) Miss Tacklos–She (Miss T.) has taken such an ardent fancy to me–Well I don't take fancies–that's just why, no doubt . . . [letter from Claribel Cone to Etta Cone, August 30–September 2, 1910, Weimar].

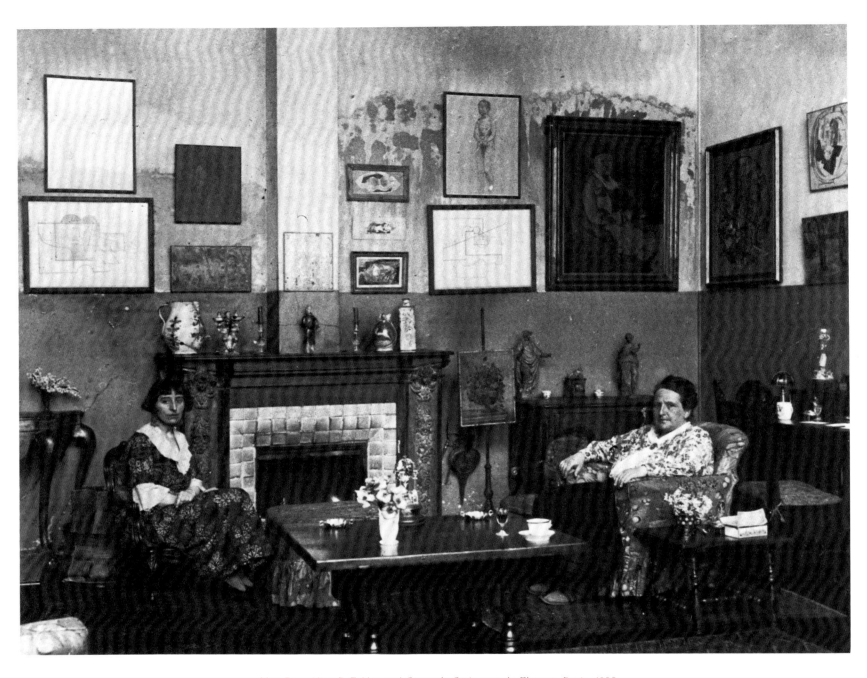

Man Ray. *Alice B. Toklas and Gertrude Stein, rue de Fleurus, Paris, 1922.*
Gelatin silver print. BMA 1950/85.1.

Both Etta and Claribel persistently misspelled Toklas's name, and until 1922 Etta's correspondence always refers to Gertrude's friend as "Miss Taklos"; in a letter of August 2, 1922, Etta finally adopts the more intimate "Alice" in sending along her greetings and thereafter refers to Toklas by her first name. Interestingly, in a letter of 1950, after the deaths of Stein and both Cones, Alice Toklas wrote rather differently of Etta:

> It was ever so kind of you to write me and to send me the clippings of the Cone collection. They interested me enormously—so much of the history of the two sisters and of Doctor Claribel's purchase of the pictures was known to me from the early days. As a matter of fact they rather than their collection were interesting—the relation between the two sisters—their markedly different characters—reactions—taste—is a passionately absorbing subject—fit for a Henry James—no less. And even in a newspaper clipping about Miss Etta's (for so she was in good Baltimore manner always called) collection something of her astounding—her colossal personality creeps in. I imagine that most of the important pictures were bought by Doctor Claribel—that is before '28 or '29 when she died. . . . [23]

From the various published memoirs of Stein and Toklas, one would not have known that Alice viewed Etta as having an "astounding . . . colossal personality." Perhaps her less generous feelings toward Etta were put to rest after the latter's death in 1949.

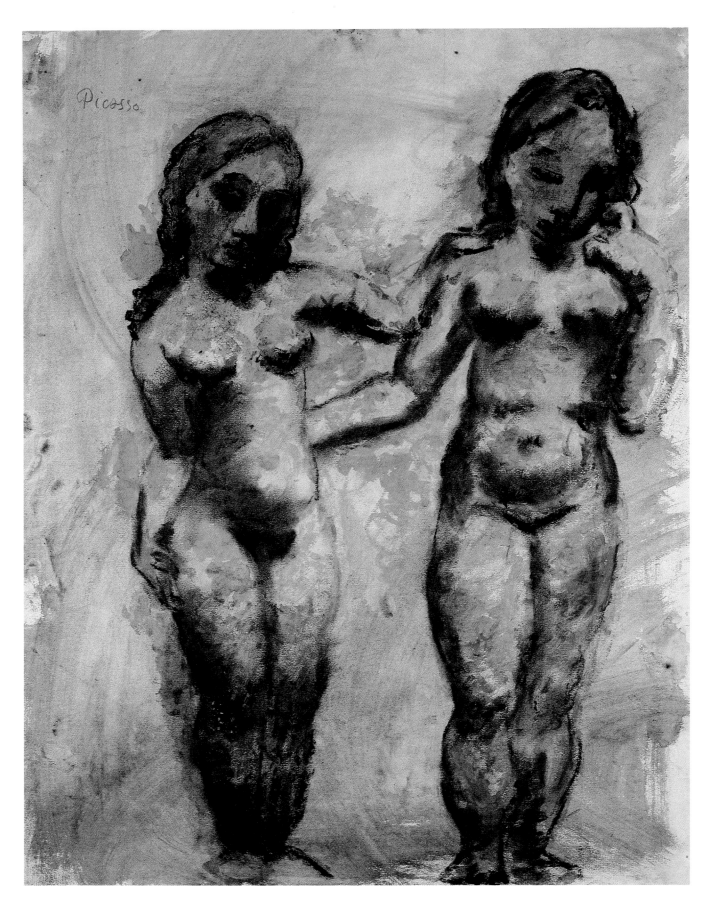

Pablo Picasso. *Two Nudes*. (1906). Gouache and black crayon on paper. BMA 1950.277.

III.

On October 18, 1905, Etta and Claribel, at the invitation of the Steins, attended the vernissage of the Paris Salon d'Automne. According to Etta's account books, which usually remark Stein's presence, she and Gertrude paid a return visit to the Salon on October 23. This was a particularly eventful exhibition, one at which startling new work by, among others, Matisse, Derain, Marquet, Vlaminck, and Rouault was hung together in one gallery, creating a special furor:

> We now come to the most stupefying gallery in this Salon so rich in astonishment. Here all description, all reporting as well as all criticism become equally impossible since what is presented to us here—apart from the materials employed—has nothing whatever to do with painting: some formless confusion of colors; blue, red, yellow, green; some splotches of pigment crudely juxtaposed; the barbaric and naive sport of a child who plays with the box of colors he just got as a Christmas present.
>
> . . . this choice gallery of pictorial aberration, of color madness, of unspeakable fantasies produced by people who, if they are not up to some game, ought to be sent back to school.[24]

For the Cone sisters the Salon represented their first real exposure to the avant-garde. Claribel would later write of her own initial impression of this gallery of "color madness":

> The walls were covered with canvases–presenting what seemed to me then a riot of color–sharp and startling, drawing crude and uneven, distortions and exaggerations–composition primitive and simple as though done by a child. We stood in front of a portrait–it was that of a man bearded, brooding, tense, fiercely elemental in color with green eyes (if I remember correctly), blue beard, pink and yellow complexion. It seemed to me grotesque. We asked ourselves, are these things to be taken seriously.[25]

The response of the Cones to what they saw at the 1905 Salon was not so different from that of the contemporary critics, nor for that matter so very far from the initial response of the Steins themselves, though the latter quickly overcame their misgivings. The picture in the exhibition that caused the single greatest response was Matisse's *Woman with the Hat*, a portrait of the artist's wife. Leo Stein reported that visitors howled and jeered at this painting and even Matisse's most faithful admirers considered it a folly and were alarmed for the artist's reputation. *Woman with the Hat* was the first Matisse purchased by the

Steins, who bought it from the artist for five hundred francs on the final day of the Salon exhibition (November 25, 1905). The Steins' purchase of this Matisse must have caused a sensation within the Paris art world, given the central role of this picture in the overall Salon controversy, and Etta and Claribel were no doubt privy to the eddies of conversation that must have surrounded the purchase deliberations. Only ten days after the Salon opening, on October 29, 1905, Etta recorded her first painting purchase since the Robinsons. Her account book for that date notes "1 painting Mons. Tarkuff 125," referring to the artist Nicolas A. Tarkhoff, Russian-born in 1871 but active in Paris until his death in 1930, who is represented in The Cone Collection by two paintings, *Woman Reading* (ca. 1905) and *Landscape*, 1928. Descriptions of the Stein Saturday evenings mention the numerous Russian and Hungarian artists who were present at 27, rue de Fleurus, and Etta may have met Tarkhoff there. Although Etta's purchase of a tiny, very tame Tarkhoff portrait does not compare to the Steins' first courageous Matisse acquisition, it seems likely that her renewed interest in art collecting at this moment must have developed from the excitement of the Salon and the Steins' encouragement. Just three days later, on November 2, 1905, Etta went with Gertrude Stein for one of the latter's portrait sittings at Picasso's rue Ravignan studio. There Etta bought, according to her account book, "1 picture 1 etching Picasso 120." None of the Picasso paintings in The Cone Collection were acquired as early as 1905. The price of 120 French francs is quite high for two works on paper by Picasso at this time; only four months later Etta and Claribel would buy a total of eighteen Picasso works on paper for only 175 francs. The price of the November 2 purchase suggests, then, that the "picture" may have been a watercolor or gouache. Neither Etta nor Claribel bought extensively during 1905–1906. They were meeting artists through the Steins, and the Steins made all their American friends aware of the financial need of these artists. Stein recorded in *The Autobiography* her charitable motive in urging Etta to buy Picasso's work:

> Etta Cone found the Picassos appalling but romantic. She was taken there by Gertrude Stein whenever the Picasso finances got beyond everybody and was made to buy a hundred francs' worth of drawings. After all a hundred francs in those days was twenty dollars. She was quite willing to indulge in this romantic charity. Needless to say these drawings became in very much later years the nucleus of her collection.[26]

Indeed, Stein's description of the Cones' collecting at this point as "romantic charity" is probably a rather accurate view of the sisters' motives in acquiring works of art. They did not collect on a consistent scale until much later.

These two Picasso works on paper bought by Etta in November 1905 were to be the first of 113 works by the artist in The Cone Collection. With the exception of three paintings and two sculptures, all were works on paper or board, either prints, illustrated books, drawings, watercolors, or gouaches. Although there are drawings in the collection which date as early as 1899 and as late as 1933, the majority date from 1905–1906. These latter works, many of which are studies related to major paintings, survey the artist's entire range of iconography of the Rose (or Saltimbanque) Period: solitary and double figures, circus themes, animals, and domestic scenes. Gertrude Stein has written of this period in Picasso's work:

> In 1904 he came back to France, he forgot all the Spanish sadness and Spanish reality, he let himself go, living in the gaiety of things seen, the gaiety of French sentimental-

ity. . . . Really it is difficult to believe that the harlequin period only lasted from 1904 to 1906, but it is true, there is no denying it, his production upon his first definite contact with France was enormous. This was the rose period. . . . When I say that the rose period is light and happy everything is relative, even the subjects which were happy ones were a little sad, the families of the harlequins were wretched families but from Picasso's point of view it was a light happy joyous period and a period when he contented himself with seeing things as anybody did. And then in 1906 this period was over.[27]

Many of these early Picasso drawings are quick sketches in pencil or ink of single figures from specific paintings (especially numerous are studies for *The Acrobat's Family with a Monkey*, spring 1905, and *The Family of Saltimbanques*, 1905). Victor Carlson has noted that in them one can almost see "the artist's inventive powers, as ideas and alternative poses crowd the boundaries of the small sheets . . . [with] an almost obsessional outpouring of ideas."[28] The quality of spontaneity in these works lends credence to the story that Etta and Claribel picked them off the studio floor; many of them seem to have been generated as part of the artist's creative process, literally working drawings rather than finished studies. Some of the most beautiful drawings in The Cone Collection date from a few months later, in 1906, when Picasso was working under the influence of Greek art and of Cézanne. These "Iberian" works (so called for their "Iberian stylization and sculptural, bas-relief modeling," inspired by Picasso's viewing of an exhibition of pre-Roman Iberian sculpture at the Louvre in the spring of 1906)[29] were also described by Gertrude Stein:

> In 1906 Picasso worked on my portrait during the whole winter, he commenced to paint figures in colors that were almost monotones, still a little rose but mostly an earth color, the lines of the bodies harder, with a great deal of force there was the beginning of his own vision. It was like the blue period, but much more felt and less colored and less sentimental. His art commenced to be much purer.
> So he renewed his vision which was of things seen as he saw them.[30]

Etta followed Picasso, in a limited way, into his Iberian period, though she bought these few drawings mostly in later years. Among the most extraordinary of the Cone Picassos from the later months of 1906 is the gouache, *Two Nudes*, one of several studies for a painting of the same title and date. In the painting facial and body features are more realistically delineated, and the dark background casts the nudes in sculptural relief. In the Cone study, however, the figures are colored to the background (like the imprint of fossils in ancient earth-embedded stone), and features are indicated only sketchily in charcoal and watercolor. Clouds of ocher gouache erode outlines and the forms dissolve in impressionist light. The tender eloquence of the subject and the subtle body language of the models' pose underscore the nervous energy of the brushwork. Molecules of corporeal form seem to merge with paper and pigment in a balanced tension. This drawing shows the artist at his most fluent and most feeling. Once Picasso moved into his more radical styles, first under the influence of African sculpture and then in the Cubist mode he and Braque invented, the Cones lost interest in the work. They were not alone in their inability to move forward with the Cubist vision. Leo Stein too rejected the work of Picasso after 1910 and expressed adamant disdain for the Cubist movement, whether in painting or in (his sister's) literature:

> . . . You people in New York will soon be in the whirlpool of modern art. I, on the other hand, am out of it. The present enthusiasm is for cubism of one species or another and

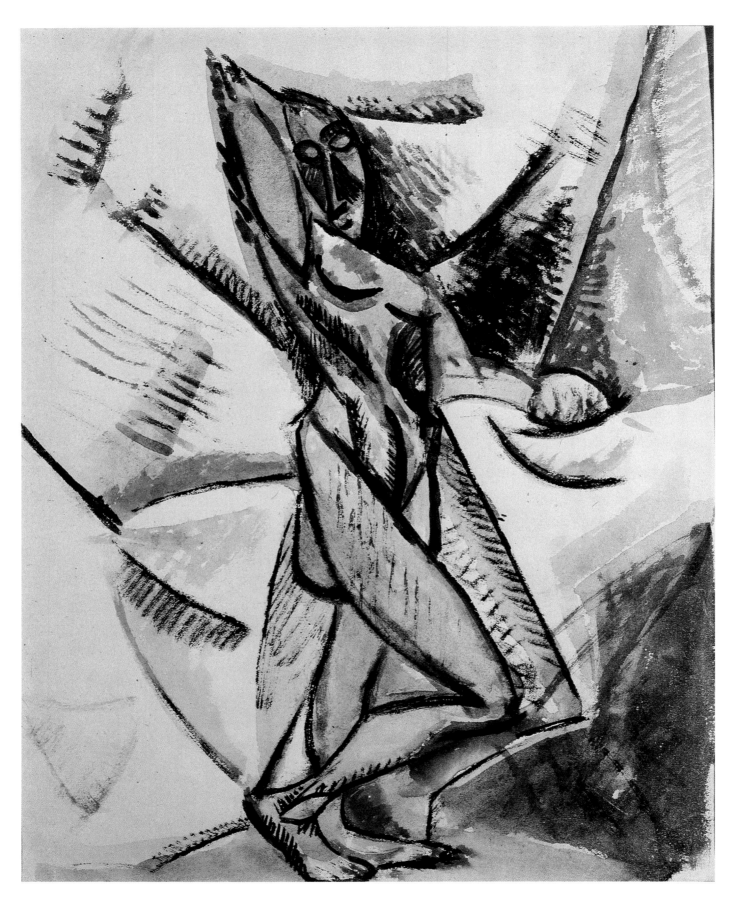

Pablo Picasso. *Study for Nude with Drapery*. (1907). Watercolor on paper. BMA 1950.278.

I think cubism whether in paint or ink is tommyrot. It seems to me to be the intellectual product of the unintellectual and I prefer the unintellectual to manifest themselves on a merely intelligent plane . . . [letter from Leo Stein to Mabel Weeks, February 4, 1913].[31]

The only substantive exception to the genre of Picasso drawings bought by the Cones is the watercolor, *Study for Nude with Drapery* (1907), purchased by Etta in the late 1930's. It is a study for the painting *Nude with Drapery* in The Hermitage collection, Leningrad; the painting shows the figure in precisely the same pose as in the Baltimore watercolor, but with figure and drapery merged in an active pattern of "hatched" lines. *Nude with Drapery* represents a transitional stage between Picasso's *Les Demoiselles d'Avignon* (The Museum of Modern Art, New York), where the figure in the Cone drawing appears second from left, and the subsequent "African" paintings done under the influence of the artist's recent interest in African sculpture.[32] Both the Cone drawing and the Hermitage painting originally belonged to Gertrude Stein. The *Study for Nude with Drapery* is very far in style from the Picasso work which immediately precedes it in time, and thus stands in isolation from the sensibility of the other Cone Picasso acquisitions. It is as close as either sister would ever come to the artist's Cubist mode. Its purchase by Etta in the 1930's may have been in part a response to comments that the collection did not include any Cubism; certainly at that time she was attempting to fill out the collection with objects that provided historical context for the works already owned. At that time, too, Etta was transparently interested in acquiring works with a Stein provenance. In any case, she reported to Adelyn Breeskin that she bought the *Study for Nude with Drapery* "because she felt she should" rather than out of any personal aesthetic commitment.

Having rekindled the collecting "fever" that Etta first identified during her 1901 European trip, she continued to buy actively in the next few months. On January 15, 1906, Sarah Stein took Etta to meet the artist of the controversial *Woman with the Hat*. Etta notes in her account book that on that day she bought "2 Matisse drawings (1 for [M.?] Sallie)." (Sarah Stein was called Sally, which both Etta and Claribel usually spelled Sallie.) Etta must have expressed her gratitude to Sarah for introducing her to Matisse by buying two drawings, one for herself and one for her "hostess." In the following weeks of 1906 the account book documents frequent art purchases, though still confined to prints and drawings: "Feb. 1 Cezanne lithograph, portfolio. . . . Feb. 28 Renoir lithograph, Meir Grafe 3 vols. . . . Mar 3 11 drawings 7 etchings Picasso 175. . . . Mar 17 2 Manet etchings 75." Claribel had joined Etta in Paris for the March visit to Picasso's studio, again probably in the company of Gertrude Stein. Along with the purchases of Matisse and Picasso, Etta had added works on paper by other Stein-approved artists—Cézanne, Renoir, and Manet. By early 1906, then, Etta had formed the nucleus of what would become the Cones' major commitments in art, focusing already on Leo Stein's "Big Four" (only Degas, of Leo's pantheon, would await later purchase), the "great men and the inspirers" of the younger masters Matisse and Picasso. It is noteworthy that this infant collection appears to have been Etta's; with the exception of the one significant visit to Picasso's studio on March 3 when the sisters purchased eleven drawings and seven etchings, Claribel was apparently not party to the other purchases.

Of all the artists whose work the Cones would collect over the years, Matisse became their touchstone. Both Etta and Claribel remained devoted to Matisse's art throughout their

93

lives, and Etta maintained a cordial personal relationship with Matisse which she held very dear. Their commitment to Matisse did not alter when Gertrude Stein's allegiance shifted so categorically from Matisse to Picasso, nor did either sister follow the collecting patterns of other early Matisse devotees (Dr. Albert C. Barnes in Merion, Pennsylvania; Sergei Shchukin and Ivan Morosov in Moscow; Michael and Sarah Stein in Paris) who often showed more adventuresome taste and grander ambition when selecting their Matisses. Etta and Claribel Cone selected each of their Matisses from their own idiosyncratic perspective, without outside advice and without reference to current critical opinion; they bought what they liked, with an eye to how it would fit with everything else in the collection (both literally, in view of their relatively small-scale apartments in Baltimore, and aesthetically). In the 1930's, after Claribel's death, Etta often relied on Matisse's judgment about which pictures would best suit the growing Cone Collection. Etta Cone and Henri Matisse were contemporaries (Matisse was eleven months older), and it is a hallmark of The Cone Collection that many of the Matisse paintings were collected in the year they were painted. Matisse's work evolved along alternate lines of inquiry, between periods of experimentation and dramatic formal invention, and periods in which the work reverts to the traditional. It is, of course, that more advanced work by which Matisse is defined by today's critical standards—the great decorations of 1909–1910, the extraordinary achievements of 1912–1919 with their structural abstraction, and the sublime still lifes, interiors, and cut-outs of the late 1930's and 1940's. Despite Etta's loyalty to the artist throughout her lifetime, she bought from none of those more advanced bodies of work. With few exceptions (foremost among them the powerful, brilliant *Blue Nude*), The Cone Collection represents Matisse at his most conservative and traditional and within a range of subject matter that is fundamentally decorous. Above all, the Cones responded most warmly and with their most astute critical judgment to that aspect of Matisse's art that can be broadly defined as portraiture. The overriding strength of the collection is in its bold, singular images: *Blue Nude ("Souvenir de Biskra")*; *Woman in Turban (Lorette)*; *The Pewter Jug*; *Ballet Dancer Seated on a Stool*; *Seated Odalisque, Left Knee Bent, with Ornamental Background and Checkerboard*; *The Yellow Dress*; *The Blue Eyes*; *Large Reclining Nude*; *Purple Robe and Anemones*; *Striped Robe, Fruit, and Anemones*. Whether portraits of models or of inanimate objects, these paintings spoke to the Cone sisters' responsiveness to tough, evocative figuration. With the exception of *Large Cliff— Fish*, the collection's landscapes are minor, small in scale, and of conventional composition. For the most part (and with the notable exceptions of *Interior, Flowers and Parakeets*; *Anemones and Chinese Vase*; and *Still Life, Bouquet of Dahlias and White Book*), the Cones' interior scenes with figures, their odalisques, and their still lifes are either very early in date or among the artist's milder and less challenging efforts. This propensity for strong portraiture is revealed in the work of other artists in the collection as well, especially for those acquired by Etta. While Claribel bought masterpiece landscapes by Cézanne and Courbet, for example, Etta bought powerful portrait images by Picasso and Gauguin. Even their still life acquisitions, whether on canvas or paper, tended to be closely cropped "portrait" studies of isolated objects (flowers in a vase, or as with the van Gogh, boots).

Just the same, it cannot be overlooked that the Cone sisters were among the earliest patrons of Matisse's work. Even granting the magnitude of difference between the respective purchases, it is notable that the Steins bought their first Matisse only in November 1905,

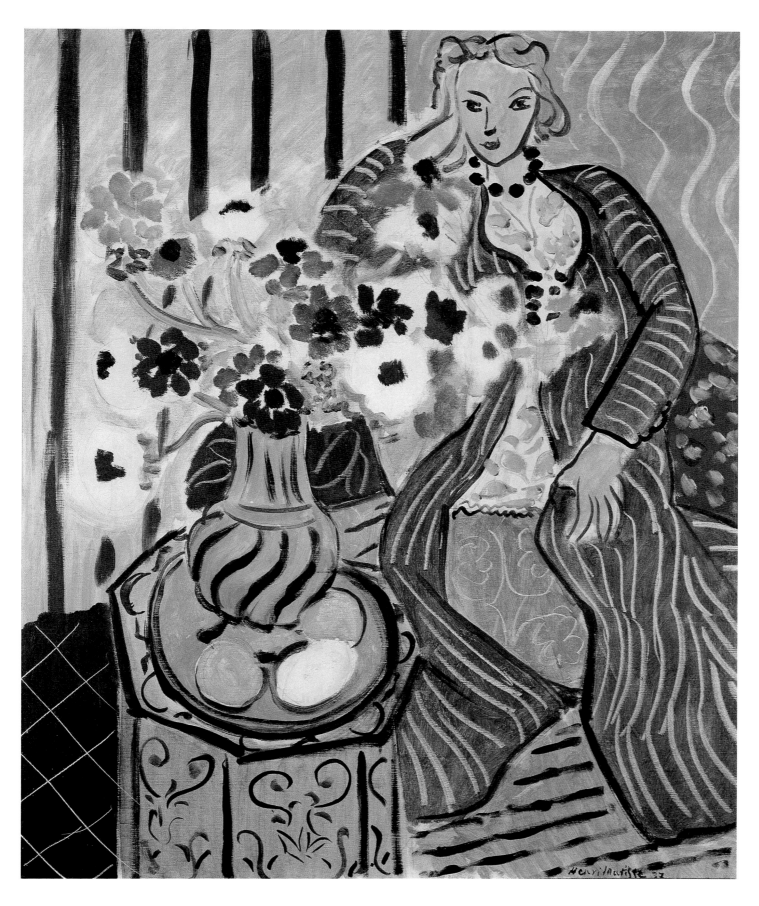

Henri Matisse. *Purple Robe and Anemones*. 1937. Oil on canvas. BMA 1950.261.

and Etta bought her first Matisses in January 1906. Similarly, Leo Stein bought from the dealer Clovis Sagot his first Picasso (the large 1905 gouache, *The Acrobat's Family with a Monkey*) in the summer or fall of 1905, and Etta bought her first Picassos (studies for this same work) on November 2, 1905. Interest in Matisse's work was quite active in 1906, and by 1907 Daniel-Henry Kahnweiler (who would become the leading dealer in Picasso's work), upon arriving from Germany to establish a gallery in Paris, refrained from any attempt to negotiate a contract with Matisse because the latter's market "was already too big for me."[33] Since there was certainly no critical support structure to lend credibility to the artistic efforts of either Matisse or Picasso at this time, Etta Cone joined the Steins in early patronage of these artists at precisely the moment when it was most needed and appreciated. Unhappily, the Cones failed to pursue their interest in the ensuing fifteen years, a period when the Steins, Albert Barnes, and John Quinn, along with the Russians Shchukin and Morosov, amassed brilliant Matisse collections (with Quinn, at least, also acquiring masterworks of extraordinary significance by many of the other leading avant-garde artists of both Europe and America).

A month after Etta's first Matisse purchase of two drawings (one of which was given to Sarah), she was back in the artist's studio. Her account book notes "1 water color, 1 drawing Matisse" on February 18, 1906. The watercolor was the 1905 *The Harbor of Collioure*. Collioure is a small fishing port on the French coast just north of the Spanish border. From 1905 for about a decade the Matisses summered there and its landscape figures in many of the artist's works. Several of the Collioure subjects from the summer of 1905 were included in the 1905 Salon d'Automne, and it is possible that this watercolor was among the group Etta saw there. Alfred Barr has written "That first summer at Collioure proved to be of the greatest importance to both Matisse and Derain, for during it they painted their first pure and characteristic fauve canvases."[34] The 1905 Collioure work moves away from Matisse's "Neo-Impressionist" work of the preceding summer when in the south of France he had experimented with the "spot technique" introduced by Paul Signac and Henri-Edmond Cross, laying down bright color spots or short dashes to create the sensation of light and color moving evenly across the painted surface. (In later years, when the Cones supplemented their Matisse holdings by collecting works related in conception to those of the master, they would in 1927 buy small pieces by both Cross and Signac similar in feeling, if not precisely in date, to *The Harbor of Collioure*.) The summer 1905 work employed much more exaggerated brush strokes and aggressively brilliant color than that of 1904. The Cone watercolor in this regard is not among the most characteristic of these Fauve works, since it relies on soft color and an Impressionistic view, with the subjects (sailboats, water, a point of land) emerging from the undelineated white paper ground, almost in the manner of Cézanne or Turner. Within the next few months Etta bought her first Matisse painting, the 1906 *Yellow Pottery from Provence*.[35] Also painted in Collioure (a year after *The Harbor of Collioure* watercolor), this unfinished canvas comes from a group of works which seems relatively tame compared to the exuberant and daring *Joy of Life* (Barnes Foundation) from the preceding spring. Nonetheless, in its definition of form by the use of discrete blocks of contrasting color, it looks toward the paintings of 1907–1909 in which Matisse used surface patterns of flat color to produce some of his most radical paintings.

Henri Matisse. *The Harbor of Collioure.* (1905). Watercolor on paper. BMA 1950.226.

In late April 1906 Etta left Paris to join Sister Claribel in Frankfurt. Arrangements had been made for Brother Moses and his wife Bertha to come to Europe to join Etta and Claribel for a trip around the world. Meeting in Italy, the four would travel from the fall of 1906 until the spring of 1907, visiting Egypt, India, Turkey, Japan, and China. At intervals throughout the trip Etta corresponded with Gertrude Stein, exclaiming over her delight at the exotic peoples they encountered, describing their activities, and hinting at the stresses of traveling in such familial proximity. Claribel kept a few notes of her shopping successes and of historical or sociological observations. Returning to Baltimore by way of San Francisco, they resumed for the first time in many months a more routine domestic life. Claribel took a "bachelor apartment" at The Marlborough, and Etta returned to her duties as family manager. Already in September of 1907 Etta writes endearingly to Gertrude Stein to tell her how much she misses her:

> Happy New Year [Rosh Hashanah] to you, you heathen, but I like you even if you be a heathen & I wish I had you a little nearer, but its a good thing I have not, or you'd get too much material for your novels and it would keep you busier than is good for your ealth [sic] . . . [letter from Etta Cone to Gertrude Stein, September 9, 1907, Baltimore (Yale)].

Etta's letters to Stein in these months are remarkably cheerful, full of chatty news about friends and family, and fairly stoic about her continuing infatuation for Ida. Though she continued to miss Paris and Florence and the Steins, she was deeply involved in daily family matters and seemed especially at peace when she was in the "country" at Greensboro.

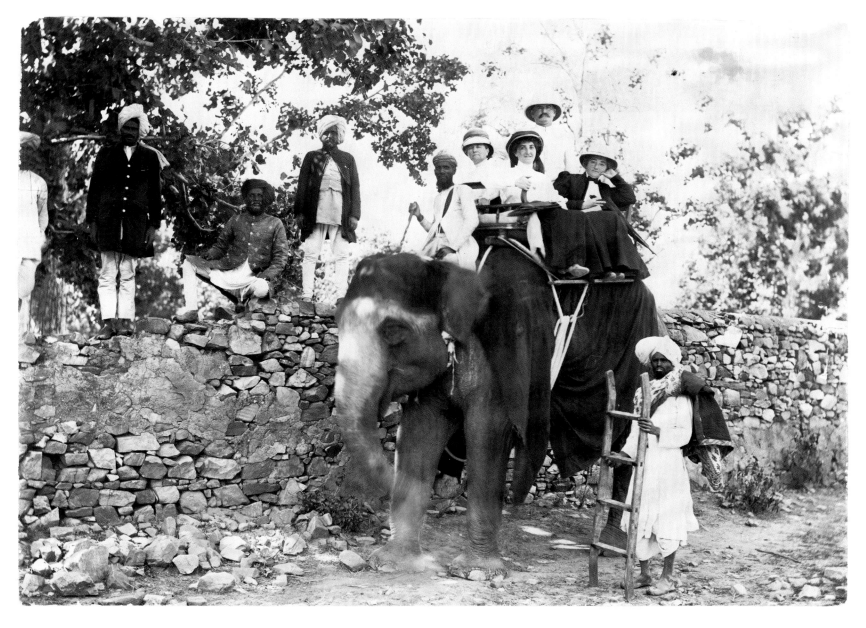

Bertha, Etta, Claribel, and Moses Cone, India, 1907.

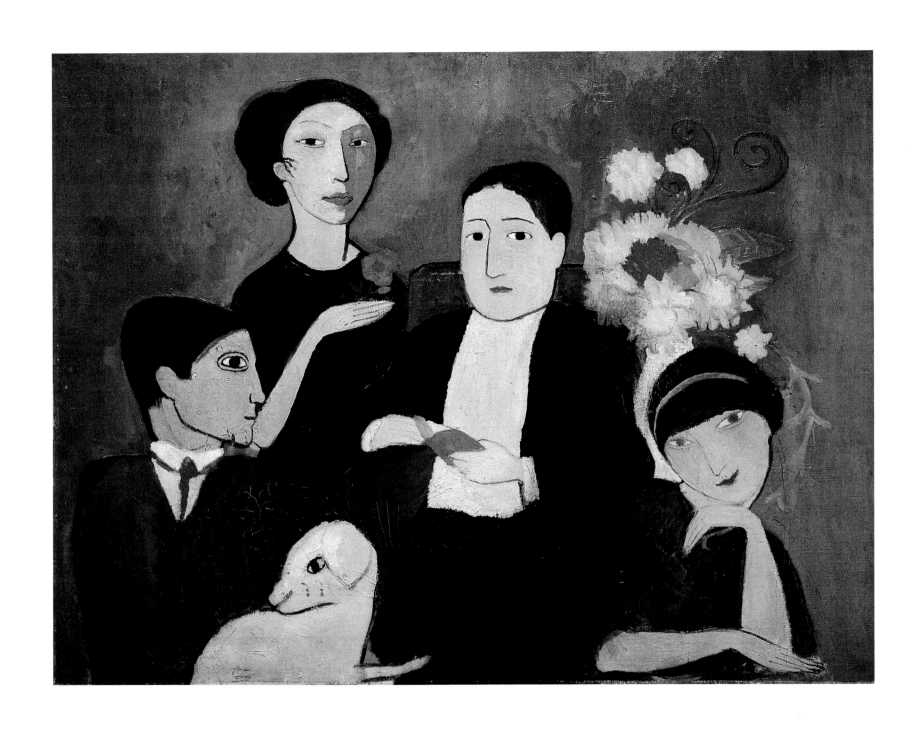

Marie Laurencin. *Group of Artists*. 1908. Oil on canvas. BMA 1950.215.

IV.

The nascent Cone Collection remained unchanged, as far as is known, from 1906 until 1922: five Robinson paintings, a Barye bronze plaque, Japanese prints, one Tarkhoff oil, one oil and three drawings by Matisse, twelve drawings and eight etchings by Picasso, one lithograph each by Cézanne and Renoir, two etchings by Manet, and possibly one oil by Patrick Henry Bruce. In early January 1908 a charming drawing was added to Etta's art holdings. Writing from Paris, Gertrude Stein enclosed an ink-sketched self-portrait, inscribed "Bonjour Mlle Cone" by Picasso. Etta responded: " . . . here comes your dear old letter with this delightful sketch of Picasso and Fernando's nice wishes. Dey am sure nice folk . . . & tell Pablo that Fernando ought massage his tummy into shape again. I love his picture for it is just like him . . . " [letter from Etta Cone to Gertrude Stein, January 7, 1908, Greensboro (Yale)]. These art works joined a collection of miscellaneous curios from around the world, exotic textiles, and antique jewelry. In this context, the art works seem souvenirs more than an art collection. Whatever was brought home to Baltimore in the Cones' capacious trunks had been bought to enhance their personal environment. It was not an art collection yet, despite the avant-garde nature of some of its contents. In fact, in some important sense for the Cone sisters, it never was an art collection. In an interview in Baltimore's *Sun* in 1928, Claribel commented, "As a matter of fact . . . I didn't even know that the things I had could be called a collection until people began to use the term in talking to me about them. Ever since I was a small girl and picked up all the shells I could find, reveling in their color and in their forms, I've been acquiring beautiful things. I've picked them up here and there all over the world, some of them at first hand, some from dealers. I took beauty where I found it and . . . it has emanated from American sources and from the most remote villages of Asia and the heart of Africa . . . " [April 15, 1928, Sunday Magazine Section, p. 20].

In the summer of 1908 Etta and Claribel again traveled to Europe together. They had a relatively short summer stay, and their visit with the Steins in Italy was no doubt highlighted by their first meeting with Alice B. Toklas. Although Toklas did not move into 27, rue de Fleurus until 1909, she and Gertrude were already inseparable companions by the summer of 1908. Leo Stein would leave the rue de Fleurus in 1913, when their shared collection was divided between them, with Leo taking the Renoirs and Matisses and Gertrude retaining all of the Picassos and some Cézannes. The Cones were probably brought up to date about the additions to the Stein collection, including the 1907 acquisition of Matisse's *Blue Nude*, the

Fauve masterpiece which Claribel later bought from the John Quinn Estate sale in 1926. The Cones' European trip was cut short by news of Brother Moses's ill health, and they returned to Baltimore in August 1908 without going on to Paris. Moses died in December 1908 and Etta became the devoted companion of his widow Bertha. Her letters to Gertrude over the next four years (like those to Claribel cited earlier) are devastating in their revelation of grief. She was even more explicit to Stein about the debilitating depression she suffered over her brother's death (" . . . Somehow its hard to pull myself together, and honestly I feel so indifferent whether I live or not . . . " [letter from Etta Cone to Gertrude Stein, April 11, 1909, Greensboro (Yale)]). She described incapacitating physical symptoms (chronic insomnia and addiction to Veronal) and utter dejection about her life without Moses: " . . . The most terrible trial that could have come into my life has come. I miss my brother's intense devotion and approval of me. I miss—well the only people in the world who could give me something that I know I need, are you and Mike & Sallie. Sister Claribel is as gentle and considerate as she can be, but it wouldn't do to have her sacrifice–her nature for long. I could'nt stand it . . . " [letter from Etta Cone to Gertrude Stein, December 12, 1909, Baltimore (Yale)]. For her part, Gertrude must have written in strong terms to Etta in an attempt to shake her from her grief; though the Stein letter has been lost, Etta's response indicates the degree of her pain:

> My dear Gertrude, Your letter of Aug 6 just came and honestly you have simply shocked me with your unfair outburst. Why how can you talk to me in such a way dear Gertrude, when you know me and the depths of my feelings for you. As to my silence, you are most unjust, for I wrote to both you & Mike & Sallie just about four weeks ago & in my letter I acknowledged that I am having a hard fight, for goodness knows my load is the heaviest that could have fallen on me & for a time I really wished I could die. Even now life without the love & influence of my brother, who had simply clung closer than ever to me during the last two years, seems almost without aim. I ought be ashamed to acknowledge myself so weak, but honestly Gertrude you cannot possibly know how unhappy I am & you could not have realized how I adored, almost worshipped my brother & how I fought hard against depending on him & his exaggerated approval & love for me. . . . Really you must not misinterpret my silence and you must not talk to me as you did, for it looks terrible to me in writing & I could not sleep at all last night, after reading your letter. You and Sallie & Mike and even Leo ought know me well enough to know how deeply I have & do appreciate your friendship & the _enormous_ help you have all been to me and you ought know that you have'nt a better more appreciative friend on earth, but you dont need all these explanations & I am in a very nervous state, but striving with all my will power to overcome a devilishly emotional nature that has been stirred to its depths & it is a hard fight. . . . Take lots of love & please _never_ write me such a letter again . . . [letter from Etta Cone to Gertrude Stein, August 22, 1909, Blowing Rock, North Carolina (Yale)].

There is no comparable example of such an impassioned Etta, and her letter reflects perhaps in equal parts her grief-induced mental instability and her vulnerability to Gertrude's criticism. Finally striking a note of optimism, on January 21, 1912, Etta wrote Stein that she was planning a trip to Europe and was looking forward to seeing her again. That summer she and Nora Kaufman joined Claribel in Frankfurt and together they traveled in Italy and in the fall went to Paris. There they again attended the Stein Saturday evenings, and went

with Michael and Sarah Stein to visit Matisse outside of Paris, at Issy-les-Moulineaux. In Paris they were known as "The Miss Etta Cones," despite what was reputedly Claribel's greater "distinction." The sobriquet had been given by Picasso whose first impression of the Cone sisters of course came through Etta when she visited and bought from his studio. The sisters must have been once again swept up in the doings of the Stein circle but, though it is scarcely credible, there is no evidence that they bought art during these years (no account books or diaries, from either sister, have surfaced). It was during the 1912 visit in Paris that Gertrude Stein showed her word portrait, *Two Women*, to Etta and Claribel. Stein wrote portraits only of individuals who were relatively close to her or of some special fascination. The fact that she wrote *Two Women* at this time (between 1908 or 1910 and 1912) reflects the extent of her involvement, at least on a psychological level, with the sisters. In addition, many details of the Cone family relationships were available to Stein through Etta's outpouring of letters in these years. Stein's international reputation as a literary innovator and cultural force was growing. During the Cones' 1913 visit in Europe they saw a good deal of Gertrude and Alice as well as of Michael and Sarah Stein, and Leo, and the Matisses. On May 30, 1913, Claribel noted " . . . Etta Miss K & self–to Gertrude's. Spent evening at Gertrude's. Read Gertrude's new literature aloud." It is reported that Gertrude Stein was particularly taken with Claribel's readings of her work, and both Gertrude and Claribel were known for their dramatic projection. In this same year Etta had written to Stein, " . . . Yes, you are right that it is a toss-up as to which, you or Sister Claribel, likes the being lionized the most. She sure likes it powerful well" [letter from Etta Cone to Gertrude Stein, March 25, 1913, Greensboro (Yale)]. In 1913 there appears, too, the first indication of the Cones' buying from the Steins, motivated at least in part as a method of extending financial assistance; on June 2, 1913, Claribel reports that she went to Gertrude's for tea and "pd. Mike for cabinet & restoration."

For the next decade, despite the war, the Cone sisters sustained their respective routines with little alteration. It was only after World War I that the Cones consciously began to build an art collection. The Cone family business prospered during the war and the Cone sisters were even more affluent. After Claribel's return from Germany in 1921, she and Etta regularly traveled to Europe for the spring and summer. They shopped more compulsively than ever; Claribel in particular grew notorious for her acquisitiveness. Writing Stein one afternoon in Paris, Etta interrupted her note, " . . . There's the phone again. Its my sister about some bagdad covers. We are being drowned in things . . . " [letter from Etta Cone to Gertrude Stein, September 26, 1922, Paris (Yale)]. Michael Stein too registered impatience with the clutter of the Cones' lives: " . . . The Cones leave tomorrow for Lausanne and of course I had to go today and pack off our car full of Claribel's truck so that she will get off. Her room was full of it as usual . . . " [letter from Michael Stein to Gertrude Stein, July 28, 1926(?), Paris (Yale)]. After the war the Cones always stayed at the Lutetia when in Paris and although many recognized artists and writers also stayed at the Lutetia, Etta and Claribel did not seem to engage in artistic or literary relationships independent of the Steins. In the 1920's they apparently saw rather less of Gertrude and Alice, and rather more of Michael and Sarah. For the first time they began to buy art through dealers (rather than directly from the artists), and their network of "professional" art acquaintances began to expand. Despite her eight-year absence Etta quickly readapted to the lively lifestyle of

Europe and after her 1922 summer wrote Stein from Baltimore: "I wish I had remained in Paris. It is nicer there than it is here. One is torn to pieces over here with all kinds of conflicting emotions . . . " [letter from Etta Cone to Gertrude Stein, November 4, 1922, Baltimore (Yale)]. The sisters were often apart, even during the European summers, with Claribel going in one direction and Etta, generally in the company of Nora Kaufman, in another.

However much "nicer" Paris was than Baltimore, it is certain that there has never been an era more exciting and culturally explosive than that of France and Germany in the 1920's. Unconventional does not begin to describe the extremes manifest in both the arts and personal behavior in that post-war period of experimentation on every front. The proprieties were observed in public, perhaps, but in private and in the permissively bohemian world of the arts, there was a thrilling liberation. The Cones witnessed that revolution in life, and in art (Picasso and Matisse, above all), in theatre and music and dance (from Isadora Duncan to Diaghilev to Argentina of Spain dancing with castanets at the Moulin Rouge), in literature (Stein, Hemingway, Fitzgerald, Joyce, Eliot, Pound), and in architecture and design (the Cones visited the Exposition Internationale des Arts décoratifs et Industriels modernes in the summer of 1925—the exhibition that launched Art Deco as an international movement— and shared the excitement of Michael and Sarah Stein's commission of Le Corbusier to design their new home). The Cones, unlike the pioneer Steins, remained steadfast witnesses, however. They followed with enthusiasm but they were never able to lead with the daring of pure vision.

Among the first purchases by the Cones in the summer of 1922 were several paintings by Henri Matisse. Apparently Claribel bought *The Pewter Jug* and *Woman in Turban (Lorette)*, both 1917, as well as *Girl Reading, Vase of Flowers* of 1922, and Etta bought *Etretat, The Beach* (1920), and *The Brown Dress* and *Two Women in a Landscape, Vallée du Loup* (both 1922). For her earliest Matisse acquisitions, Claribel strode out bravely. *Woman in Turban* is one of a series of exceptionally powerful portraits of the Italian model Lorette done by Matisse in 1915–1917, culminating in the Barnes Foundation triptych, *Three Sisters*, 1916– 1917, featuring Lorette and her two sisters. Reflecting his Moroccan trip of 1913, Matisse painted Lorette in oriental costume. Barr has noted that "*The White Turban* [the Cone painting] . . . because of the frontal pose and severe demeanor of the model is the most striking of the numerous studies of Lorette in oriental headdress."[36] The painting is radiant in color, although the artist restricted his palette to relatively somber green, white, brown, and flesh. There is a riveting composure about the sitter, with the suggestion of disquiet in the tilted slash of brown paint hinting at a chair back. The painting's magnetic presence makes it one of the strongest Matisses in The Cone Collection. While Claribel responded to Matisse's boldest period of the teens in her initial purchases, Etta instead turned to the artist's current work which shared a sensibility with the impressionist mood of her 1905 Collioure watercolor. In December 1916 Matisse had moved to Nice for the winter season; he would continue to spend winters in Nice through 1929 and in recognition of the profound effect this migration to the south of France had on his work, the art of 1917 to 1930 has come to be known as Matisse's Nice Period. Alfred Barr has suggested that "the transformation [represented in the paintings of 1917 to 1925]—the move toward a less strenuous, more traditional and more popularly acceptable style—had been intimated as early as 1912, had

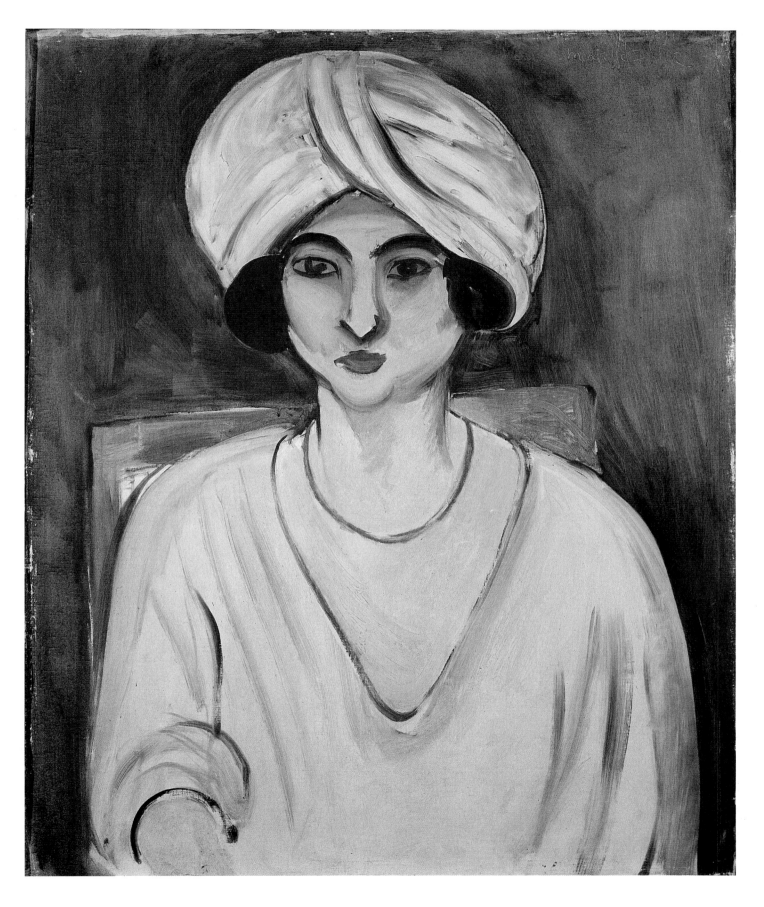

Henri Matisse. *Woman in Turban (Lorette)*. (early 1917). Oil on canvas. BMA 1950.229.

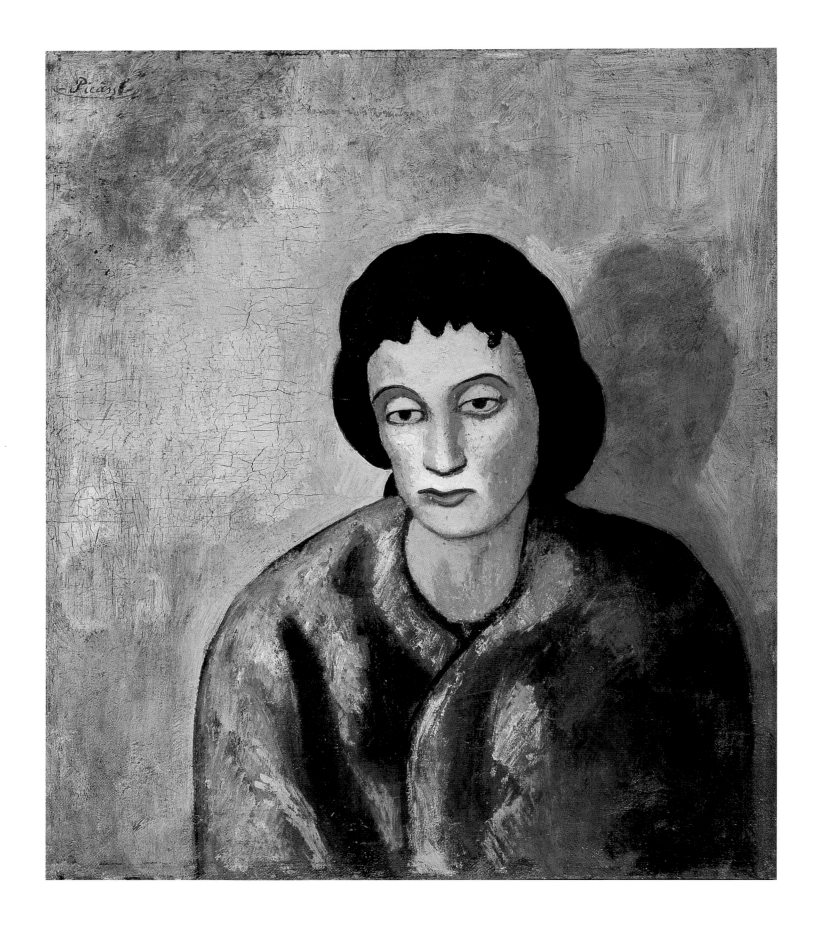

Pablo Picasso. *Woman with Bangs*. (1902). Oil on canvas. BMA 1950.268.

already begun in Paris toward the end of 1916 and was further developed in the summer of 1917 at Issy . . . " and thus concludes that the change in Matisse's art had less to do with his move to Nice than it did with a general groundswell "against the rigors and austerities of the various more or less abstract movements of the first dozen years of the century."[37] Whatever the roots of this change, the paintings of the early and mid-twenties shifted measurably away from Matisse's ambitious experiments of the preceding decade and toward conventional subject matter at modest scale, painted with almost ingratiating charm. *Two Women in a Landscape, Vallée du Loup* is characteristic of these pictures, and it was to its pleasant, pastoral mood (perhaps reminiscent of Greensboro and Blowing Rock) that Etta seems to have been drawn for one of her first 1922 purchases. Neither sister was immune to the charms of these mild Nice paintings: the collection includes fourteen Matisses all dating from 1920–1922. One is reminded of Claribel's writing to Etta that she found living with people less satisfactory than living with things, because "things are soothing–if they are works of art–most people are over-stimulating" [March 16, 1920]. If Claribel wanted to be surrounded by soothing paintings, she could do no better than Matisse of the early 1920's. While none of these pictures are without quality—and many reveal the unique touch of the master in peculiar, "unsoothing" ways—as a body they nonetheless represent the least challenging and somehow most complacent of his works. This sedate group of paintings comprises about one-third of the Cone sisters' collection of Matisse paintings and, as such, lends the collection as a whole a less progressive character than it would otherwise have. In contrast, *Blue Nude* and *Large Reclining Nude, Woman in Turban (Lorette)* and *The Yellow Dress*, all represent Matisse's easel-scale paintings at their most experimental and confrontational.

Curiously, the 1922 Matisse painting acquisitions are not reflected in the customs declaration compiled by Michael Stein on behalf of Etta Cone in November 1922. Michael became almost an official representative of the Cones in Paris in regard to certain business aspects of the collection (seemingly a kind of "double agent" in view of his activity as a salesman for Gertrude's things). It may be that the paintings stayed in Europe. It is also possible that the itemization for export was intentionally inaccurate in order to reduce the duty levied on the shipment. Whatever smokescreen this 1922 customs declaration may represent concerning the actual art purchases by the Cones in the preceding summer, it is a fact that Michael Stein arranged to ship to Baltimore seven crates containing fifty-seven works of art.[38] Etta and Claribel in a few weeks in Paris in the summer of 1922 set the pattern of prodigious art collecting that would continue unabated through the decade and for Etta (after Claribel's death in 1929) for still another two decades. Michael Stein would continue to act as administrator and provocateur (almost a private dealer as far as the Cones were concerned), constantly needling Etta to buy more art and hinting that such purchases could prove financially advantageous. In 1927 he wrote, " . . . There was a sale the other day in which there were 6 Matisses and they brought very high prices. I am enclosing the photos out of the catalog with the prices . . . " [letter from Michael Stein to Etta Cone, December 30, 1927, Paris].

If the 1922 customs declaration is at all reliable, it would appear that the Cones also bought their first Picasso painting that summer. The Cone Collection's *Woman with Bangs* of 1902, a classic example of Picasso's Blue Period work, is the only Picasso oil acquired

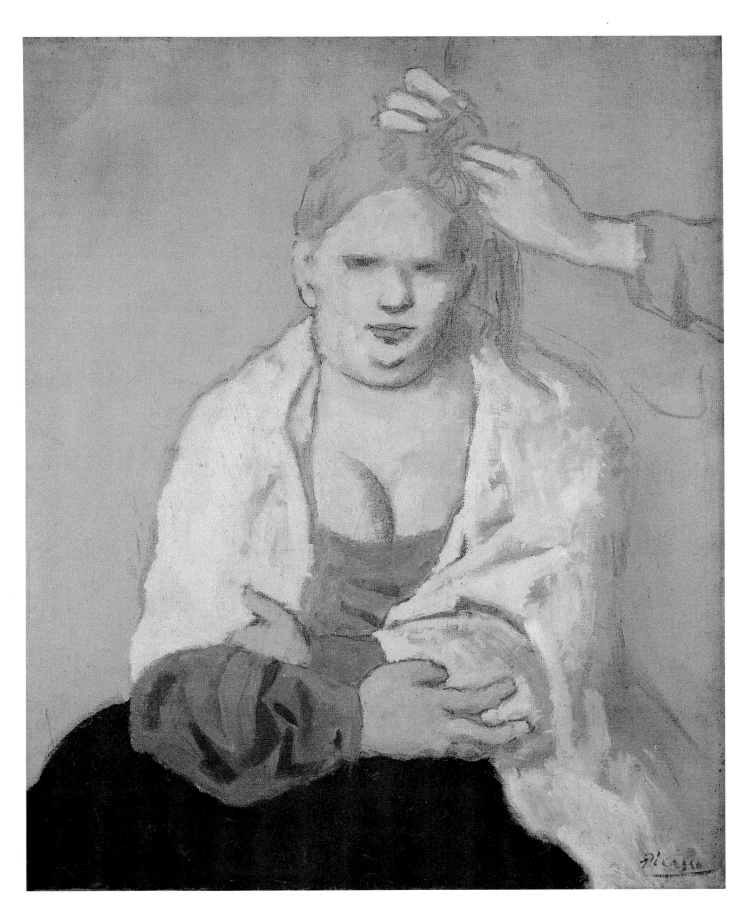

Pablo Picasso. *La Coiffure*. (1905). Oil and charcoal on canvas. BMA 1950.269.

by the Cones prior to 1934 (when it was published by Etta in the Cone memorial volume), although they had bought several Picasso gouaches of importance that might have been categorized by Michael Stein as paintings rather than as drawings. *Woman with Bangs* was owned by the Steins, and while it is possible the Cones bought the painting as early as 1922, other evidence suggests that Etta acquired it only in 1929. It was not until 1937 that Etta bought Picasso's *Mother and Child*, a 1922 painting which has become the collection's icon of popular sentiment despite its deft brushwork. The finest Picasso painting in the collection is *La Coiffure* of 1906, one of his group of works on this theme (its post-1934 date of acquisition is unknown). Etta also acquired the Picasso bronze, *Woman Combing her Hair* of the same date and from the same series, and the collection includes several related drawings with coiffure subjects. The Cone *Coiffure* isolates the head and torso of a single figure seated in full frontal pose, with only disembodied hands and wrist at the upper right to indicate the hairdresser's presence. In the definitive, larger-scale version of the subject (The Metropolitan Museum of Art, New York), two female figures appear along with a nude child at the lower left. The Metropolitan painting explores the motif; the Baltimore painting is a portrait. The woman is lumpy and pensive, her gaze slightly averted, her body protectively enfolded by her crossed arms. The hand mirror held by the subject and the hairdresser in the Metropolitan painting is meant to reflect the progress of the coiffure; in the Baltimore painting, the viewer becomes the subject's only mirror. The coarseness of the woman's body and features is softened by a neutral palette thinly applied as "washes" of discrete color. The picture is surprisingly flat and abstract—in contradiction of the subject's physical bulk— as a result of the broad areas of color patches, boldly grounded in the deep maroon swath of the figure's skirt. In its austerity and depth of feeling *La Coiffure* by Picasso comprises a virtual pendant to Matisse's *Woman in Turban (Lorette)*, and represents a startling departure for Etta.

The summer of 1925 brought to The Cone Collection several of its most important pictures. In June and July Claribel bought from the Steins the Marie Laurencin *Group of Artists*, and three paintings by Louis Favre; a Cézanne landscape from Bernheim Jeune; and Matisse's *Painter in the Olive Grove* from the artist's son, Pierre Matisse. The *Group of Artists* is one of the most enchanting pictures in the collection, a group portrait of Marie Laurencin, Guillaume Apollinaire, Picasso (with his dog Frika), and Fernande. Dating from 1908, the painting must have recalled for Gertrude Stein and the Cones alike the vivid and eccentric years of Picasso's life in the Bateau-Lavoir of Montmartre. It was here that Picasso hosted the famous and absurd Rousseau Banquet; here that Stein sat some eighty or ninety times for her portrait by Picasso; here that the Cones, twenty years before, bought their first Picasso drawings; here that artists, wives, and mistresses intermingled freely; and here that the legend had begun. The great poet and critic Apollinaire, his mistress and muse, the mercurial Laurencin, and of course Picasso and his mistress Fernande Olivier (ever "Madame Picasso" to Etta) came together in this group portrait as archetypes of an era. The directness of pose and freshness of color employed by Laurencin engage the viewer with seductive charm and innocence. In retrospect, it seems remarkable that Stein could sell this bold and endearing memento of her love affair with Montmartre; Claribel bought it for 10,000 francs (about $500). The "Cezanne landscape" which Claribel first reports buying in June 1925 was the monumental *Mont Sainte-Victoire Seen from the Bibémus Quarry*, arguably the

finest single painting in The Cone Collection. These "turbulent, ecstatic last views of Mont Sainte-Victoire in the distance . . . represent the consummation of Cézanne's career."[39] The Cone *Mont Sainte-Victoire* is a particularly dramatic rendering of the subject because it divides the canvas horizontally between a near view of the sheer walls of the quarry and a far view of the mountain, producing a virtual abstraction in blue and orange. The painting is a masterpiece of color wizardry, drawing radiant transparency from rich, dense hue. The Cézanne came from the collection of Maurice Gangnat; the Gangnat sale at the Hôtel Drouot on June 24–25, 1925, was of enormous interest to collectors of modern art since it featured 160 paintings by Renoir, Cézanne, Vuillard, and other early twentieth-century masters. Claribel purchased the painting from Bernheim Jeune et Cie. on June 26, 1925, for 410,000 francs, which in elaborate exchange rate calculations in her account book she converted to $18,860 (on June 29, 1925), the highest price either sister would ever pay for a work of art. It is not known whether Claribel instructed the gallery to bid at auction for the painting on her behalf or fortuitously bought it from Bernheim Jeune the day following the sale. The timing certainly suggests the former.

The following year Etta would buy Cézanne's *Bathers* from Gertrude Stein's collection. This had been one of the earliest art acquisitions by the Steins, purchased from Ambroise Vollard in 1904 or 1905, after Leo Stein had been advised by Bernard Berenson to look at the work of Cézanne. Gertrude retained the *Bathers* after she and Leo divided their household in 1913, and she in turn sold it to Etta in 1926. Twenty years before Etta had bought the Cézanne lithograph of the *Bathers* (both the large and small versions of this lithograph are included in The Cone Collection, and it is not known which version was acquired by Etta for fifty francs on February 1, 1906). In 1906 Etta was surely following Leo Stein's commitment to Cézanne as the old master of modernism. By the 1920's Leo had recanted: " 'Damn Cézanne. . . . ' For a while, no painter excited my interest more vitally. Now no pictures interest me less. . . ."[40] Despite Leo's angry disappointment, by 1925–1926 the fundamental art historical significance of Cézanne's work was almost universally acknowledged and, more particularly, recognized as essential to the development of the work of Matisse and Picasso. Both had early acquired Cézanne paintings for their personal collections and reported him to be their artistic "father." With these two important paintings, Claribel and Etta began to build a historical foundation for their more contemporary interests, and they would continue to do so in future years as they added works by Renoir, van Gogh, Pissarro, Courbet, and Delacroix, among others. Although Etta's *Bathers* is not one of the finished, large-scale paintings from the series done by Cézanne between 1895 and 1906, this smaller Cone study is revelatory, as John Rewald has pointed out, for "it was here, in canvases of more modest dimensions, that [Cézanne] could improvise more readily and give freer rein to his imagination and his sense of rhythm and movement."[41] Etta's acquisition of the *Bathers* a few months after Claribel's purchase of the *Mont Sainte-Victoire* followed a somewhat characteristic pattern in these years. It was not uncommon for Etta to emulate her sister's interests, often with a less daring selection: Claribel would buy a van Gogh, and Etta would buy her own van Gogh shortly thereafter, or Claribel a Renoir and then Etta a Renoir. Despite Etta's initial modest purchase of the Cézanne lithograph in 1906, her more substantive commitment to the artist's work came only after Claribel's ambitious acquisition of the landscape.

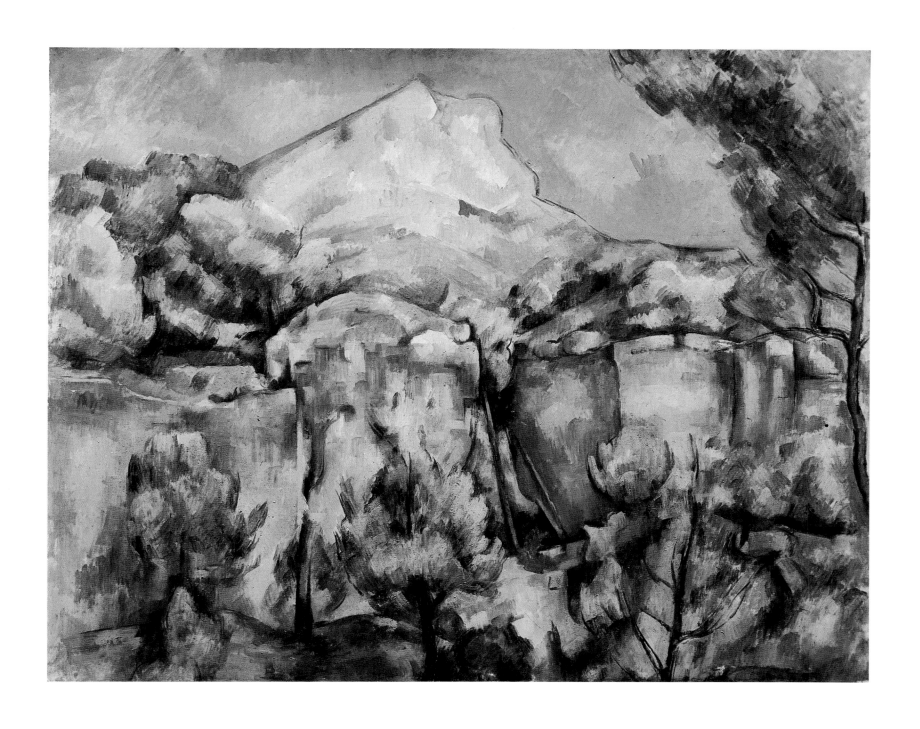

Paul Cézanne. *Mont Sainte-Victoire Seen from the Bibémus Quarry.* (ca. 1897). Oil on canvas. BMA 1950.196.

In the same month of 1925 Claribel and Etta each bought Matisse paintings from the artist's son. Claribel purchased *Painter in the Olive Grove* and Etta *Interior, Flowers and Parakeets*, both dating from 1924. In Claribel's notebook for July 6, 1926, she reports, "Pd Pierre Matisse 10.30 a.m.-11.30 a.m—30000 fr for his father's picture 'The Olive-Trees of Cannes.' 'Oliviers 1924' . . . Etta paid at same time 70000 fr for her Still Life Study in Red." In a 1927 letter to Etta, Claribel wrote, " . . . If Matisse has something, I want one as brilliant as your lovely red interior . . . " [letter from Claribel Cone to Etta Cone, August 18, 1927, Lausanne]. *Interior, Flowers and Parakeets* is certainly a "lovely red interior," and it is understandable that Claribel might initially perceive it as a "Still Life Study in Red" in view of the prominence of its foreground still life feature. It is the only Matisse in The Cone Collection which is sufficiently suffused with predominant red to be interpreted so consistently as a "red" subject. Additionally, the *Interior* is a large and ambitious canvas, warranting the price differential between 30,000 francs for the *Painter in the Olive Grove* and 70,000 francs for the *Interior*. It is almost certain, then, that it is to this painting that Claribel refers regarding Etta's purchase on July 6, 1925. Both of these paintings have become highlights of the collection.[42] According to Gertrude Rosenthal, *Interior, Flowers and Parakeets* was Etta's favorite Matisse in the collection, an opinion she frequently voiced (Renoir's *Washerwomen*, purchased by Etta in 1928, was her favorite "non-Matisse"). Alfred Barr shared Etta's admiration for the *Interior*:

> The interiors of 1924 are painted with the same wonderful appetite for color and ornament [as the still lifes] but, though they are more complex, they surfeit less because they are more spacious both in their two-dimensional composition and in depth. The window, which one can see at the end of a vista—after the eye has passed over the elaborate foreground still life and under the ornate half-drawn oriental hanging and past a flowered screen—the window, esthetically, lets in both light and air. The *Interior with Flowers and Parrots* in the Cone Collection of the Baltimore Museum is the largest and most magnificent of these. . . .[43]

The luxuriant *Interior* derives from the period in Matisse's work when the artist was most committed to the sensuous and exotic in terms explicitly dominated by the orientalism of North Africa. As Lawrence Gowing has written, "more and more vivid Moroccan decorations . . . [became] the setting for his increasing engrossment in the flesh."[44] The Cones would acquire several of Matisse's odalisque paintings dating from these years, in which models pose with erotic abandon in lush, ornate interiors. The settings are rich with color and pattern, crowded with oriental rugs and flowered wallpaper, heavy with mirrors and furniture, increasingly claustrophobic and windowless. In these paintings, narrowly framed abstractions of flat, fragmented pattern contrast with the realism of sensuously rendered nudes or partially draped figures. The artist's conflict between abstraction and realism would be settled by the late 1920's when pattern subsumed figuration in some of the most astonishing still lifes and interiors of his career.

On October 28, 1926 Claribel bought the painting that would become the keystone of The Cone Collection. Seventy-two works from the collection of New York attorney and collector John Quinn were offered at auction by his estate at the Hôtel Drouot, Paris, on that day. Having enlisted Michael Stein to bid for her, Claribel purchased Matisse's formidable Fauve masterpiece, *Blue Nude ("Souvenir de Biskra")*, 1907.[45] Leo Stein had bought the *Blue Nude*

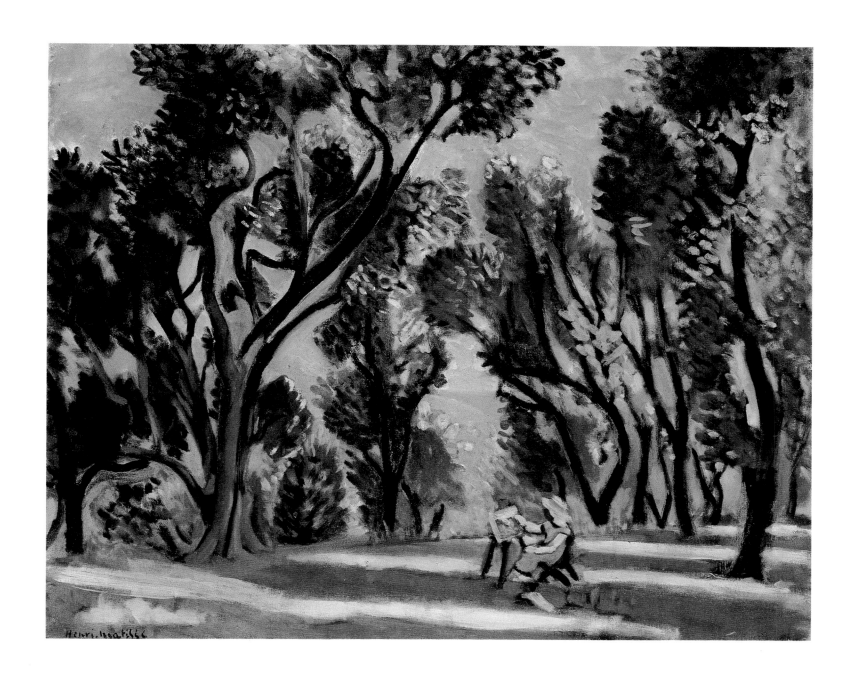

Henri Matisse. *Painter in the Olive Grove*. (1923–early 1924). Oil on canvas. BMA 1950.239.

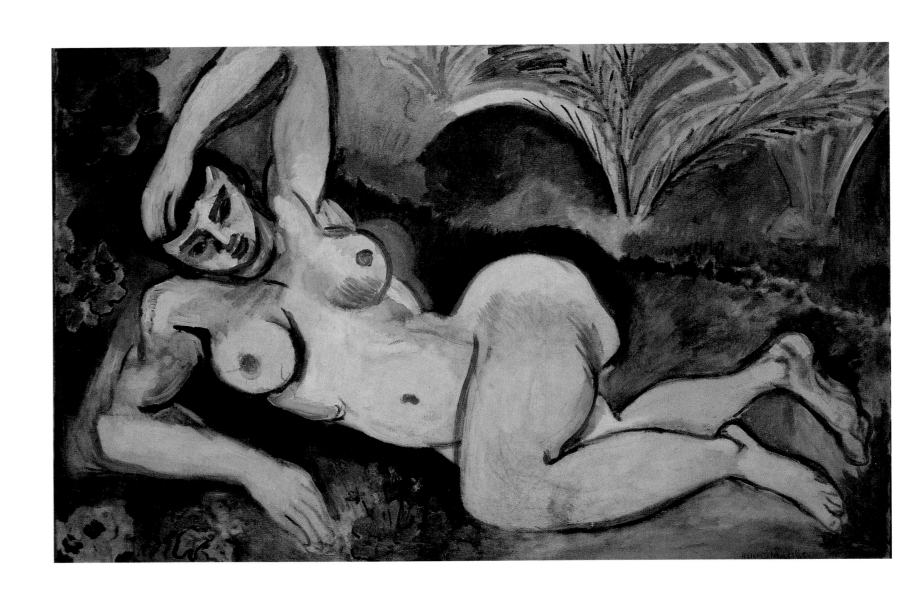

Henri Matisse. *Blue Nude ("Souvenir de Biskra")*. (1907). Oil on canvas. BMA 1950.228.

in 1908; it was in fact the last Matisse either Leo or Gertrude would acquire. The painting hung at the rue de Fleurus for the next five years where, according to Stein memoirs, it always elicited a dramatic and usually negative response from visitors for its allegedly gratuitous ugliness. In about 1913, when Leo and Gertrude parted ways, Leo sold the *Blue Nude*. For the next seven years the painting made the rounds of dealers in both Paris and New York, until December 1920 when John Quinn bought the painting for $4,500 from the Marius de Zayas Gallery in New York where it was included in an exhibition of Matisse paintings. Before selling the painting, however, Leo Stein loaned it to the International Exhibition of Modern Art, the famous "Armory Show" in New York (February 17–March 15, 1913) which also traveled in somewhat revised form to both Chicago and Boston. The *Blue Nude* was a succès de scandale of the Armory Show, and Matisse and Brancusi were singled out to be burned in effigy by students of The Art Institute of Chicago. As late as 1931 Barr wrote of the *Blue Nude* as "one of Matisse's most powerful and most difficult works," noting that it demonstrated a "savage power rare in Matisse's works."[46] Its savage power has diminished little in the ensuing fifty years and it is still a difficult work insofar as great paintings challenge perception with a seeming arbitrariness of form and color that could not have been imagined before artist put brush to canvas. Most viewers still find the *Blue Nude* ugly, and many still ask, in sincere bafflement, "why blue?" (One report has it that the *Blue Nude* was "the result of a friendly competition with Derain as to who could paint the best figure in blue. When Derain saw Matisse's *Blue Nude* he conceded his defeat and destroyed his canvas.")[47] There is at least a subliminal shock value in the fact that the nude is posed in an exterior setting (public exposure versus private), in itself a rare motif for Matisse. With the notable exception of key early works more or less derived from a "bathers" theme (*Luxe, Calme et Volupté*, 1904–1905; *Joy of Life*, 1905–1906; *Le Luxe*, 1907 and 1908; *Dance*, 1909–1910; *Music*, 1910; and *Bathers by a River*, 1916–1917), in which groups of nudes frolic in outdoor settings, Matisse's nudes are models posed in studio or interior spaces. The *Blue Nude* stands virtually alone in the artist's oeuvre as a single nude figure reclining erotically in a landscape. Neither does the figure have any of the flattened androgynous stylization of the figure groups from these other paintings of exterior-posed nudes. The *Blue Nude*, on the contrary, is sensuously painted as muscle and flesh, stretched in exaggerated *contrapposto* across the canvas, with her bent left arm extended over her head. Despite the heavily muscled arms and legs, the abandoned pose, and the extreme distortions of form, her sweet facial features and the pert tilt of her head make the subject seem somehow demure. Contrived and static as the pose is, there is the suggestion of movement in the aura of blue the artist added along the figure's right arm and left breast. The pose of the *Blue Nude* was derived from that of the 1907 sculpture, *Reclining Nude I* (a cast of which is in The Cone Collection); the original version of the sculpture was accidentally ruined by the artist as it was being modeled and, in exasperation, Matisse turned to painting the subject instead. It was the artist's first life-size nude and the first to so explosively fill the format of the picture. In its aggressively enunciated physicality, the *Blue Nude* meets Matisse's criteria for correct figure sculpture:

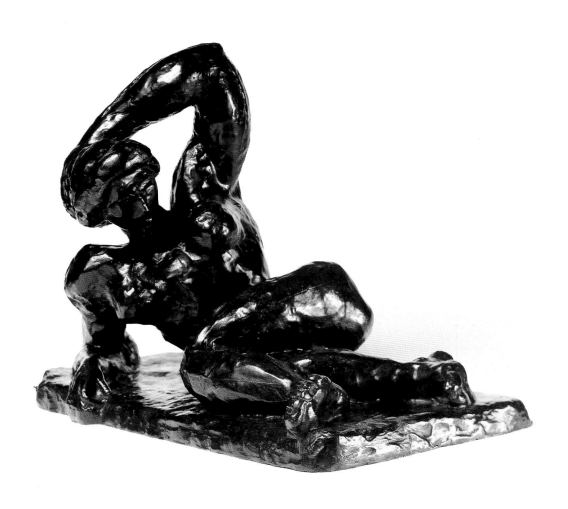

Henri Matisse. *Reclining Nude I (Aurore)*. (1907). Bronze. BMA 1950.429.

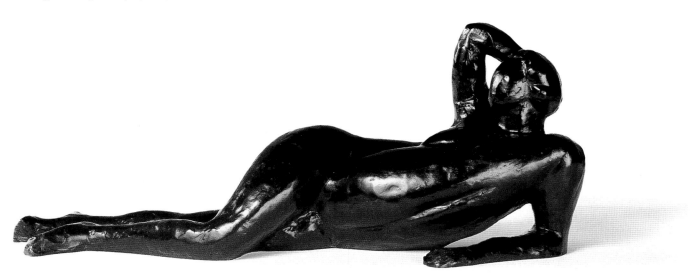

Henri Matisse. *Reclining Nude III*. (1929). Bronze. BMA 1950.437.

116

The joints, like wrists, ankles, knees, and elbows must show that they can support the limbs—especially when the limbs are supporting the body. And in cases of poses resting upon a special limb, arm or leg, the joint is better when exaggerated than when underexpressed. . . . The model must not be made to agree with a preconceived theory or effect. It must impress you, awaken in you an emotion, which in turn you seek to express. . . .[48]

From Michael Stein, the Cones learned of Matisse's pleasure at their acquisition of the *Blue Nude*. Claribel must have passed along her wish that the unsigned painting could be given the artist's official imprint: ". . . Please tell Claribel that Matisse was most nice about 'femme bleu.' He said he would be very happy to see it again when he comes up and will then sign it" [letter from Michael Stein to Etta Cone, December 8, 1926, Paris]. Indeed, the painting is signed "Henri-Matisse" at the lower right, a signature that must have been added in late December 1926 or early 1927.

The Cone sisters bought their first four Matisse bronzes in 1922; by the time of Etta's death, the collection included eighteen of the artist's sixty-nine sculptures, ranging in date from 1900 to 1930. Although they never bought from the great sculptural series of *The Back* or *Jeannette*, virtually every other motif in Matisse's bronze oeuvre is represented, including the unique *Tiari (with Necklace)* from 1930. The *Tiari*, made by Matisse after his visit to Tahiti, was inspired by the Tahitian gardenia (called tiari), but its form is dependent on the stylization of African masks. The ovoid face and elongated nose form a continuous line with the figure's elaborate hairdo, resulting in a cluster of mounded shapes. For unknown reasons the artist drilled one cast of the bronze and strung it with a gold chain necklace; it is the version bought by Etta Cone. The necklace lends the otherwise extremely abstract head a distinct realism but it also alludes, if only subliminally, to a certain ritual authority (like beads strung on an African power figure). Matisse's sculpture relates integrally to the development of his painting. There are figure poses shared in paintings, drawings, and sculptures; works of sculpture often appear as still life components in paintings; movement from realism to abstraction and back is generally echoed from sculpture to painting. Most of the sculpture in The Cone Collection dates from the early 1900's (including *The Serf* of 1900–1903 and the stately *Two Negresses* of 1908), but Etta's later purchases, along with the *Tiari*, included the important *Large Seated Nude* (1923–1925) and *Venus in a Shell I* (1930), as well as the refined and sensuous *Reclining Nude III* from 1929.

Throughout the 1920's the Cone sisters continued to buy with avidity. Their concentration on Matisse began to diminish somewhat as they forged new relationships among art professionals and were guided toward greater diversity. In particular, Claribel found herself drawn increasingly to the Swiss dealer Paul Vallotton in Lausanne, where she spent several weeks each summer. She liked and trusted the Vallotton family, and in the years before her death she bought regularly through this dealer (including several paintings by his brother, the painter Félix Vallotton). In 1927 Claribel wrote Etta of her flagging enthusiasm for Matisse: " . . . but Matisse has seen the heydey of his virility and I fear is toppling downward . . . " [letter from Claribel Cone to Etta Cone, August 18, 1927, Lausanne]. It is striking how often the term virility was used to describe Matisse and his work. Writing of the artist in *The Autobiography of Alice B. Toklas*, Gertrude Stein also emphasized this quality:

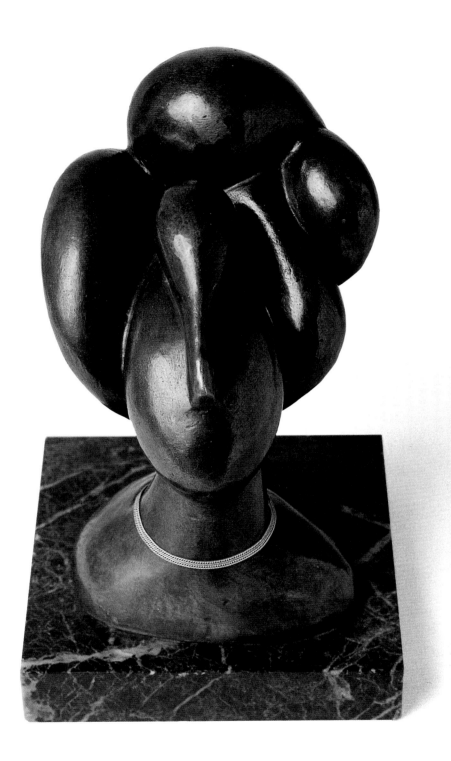

Henri Matisse. *Tiari (with Necklace)*. (1930). Bronze, with gold chain. BMA 1950.438.

Matisse had an astonishing virility that always gave one an extraordinary pleasure when one had not seen him for some time. Less the first time of seeing him than later. And one did not lose the pleasure of this virility all the time he was with one. But there was not much feeling of life in this virility.[49]

The Steins lost confidence in Matisse by 1908; Claribel by 1927; Etta never. Whatever their respective regard for Matisse, both Claribel and Etta broadened their tastes and added a growing range of art to their collections. Cone letters from the late 1920's are full of art-buying news:

> But where did I leave those photographs Mr. Vallotton brought over—There were two of them—one a Degas—which Mr. V. says is not very large—it has quality though and you may be interested. The other a Renoir he says is beautiful in color—but as I do not like Renoir I am not enthusiastic. . . . we are not obligated in any fashion and I shall look at them for you—and if they are at all attractive shall ask him to hold them until your return. The Degas you may like—maybe also the Renoir—we shall see. I told Mr. V. that you may not have any money left upon your return as the trip (esp. Villa d'Este) is very expensive.– . . . [letter from Claribel Cone to Etta Cone, August 18, 1927, Lausanne].

Claribel's remark about not liking Renoir is curious in view of her purchases in the preceding two years. In October 1925, only three months after her acquisition of the Matisse painting that echoes it in subject and composition, she bought Renoir's *Olive Trees* (ca. 1905), and in 1926 she bought his *Bouquet of Roses* (ca. 1909). The work must have worn very thin indeed if by the summer of 1927 Claribel could so definitely state her dislike for Renoir. Contradicting herself, she purchased still another Renoir (the 1912 portrait, *Mlle. Estable*) in the summer of 1928. Etta bought her favorite Renoir, *Washerwomen*, also in 1928. Possibly as a reflection of Matisse's special interest in the older artist's work—particularly during his years in Nice—Etta acquired several other Renoirs, both painting and sculpture, before her death. Between 1927 and 1929 Claribel bought, among many other things, sculpture by Rodin and Dalou and paintings by van Gogh (*A Pair of Boots*), Pissarro, Redon (the exquisite *Peonies*), and Sisley. Within a few months of Claribel's purchase of the elegiac 1887 *Boots* by van Gogh, Etta bought a modest floral subject by the artist and in the 1930's would add the major early pastel, *Beach at Scheveningen*, and the oil, *Landscape with Figures* (1889).[50] Claribel rather quickly tired of her van Gogh, as she had her two Renoirs. She wrote Etta in August 1927, "I am not so pleased with my Van Gogh—it is so unlike his better (more forceful more mad style perhaps) style. And the pair of shoes will not grace my living room with beauty—however—it is a Van Gogh—almost—certainly—Mr. V. says sans doutes . . . " [letter from Claribel Cone to Etta Cone, August 22/28, 1927, Lausanne]. Claribel's taste was sufficiently refined by now for her to identify accurately the more "forceful" aspects of an artist's work and also to recognize the absence of those characteristics. In addition, her letter makes it clear that she wishes her acquisitions to fulfill one of two primary functions, either representing the artist's best style (regardless of "beauty") or serving as soothing decoration to "grace [her] living room." From her point of view, the van Gogh *Boots* did neither. Only days before her death, Claribel confirmed her purchase of the great Courbet forest landscape, *The Shaded Stream at Le Puits Noir* (Paul Vallotton's invoice was in fact dated on the very day of her death).

Henri Matisse, in Etta Cone's dining room at The Marlborough Apartments, Baltimore, December 17–18, 1930.

V.

Claribel Cone died of pneumonia in Lausanne on September 20, 1929, just two months before her sixty-fifth birthday. Etta received messages of condolence from around the world, and she now assumed responsibility for her sister's collection as well as her own. She and younger brother Fred and their household staff would continue to maintain three apartments at The Marlborough, as they had done during the last years of Claribel's life. Claribel's apartment had already been designated by her "a museum," and was used only for sleeping when she was in Baltimore (the three siblings had always taken their meals in Etta's apartment). After Claribel's possessions were returned to Baltimore, Etta placed everything in her sister's rooms as they would have been in life (including packed trunks, readied for another European trip); the rooms were regularly cleaned and decorated with fresh flowers, and the art was hung on the walls to stay. Etta traveled to Europe, as usual, in the summer of 1930. More remarkably, in that same year Matisse came to see her. In America to judge the 29th International Exhibition of Modern Painting at the Carnegie Institute in Pittsburgh (Matisse had won first prize in the 1927 Carnegie show; he and his fellow jurors would award the 1929 prize to Picasso), he also visited New York City; Merion, Pennsylvania, to view his work at the Barnes Foundation; and Baltimore to see The Cone Collection. He arrived on December 17, 1930, and stayed overnight with Etta. The Baltimore press took notice of his presence; indeed, he was such an international celebrity by 1930 that *Time* gave him its cover story on October 30, 1930. The Cone Collection was described by Barr as "the second most important Matisse collection in the country" (after the Barnes), and Etta Cone, unlike Dr. Barnes, was still an active collector of the artist's easel paintings. For Etta, Matisse's visit must have been a great privilege and joy; for Matisse, it must have been gratifying to see so many of his works lovingly displayed in such an intimate setting. The artist granted an interview to the Baltimore *Sun*'s art critic, A. D. Emmart, who noted that it was conducted at Etta Cone's "in one of their picture-crowded rooms against a background of his own paintings and bronzes."[51]

When Matisse was in Merion, Albert Barnes invited Matisse to paint a mural decoration for the lunettes of the Foundation's great hall. This commission would occupy the artist for almost three years, until May 1933 when the magnificent *Dance* was finally installed under Matisse's personal supervision. When in Baltimore, Matisse was commissioned by Etta for a much more modest project, a portrait drawing of Claribel, to be done from memory and

I. BMA 1950.12.65.

II. BMA 1950.12.72.

III. BMA 1950.12.66.

IV. BMA 1950.12.71.

Henri Matisse. *Dr. Claribel Cone*. (1931–1934). Pencil or charcoal on paper.

I. BMA 1950.12.63. II. BMA 1950.12.64. III. BMA 1950.12.67.

IV. BMA 1950.12.68. V. BMA 1950.12.69. VI. BMA 1950.12.70.

Henri Matisse. *Etta Cone*. (1931–1934). Charcoal or crayon on paper.

123

from a photograph supplied by Etta. She must have immediately written Michael and Sarah Stein with great excitement of Matisse's visit and agreement with her proposal, because the Steins responded warmly:

> My dearest Etta, Your good letter came this morning. It was most interesting, and I am very sure that Mons. Matisse enjoyed being your guest quite as much as you enjoyed having him—When we had that nice talk the last time he was here, he spoke of doing a drawing of dear Claribel and I knew what a great comfort it would be to you to have something done with true feeling and genuine understanding—by his hand . . . [letter from Sarah Stein, signed "Sally Anne & Mike," to Etta Cone, January 2, 1931, from Les Terrasses].

It is a reflection of Matisse's personal integrity and artistic rigor that the minor Cone commission would in fact take longer to complete than the major Barnes commission. In the interim, too, probably as a surprise for Etta, he decided to draw her as well, and he struggled resolutely with both the psychology and the aesthetics of the dual portraits:

> I'm still on my portraits from photographs of my two Baltimore ladies, which you perhaps don't remember. I'm finishing them—somewhat arduous work (what work isn't?), particularly so because imagination, memory and the precision of the photograph must join forces to produce the truth. But all the same, very interesting because it's based on two opposing characters from the same family, since they are sisters—one of them beautiful, a great beauty, noble and glorious, lovely hair with ample waves in the old style—satisfied and dominating—the other with the majesty of a Queen of Israel, but with lovely lines that fall, however, like those in her face, but with a depth of expression which is touching—always submissive to her glorious sister but attentive to everything. Simplified means, paper and charcoal—the second portrait is finished, I'm on the first, the studies for which in lead pencil you've already seen. I've been working on them every morning for nearly a month now—it's hard but I'm learning a lot [letter from Henri Matisse to Simon Bussy, May 24, 1934].[52]

Matisse in fact did six studies of Etta and four of Claribel, which he designated 1st state, 2nd state, etc., in the order of their execution. As soon as the drawings were finished, he forwarded photographs of them to Siegfried Rosengart for publication in the Cone memorial volume. In his letter to Rosengart of July 22, 1934, he specified that the two frontispiece portraits were to be the fourth and last state of Claribel, and of Etta the fifth (not the last) state. He numbered the photographs in sequence and firmly indicated that where all states of each portrait drawing were to be reproduced in the body of the book there should be an explicit caption indicating the state's respective chronological place in the series. All ten states of the portrait drawings were sent to Etta and remain in The Cone Collection. In these drawings one sees Claribel as the "great beauty . . . satisfied and dominating" (especially in the second state) and Etta as "a Queen of Israel . . . submissive . . . but attentive to everything" (especially in the fourth state). Matisse explored these elusive souls in pencil and charcoal in 1931–1934 with the same vivid and frustrated curiosity that Gertrude Stein brought to her word portrait twenty years earlier.

Another commission intimately engaged Matisse during the early 1930's. The Swiss publisher Albert Skira approached the artist in 1930 and invited him to illustrate a deluxe volume of poems by Stéphane Mallarmé. Many of Matisse's fellow artists of the period,

LES FLEURS

Des avalanches d'or du vieil azur, au jour
Premier & de la neige éternelle des astres
Jadis tu détachas les grands calices pour
La terre jeune encore & vierge de désastres,

Le glaïeul fauve, avec les cygnes au col fin,
Et ce divin laurier des âmes exilées
Vermeil comme le pur orteil du séraphin
Que rougit la pudeur des aurores foulées,

L'hyacinthe, le myrte à l'adorable éclair
Et, pareille à la chair de la femme, la rose
Cruelle, Hérodiade en fleur du jardin clair,
Celle qu'un sang farouche & radieux arrose!

28

Henri Matisse. *Les Fleurs*, from *Poésies de Stéphane Mallarmé*. Illustrated book. 1932. BMA 1950.12.691.

LE PITRE CHÂTIÉ

Yeux, lacs avec ma simple ivresse de renaître
Autre que l'histrion qui du geste évoquais
Comme plume la suie ignoble des quinquets,
J'ai troué dans le mur de toile une fenêtre.

De ma jambe & des bras limpide nageur traître,
A bonds multipliés, reniant le mauvais
Hamlet! c'est comme si dans l'onde j'innovais
Mille sépulcres pour y vierge disparaître.

Hilare or de cymbale à des poings irrité,
Tout à coup le soleil frappe la nudité
Qui pure s'exhala de ma fraîcheur de nacre,

Rance nuit de la peau quand sur moi vous passiez,
Ne sachant pas, ingrat! que c'était tout mon sacre,
Ce fard noyé dans l'eau perfide des glaciers.

18

Henri Matisse. *Le Pitre Châtié*, from *Poésies de Stéphane Mallarmé*. Illustrated book. 1932. BMA 1950.12.691.

Henri Matisse. *Le concert*. Refused plate for *Poésies de Stéphane Mallarmé*. Etching. BMA 1950.12.694xvii.

Henri Matisse. *Les glaïeuls*. Study for *Poésies de Stéphane Mallarmé*. Pen and black ink. BMA 1950.12.705.

Henri Matisse. *Triste fleur qui crôit seule*. Refused plate for *Poésies de Stéphane Mallarmé*. Etching. BMA 1950.12.694x.

Henri Matisse. *Nymph and Faun III*. Study for *Poésies de Stéphane Mallarmé*. Pencil. BMA 1950.12.726.

prominently including Picasso, had done distinguished illustrations for limited-edition books, but Matisse had not previously embarked on such a project. It was thus, as Barr has pointed out, with perhaps a touch of the competitive and even more than the artist's usual rigor that he approached the Mallarmé commission. Matisse had to "invent and develop his designs . . . to create an 'equivalent' not only to the typography of the page but to its poetry too."[53] In the process of inventing designs to suit and balance Mallarmé's verse, Matisse drew on iconography ranging from exquisitely elegant floral patterns to sensitive portraiture (of Poe and Baudelaire) to fragments of landscape and architectural elements to powerful, sweeping female outlines sketched with stunning refinement. Through all of the drawn studies Matisse kept the challenge of book design foremost in mind:

> As for my first book—the poems of Mallarmé.
> Some etchings, done in an even, very thin line, without shading, so that the printed page is almost as white as it was before the etching was printed.
> The design fills the page without a margin so that the page stays light, because the design is not, as usual, massed toward the center but spreads out over the whole page.
> The right-hand pages carrying the full-page illustrations were placed opposite left-hand pages which carry the text in 20-point Garamond italic. The problem was then to balance the two pages—one white, with the etching, and one comparatively black, with the printing.
> I obtained my goal by modifying my arabesque in such a way that the attention of the spectator should be interested as much by the white page as by his expectation of reading the text.
> I might compare my two pages to two objects chosen by a juggler. His white ball and black ball are like my two pages, the light one and the dark one, so different yet face to face. In spite of the differences between the two objects the art of the juggler makes a harmonious ensemble before the eyes of the spectator.[54]

There can be no more sensitive and informed articulation of the aesthetics of book design. The product, *Poésies de Stéphane Mallarmé*, published in October 1932 in an edition of 145 copies, is one of the most beautiful illustrated books ever printed. Matisse worked closely with Skira and with the printer Lacourière throughout the book's production, meticulously attentive to issues of paper and quality of etched line. When the book was completed Matisse remarked with a modesty that can only derive from the confidence of full artistic satisfaction: "After concluding these illustrations of the poems of Mallarmé, I would like to simply state: 'This is the work I have done after having read Mallarmé with pleasure.'"[55] Etta Cone, at the artist's request because of his faith that she would never disperse the set, purchased from Matisse all of the Mallarmé materials: original drawings, printed and refused copper plates (all cancelled), three proof volumes, and the signed first copy of the printed edition. It was an extraordinary commitment on her part to a landmark work by Matisse, a commitment made all the more striking for its impracticality as an exhibition piece.[56]

Etta Cone's intimate involvement with Matisse and his art was exceptional in these early years of the 1930's. Because of the artist's extended work on the Barnes murals and the Mallarmé book, as well as the Cone portraits, he did not produce many easel paintings between 1930 and 1935. Of the relatively few pictures he did paint at this time, three of the most important are in The Cone Collection: *The Yellow Dress* (1929–1931), *Interior with Dog*

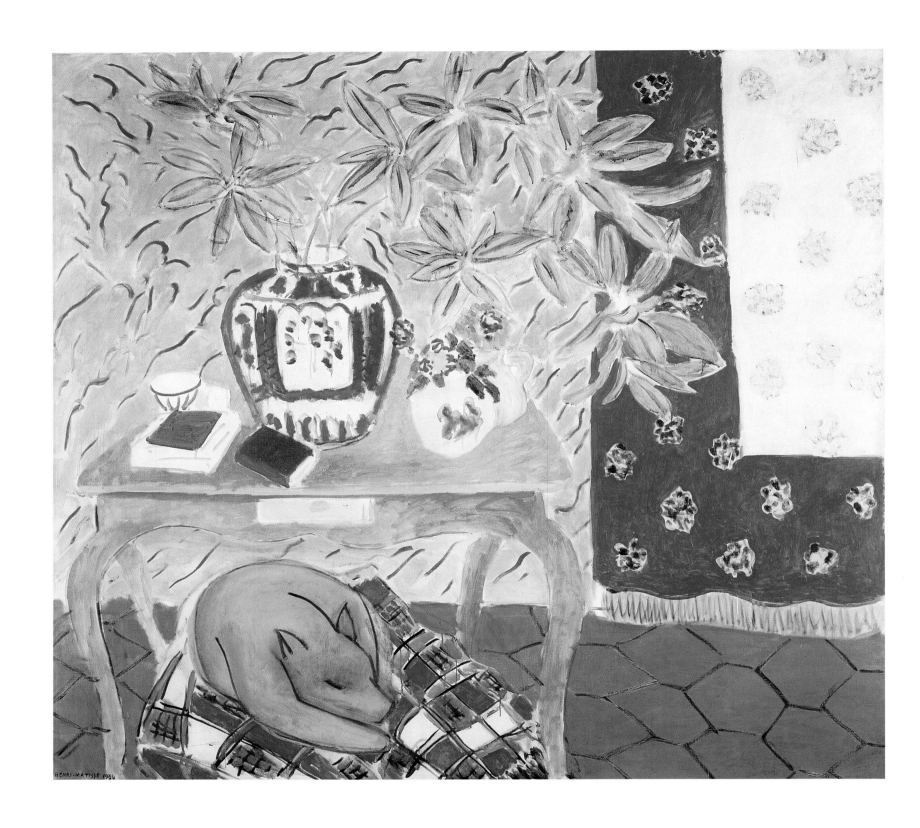

Henri Matisse. *Interior with Dog*. 1934. Oil on canvas. BMA 1950.257.

(1934), and *Large Reclining Nude* (1935). Each was acquired by Etta, in turn, almost as soon as it was finished by the artist. She also bought the lovely, if more modest, *The Blue Eyes* of 1935, a painting of the head and arms of the subject featured in the large drawing of the same year, *Seated Nude, Head on Arms* (which she did not buy). In September 1935 Matisse sent Etta six photographs of this drawing marked "I état" through "VI definitif," and writing in his cover letter:

> I am sending you some photographs representing various states of work in progress. First a suite of drawings from which "the blue eyes," that you very much wanted to buy from me, derived. Then the states of a painting, "reclining nude," and the sketch for a painting "sleeping nymph awakened by a faun playing the flute." The dates of the different states are indicated on the photos–I hope that these different works give you a little amusement–and my goal will be realized [letter from Henri Matisse to Etta Cone, September 19, 1935, Nice].

The packet with the letter and photographs of the "Seated Nude" and "Sleeping Nymph" drawings, as well as the first nineteen states of the "nu couché," was postmarked in Nice on September 23; a second letter and packet of photographs with the last three states of the "nu couché" were sent later, postmarked November 16. All of these photographs are fascinating and revealing documents. It was in about 1935 that Matisse began photographic documentation of his work in progress; at regular intervals as the work evolved it would be photographed with a dated scrap of paper attached to the image. Matisse then annotated the photographs from "I état" through "Etat definitif." In certain instances, as with the drawing *Seated Nude, Head on Arms*, some of the states are reworked on the same sheet and others started on fresh paper. This drawing is startling for the extreme abstraction of its fifth state, reworked in the final version to a much more realistic (and, to the modern eye, much less exciting) figure study. This visual evidence—along with similar patterns of experimentation with radical abstraction subsequently retracted, as evident in other progressive photographs of Matisse works—categorically contradicts notions about progress in modern art depending on the evolution from realism to abstraction, at least insofar as Matisse was concerned. Rather, the evidence suggests that Matisse proceeded methodically from a position of conventional realism through gradual modifications toward greater abstraction; then, a sudden unpredictable leap into more radical abstraction emphasizing draftsmanship and simplified geometric forms; and finally, with this latter state serving as a springboard, the definitive resolution merging the two divergent impulses. The photograph of the "Sleeping Nymph" drawing sent by Matisse to Etta is also illuminating, not only for the beauty of the drawing's feathery lines, but for its indication of the artist's intention to include a decorative painted border. Pinned to the delineated "frame" around the image are two scraps of paper (pinned left and right) with simple sketches of a running floral pattern. Matisse had previously used a decorative border or "frame within a frame" for paintings, most notably in the *Interior with Eggplants* of 1911 and *The Moorish Café* of 1913. The 1935 tapestry design, *Window at Tahiti*, also includes a decorative floral border (Matisse mentions this tapestry commission in his letter to Etta of November 16, 1935). Both the "Window at Tahiti" and the "Sleeping Nymph" subjects relate as well to Mallarmé drawings, but the nymph and faun image had been used frequently by Matisse since at least 1910. The unfinished

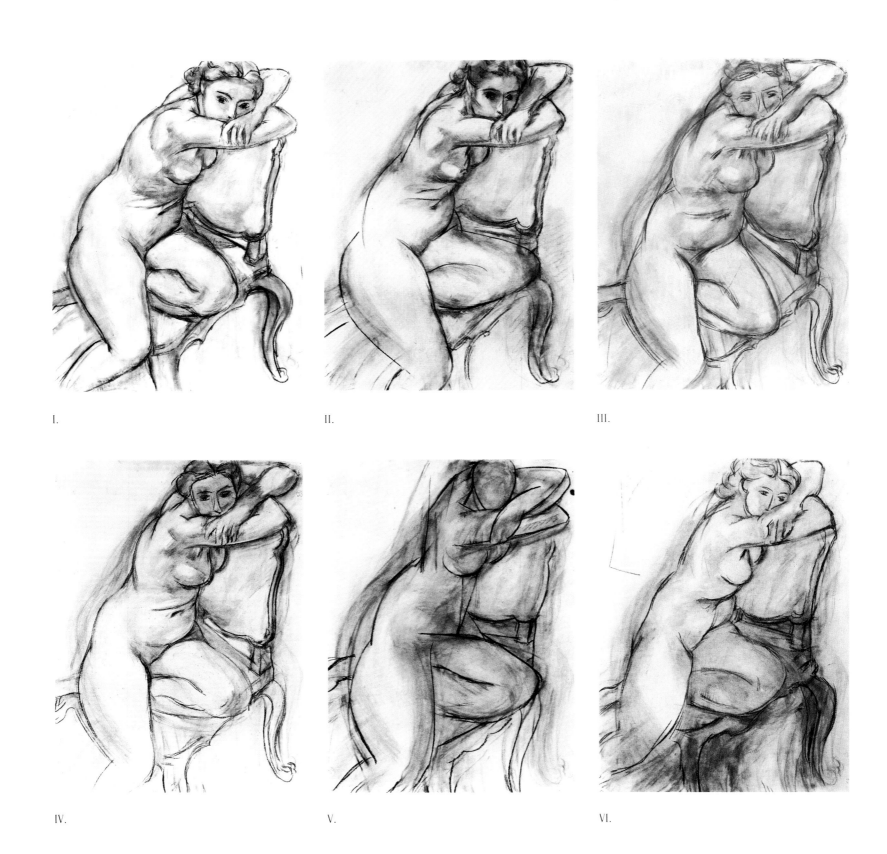

I.

II.

III.

IV.

V.

VI.

Henri Matisse. *Seated Nude, Head on Arms*. 1935.
Six states; photographs sent by the artist to Etta Cone, in a letter of September 19, 1935, from Nice.

Henri Matisse. *Sleeping Nymph Awakened by a Faun Playing the Flute.* 1935.
Photograph sent by the artist to Etta Cone, in a letter of September 19, 1935, from Nice.

Henri Matisse. *The Blue Eyes*. 1935. Oil on canvas. BMA 1950.259.

Henri Matisse. *Study for The Blue Eyes*. (1935)/1936. Pencil on paper. BMA 1950.12.49.

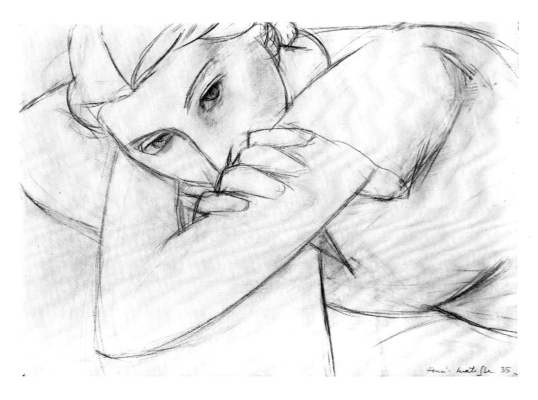

Henri Matisse. *Study for The Blue Eyes*. 1935.
Photograph sent by the artist to Etta Cone, in a letter of February 22, 1936, from Nice.

painting *Nymph in the Forest*, 1936/1942–1943 (Musée Matisse, Nice), based on the drawing shown in the Cone photograph, is in composition a fairly literal translation from the drawing and includes a painted border. Matisse abandoned the painting after working on it for seven years. The pose of the reclining nymph is almost a mirror image of the pose of the *Large Reclining Nude*, a relationship which becomes more explicit in the Nymph painting where her lines are more abstract (like those in the *Large Reclining Nude*) and where she is colored a vivid pink. This apparent kinship with the traditional eroticism of the mythological nymph and faun subject adds another dimension to Baltimore's *Large Reclining Nude*, especially when put in the context of Matisse's concurrent submission of photographs of the two subjects to Etta Cone in late 1935.

The photographs cited by Matisse in his September 19, 1935 letter as documenting "des états d'un tableau 'nu couché' . . . " belong to the Cone painting that came to be called "The Pink Nude." The photographs show the painting from its first state on May 3, 1935 through its definitive state on October 30, 1935, with virtually all of the work done on the painting in the months of May and September. The final states (the photographs sent by Matisse on November 16) of October 12 (20th), October 16 (21st), and October 30 (22nd and definitive) reveal a remarkable transformation. In the twentieth state the figure is all twisted limbs skewed at multiple angles out of the picture plane; facial features are sweet and prim, with a head tilt very similar to that in the *Blue Nude*. In the twenty-first state Matisse obliterates distinguishing features and skin modulation; he attenuates and refines the figure to a severe horizontal plane and constricts the jutting angles of the limbs to more fluid outlines. In the definitive state the artist toughens the image: he covers over the white of the preceding state's modulation and pentimenti; sharpens the figure's outlines; gives the face its stylized but confrontational features, with head frontal and nearly upright; and boldly flattens his subject by removing the vestige of her right hip and merging it with the broad curve of waist, stomach, and left thigh. Finally, and from the black and white photographs it is impossible to know how dramatic an alteration this may represent from preceding states, Matisse blanketed the figure in a dense, vibrant, almost harsh, deep pink so opaque and with so little gradation that perception of volume or depth is effectively nullified. *Large Reclining Nude* began in its first state as a pert and quite conventional nude reclining on a chaise in a depicted interior in which a small vase of flowers sits on an ornate chair. In the sixth state Matisse began to pin shards of painted paper to the canvas, camouflaging all detail of the interior and its furnishings. Pinholes, easily visible in the progressive photographs (and in the finished painting), puncture the painted surface in dozens of locations. In the ninth state the chaise is replaced with a bold pattern of vertical paper strips pinned in place; in the tenth, eleventh, and twelfth states Matisse experiments with varying patterns of irregular, interrupted paper grids as background, and the nude begins to transmute to a much more exaggerated, geometric configuration. The grid is painted in and the chair and vase of flowers converted to abstract color shapes in the thirteenth state, which essentially establishes the painting's key elements. Throughout the September states Matisse explores an amazing range of facial types for his figure, as if he were looking at a different model every day; only in states seventeen and twenty-one is she faceless. It is in this seventeenth state—featureless, heavily muscled, aggressively filling the canvas, the strong line of the back firmly grounded—that *Large Reclining Nude* seems most abstract, most evocative, and most powerful.

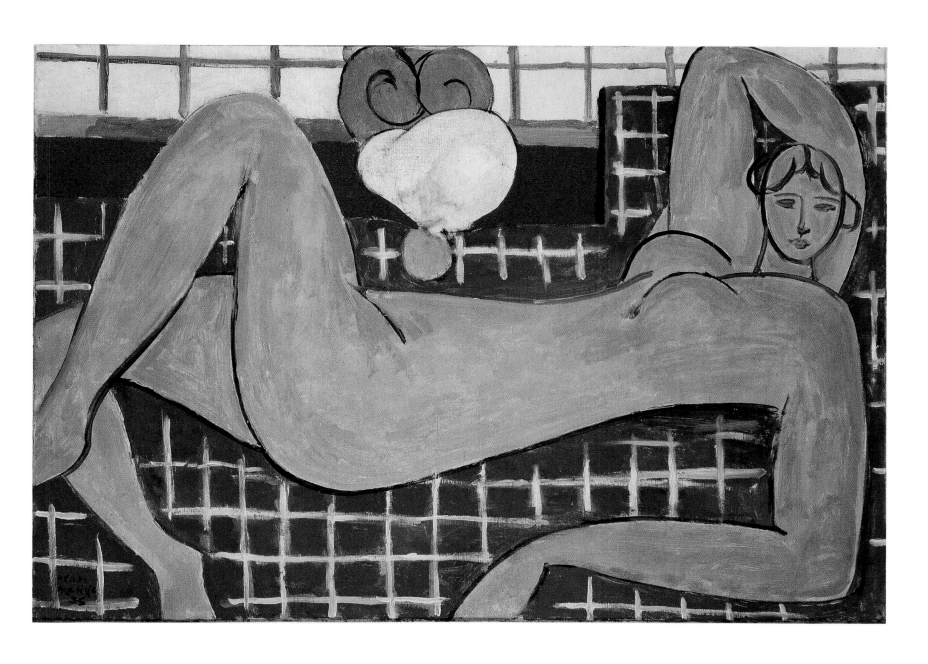

Henri Matisse. *Large Reclining Nude*. 1935. Oil on canvas. BMA 1950.258.

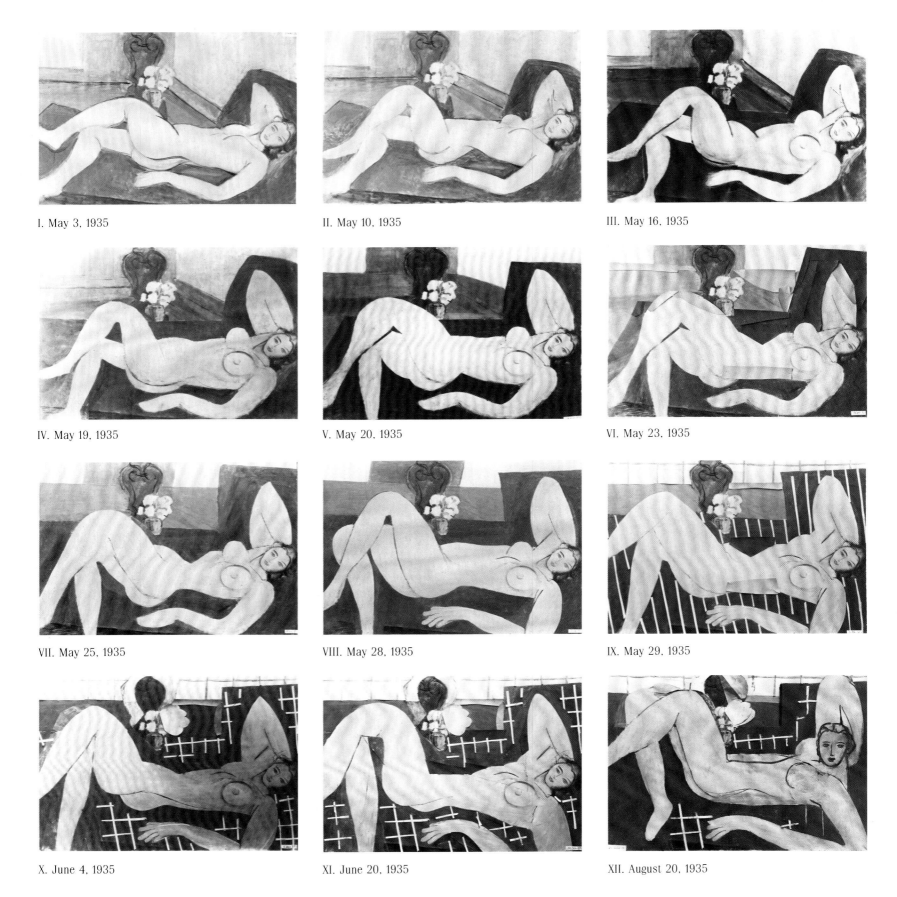

I. May 3, 1935

II. May 10, 1935

III. May 16, 1935

IV. May 19, 1935

V. May 20, 1935

VI. May 23, 1935

VII. May 25, 1935

VIII. May 28, 1935

IX. May 29, 1935

X. June 4, 1935

XI. June 20, 1935

XII. August 20, 1935

Henri Matisse. *Large Reclining Nude*. 1935.
Twenty-two states; photographs sent by the artist to Etta Cone, in letters of September 19 and November 16, 1935.

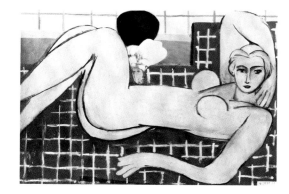

XIII. September 4, 1935

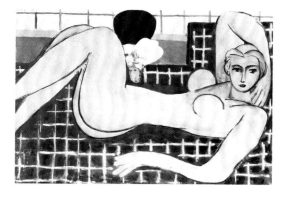

XIV. September 6, 1935

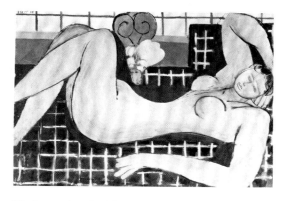

XV. September 7, 1935

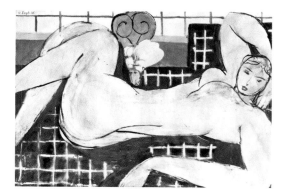

XVI. September 11, 1935

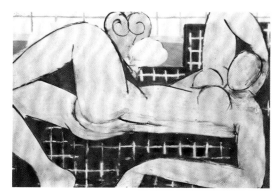

XVII. September 14, 1935

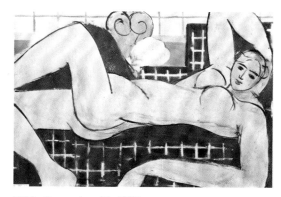

XVIII. September 15, 1935

XIX. September 17, 1935

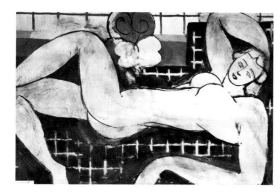

XX. October 12, 1935

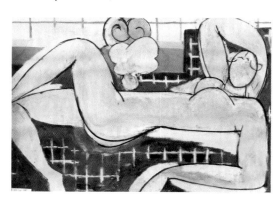

XXI. October 16, 1935

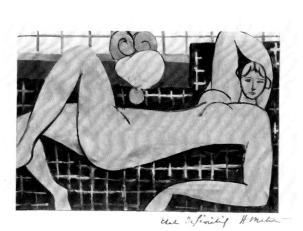

XXII. October 30, 1935 (definitive)

137

It is also in the seventeenth state that the *Large Reclining Nude* reveals itself to be a pendant to the recently published (1984) *Seated Pink Nude*.[57] The progressive states of the *Seated Pink Nude*, initially in charcoal on canvas and then in oil, date primarily from August 1935, which explains Matisse's hiatus on the Cone "Reclining Pink Nude" during that summer. The two paintings proceeded concurrently. The twelfth state of the *Seated Pink Nude* is dated October 30, 1935, the same day that Matisse finished the definitive state of the *Large Reclining Nude*. He continued to work on the seated figure, completing its thirteenth and penultimate state on December 16, 1935, some six weeks after completion of the reclining figure. Both paintings are of virtually the same dimensions, one a vertical (seated) and one a horizontal (reclining). The background windowpane grid of the reclining nude appears (modified slightly to suggest a tiled bath interior) in the seventh through thirteenth states of the seated nude but is painted out in the final version, though its ghostly presence is still visible on the canvas. If one can generalize from the progressive photographs of parallel works from this year—both the drawing, *Seated Nude, Head on Arms*, which clearly relates very directly to the *Seated Pink Nude*, and the *Large Reclining Nude*—it could be concluded that the *Seated Pink Nude* is indeed an unfinished canvas. It is closer kin to the fifth state (of six) of the *Seated Nude* drawing, and to the seventeenth state (of twenty-two) of *Large Reclining Nude* than to either of the definitive states of these works. There is no suggestion in the progressive photographs of the *Seated Pink Nude* that Matisse employed the cut and painted paper collage technique that he relied on so heavily for the *Large Reclining Nude*. He may have learned so much from his use of the technique for *Large Reclining Nude* in May 1935—a technique that would eventually generate an entirely new and brilliant body of work in the paper cut-outs of the 1940's—that he could dispense with that working tool for the *Seated Pink Nude* in August 1935. Both the seated and reclining pink nudes look back a decade to Matisse's monumental odalisque masterpiece, *Decorative Figure on an Ornamental Background*, 1925 (Musée d'Art Moderne, Centre Pompidou, Paris), as their progenitor. The latter's nude figure, seated implacably as stone in a field of effulgent color and pattern, sets the stage for the imposing, iconic "Pink Nudes."

One of the irresolvable mysteries of The Cone Collection is precisely how each work was chosen by the sisters. Claribel Cone's 1927 letters to Etta in which she writes discontentedly of her van Gogh *Boots* and with envy that she wants a Matisse "as brilliant as your lovely red interior" are among the exceedingly rare glimpses into either sister's aesthetic taste or capacity for critical judgment, beyond what can be concluded from the contents of the collection itself. What is of course unknown is precisely what they rejected in favor of what they bought. If a sophisticated Matisse connoisseur were confronted today with the choice between, for example, the reclining and the seated versions of "The Pink Nude," would not a discerning eye favor the powerful line and advanced abstraction of the *Seated Pink Nude*? But did Etta Cone even know of the existence of the latter version? In November 1935 when Matisse sent the photographs of *Large Reclining Nude*, the seated version was not yet finished though it was well underway. He did not mention the second, seated version in his letter of September 19, 1935. Was the artist so eager to make a sale that he forwarded to Etta Cone the *Large Reclining Nude* photographs as quickly as they could be developed? The

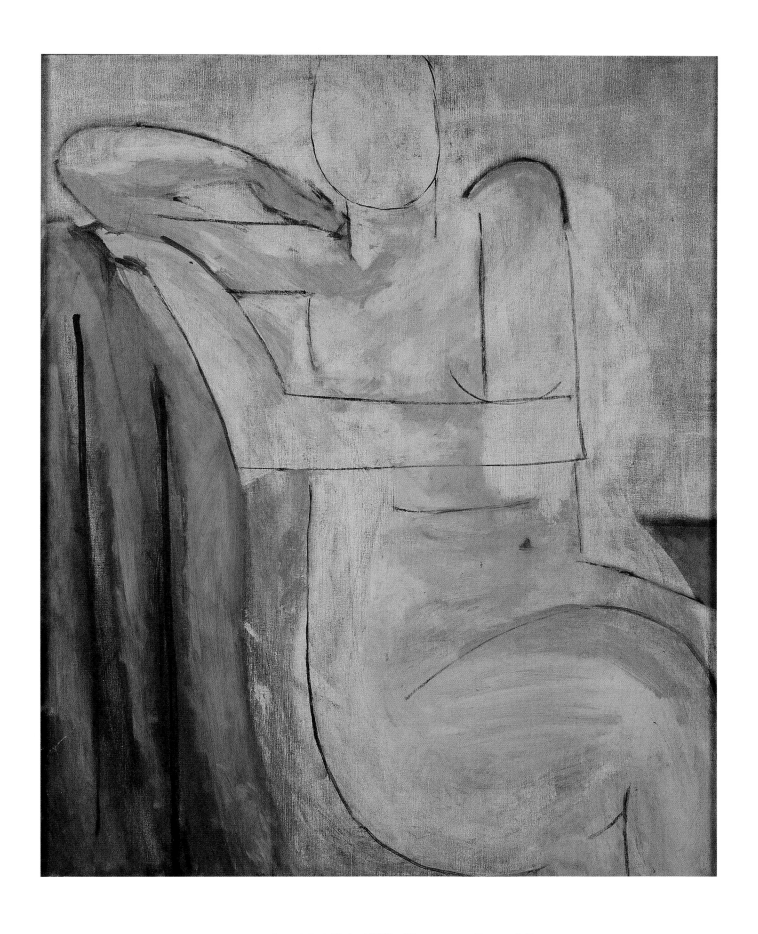

Henri Matisse. *Seated Pink Nude*. (1935). Oil on canvas. Private Collection.

painting was finished on October 30, photographically documented, and the photos mailed from Nice on November 16. Or is it possible that Matisse, knowing Etta and the Cone collection as installed at The Marlborough, consciously selected the reclining pink nude over the seated pink nude as somehow being more appropriate to this collector's taste? It is difficult to rationalize that position when the *Seated Pink Nude* had not yet been completed and when, from an objective point of view, there are negligible differences between the two paintings—they are both nudes, both pink, both relatively abstract (particularly if considered from Etta's perspective at the time), both of the same size and date. Given Matisse's intimacy with Etta and her demonstrated commitment to his work in the 1930's—her 1930 commission of the Cone portraits, her major purchase in 1932 of the Mallarmé materials, and of *The Yellow Dress* in 1931 and *Interior with Dog* in 1934, her expressed intention to buy *The Blue Eyes*—it is more likely that the artist simply and charmingly, in a burst of enthusiasm for his just-completed "nu couché," rushed the photos off to his friend Etta Cone to provide her with "a little amusement" and perhaps, in equal measure, in the hope of eliciting a responsive chord. Since Etta's letters to Matisse have not surfaced, it cannot be determined how quickly or how enthusiastically she responded to the photographs nor how promptly she stated her purchase interest.

Etta visited Matisse on her annual summer trips to Europe, at which time she ordinarily selected paintings from the artist's studio for her collection. It is not known on what basis or precisely to what extent the artist pre-selected work for her consideration. It has been reported that on at least some of these visits Etta's deliberations were mediated by the artist's daughter, Marguerite, who at Matisse's instruction would bring specific works from the studio for Etta to view.[58] Siegfried Rosengart, whom Etta often visited in Lucerne after her visits in Nice with Matisse, confirms the system adopted by the artist in relation to Etta's selections:

> Matisse always had prepared pictures to offer [Etta]—set out before she came. He made
> a choice of a few pictures. I would never have offered her a Matisse because I knew she
> only liked to buy Matisses directly, [taking into account] what Matisse thought would be
> nice to complete the [Cone] Matisse collection [Rosengart/BMA interview, 1983].

Even in the 1920's the Cones felt some concern that they were not being given sufficient priority in their selection of Matisse's work. In a letter from Claribel to Etta, the older sister reported: " . . . Margot [Marguerite Matisse] . . . was interested to know what I thought of the pictures her father brought back and which I preferred. He did only 4 large paintings 1 of which he will keep (the least important one) and 7 lovely lithographs. He wishes to show that he is not considering himself or Bernheim-Jeune first. Apropos of my remark to Sally as to our having third or four choice, Sally says that is why he asked us out—rather complimentary was it not?"[59] If Matisse was indeed the éminence grise of The Cone Collection as it grew in representation of his work, he also went to considerable effort to demonstrate his genuine affection and friendship for Etta. In the summer of 1933 Etta traveled to Europe with her sister-in-law, Mrs. Julius (Laura) Cone, and her two teenage children, Edward and Frances. In Nice Etta went alone to call on Matisse:

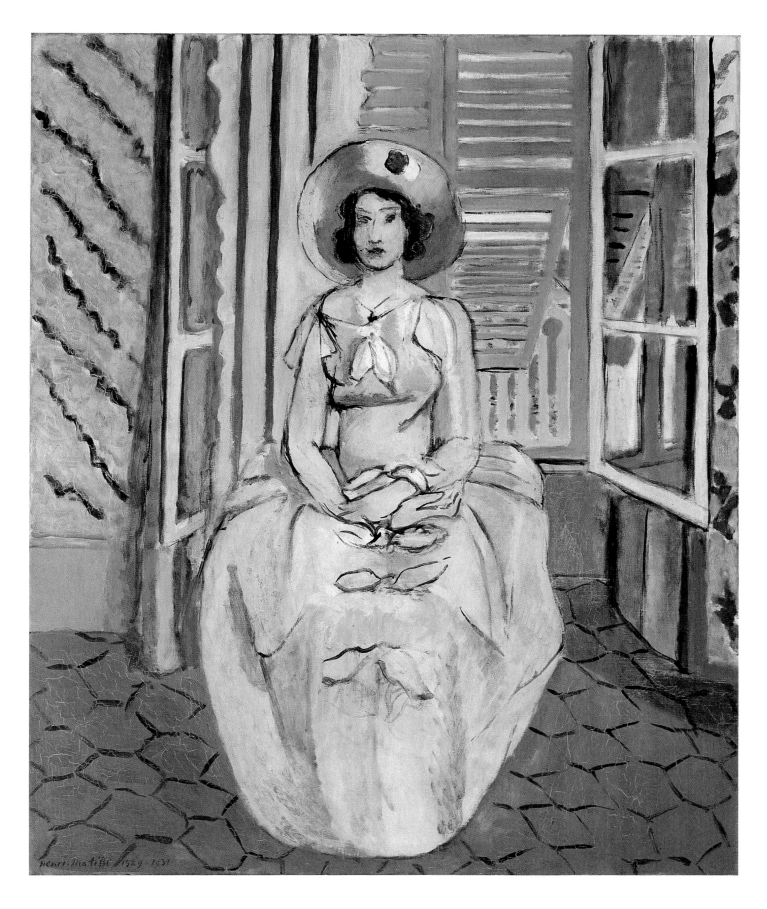

Henri Matisse. *The Yellow Dress*. 1929–1931. Oil on canvas. BMA 1950.256.

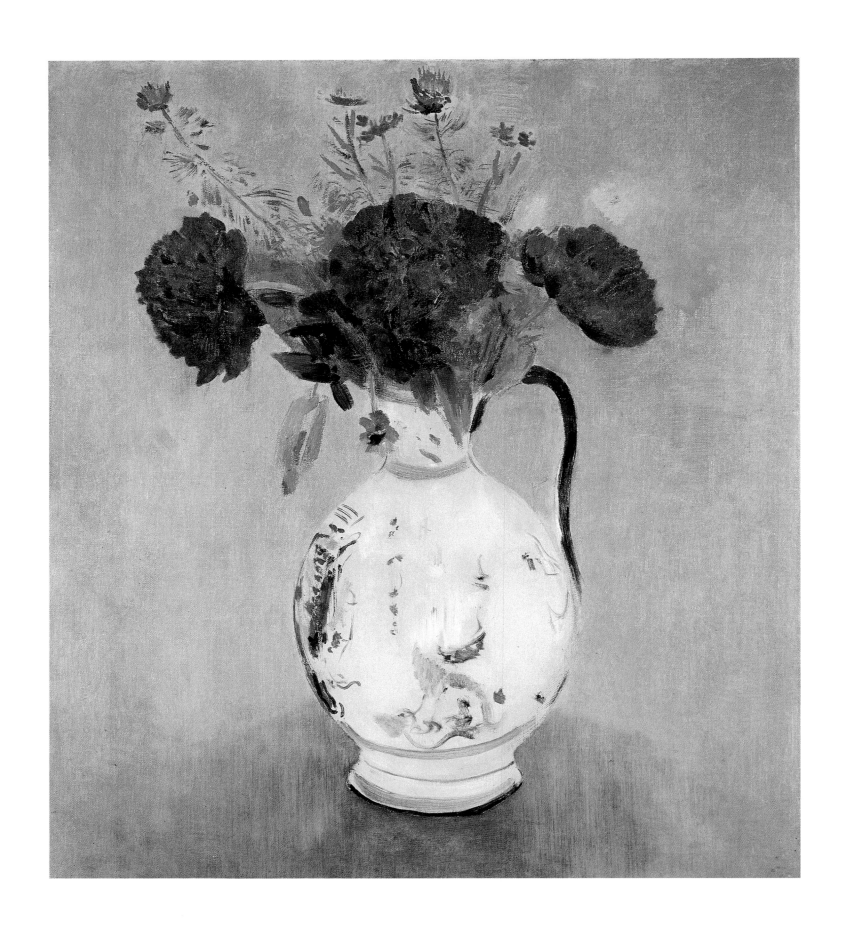

Odilon Redon. *Peonies*. (ca. 1900–1905). Oil on canvas. BMA 1950.281.

... My visit [to Matisse] was a joy. ... he said 'I have a surprise for you' & presently I turned & there sat the model in the yellow taffeta dress with the large yellow hat on, just in front of the window—the exact reproduction of my latest painting. His bed-room (which is his studio when he is well) was the scene of this picture. Needless to say I was thrilled [letter from Etta Cone to Fred Cone, July 22, 1933, Nice].

In this same summer Gertrude Stein issued an invitation for Etta and her family to visit with her and Alice in southern France. Etta declined in a note made cool by its formality:

Dear Gertrude: Your very kind letter followed us and was received several days ago. I thank you for your kind invitation for my family and me, but as our route from here will be directly to Paris, we shall not be able to accept, and I am sorry ... [letter from Etta Cone to Gertrude Stein, August 9, 1933, Lucerne (Yale)].

Edward Cone's memoir makes specific the snub that Etta hinted at between the lines of her note to Gertrude:

From Italy we proceeded to Lucerne, where we spent several quiet weeks. While there, Aunt Etta received from Gertrude a cordial invitation for the four of us to take lunch with her on our way back to Paris. Gertrude was summering with Alice near Aix-les-Bains, and it would have been very easy for us to make a short detour. Of course Mother, Frances and I were eager to accept, but Aunt Etta would have none of it. The reason she gave Gertrude was that the visit would take us out of our way—a patent excuse that Gertrude must have seen through. Aunt Etta declared to Mother that the real reason for her refusal was that Gertrude wasn't worthy of meeting us! Naturally, we felt differently, but there was nothing we could say. We motored straight to Paris, where we spent the rest of the summer.[60]

Years later, according to Edward Cone, Etta still felt guilty about her rejection of Gertrude on this occasion and always professed to forget exactly why the invitation had been declined. A telling clue regarding Etta's sense of injury in relation to Gertrude Stein can be found in another letter of this same summer. Writing Gertrude from shipboard on her way to Europe, she commented, "I was very flattered to see from your 'Autobiography of Alice Taklos' that you remembered my one time remark as to my 'Ability to forgive but not to forget.' I have'nt changed. Those were wonderful days ..." [letter from Etta Cone to Gertrude Stein, June 13, 1933, S. S. Statendam (Yale)]. Her barbed "I have'nt changed" linked to her reminder that she could forgive but not forget, no doubt had specific meaning for Stein who must have known to what lasting hurt her friend referred. Whether this was the calamitous offer to sell the manuscript of *Three Lives*, or something far more intimate, will probably never be known. Although Edward Cone reports that Etta was "incensed" and resentful of Stein's *Autobiography of Alice B. Toklas* (a copy of which had been sent to Etta by Alice immediately upon the book's publication in 1933), Etta's letters to Stein contradict this notion:

Your "Autobiography of Alice Toklas" is one of the most interesting and the best of the literature of today [letter from Etta Cone to Gertrude Stein, August 9, 1933, Lucerne (Yale)].

Dear Gertrude: Last fall I wrote you a letter and then became ill. In that letter I expressed admiration for your book, which as you know has become the most popular of the recent

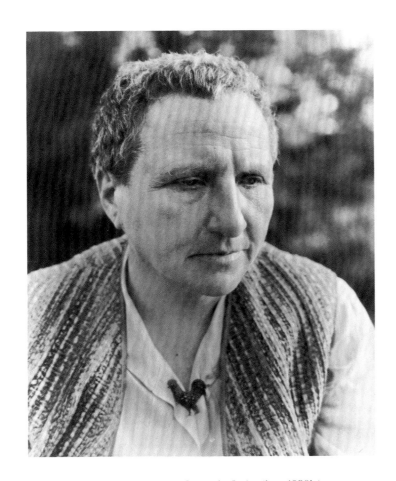

George Platt Lynes. *Gertrude Stein*. (late 1920's).
Toned gelatin silver print. BMA 1950/85.4.

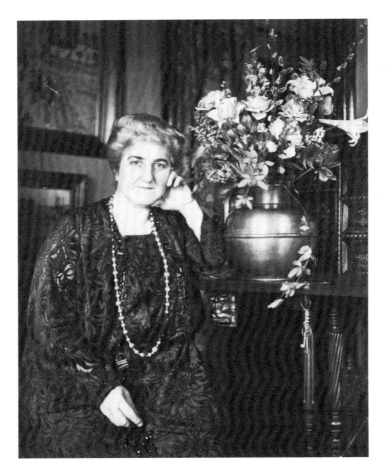

Etta Cone, Baltimore, 1930's.

publications. I was deeply touched to find myself one of the characters, and what you said of my Sister was beautiful & it grieves me that she can not know what you thought of her. . . . "The Autobiography of Alice Taklos" now, I think there is nothing of today, that can take its place in the future, as a chronicle of the art of the first years of this century . . . [letter from Etta Cone to Gertrude Stein, April 17, 1934, Baltimore (Yale)].

Only a year later Stein had an opportunity to reciprocate Etta's snub. Despite the fact that Etta extended modest assistance in arranging Baltimore contacts for that leg of Stein's American lecture tour in 1934, Gertrude declined Etta's invitation to visit with her in Baltimore and to view the collection at The Marlborough. In a letter of October 29, 1934 [Yale], Etta expressed to Gertrude her anticipation at having "the pleasure of entertaining you & Alice," and offered use of her "small place" as a base of operation during Gertrude's visit. She reported her plans to "go south" but noted that she would make her date of departure definite only after hearing from Gertrude. Once Stein refused the invitation, Etta arranged her North Carolina plans to be away from Baltimore during the Stein and Toklas visit. She never again had any direct contact with Gertrude Stein although she continued to correspond with Michael and Sarah Stein.

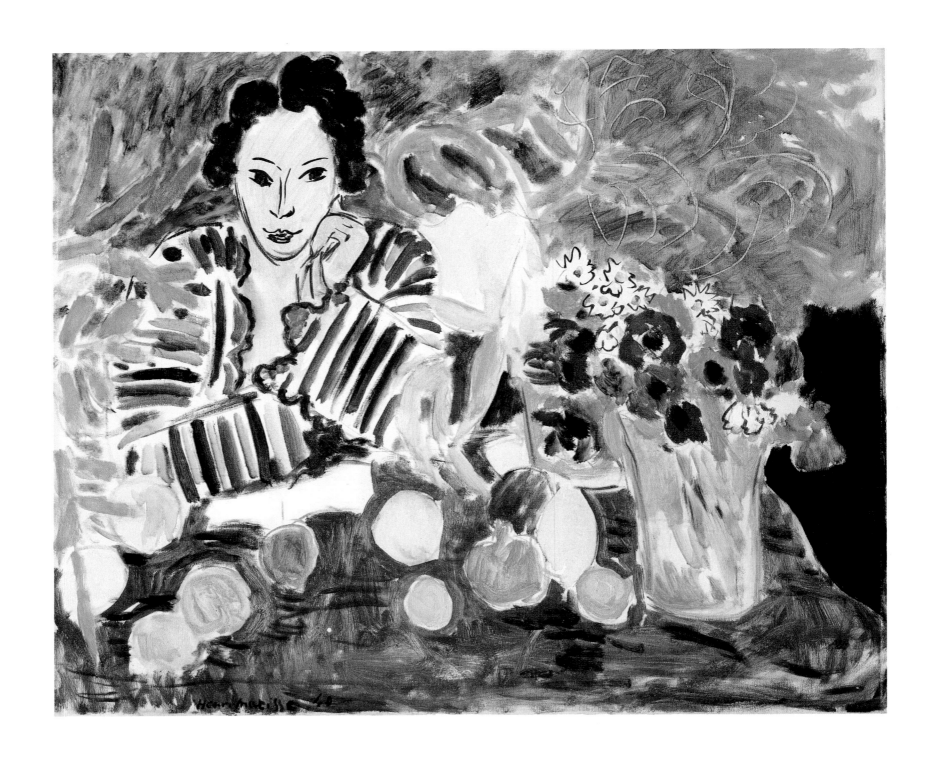

Henri Matisse. *Striped Robe, Fruit, and Anemones*. 1940. Oil on canvas. BMA 1950.263.

VI.

Etta Cone traveled to Europe for the last time in 1938. Advancing age and political unrest in Europe combined to keep her at home. She divided her time between Baltimore and the family summer home in Blowing Rock. To protect the collection during her absence, she often loaned paintings to the Museum when she was in North Carolina. Nora Kaufman remained a devoted companion until at least 1940 (in each letter through 1939 Michael and Sarah Stein convey their greetings and love to Miss Kaufman, but her name does not appear in the letters after that date). From then until her death, Etta shared the companionship of Lilly K. Schwarz, an accomplished pianist who encouraged Etta's love of music. Etta provided in her will lifetime annuities for both Kaufman and Schwarz, and for Kaufman's mother as well. Through her last decade Etta continued to collect actively, usually through New York dealers and often enlisting either Adelyn Breeskin or Gertrude Rosenthal to travel to Manhattan to look at possible purchases on her behalf. Her stubborn insistence on her own taste did not diminish with the years. Attracted to the Matisse oil, *Two Girls, Red and Green Background*, included in the 1949 Pierre Matisse exhibition, she sent Dr. Rosenthal to look at it in person. Rosenthal carefully studied the paintings available and recommended to Etta that she buy instead Matisse's masterpiece interior of the 1940's, *The Egyptian Curtain* (early 1948). Pleading her inability to afford the larger and more important picture, Etta went ahead and bought the modest *Two Girls* of 1947, the latest date of any Matisse painting in the collection. Although it by no means competes favorably with *The Egyptian Curtain* (which went to The Phillips Collection in Washington, D.C.), the painting does extend in style and content the continuum introduced in two very fine Matisse paintings acquired earlier by Etta: *Small Rumanian Blouse with Foliage* of 1937 and *Striped Robe, Fruit, and Anemones* of 1940. These are characteristic of the period in their patches of raw canvas and integration of spontaneous mark-making techniques (as when Matisse etched in lines with the stem end of the paintbrush); they burst with fresh, bright color, and convey the unconstrained touch and structure of Matisse's best drawings. Etta avoided the great 1940's Matisses of similar subjects set against a striking black background, as well as the powerful, stylized still lifes of these same years. Nor did Etta ever buy any of Matisse's *papiers découpés*, the medium in which he expressed himself with such energy and brilliance in his later years. She did, on the other hand, buy a copy of the extraordinary illustrated book in which Matisse demonstrated his mastery in converting the paper cut-out medium to the

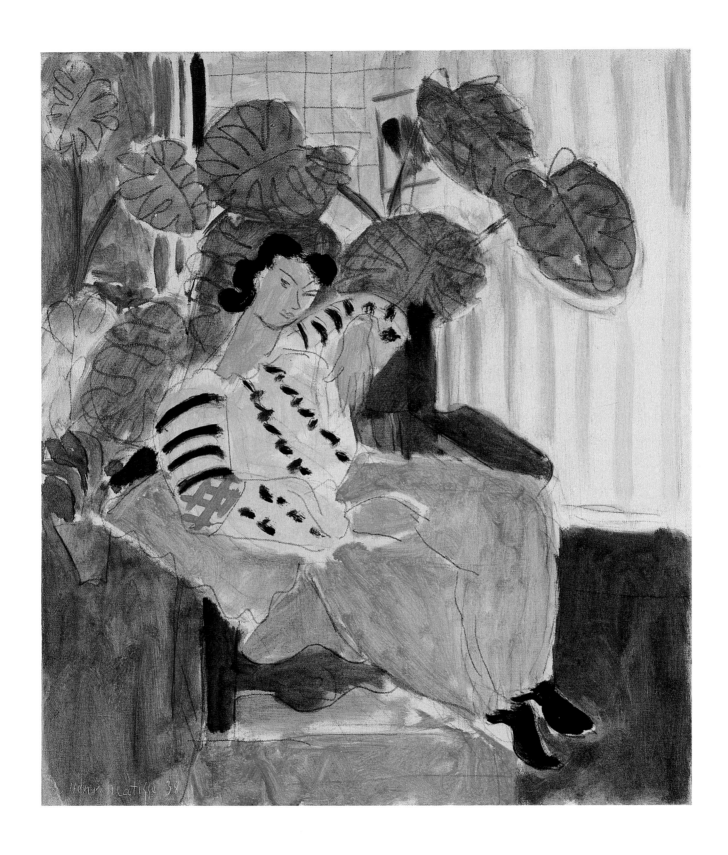

Henri Matisse. *Small Rumanian Blouse with Foliage*. (1937). Oil on canvas. BMA 1950.262.

Henri Matisse. *The Rumanian Blouse*. 1937.
Pen and ink on paper. BMA 1950.12.57.

Henri Matisse. *Artist and Model Reflected in a Mirror*. 1937.
Pen and ink on paper. BMA 1950.12.51.

printed page, *Jazz* of 1947, and she bought most of Matisse's other illustrated books, including the 1948 *Florilège des Amours de Ronsard*. It was in recognition of Etta's commitment to his work in this medium that Matisse, in 1950, presented as a gift to the Museum a copy of his *Poèmes de Charles d'Orléans*, of the same year, "in memory of Claribel and Etta Cone."

Despite exposure to the American avant-garde of the 1920's and 1930's through the Stein circle and through Alfred Stieglitz's An American Place gallery, from which in 1944 Etta bought a splendid John Marin watercolor (1919), neither Cone sister ever developed an active interest in American art of that generation. Claribel did purchase two paintings by John Graham—a 1926 still life heavily indebted to Matisse's work of the teens but of a bold freshness that bespoke an original talent, and an inventive 1926–1927 landscape with evident influence from Braque and Picasso. Neither sister acquired any of the revolutionary figure subjects for which Graham is so admired today, even though the balance of the collection focused on figuration. The Cones also bought *Still Life: Flowers in a Vase* (ca. 1911) by Patrick Henry Bruce, an attractive but tame subject by an artist who would later create abstractions of considerable authority, a Cézanne-inspired *Bathers* by Max Weber, and three major paintings by Leon Kroll. Although one would expect that Etta might have been drawn to the work of Milton Avery, the younger American artist whose work most closely paralleled that of Matisse, in fact no Avery was ever added to the collection. Gertrude Stein was particularly devoted to the artists Marsden Hartley, Charles Demuth, and Alfred Maurer, but Etta did not buy their work, nor examples by Stuart Davis or Georgia O'Keeffe, Arthur Dove or Joseph Stella, Charles Sheeler or Morton Schamberg, Morgan Russell or Stanton MacDonald-Wright. It is not surprising that Etta failed to embrace the new American geometric abstraction, but it is surprising that she declined to collect the innovative figure painting of the period in America, especially since by that time she was spending a good deal more time in the United States than in Europe. She did befriend and buy extensively from young artists in Baltimore, especially those associated with The Maryland Institute. These acquisitions fall broadly within the category of the "romantic charity" she extended to Matisse and Picasso at the turn of the century, except that the accomplishments of most of these regional artists generated only parochial interest. Gertrude Stein was not the only observer to comment on the Cones' altruism in their patronage of young artists. A Cone relative, writing in 1935, commented to Etta, "I wonder whether there are new works of art which will be waiting for my eager inspection in the Cone collection, and how many of them represent good art and how many represent good deeds on the part of the collector . . . " [letter from Elinor Ulman to Etta Cone, August 17, 1935, Peiping, China]. The "good deeds" of the Cone sisters, as well as their sincere admiration for the work of many regional artists, are reflected perhaps most dramatically in any numerical assessment of the collection—there are, for instance, fifty-one drawings by Baltimore artist Aaron Sopher, almost half again as many as there are by Matisse.

In her last years Etta lived rich and happy days, surrounded by many friends and relatives, immersed in art and music, enjoying the tribute of those who admired her collection and the courage it had taken to assemble. In 1941 Sarah Stein wrote with affection, "I am happy to know that you have such a full and interesting life" [letter from Sarah Stein to Etta Cone, March 9, 1941, Palo Alto, California]. At the end of almost every year she received a telegram of holiday greetings from Matisse. In 1949 Allan Stein offered Etta his Picasso gouache

John D. Graham. *Still Life with Fruit and Blue and White Pitcher*. 1926. Oil on canvas. BMA 1950.334.

Paul Gauguin. *Vahine no te Vi (Woman with Mango)*. 1892. Oil on canvas. BMA 1950.213.

portrait of 1906 (Etta already owned the "companion" portrait of Leo Stein by Picasso). She happily agreed, and bought what would be her last acquisition for The Cone Collection. She died on August 31, 1949, not yet having received the *Allan Stein* shipped from California.

The scope of The Cone Collection is extraordinary. In her later years, in particular, Etta added to the collection works of the nineteenth and twentieth centuries to provide historical depth to her more contemporary holdings—works by Degas, Manet, van Gogh, Corot, Gauguin (the majestic *Woman with Mango*), Renoir, Chagall, Braque, even a drawing by Ingres. And yet, above all, The Cone Collection is a collection of the work of Henri Matisse: forty-two oils (at least one painting representing almost every year of the artist's work between 1917 and 1940), eighteen sculptures, thirty-six drawings (including gouaches and one watercolor), 155 prints (thirty-six etchings, three woodcuts, 114 lithographs, and two posters), seven illustrated books, plus the 250 items of the Mallarmé *Poésies*. It is impossible from the perspective of the late twentieth century to recapture the palpable excitement, challenge, and modernity these works radiated at the time of their making. As Gertrude Stein wrote in *The Autobiography of Alice B. Toklas*, describing Alice's first visit to the Stein atelier in 1907:

> It is very difficult now that everybody is accustomed to everything to give some idea of
> the kind of uneasiness one felt when one first looked at all these pictures on these
> walls. . . . Now I was confused and I looked and I looked and I was confused.[61]

Dr. Claribel and Miss Etta Cone looked and looked and were confused, but for whatever reasons, they bought anyway. They bought prodigiously in that "spirit of appreciation for modern art" that characterizes great collectors and that remains fundamentally obscure in motive and inspiration. Their modern spirit can be quantified only in the collection they left behind, in its depth, its passion, its reflection of an era of explosive originality, in its sheer abundance. It is a collection whose critical lapses tell of the Cone sisters' humanity and whose incomparable artistic achievements tell of their ingenuous conviction. Even if today "everybody is accustomed to everything," the collection built by Claribel and Etta Cone can still articulate how radical art and spirited collecting evolve.

BRENDA RICHARDSON

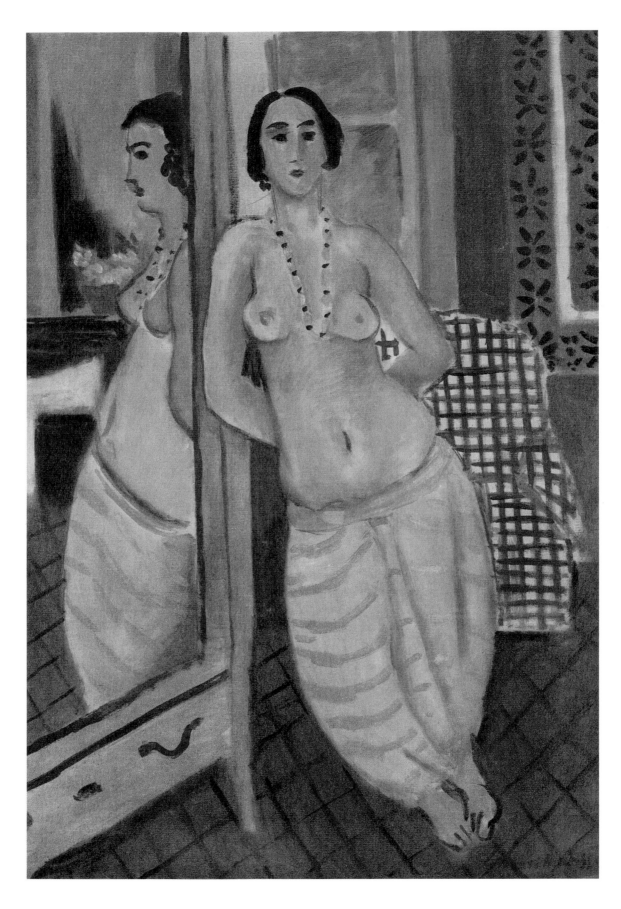

Henri Matisse. *Standing Odalisque Reflected in a Mirror*. (1923). Oil on canvas. BMA 1950.250.

1. Biographical information on the Cones and the Steins has been gathered from numerous sources. The primary research resource for the present publication is the original material deposited with the Cone Archives of The Baltimore Museum of Art which came to the Museum with the Cone bequest in 1950. The archives include original correspondence both from and to Claribel and Etta Cone from countless correspondents over four decades; extensive correspondence from Claribel Cone to Etta Cone (Etta saved most of her older sister's letters; with notable exceptions, Claribel did not save Etta's letters); both sisters' "account books" for a few years (Etta's from 1903–1906, and Claribel's from various months of 1925–1928); some of Claribel's notebooks, identified by her as "The Day's Work" (various months from 1913 and from 1924–1926); Etta's travel diaries from her European trips of 1901 and 1903; certain of Claribel's professional papers, including publications; lecture and reading notes; photographs of family members and of tourist sites; newspaper clippings, generally about art or family matters; and other miscellaneous personal papers (Claribel's ca. 1910–1911 handwritten curriculum vitae; a family genealogy; publications related to the Cone Mills; etc.). It is clear from what has survived in the Cone Archives that there are significant lacunae in these papers. Many years are not represented in the form of correspondence between the sisters, although they obviously maintained a prodigious written contact with one another throughout their lives (with letters sometimes running to twenty sheets), and the absence of travel diaries or "account books" for most years is notable. Some of these materials may have been given to Cone family members before the Museum took possession of the apartments' contents. In 1959 the Museum released to Mrs. Julius Cone a large group of Cone Archives material (identified in Museum records only generically as correspondence and travel diaries), and again in 1963 the Museum released to Mrs. Julius Cone a group of almost two hundred letters between the Cone sisters (dating from 1890 to 1927) along with certain other archival material. Although all of this material was apparently sent on a loan basis for the late Mrs. Cone's research purposes, it remains unclear how much of the material, if any, was returned to the archives. Efforts to date to trace the present whereabouts of these materials have been unsuccessful. It is also assumed that there are extant Cone-related documents among heirs to the many friends and family members to whom Etta and Claribel addressed correspondence over the years. It is hoped that eventually many more such materials will join the Cone Archives through the generosity of donors who recognize the research significance of these papers.

In 1948 Etta Cone donated to the Gertrude Stein Collection at the Yale University Library most of the materials in her possession that related to the Stein family, including eighty-two letters addressed by Etta to Gertrude Stein between 1906 and 1934. Although a few original Stein family papers (including correspondence) remain in the Baltimore ar-chives, most of this material is now at Yale. We gratefully acknowledge the cooperation of Yale University, The Collection of American Literature, The Beinecke Rare Book and Manuscript Library, not only in making this material accessible for our present research purposes, but in generously granting our request to obtain photocopies of all such Cone-related material for permanent deposit with the Cone Archives in Baltimore for future research purposes. An original annotated typescript of Gertrude Stein's word portrait of the Cone sisters, *Two Women*, given by Stein to Etta Cone in 1932 in memory of Claribel, was donated to the Stein papers at Yale in 1950 by Mrs. Julius W. Cone.

When not otherwise specifically attributed, citations in the present text from Stein correspondence and from Cone correspondence, diaries, or account books refer to material in the Cone Archives of The Baltimore Museum of Art. When such citations derive from original material at the Yale University Library, the name Yale appears in the bracketed attribution at the end of the citation. All such quotations from Yale material are published here with the kind permission of the Yale University Library. Sources of other citations are individually attributed. All quotations are cited in the precise form in which they appear in the original, with retention of misspellings and punctuation. Editorial insertions are indicated in brackets, as are question marks denoting uncertain transcription or illegible words or phrases. Virtually all of the original documents are handwritten in script that challenges reliable transcription. All citations from the above-named sources are from the original documents for the present publication; when a quotation derives from a secondary source, that source is named or noted. In certain instances quotations used in the present volume have been published previously in variant, incorrect transcriptions. For purposes of the present book, multiple readers have checked original documents (and compared notes in instances of questioned transcription) to assure the greatest possible degree of accuracy in printing.

There is only one substantive publication dealing with the Cone family: Barbara Pollack, *The Collectors: Dr. Claribel and Miss Etta Cone* (Indianapolis and New York: The Bobbs-Merrill Company, Inc., 1962). Pollack's book, addressed to a popular audience, represents the first serious attempt to document the lives of the Cone sisters and was based on extensive research (including access to the Baltimore and Yale archives) and personal interviews. While it contains a great deal of invaluable information not available from any other source, it is also flawed with factual error, incorrect transcriptions from original source material, and imaginative speculation cast as history. There are only scattered references to the Cones in Aline B. Saarinen, *The Proud Possessors* (New York: Random House, 1958), particularly in the chapters devoted to the Steins and to John Quinn.

Published reminiscences by Cone family members include Ellen B. Hirschland, "The Cone Sisters and the Stein Family," in *Four Americans in Paris: The Collections of*

Gertrude Stein and her Family (New York: The Museum of Modern Art, 1970), pp. 74–86, and Edward T. Cone, "The Miss Etta Cones, The Steins, and M'sieu Matisse: A Memoir," The American Scholar, Summer 1973 (vol. 42, no. 3), pp. 441–460. Oral history was extremely useful, even as it often confirmed published accounts. Most important in this regard were extensive interviews and correspondence between Gertrude Rosenthal and both Brenda Richardson and William C. Ameringer between 1983 and 1985; an interview between Adelyn D. Breeskin and Will Ameringer on July 17, 1984; and Will Ameringer's interviews with Siegfried Rosengart and Angela Rosengart in Lucerne, Switzerland on September 9, 1983; with Ellen B. Hirschland in New York on January 23, 1985; and with Edward T. Cone in Princeton, New Jersey on January 29, 1985.

In addition to the personal correspondence of the two sisters, Gertrude Stein's writings often proved the most revelatory of the Cones. Permission to reprint Stein's Two Women, both in its entirety and as excerpted in the text, was granted by the Estate of Gertrude Stein, courtesy of Calman A. Levin of Levin, Gann & Hankin, Baltimore. Equally useful, for both Cone and Stein biographical data, was Gertrude Stein, The Autobiography of Alice B. Toklas (written in 1932 and first published in 1933); the author used the copy printed in Carl Van Vechten, Selected Writings of Gertrude Stein (New York: Random House, 1946), pp. 3–208, the edition in Etta Cone's personal library. Two volumes of published Stein letters were also very helpful: Donald Gallup, ed., The Flowers of Friendship: Letters written to Gertrude Stein (New York: Alfred A. Knopf, 1953), and Edmund Fuller, ed., Journey Into the Self: being the letters, papers & journals of Leo Stein (New York: Crown Publishers, 1950). Stein biographical material to which the author referred include, among others: Elizabeth Sprigge, Gertrude Stein: Her Life and Work (New York: Harper & Brothers Publishers, 1957); John Malcolm Brinnin, The Third Rose: Gertrude Stein and her World (Boston and Toronto: Little, Brown and Company, 1959); Alice B. Toklas, What Is Remembered (New York: Holt, Rinehart and Winston, 1963); Four Americans in Paris: The Collections of Gertrude Stein and her Family (New York: The Museum of Modern Art, 1970); and James R. Mellow, Charmed Circle: Gertrude Stein & Company (New York and Washington: Praeger Publishers, 1974). The Mellow book is heavily indebted to The Autobiography of Alice B. Toklas, of which it often seems an expanded narrative, and, in relation to the Cones, perpetuates errors which appeared in the Pollack book, The Collectors.

Among dozens of valuable studies of the work of Matisse and Picasso, only the most notable can be cited. The preeminent publication on Matisse remains Alfred H. Barr, Jr., Matisse: His Art and His Public (New York: The Museum of Modern Art, 1951; paperbound edition, 1974). Although there is more recent scholarship on the art of Matisse, there can be no more sensitive and eloquent appraisal of the artist's work than that demonstrated by Barr almost three decades ago. Also extremely helpful is Albert E. Elsen, The Sculpture of Henri Matisse (New York: Harry N. Abrams,

Inc., Publishers, 1972), and Isabelle Monod-Fontaine, The Sculpture of Henri Matisse (London: Arts Council of Great Britain and Thames and Hudson Ltd., 1984). A recent publication, more definitive by virtue of its author's unprecedented access to Matisse Estate materials, is Pierre Schneider, Matisse (New York: Rizzoli, 1984), which includes illustration of important Matisse works previously unknown and/or unpublished. For the work of Picasso, the author relied heavily on William Rubin, ed., Pablo Picasso: A Retrospective (New York: The Museum of Modern Art, 1980), and also found useful Edward Burns, ed., Gertrude Stein on Picasso (New York: Liveright, 1970). Two of the Baltimore Museum's own earlier publications should be noted in this context: Victor I. Carlson, Matisse as a Draughtsman (Baltimore: The Baltimore Museum of Art, 1971), and Picasso: Drawings and Watercolors, 1899–1907, in the Collection of The Baltimore Museum of Art (Baltimore: The Baltimore Museum of Art, 1976). Both of the latter volumes include substantial material on the Cone collections of works on paper by these two artists.

2. In the autograph manuscript of Two Women Stein uses the name Bertha to stand for Claribel. Stein's older sister was named Bertha, and Claribel's sister-in-law (Moses's wife) was named Bertha—neither of whom was held in much esteem by, respectively, Gertrude and Claribel. All subsequent typescripts of the Stein manuscript substitute the name Martha for Bertha.

3. "Dr. Claribel Cone A Remarkable Woman," The Evening Sun, Baltimore, April 8, 1911. This is a long feature story, based on an interview with Claribel, emphasizing her medical achievements and extraordinary character.

4. Although it has been suggested (Pollack, p. 34) that Etta first saw Robinson's work in a group exhibition at The Peabody Institute in Baltimore in the mid-1890's, there is no evidence to support such a claim. Neither John I. H. Baur, Theodore Robinson, 1852–1896 (New York: The Brooklyn Museum, 1946), nor Sona Johnston, Theodore Robinson, 1852–1896 (Baltimore: The Baltimore Museum of Art, 1973), both of which include extensive exhibition history for Robinson's work, indicate any exhibition in Baltimore. For purposes of the present publication, Johnston again researched the question and confirmed that there is no documentary record of Theodore Robinson's work having been shown in Baltimore during the period at issue. The work of a relatively unknown artist, Will S. Robinson, was shown at the Charcoal Club of Baltimore from March 29–April 2, 1897, and confusion over the two artists named Robinson may have been the source of Pollack's error.

5. Edward Cone, "The Miss Etta Cones . . . ," p. 457.

6. Edward Cone, "The Miss Etta Cones . . . ," p. 457.

7. Journey Into the Self, pp. 15–16. Although the letter is not dated, references in the body of the letter suggest a dating to 1905–1906.

8. Q. E. D. was not published until 1950, four years after Stein's death, when it appeared in a limited, somewhat emended edition under the title Things As They Are. In later years when scholars attempted to reconstruct the relationship between Stein's real life encounters and those narrated

in *Q. E. D.*, Alice B. Toklas confirmed that "in the writing of the book, Gertrude had literally transcribed passages from the correspondence between herself and May [Bookstaver] to create portions of the book's dialogue" (*Charmed Circle*, p. 59). The 1903 manuscript was set aside by Stein and only rediscovered in the 1930's. Toklas reported that the rediscovery of this manuscript and consequent conversation about its contents resulted in such domestic tension that she destroyed all the Bookstaver letters "in a passion."

9. Carl N. Degler, *At Odds: Women and the Family in America from the Revolution to the Present* (New York and Oxford: Oxford University Press, 1980), p. 152. This paragraph is based on Degler's book, in particular on his chapter VII, "Women Challenge the Family," from which specific quotations are drawn unless otherwise noted. The author also consulted Carroll Smith-Rosenberg, "The Female World of Love and Ritual: Relations between Women in Nineteenth-Century America," *Signs 1* (Autumn 1975), pp. 1–29, a primary source on which Degler relied, among many others.

It is interesting to note that in surprising contrast to the high proportions of unmarried women at the turn of the century, in the twentieth century of seemingly independent women that proportion has declined steadily, "from 7.7 per cent of those born at the opening of the century to 4.5 per cent for those born in the early twenties" (*At Odds*, p. 152).

10. *At Odds*, p. 156: "By 1900 . . . no more than 7 per cent of all seventeen-year-olds of both sexes graduated from secondary school [57,000 girls and 38,000 boys]. . . ." and "In 1900 about 5000 women graduated from college as compared with 22,000 men." "Educated and middle-class single women by the last decades of the 19th century had opportunities in the arts, professions like law and medicine as well as in business, government, teaching, and scholarship." Education did not, just the same, preclude marriage: "The great majority of women in 19th-century America, including those who went to college, eventually married." The adverb "eventually" is meaningful here; of the Cones' many single women friends, numbers of them did indeed eventually marry when in their thirties and even forties.

11. Edward Cone, "The Miss Etta Cones . . . ," p. 457.

12. Edward Cone, "The Miss Etta Cones . . . ," p. 458.

13. *Charmed Circle*, pp. 135–136.

14. Letter from Marian Walker Williams to Gertrude Stein, June 11, 1909, Hartford, Connecticut (*The Flowers of Friendship*, p. 45): " . . . By the way, in an idle moment I read the book on sex which you said exactly embodied your views—the one by the Viennese lunatic. It struck me that you made a mistake in your statement—it was evidently before not after he wrote the book that he went insane. We had a considerable amount of fun, however, in calculating the percentage of male and female in our various friends according to his classification. But he was really a very half-baked individual. . . ."

15. *Gertrude Stein on Picasso*, p. 97.

16. Smith-Rosenberg, pp. 8, 13, 27, writes sensitively about the issue of sexuality in sororial relationships: "The essential question is not whether these women had genital contact and can therefore be defined as heterosexual or homosexual. The twentieth-century tendency to view human love and sexuality within a dichotomized universe of deviance and normality, genitality and platonic love, is alien to the emotions and attitudes of the nineteenth century and fundamentally distorts the nature of these women's emotional interaction. . . . Such women, whether friends or relatives, assumed an emotional centrality in each others' lives. In their diaries and letters they wrote of the joy and contentment they felt in each others' company, their sense of isolation and despair when apart. The regularity of their correspondence underlines the sincerity of their words. . . . It is possible to speculate that in the twentieth century a number of cultural taboos evolved to cut short the homosocial ties of girlhood and to impel the emerging women of thirteen or fourteen toward heterosexual relationships. In contrast, nineteenth-century American society did not taboo close female relationships but rather recognized them as a socially viable form of human contact—and, as such, acceptable throughout a woman's life. . . ."

17. Sprigge, p. 39.

18. Letter from Mabel Foote Weeks to Gertrude Stein, January 2, 1901, London, *The Flowers of Friendship*, p. 21.

19. The "Festschrift" article was in fact published, in the *Frankfurter Zeitschrift für Pathologie* (February 28, 1907, Wiesbaden) as written by "Prof. Dr. Claribel Cone aus Baltimore," under the title "Zur Kenntnis der Zellveränderungen in der normalen und pathologischen Epidermis des Menschen" [Considerations of Cell Changes in the Normal and Pathological Epidermis of Man, according to Claribel's title translation]. Several offprints of the article remained in the Cone papers at the time of Etta's death.

20. *The Autobiography of Alice B. Toklas*, from *Selected Writings of Gertrude Stein*, p. 44.

21. This series of letters has been widely published and variously dated. Donald Gallup published Etta Cone's refusal to buy the manuscript in *The Flowers of Friendship*, p. 45, as 1909, with the annotation, "Miss Etta Cone and her sister Dr. Claribel Cone of Baltimore were in Paris, and it occurred to Gertrude Stein that Etta Cone, having made the first typed copy of the manuscript, might be willing to help finance the publication of *Three Lives*." Michael Stein's letter offering to "work" Etta for the sale of the manuscript is dated August 26 without a year, on 59, rue de la Tour (Paris) letterhead; one-time Cone archivist Irene Gordon ascribed the year 1926 to the Michael Stein letter based on contextual references in related correspondence. Etta's letter is dated "Monday June 23/04[?]," with the illegibility of the "04" the source of incorrectly ascribed dates for the exchange. Prior to 1922 the Cones had bought only one painting by Matisse and one by Tarkhoff; Etta's reference to saving her money to put "into a Renoir painting" assures dating of this letter to the 1920's. It was also in the 1920's that Michael Stein was working most actively on behalf of his sister Gertrude to sell art from the Stein collection to the Cones. Clearly, the *Three Lives* manuscript sales effort fits most appropriately in this period. There are other communications between Gertrude and Etta in this same month, including one in which Etta extends an invitation to

Gertrude to attend a performance of a Picasso ballet (named by Etta as "Parade") on June 27. In June of 1924 in Paris the premiere performances of the ballets *Mercure*, with decor and costumes by Picasso, and of *Le Train bleu*, with curtain design by Picasso, both took place (on June 18 and June 20, respectively). Finally, reference to a perpetual calendar confirms that in 1924, June 23 was a Monday (which correlates with Etta's dating). June 23 was not a Monday in 1904, 1909, or 1926. Since the early 1960's (after consultation with Barbara Pollack) Yale has had both Gertrude's and Etta's letters correctly catalogued as 1924.

22. *What is Remembered*, p. 48.

23. Letter from Alice B. Toklas to Mark Lutz, November 1950, Paris, in Edward Burns, ed., *Staying on Alone: Letters of Alice B. Toklas* (New York: Vintage Books, 1975), pp. 216–217.

24. First citation by Marcel Nicolle, second citation by Jean-Baptiste Hall, both quoted in Barr, p. 55. Barr includes a detailed discussion of the 1905 Salon d'Automne, the critical reception that surrounded it, and, in particular, the controversy about *Woman with the Hat* (see pp. 55–58). He also reviews the purchase of the Matisse painting by the Stein family, and discusses Stein responses to the picture (see pp. 57–58).

25. *Charmed Circle*, p. 79. Mellow in turn (in his Notes, p. 485, note/page 79) credits Pollack, p. 70, who uses a slightly expanded quotation. Pollack (in her Sources and Credits, p. 313) reports that "Dr. Cone's account of attending the vernissage of 1905 Salon d'Automne" was drawn from the Cone Archives at the Baltimore Museum. This account and thus the source of the quotation have not been traced in the Cone Archives. Mellow's note, on the other hand, reports that "The manuscript for Claribel Cone's memoir is owned by Ellen B. Hirschland." Much of Pollack's material (and, consequently, of Mellow's) cannot be satisfactorily correlated and confirmed by documents in the Cone Archives. Pollack conducted personal interviews with many individuals who are no longer living (including Alice B. Toklas, Nora Kaufman, Lilly Schwarz, and Marguerite Matisse Duthuit); information derived from those sources cannot be further confirmed. The author has not been given access to a Claribel Cone "memoir" allegedly in the possession of Ellen B. Hirschland; without any doubt such a memoir would offer invaluable confirming evidence for what must otherwise remain speculation.

26. *The Autobiography of Alice B. Toklas*, from *Selected Writings of Gertrude Stein*, p. 44.

27. *Gertrude Stein on Picasso*, pp. 29–30.

28. Carlson, *Picasso*, p. xiv.

29. Rubin, p. 59. The monographic chronology on Picasso and his work which forms such a substantive part of this book was prepared by Jane Fluegel; this citation is drawn from the Fluegel chronology.

30. *Gertrude Stein on Picasso*, p. 30.

31. *Journey Into the Self*, p. 48.

32. For more detailed review of this transitional period in Picasso's work, see Rubin (Fluegel), pp. 86–88, 98–105.

33. Schneider, p. 730.

34. Barr, pp. 54–55.

35. The purchase of the Matisse oil, *Yellow Pottery from Provence*, represents an oddly daring step for Etta in 1906. There is no original source documentation for the purchase; it is not cited in Etta's account book for the period. Etta reported to various people in later years that she had bought the painting in 1905 (see Ellen Hirschland, in *Four Americans in Paris*, p. 86, note 8). The painting is definitively dated to 1906, so Etta's memory was mistaken by at least one year. A photograph of the Stein studio, dating to ca. 1907 (see *Four Americans in Paris*, p. 90), shows *Yellow Pottery* hanging with the Steins' collection. No doubt based on this photographic documentation, Barr noted (p. 532, note 4 to p. 83) that "The *Yellow Jug* originally hung in the collection of Leo and Gertrude Stein." It is difficult to understand why a 1906 painting would have been acquired by the Steins in 1906–1907 and resold to Etta within the same year. Although the Cones did buy from the Stein collection (both directly and indirectly), there is no record that they were doing so at this early date. It is also likely that if Etta had bought the painting from the Steins she would have mentioned this fact in recounting its purchase. Since Etta left Paris in the spring of 1906 to travel around the world with her family, it is possible, if only speculation, that she "loaned" the painting to the Steins to hang until she could practically retrieve the picture and give it a home. If in fact Etta bought *Yellow Pottery* during her six months of collecting in 1905–1906, it represents a significant departure from her other purchases. With the exception of the extremely minor Tarkhoff oil, all her acquisitions were works on paper of modest price. Since *Woman with the Hat* was priced at 500 francs, *Yellow Pottery*, even though unfinished and a smaller, less important canvas, would have been more expensive than anything else bought by Etta in this period. Neither she nor Claribel, as far as is known, bought any additional Matisse paintings between 1906 and 1922. Thus, if Etta's memory was faulty about the "1905" purchase, it would have to have been faulty by almost two decades, which is improbable.

36. Barr, p. 192.

37. Barr, p. 203.

38. Apparently without direct recompense, Michael Stein expended considerable effort in arranging packing, transport, and official paperwork to assure that the Cones' purchases got safely from Paris to Baltimore. On November 19, 1922, he wrote Etta:

There are seven cases in all 1-2-3-4 are Claribel's 5-6-7 are yours. They are now at Havre. Rancheraye (my expediteur) found that there were boats direct to Baltimore and as that avoided the expense as well as the risk of damage of the trans shipment at N.Y. we are going to use that method and they are to be put aboard the steamer "Sonorah" direct to Balto . . . [letter from Michael Stein to Etta Cone, November 19, 1922, Paris].

He enclosed a copy of the tariff declaration he had sworn in Etta's name, itemizing the contents of the shipment:

14 paintings by Favre	22 Engravings by Matisse
4 " " " Milman	1 painting by Valloton
4 bronzes " Matisse	2 " " " Homolacs [?]
1 Etching " Renoir	2 " " " S.S.S.
1 painting " Picasso	1 drawing " Picasso
2 Engravings " Picasso	

Then, perjuring himself, Michael Stein wrote in Etta's name, "I further declare that it is impracticable to obtain declarations from the artists, as they are either dead or their whereabouts are unknown to me." Michael's correspondence with Etta often alludes to a variety of techniques employed to evade export/import duties on art shipments in order to save money for the Cones, and this 1922 declaration is a patent falsification probably designed to avoid declaring actual values. Michael Stein's letter makes it clear that not only were the sisters' purchases made specifically by one or the other, but were in fact sufficiently identified as such that they could be crated separately (four crates for Claribel, and three for Etta). Since in most cases the Cones had their art purchases framed in Paris (often with the consultation of Michael and Sarah Stein, occasionally with the advice of Matisse himself when his own work was involved, and in certain instances with frames apparently designed by Matisse's daughter, Marguerite, with her father's approval), it is unlikely that they carried with them the art works bought over the summer of 1922. It simply would not have been practical to add such bulk to their already numerous travel trunks and cases. Accordingly, unless the paintings were left in Europe, it is mysterious that there is no citation in the November 1922 customs declaration to paintings by Matisse. Nor are there in The Cone Collection today any works or artists that can be correlated to the initials "S. S. S." or the name "Homolacs[?]." While there are several works by Louis Favre in the collection, there are not fourteen paintings (although a number of Favres may have been given by Etta to Cone family members rather than included in the Museum bequest). It may be that Michael Stein, knowing that even customs officials recognized the name and value of Matisse by 1922 but would probably not be able to distinguish between a Favre and a Matisse, consciously incorporated the shipment's Matisse paintings under the category of "14 paintings by Favre."

39. F. Novotny, "The Late Landscape Paintings," *Cézanne: The Late Work* (New York: The Museum of Modern Art, 1977), p. 111. The Cone view of Mont Sainte-Victoire seems to date from the midpoint of the artist's extensive series of works on the forest and mountain motifs of Aix, dating between 1895 and 1906. Novotny's remarks are intended to apply specifically to the works of 1904–1906 but seem equally appropriate to the Cone painting. Recent Cézanne scholarship has dated the Cone picture to ca. 1897. Claribel Cone's account book for 1925 includes the following notation: ". . . Received Mr. Ebstein's letter enclosing note from Paul Cezanne son of Paul Cezanne the artist saying the Picture Montagne St-Victoire 'vendu la collection Gangnat— no 162–est–je crois 1886' 'la date–de composition est' . . ." [Claribel Cone notebook, July 8, 1925]. The original note

from Cézanne's son authenticating the painting and dating it to, he believes, 1886, has survived in Claribel Cone's papers, and confirms his dating opinion. Just the same, the Cone painting cannot date from 1886, but must date from 1896–1897 or later.

40. Leo Stein, *The A-B-C of Aesthetics* (New York: Boni & Liveright, 1927), pp. 266–267.

41. John Rewald, "Catalog" (paintings entries), in *Cézanne: The Late Work* (MoMA), cat. no. 35, pp. 397–398.

42. *Painter in the Olive Grove* has traditionally been called "The Artist in the Olive Grove" and dated to ca. 1922. Dominique Fourcade, in conversation with Brenda Richardson at the Baltimore Museum on October 30, 1984, pointed out that the subject cannot possibly be "the artist" (i.e., Matisse himself) since the figure at the easel painting from nature is female. Fourcade has subsequently confirmed that the sitter is Matisse's model Henriette Darricarrère, who studied painting with the artist. Claribel's notes from the day of the purchase, presumably comprising a relatively reliable source, cite the title for the painting as simply *Oliviers*, shifting the emphasis away from the depicted figure and toward the windswept grove of olive trees. This original source material also cites the painting's date as 1924 and places it in either Cannes or Nice. Fourcade's research confirms the location as Nice, and the date as 1923–early 1924.

43. Barr, p. 212.

44. Lawrence Gowing, *Matisse* (New York and Toronto: Oxford University Press, 1979), pp. 150, 154.

45. The title *Blue Nude ("Souvenir de Biskra")* has been so long attached to this famous Matisse painting that one would not attempt to change it now. However, there is no evidence to provide any rationale for this titling. Leo Stein bought the painting in 1908 as "The Blue Woman"; it was cited in the Armory Show catalogue as number 411, "La Femme Bleu / Lent by Leo Stein"; in the 1926 publication on John Quinn's collection it was cited as "Nude, Reclining"; and the official documents accompanying Claribel's purchase in October 1926 refer to the painting as "La Femme Bleu," although the Quinn auction catalogue from the Hôtel Drouot cites the painting as "femme nue couchée." Since the Cone purchase documents seem to have been executed under Michael Stein's supervision (in fact, his name is inked in as buyer and then crossed out and replaced with "Claribel Cone / Hotel Lutetia"), it can be concluded that Michael identified the painting as "La Femme Bleu" in keeping with the title he knew to be in use by the Steins during their ownership. As far as can be documented, the first instance of the title "la nu bleu (souvenir de Biskra)" was in a 1931 Matisse exhibition catalogue from the Galeries Georges Petit, Paris. Then in November 1931 there was published the seminal Matisse exhibition catalogue, Alfred Barr's *Henri-Matisse: Retrospective Exhibition* (The Museum of Modern Art, New York, November 3–December 6, 1931), in which he cited the painting as *Blue Nude (Souvenir de Biskra)*. Etta Cone perpetuated this title, though entirely in French, in the 1934 volume she published in Claribel's memory, where the painting appears as *Le Nu Bleu (Souvenir*

de Biskra). Existing records thus suggest that the painting's title should be "The Blue Woman," as originally transmitted from Matisse to Leo Stein (Barr's 1951 Matisse monograph indeed makes footnote reference to the Stein title, p. 553, note 4 to p. 94). Barr's 1931 exhibition and catalogue were produced in extremely close collaboration with Matisse, as for that matter was Barr's 1951 monograph. The latter includes both textual and note references indicating that the subject of the *Blue Nude* (though not necessarily the title specifically) was discussed by Barr and Matisse. The artist would not have been unaware of the painting's exhibition and publication under varying titles, and this could easily have been the subject of consultation between Barr and the artist, as well as between Matisse and Etta Cone. It is conceivable, then, that Barr's title derives from the authority of Matisse himself, despite the absence of documentary proof. As Barr has noted, other than the palm fronds in the right background of the painting there is no suggestion of its relationship to North Africa; therefore, it must be assumed that the addition of the subtitle "Souvenir de Biskra" came from conversations with the artist specifically alluding to the importance of the Algerian trip in the evolution of the painting.

46. Alfred H. Barr, Jr., *Henri-Matisse: Retrospective Exhibition* (New York: The Museum of Modern Art, 1931), pp. 14–15.

47. Barr, p. 533, note 3 to p. 94, paraphrasing from correspondence with Hans Purrmann.

48. Barr, p. 551: Matisse, 1908, based on notes taken by Sarah Stein during her studies with the artist (these teaching comments were first published by Barr in 1951 as "Appendix A" to his monograph).

49. *The Autobiography of Alice B. Toklas*, from *Selected Writings of Gertrude Stein*, p. 31.

50. The van Gogh *Flowers in a Vase* bought by Etta in 1927 from a New York dealer was adjudged to be a forgery by Siegfried Rosengart in 1931. Etta was especially fond of this painting (there is in the Cone Archives a letter from Claribel in Baltimore to Etta in New York [January 12, 1927] in which this potential purchase is discussed at some length), and she attempted to have it authenticated by van Gogh experts. Rosengart's opinion was upheld. This forged "van Gogh" is retained in The Cone Collection as BMA 1950.381. Subsequent to her death, it was determined that four other paintings bought by Etta Cone were either forgeries or copies: a *Landscape* attributed to Corot (BMA 1950.380); *Apples*, attributed to Courbet (this attribution was questioned even at the time of the painting's purchase), but determined by 1960 to be an imitator's copy after a Courbet original in Munich; a *Coast of Etretat* attributed to Monet (ex-BMA 1950.265), purchased through Rosengart/ Thannhauser on August 16, 1930; and *Tahitienne royale* attributed to Gauguin (ex-BMA 1950.214), purchased through Rosengart/Thannhauser on August 5, 1936. The latter two paintings (forgeries of the work of Monet and Gauguin) were taken back in trade by the dealer in 1955, in exchange for a Degas drawing, *Head of a Roman Girl*, ca. 1856. The Degas drawing was assigned a duplicate Cone accession number, BMA 1950.12.457 (previously assigned in error to a Matisse Mallarmé drawing that already had a number), rather than being numbered in sequence with 1955 accession chronology. There are several drawings in The Cone Collection that have been designated forgeries; a few others remain of questionable authenticity and await further study for a definitive judgment. On balance, the Cone sisters, in part as a reflection of their reliance on reputable dealers, did extremely well in terms of avoiding forgeries and copies.

51. A. D. Emmart, "Matisse Disclaims Prophetic Knowledge of Future of Art," *The Sun*, Baltimore, December 18, 1930, p. 22.

52. Quoted in Schneider, p. 416, note 52.

53. Barr, p. 245.

54. Quoted in Barr, pp. 244–245: Matisse, 1946, from "Comment j'ai fait mes livres," in *Anthologie du livre illustré per les peintres et sculpteurs de l'école de Paris* [see Barr, p. 567, bib. no. 46].

55. Quoted in Adelyn D. Breeskin, "Swans by Matisse," *The American Magazine of Art*, October 1935 (vol. 28, no. 10), p. 622. This article by Breeskin, pp. 622–629, along with the always eloquent, indispensable Barr ("The Mallarmé Etchings," pp. 244–246), comprise essential literature on this book design by Matisse. Because the Mallarmé material, in its entirety, represents a unique and irreplaceable resource in The Cone Collection of The Baltimore Museum of Art, it is prohibited from loan (although it is readily accessible for study). Accordingly, except for occasional exhibition of the material at the Baltimore Museum, the original drawings, plates, and proof editions are known for the most part only through reproduction. A definitive facsimile edition of the Mallarmé material is projected by the Museum within the next few years.

56. The Mallarmé material was in fact so copious and so impractical for private ownership that Etta immediately deposited the material on loan to the Print Department of The Baltimore Museum of Art, in Adelyn Breeskin's care, where it remained until its formal accession by Etta's bequest in 1950. Over the years the Mallarmé material has been published with varying description of its precise contents. For purposes of the present publication, L. Carol Murray, the Museum's Collections Manager, conducted a definitive inventory in February 1985 of the Mallarmé material in its entirety. The following is an itemization of Mallarmé contents as purchased by Etta Cone and subsequently acquired by the Museum and as intact to the present day, outlined in order of execution by the artist:

I. 51 drawn sheets (some with images recto and verso).
II. page proof volume in portfolio format, containing 10 drawn sheets (some with images recto and verso).
III. 29 printed copper plates and 5 refused copper plates, all with cancellation legend, in the artist's hand, within the image.
IV. trial proof volume in portfolio format, containing 34 etchings.

V. trial proof volume, marked "planche refusée," in portfolio format, containing 30 etchings from refused plates, plus 3 etched studies for remarques.

VI. first number (of 145) of published volume in portfolio format, with binding, containing 29 etchings.

VII. 58 duplicate etchings (without text), in portfolio format, printed on two variant papers of the published edition (Japon and chine) and issued as companion volumes to edition numbers 1 through 5 (printed on Japon impériale). The inclusion of three sets of etchings, one from each fine paper printing, for edition numbers 1 through 5, is so noted in the book's colophon.

VIII. 1 toned-plate etching, of the image "Hérodiade," annotated as a "special printing," on untrimmed paper.

IX. the published book's colophon notes that an original drawing by the artist was incorporated in edition numbers 1 through 5; such a drawing is not presently included in the Cone number one Mallarmé, but must have been removed and consolidated at some point with the 51 drawn sheets noted in item I above (it cannot be separately identified at this time).

Totaling all of the items above, the Cone Mallarmé material includes 61 drawn sheets; 34 copper plates; one proof volume of 34 etchings; one proof volume of 33 etchings; and one final edition volume of 29 etchings, along with its companion portfolio of 58 duplicate etchings; and 1 "Hérodiade" etching in a "special printing." Counted individually, the Mallarmé set thus includes 250 items.

57. Reproduced in color in Schneider, p. 365, along with reproduction of the thirteen preceding states, p. 364.

58. Reported to Brenda Richardson in conversation with Claude Duthuit (son of Marguerite Matisse Duthuit and Georges Duthuit, thus grandson of Matisse) at The Baltimore Museum of Art, ca. 1975–1976. M. Duthuit noted that whatever degree of social communication might have transpired between Matisse and Etta on these visits, the "business" of selecting paintings and negotiating prices was conducted between Marguerite and Etta, in the notable absence of Matisse himself.

59. Quoted in Pollack, p. 151. The original of this letter has not been traced (the citation cannot be found in correspondence in the Cone Archives in Baltimore), and Pollack provides neither specific date nor source.

60. Edward Cone, "The Miss Etta Cones . . . ," pp. 455–456.

61. *The Autobiography of Alice B. Toklas*, from *Selected Writings of Gertrude Stein*, p. 9.

Henri Matisse. *The Pewter Jug.* (1917). Oil on canvas. BMA 1950.230.

Annotated Chronology of Cone Acquisitions

COMPILATION: Although it is not possible to compile a definitive chronological sequence in which the Cone sisters acquired the works in their collections, it is possible to compile a substantive chronology in order to understand the gradual growth of The Cone Collection and the evolution of the sisters' tastes. The following Chronology is of necessity a partial listing drawn from the entire range of original documents available. With certain notable exceptions (included for specific reasons), the Chronology does not itemize print purchases. Prints were acquired in quantity and usually without individual identification (often, in fact, with citations applying to reproductions intermixed). Rather, the Chronology focuses on the paintings, sculptures, and unique works on paper that could more confidently be identified and correlated to source documents. Although on preliminary review, specific acquisition data seemed scant, in fact after careful analysis of the thousands of documents in the Cone Archives (and with only a minimum of speculation based on a process of elimination), it was possible to document with considerable detail acquisition data on over 300 works in the Collection. (In the present Chronology, the term "the Collection" always refers specifically to The Cone Collection.)

Records, research notes, and support documents on which the present Chronology is based are retained in the Cone Archives and are accessible to scholarly inquiry. Files on each object in the Collection are annotated with sources of information related to the author's decisions regarding titles, dates, and other Chronology data.

The Chronology was compiled and annotated by Brenda Richardson, based on research by Brenda Richardson, L. Carol Murray, and William C. Ameringer. Additional research assistance was provided by Anita Gilden and Margaret Prescott of the Baltimore Museum Library, and by Jay M. Fisher, Curator of Prints, Drawings, and Photographs. The collaboration of Matisse scholar Dominique Fourcade in Paris, regarding definitive titles, dates, and in some cases provenance, for certain of the Matisse paintings in the Collection, was invaluable and exceptional for its collegial generosity. Cooperation was also extended by Jack Cowart, National Gallery of Art, Washington, D.C.; Sarah Faunce, The Brooklyn Museum; and William S. Rubin, The Museum of Modern Art, New York.

DOCUMENTATION: The Cone Archives include many receipts or bills of sale from dealers or artists which specify date, amount, and/or item. In most cases, however, these items are listed only by a generic title (e.g., "nature morte" or "paysage") that cannot always be correlated with certainty to a specific object in the Collection. In certain instances, references to individual purchases in the sisters' account books or correspondence permit definitive identification. Correspondence in the Archives from Marguerite Duthuit offers some evidence on purchases from Matisse. The Cone Archives also include packing lists compiled by the Paris shipper, de la Rancheraye & Co., for the years 1928–1931, 1934, and 1936, which provide some clues as to purchases of those years; again, it is not always possible to correlate objects in the Collection with abbreviated citations on the Rancheraye lists. An envelope labeled in Claribel's handwriting "Matisse paintings selected [by] 1923," with citation of fifteen paintings under descriptive titles and with ascribed dates, permits identification of works acquired at least by 1923. (This envelope was originally found in the Cone Archives but has been missing since at least 1970; the list was quoted in its entirety, however, in a letter from Gertrude Rosenthal to Alfred Barr, July 25, 1950.) A terminus ad quem can be established for the acquisition of certain works through early exhibition documentation (The Maryland Institute, January 1923; The Baltimore Museum of Art, January 1925). In a few instances original documents are mutually contradictory, e.g., a receipt at variance from an entry in a Cone account book. Most often, it can be assumed that the account book entry is more reliable. Sometimes the sisters (Claribel especially) retained art purchases in Europe well past the date of their acquisition, and they apparently had occasion to request post facto receipts from friendly dealers for export purposes.

DATES OF PURCHASE: There is some latitude in the specific citation of dates of purchase. For example, a bill of sale from Bernheim Jeune may be dated June 14, 1923, with an annotation of payment on June 25, 1923. Bernheim Jeune records indicate the sale as dating from June 25, though the sisters' commitment to the object(s) dates from June 14, 1923. To avoid confusion, such a date is cited in the Chronology as June 14/25, 1923. In most cases, the specific

date of commitment or payment cannot be determined so closely. Thus, for purposes of the present Chronology, the author has assigned the date of purchase with as much specificity as documents allow. Although there may not be a record of date of payment, for instance, there may be a letter from a dealer informing the Cones that a certain work has been shipped; in that instance, the date of purchase has been designated in keeping with the date of the dealer's letter. In other words, the date indicated as a date of purchase may in fact be the actual date the sister committed to the work; the date the bill was paid; or, in many instances, a generalized marking point rather than a specific, documented date of acquisition.

SISTER: Whenever possible, indication is made as to which sister selected and acquired which object. As is discussed in the text to the present volume, Dr. Claribel and Miss Etta developed what they viewed to be independent collections, with independent financial resources. As far as can be determined, they did not buy works in common; they either selected independently, or made concrete decisions about which sister would own which work. Because bills of sale did not always reflect these decisions, it sometimes cannot be definitively ascertained which sister made the particular acquisition. In certain instances, subsequent documentation by the sisters indicates specific ownership; in other cases, suggested ownership has been indicated based on the author's speculation (in those cases, ownership is indicated with a question mark cited in brackets).

OBJECT(S): Objects are cited by artist, title, date (when known), and medium in abbreviated form. Whenever possible, works are cited under under those titles and dates that reflect most recent and responsible scholarship. Works were ordinarily sold under descriptive or generic titles. In those few instances in which it could be documented that the title carried the authority of the artist's original intention, the title has been retained or restored. Translations into English from original French titles are as literal as possible. For purposes of this publication, in those instances in which no artist-assigned title could be determined, an appropriately descriptive title has been assigned by the author. Dates that appear on the work are cited without parentheses; ascribed dates are cited with parentheses, with ascription based either on stylistic or documentary evidence. The absence of any date suggests an inability to ascribe such a date without further research. The Baltimore Museum of Art accession number appears at the end of each object citation. The Cone bequest materials were accessioned by the Museum in 1950, thus all Cone objects carry the number BMA 1950., followed by additional numerals. Prints and drawings carry the accession number BMA 1950.12., followed by additional numerals. The objects were not accessioned, for the most part, in any logical sequence, though some attempt was made to number an artist's works in sequence with reference to their dates of execution insofar as those dates were then understood.

MATISSE TITLES/DATES: The titles and dates of Matisse paintings in The Cone Collection have been determined by the author in collaboration with Dominique Fourcade. Fourcade, in conjunction with research for the Matisse exhibition scheduled at the National Gallery of Art, Washington, D.C., for the fall of 1986, was given access to Matisse Estate archives and to Matisse sales records from Bernheim Jeune & Cie., Paris. Working with Estate representatives, definitive decisions were reached regarding citation of titles and dates for those Cone Matisse paintings which will be included in the Washington exhibition. These titles and dates will thus appear consistently in the present Cone publication, in the 1986 National Gallery exhibition catalogue, and in the forthcoming catalogue raisonné of paintings planned for Matisse Estate publication. In addition, titles and dates for all Matisse paintings from The Cone Collection which date after 1932 have been definitively confirmed in collaboration between the author and Fourcade, who worked with Lydia Delectorskaya, Matisse's model and secretary during these late years. Delectorskaya kept meticulous working notes which recorded Matisse's titles, and the dates of execution, of all paintings of this period. A Delectorskaya book on Matisse, planned for publication almost concurrent with the present Cone volume, will document all of the post-1932 paintings with titles and dates consistent with those cited here. Titles and dates of Matisse paintings that date before 1916, or that date between 1916 and 1932 but are not included in the National Gallery exhibition, have been assigned by the author, with the advice and assistance of Dominique Fourcade, but have not yet been definitively adopted by the Matisse Estate. Therefore, they represent the best judgment possible, based on available research to date, of the author and Fourcade, but remain subject to Matisse Estate revision at a later date.

To assure consistency of reference, an Appendix of Matisse Paintings and Sculpture in The Cone Collection has been published in the present volume, with citation of painting titles in both English and French. In those instances in which newly adopted titles bear little or no relationship to traditional titles, the former titles are cited as well. Most often, Matisse himself did not assign specific titles to his paintings. Rather, he described pictures by variant informal titles. As paintings went into dealers' hands, the works often again changed titles. With the exception of those few paintings for which the artist assigned specific and meaningful titles, the intention of Fourcade and the Matisse Estate has been to assign definitive titles that will most clearly describe the painting and distinguish one subject from another related subject. Newly adopted titles apply only to those Matisse paintings in The Cone Collection. Other Matisse titles are cited throughout the present text by their traditional titles, since new titles/dates may not yet have been proposed or other owners may not yet have accepted revised titlings.

SOURCE OF PURCHASE: Whenever possible, the source of purchase is indicated. In a few instances, the source is unknown. Complete provenances are not indicated in the present Chronology, although in some cases a preceding ownership was deemed to be of sufficient interest to warrant citation (for instance, when a Stein provenance could be established, it is cited).

PRICE: Prices are indicated in dollars, French or Swiss francs, or German marks, as they appear on invoices or in correspondence; in some cases, the amount is derived from Rancheraye packing lists, which indicate shipped value (shipped values correlate consistently with purchase prices when multiple documents exist). Prices indicated in the Chronology of course refer to purchase prices at the time of acquisition, and have nothing to do with current values of works cited. In completing research for the Chronology, prices proved to be important evidence in identifying specific objects, since prices often related to issues of size or date of a particular object. In addition, prices reflect to a certain extent the "sociology" of the Cones' collecting, i.e., how much the sisters were prepared to pay, in relative terms, for each object acquired. It is also of historical interest to note that relative values of works of art in the 1920's and 1930's do not necessarily correlate with relative values of those same works today. Thus, prices are cited only for their historical or sociological interest, and as sources of information. It is revealing, for example, that the Cones were prepared to pay 10,000 francs for the Vallotton portrait of Gertrude Stein, in the same years during which they bought other Vallotton oils of comparable size and date for a fraction of that amount. Equally, it is notable that the highest price ever paid for a work of art by either Cone sister was the 410,000 francs ($18,860 at the time) Claribel paid for Cézanne's *Mont Sainte-Victoire* in 1925. Despite the fact that Etta was an active buyer until her death in 1949, she nonetheless never paid more than this amount for any work of art, no matter the inflation factor. (Etta paid $17,500 in 1930 for her Manet, *Lady in a Bonnet*, and $15,000 each for her Gauguin in 1937, her Corot in 1947, and her Matisse *Ballet Dancer* in 1948.) Given the variability of exchange rates over the years, it is impossible to know which Matisse was the most expensive of the Cones' acquisitions, but it would seem to be either the *Ballet Dancer* or *The Yellow Dress*, for which Etta apparently paid 200,000 francs in 1931, more than twice the amount she paid even for "The Pink Nude" in 1935, or the large *Interior with Dog* ("The Magnolia Branch") in 1934. In the case of those Matisses bought directly from the artist (as negotiated with Etta by Marguerite Matisse Duthuit), such price comparisons are interesting as presumed reflections of the relative importance the artist assigned to these works (indeed, correspondence in the Cone Archives from Marguerite Duthuit to Etta Cone suggests that Matisse resisted selling *The Yellow Dress* and wanted to retain it for himself, which may have been the decisive factor in setting its price).

DISPOSITION OF THE COLLECTION: Not everything acquired by the Cones came to The Baltimore Museum of Art through Etta Cone's bequest. The terms of the will, naming the Baltimore Museum as primary beneficiary of the "Art Collections" (Claribel's and Etta's) specified that a committee named by Etta should select those works it deemed to be of "museum value or interest." Any object so selected had to be maintained by the Museum on a restricted basis, that is, nothing could subsequently be sold or traded. Duplicates (whether books, prints, or sculptures) were designated for the Women's College of the University of North Carolina, for use in its Art Department and Weatherspoon Art Gallery. Frederic Cone's collection also came to the Museum with the 1950 Claribel and Etta collections, to be shown with The Cone Collection but identified in each case as coming from the collection of Frederic Cone. Fred Cone's separate bequest also designated funds for the Museum to purchase works of art. Etta Cone's bequest designated substantial funds to house and maintain the collection, but specifically precluded use of the funds for the purchase of objects (the will indeed precluded deleting from or adding to The Cone Collection). Certain works of art, presumably of lesser "museum value or interest," were passed on by Etta Cone to friends or family members during her lifetime, or had apparently been designated by her to be so passed on after her death. Numerous paintings are cited, although without identification of artist or object, in the official inventory of the Cone apartments as included in the personal effects and household goods bequeathed to the custodianship of Laura W. Cone (widow of Etta's brother Julius W. Cone). This correlates with certain apparent discrepancies in the Chronology. For instance, although it is known that the Cones acquired several oils by Ben Silbert, there are none in the Museum's Cone Collection; similarly, the Cones acquired many more paintings by Louis Favre than actually came to the Museum by Etta's bequest; five paintings by Theodore Robinson were purchased by Etta in 1898, but there are only four in the Museum's Cone holdings; etc. It can safely be concluded that such items were among works distributed by Etta to family members, since such works do not appear on inventories or accession records of objects included in the Museum bequest material. Current inventories by the Museum of The Cone Collection produce satisfactory correlation between objects and accession records; there are no accessioned works missing or unaccounted for. Vast numbers of Cone bequest materials were in fact never formally accessioned by the Museum, primarily in the genre of "curios" or "objets d'art." Certain of these materials are either personal or purely decorative in nature (costume jewelry; furniture pastiches; lingerie bags, luggage, ornamental boxes; art reproductions; rugs and textiles; Japanese prints of lesser quality; or utilitarian objects). Such materials were clearly beyond the scope or purpose of the present Chronology.

Henri Matisse. *Yellow Pottery from Provence*. (1906). Oil on canvas. BMA 1950.227.

Date Sister	Object(s) Comments	Source of Purchase Price if Known
March 24, 1898 Etta	THEODORE ROBINSON. 5 oils. *Mother and Child.* (mid-1880's). BMA 1950.357. *The Young Violinist.* (late 1880's). BMA 1950.290. *In the Grove.* (ca. 1888). BMA 1950.291. *The Watering Place.* 1891. BMA 1950.358. A fifth Robinson painting, identified in the Estate Sale catalogue as no. 80, *A Lock,* was passed on by Etta to a Cone family member and did not come to the Museum by bequest. A letter from Bertha Cone to Etta Cone, March 27, 1898, reports the five Robinson paintings bought at the auction as including catalogue no. 7, *Summer,* though in fact the Cone purchase was no. 9, *Mother and Child.* Neither Etta nor Bertha attended the auction; they enlisted a "Mr. Randolph" to bid on their behalf, with Etta's instruction "to get as many for the money as possible." Bertha's letter notes her regret at not attending the sale, since in view of the low prices she might have bought her favorite, "The Girl at Well" (which brought $160), rather than buying in quantity. The payment receipt, dated March 28, 1898, is annotated "for Moses, Ettas pictures."	Robinson Estate Sale, American Art Galleries, New York. $305 for five ($40, $55, $70, $80, and $60).
September 13, 1901 Etta	ANTOINE LOUIS BARYE. 1 bronze. *Plaque: Walking Panther.* 1831. BMA 1950.406.	Art dealer, Paris. 30 francs.
September 17, 1901 Etta	JAPANESE PRINTS. It cannot be determined which prints Etta bought in September 1901. There are over 100 Japanese prints in the Collection, of uneven quality. Prior to ca. 1904 the only substantive art collecting by Leo and Gertrude Stein was of Japanese prints. Etta emulated their interest and over the years bought extensively from their Paris dealers (and presumably from other sources as well).	". . . little shop on Rue Guegnard near Rue Mazarine," Paris. 41 francs.
October 29, 1905 Etta	NICOLAS A. TARKHOFF. 1 oil. *Woman Reading.* (ca. 1905). BMA 1950.369.	Artist, Paris. 125 francs.
November 2, 1905 Etta	PABLO PICASSO. "1 picture, 1 etching." Because so many of the Picasso works on paper acquired by the Cones date from 1905–1906, it is not possible to identify which were acquired at any given date. Documentary evidence is scant on all of the Picasso material acquired by the Cones.	Artist, Paris. 120 francs.
January 15, 1906 Etta	HENRI MATISSE. "2 drawings." Etta was taken by Sarah Stein on this date to visit Matisse. Etta's account book notes the acquisiton of two drawings, one of which she apparently gave to Mrs. Stein. With three exceptions, all Matisse drawings in the Collection date from ca. 1914 or later and thus could not have been among the purchases on this date (or the drawing purchased on February 18, 1906, below). The three early drawings in the collection are: *Nude Male Model Seated on a Stool* (ca. 1898?), BMA 1950.12.53; *Nude Female Model Seated on a Stool, Facing Right* (ca. 1898?), BMA 1950.12.54; and *Nude Female Model Seated on Floor* (ca. 1898?), BMA 1950.12.56. Of these, it is known that the first cited, BMA 1950.12.53, was not purchased until 1934.	Artist, Paris.

February 1, 1906 Etta	PAUL CÉZANNE. 1 lithograph. Either *Bathers* (1890), BMA 1950.12.605, or *Large Bathers* (1890–1900), BMA 1950.12.681. Both the Cézanne lithographs of this subject were acquired by the Cones. The Rancheraye packing list of 1929 cites a Cézanne "gravure," called "Baigneuses," valued at 175 francs; this must be the second of the two "Bathers" lithographs acquired for the Collection.	Unknown, Paris. 50 francs.
February 18, 1906 Etta	HENRI MATISSE. "1 water color, 1 drawing." *The Harbor of Collioure*. (1905). BMA 1950.226. Drawing, either BMA 1950.12.54 or BMA 1950.12.56 [see entry for January 15, 1906, above].	Artist, Paris. 100 francs. 50 francs.
February 28, 1906 Etta	AUGUSTE RENOIR. 1 lithograph. There are two Renoir color lithographs in the Collection: *Baigneuse* (1896), BMA 1950.12.650, and *L'Enfant au biscuit* (1899), BMA 1950.12.606. Although there are only two lithographs in the Collection, there are altogether nine Renoir prints acquired by the Cones, ranging in date from 1892 to 1928, including some rare early proofs on Japon of 1906 impressions.	Unknown, Paris. 80 francs.
March 3, 1906 Claribel & Etta	PABLO PICASSO. "11 drawings 7 etchings." See entry for November 2, 1905, above.	Artist, Paris. 175 francs.
March 17, 1906 Etta	EDOUARD MANET. 2 etchings. There are four Manet etchings in the Collection, all from the posthumous 1905 Ströhlin edition. Of these four, it is known that *Eva Gonzales* was purchased from Rosengart on August 5, 1936.	Unknown, Paris. 75 francs.
Spring 1906 [?] Etta	HENRI MATISSE. 1 oil. *Yellow Pottery from Provence*. (1906). BMA 1950.227. See present text, note 35.	Artist[?], Paris. [ex-coll. Gertrude Stein?].
January 7, 1908 Etta	PABLO PICASSO. 1 ink drawing. *Self-Portrait (Bonjour Mlle Cone)*. (1907). BMA 1950.12.481.	Artist, Paris. Enclosed as a gift from the artist, in a letter from Gertrude Stein to Etta Cone.
1913 [?] Etta [?]	PATRICK HENRY BRUCE. 1 oil. *Still Life: Flowers in a Vase*. (ca. late 1911). BMA 1950.316. There is no documentation on this purchase. Speculation that the painting may have been acquired by the Cones as early as 1913 is based on a newspaper article found in the Cone Archives, pencil-noted by one of the sisters "Matisse & Bruce." The article, from *The Evening Sun*, Baltimore, March 5, 1913, describes a Bruce painting exhibited in Baltimore during that month as "a bowl containing flowers, apparently nasturtiums." The description fits the Cone painting, although it equally fits several other Bruce paintings of ca. 1911. Bruce worked most of his life in Paris and was friendly with the Steins, where Claribel and Etta could have met him as early as 1906. They could have clipped the article for its citation to Bruce as well as for its mention of the work's relationship to Matisse (such an early Baltimore mention of Matisse would have interested the Cones in 1913). Thus, it is impossible to know whether the Bruce was bought by the Cones from the Baltimore exhibition in 1913, or possibly	Artist [?], Paris [?].

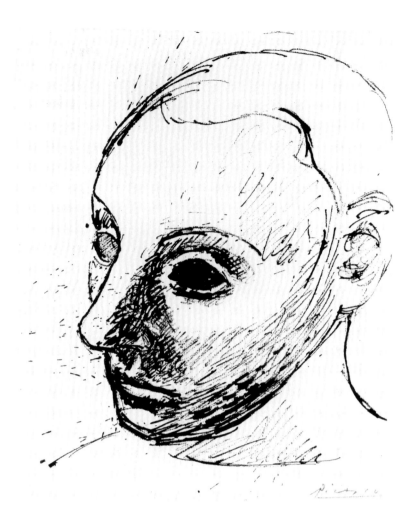

Pablo Picasso. *Head of a Young Man (Self-Portrait)*. (1906).
Pen and ink on paper. BMA 1950.12.485.

Pablo Picasso. *Self-Portrait (Bonjour Mlle Cone)*. (1907).
Pen and ink on paper. BMA 1950.12.481.

	at a later date. The painting was definitely in the Collection by 1924, when it was cited in an article on the Cones ("Baltimore Women Own Large Collection of Matisse Works," *The Sun*, Baltimore, Sunday Magazine, December 14, 1924, p. 20, Part 2, Section 1).	
July 11, 1922 Claribel [?] Etta [?] Etta [?] Etta Claribel	HENRI MATISSE. 5 oils. *Woman in Turban (Lorette)*. (1917). BMA 1950.229. *Etretat, The Beach*. (1920). BMA 1950.235. *Two Women in a Landscape, Vallée du Loup*. (1922). BMA 1950.238. *The Brown Dress*. (1922). BMA 1950.244. *Girl Reading, Vase of Flowers*. (1922). BMA 1950.246. It is not altogether certain that all five of these paintings were bought on the same day, but documentation suggests that all were bought at least in July 1922. Bills of sale from Bernheim Jeune were often made out in the name of Dr. Claribel Cone, even when pictures were in fact being purchased by Claribel and Etta, independently. Thus, it is not possible to know for certain which of the five paintings was selected by which sister in the present case. Later documentation is annotated in Etta Cone's hand indicating Claribel's ownership of *Girl Reading* and Etta's ownership of *The Brown Dress*. Given the evidence of their subsequent purchases, it seems most likely (though admittedly only speculation) that Claribel selected *Woman in Turban* and Etta chose the two smaller landscapes.	Bernheim Jeune, Paris. 8,500 francs [?]. 6,000 francs [?]. 7,000 francs [?].
July 14, 1922 Claribel	PABLO PICASSO. 1 pencil drawing. *Dr. Claribel Cone*. 1922. BMA 1950.12.499. There is no documentation on this interesting acquisition, presumably a commission by Claribel. The drawing is inscribed "Picasso/14-7-22." It is not known how the portrait sitting(s) came about, or whether at artist's or subject's instigation. This imposing image of Dr. Claribel has much in common with the artist's famous painted portrait of Gertrude Stein from 1906. Although a portrait sitting with Picasso in 1922 must have been a notable occasion, in fact no comment on the event has been found in Cone papers. In Claribel Cone's notebook for 1925 she reports, ". . . ordered 20 photographs of Picasso's drawing of CC at 6 fr each . . . to be ready in one week Mon. July 6, 1925 . . ." [June 29, 1925, Paris]. Pollack [p. 128] reports more expansively, evidently based on her interview(s) with Nora Kaufman: "Nora Kaufman accompanied Claribel one day when Claribel went to sit for her portrait. . . . After Picasso finished the ink [sic] portrait, Claribel decided to settle her account on the spot. . . . Claribel counted out a thousand francs in new bank notes and handed them to Picasso with thanks."	Artist, Paris. 1,000 francs [?].
July 24, 1922 Claribel	HENRI MATISSE. 1 oil. *The Pewter Jug*. (1917). BMA 1950.230. Although the receipt for the painting clearly indicates that it was Claribel's purchase, in fact Etta made an initial payment of 2,000 francs on July 24, 1922, with Claribel paying the balance of 18,000 francs on September 7, 1922. It was not uncommon for the sisters to advance one another cash and make repayment at a later date.	Georges Bernheim, Paris. 20,000 francs

Pablo Picasso. *Dr. Claribel Cone*. 1922. Pencil on paper. BMA 1950.12.499.

Henri Matisse. *Anemones and Chinese Vase.* (1922).
Oil on canvas. BMA 1950.248.

Henri Matisse. *Still Life, Bouquet of Dahlias and White Book.* (1923).
Oil on canvas. BMA 1950.249.

172

Summer 1922 Claribel & Etta	HENRI MATISSE. 4 bronzes. *Head of a Child (Pierre Matisse).* (1905). BMA 1950.425. *Woman Leaning on her Hands.* (1905). BMA 1950.424. *Small Head with Comb.* (1907). BMA 1950.427. *Small Crouching Nude without an Arm.* (1908). BMA 1950.432. In November 1922 four bronzes by Matisse were noted as being shipped from Paris to Baltimore on customs declarations. In January 1925 the above-cited Matisse sculptures were included in a BMA exhibition, thus indicating that these had to be the four purchased by the Cones in 1922. No additional Matisse sculpture was acquired by either sister until 1929. Duplicates of each of these four sculptures were included in the Cone bequest (the duplicates went to the Weatherspoon Art Gallery), but it is not known at what date the Cone sisters acquired the second cast of each.	Artist, Paris.
November 23, 1922 Etta	EDGAR DEGAS. 1 crayon/pastel on paper. *Ballet Dancer Standing.* (ca. 1886–1890). BMA 1950.12.659.	Durand-Ruel, Paris. $400.
June 14/25, 1923 Claribel [?] Etta [?] Etta [?] Etta [?] Claribel [?] Claribel [?]	HENRI MATISSE. 6 oils. *Still Life, Compote, Apples, and Oranges.* (1899). BMA 1950.224. *Violinist and Young Girl ("Divertissement").* (1921). BMA 1950.243. *Young Woman at the Window, Sunset.* (1921). BMA 1950.245. *Woman in Striped Pullover, Violin on the Table.* (1921– 1922). BMA 1950.241. *Anemones and Chinese Vase.* (1922). BMA 1950.248. *Standing Odalisque, Tambourine in her Right Hand.* (1922). BMA 1950.247.	Bernheim Jeune, Paris. 12,000 francs. 12,000 francs. 9,500 francs. 12,500 francs. 17,250 francs. 10,250 francs.
July 6, 1923 Claribel & Etta	HENRI MATISSE. 2 oils. *Large Cliff—Fish.* (1920). BMA 1950.233. *Standing Girl, Green Dress, White Shawl.* (1921). BMA 1950.236.	Bernheim Jeune, Paris. 25,000 francs for two.
September 1923 Etta	HENRI MATISSE. 1 oil. *Still Life, Bouquet of Dahlias and White Book.* (1923). BMA 1950.249. HENRI MATISSE. 1 oil. *Standing Odalisque Reflected in a Mirror.* (1923). BMA 1950.250. Etta's purchases of this *Odalisque* and of the *Dahlias* in September 1923 suggest that the June 1923 purchases of the "Odalisque with Tambourine" and the *Anemones and Chinese Vase* were probably Claribel's. The sisters vied with one another, if only subconsciously, in building their respective collections, and Etta's choices often mirrored her older sister's after a few months' reflection.	Bernheim Jeune, Paris. Artist, Paris. 19,000 francs.
by 1923 Etta [?]	HENRI MATISSE. 1 oil. *The Sick Woman.* (1899). BMA 1950.225. Documentation in the Cone Archives indicates that this painting was owned by 1923, but there is no other evidence to detail its acquisition. The painting was photographed by Bernheim Jeune in 1914, but its sale was apparently not handled by the dealer. Matisse Estate	Artist [?], Paris. 4,000 francs [?]. [ex-coll. Leo Stein].

173

Henri Matisse. *Large Cliff—Fish*. (1920). Oil on canvas. BMA 1950.233.

	records document the painting as being from the collection of Leo Stein, which would make it among the group of Matisses released for sale by Leo in about 1913.	
October 8, 1924 Claribel [?]	HENRI MATISSE. 1 oil. *The Maintenon Viaduct.* (1918). BMA 1950.232.	Bernheim Jeune, Paris.
June 14, 1925 Claribel	MARIE LAURENCIN. 1 oil. *Group of Artists.* 1908. BMA 1950.215.	Gertrude Stein, Paris. 10,000 francs.
June 16, 1925 Claribel	LOUIS FAVRE. 3 oils, "Dahlias . . . Balcony . . . Still life much colored." There are numerous Favre purchases documented throughout the Cone papers. The sisters became friendly with the artist and visited him in Paris almost every summer, when they would buy several works. Since there are many more documented Favre purchases than there are Favre works in the Collection, it is assumed that over the years the Cones passed these pictures on to family members. The Favre works that actually came to the Museum by Etta Cone's bequest include only four oils, one pastel, and two watercolors. None of the oils can be descriptively correlated to these cited by Claribel in her notebook entry as having been purchased from Gertrude Stein. One of the Favre oils in the Collection is documented as having been bought by Claribel in June 1928, and another by Etta in July 1931. The other two are *Still Life with Fruit and Chinese Vase,* BMA 1950.328, and *Girl in White Dress Seated in Red Chair,* 1927, BMA 1950.325. The Cones were naturally drawn to Favre's work for its close relationship to that of Matisse, and they acquired works by the two artists of very similar subject matter. Etta's 1931 Favre purchase was an anemone subject, her favorite flower. That botanical subject in a still life almost assures a picture to have been her purchase. In fact, several paintings were receipted to Etta under the title "Anemones" even when the flower depicted is clearly another variety, as if the dealers knew that the anemone description guaranteed a sale to Miss Etta Cone.	Gertrude Stein, Paris. 1,000 francs for three.
June 26, 1925 Claribel	PAUL CEZANNE. 1 oil. *Mont Sainte-Victoire Seen from the Bibémus Quarry.* (ca. 1897). BMA 1950.196.	Bernheim Jeune, Paris. 410,000 francs ($18,860). [Gangnat sale, Hôtel Drouot, Paris, June 24–25, 1925].
July 6, 1925 Claribel	HENRI MATISSE. 1 oil. *Painter in the Olive Grove.* (1923–1924). BMA 1950.239.	Pierre Matisse, Paris. 30,000 francs.
July 6, 1925 Etta	HENRI MATISSE. 1 oil. *Interior, Flowers and Parakeets.* (1924). BMA 1950.252.	Pierre Matisse, Paris. 70,000 francs.
July 9, 1925 Claribel	PABLO PICASSO. 1 bronze. *Mask.* 1905. BMA 1950.453.	Gertrude Stein, Paris. 5,000 francs.
	AFRICAN. 1 object, "Figure." Because there is more than one African "figure" in The Cone Collection, it is not possible to identify which one is referenced here, from Claribel Cone's Paris notebook entry of this date.	Gertrude Stein, Paris. 3,000 francs.
July 20, 1925 Etta	MARGUERITE MATISSE. 1 oil. *Still Life with Bottle.* (ca. 1925). BMA 1950.351.	Artist, Paris. 400 francs.

October 1, 1925 Claribel	AUGUSTE RENOIR. 1 oil. *Olive Trees.* (ca. 1905). BMA 1950.285.	Paul Vallotton, Lausanne. 15,000 Swiss francs.
August 18/23, 1926 Claribel	HENRI MATISSE. 1 oil. *The Music Lesson, Two Women Seated on a Divan.* (1921). BMA 1950.242.	Paul Vallotton, Lausanne. 10,800 Swiss francs.
	AUGUSTE RENOIR. 1 oil. *Bouquet of Roses.* (ca. 1909). BMA 1950.286.	Paul Vallotton, Paris. 26,000 Swiss francs.
	FELIX VALLOTTON. 1 oil and 1 pencil drawing. *Roses and Black Cup.* 1918. BMA 1950.373. *Seated Female Nude.* BMA 1950.12.417.	Paul Vallotton, Paris. 1,500 Swiss francs. 175 Swiss francs.
August 1926 Etta	PAUL CEZANNE. 1 oil. *Bathers.* (1898–1900). BMA 1950.195.	Gertrude Stein, Paris. [from Ambroise Vollard to Leo Stein, ca. 1904– 1905].
September 13, 1926 Claribel	FELIX VALLOTTON. 1 oil. *Fish and Lemon.* 1925. BMA 1950.374.	Paul Vallotton, Lausanne. 1,500 Swiss francs.
October 26, 1926 Claribel	MARGUERITE MATISSE. 1 oil. *Nice.* (ca. 1926). BMA 1950.350.	Artist, Paris. 1,200 francs.
	FELIX VALLOTTON. 1 oil. *Gertrude Stein.* 1907. BMA 1950.300. It is interesting to note that Claribel paid almost ten times as much for this Vallotton portrait of Gertrude Stein as she was paying for other Vallotton paintings during the same years. Claribel's willingness to pay so much more for this Vallotton probably reflected equally her eagerness to own this subject and her friendly support of the Steins' financial need.	Gertrude Stein, Paris. 10,000 francs.
October 28, 1926 Claribel	HENRI MATISSE. 1 oil. *Blue Nude.* (1907). BMA 1950.228.	John Quinn Estate Sale, Paris. 120,760 francs. [ex-coll. Leo Stein].
August 17, 1927 Etta	OTHON COUBINE. 1 oil. *Head of a Woman.* BMA 1950.321.	Paul Vallotton, Lausanne. 225 Swiss francs.
	HENRI-EDMOND CROSS. 1 watercolor. Probably *Landscape.* BMA 1950.204.	Paul Vallotton, Lausanne. 160 Swiss francs.
	AUGUSTE RODIN. 1 bronze. *Little Man with the Broken Nose.* (1882). BMA 1950.447.	Paul Vallotton, Lausanne. 600 Swiss francs.
	PAUL SIGNAC. 1 watercolor. *Harbor of Le Trieux.* 1925. BMA 1950.295.	Paul Vallotton, Lausanne. 300 Swiss francs.
September 3, 1927 Claribel	EGYPTIAN. 1 bronze. *Seated Cat.* (Saitic Period). BMA 1950.405.	Paul Vallotton, Lausanne. 4,500 Swiss francs.
	ODILON REDON. 1 oil. *Peonies.* (ca. 1900–1905). BMA 1950.281. VINCENT VAN GOGH. 1 oil. *A Pair of Boots.* 1887. BMA 1950.302.	Paul Vallotton, Lausanne. 25,000 Swiss francs (inclusive with van Gogh).

Vincent van Gogh. *A Pair of Boots*. 1887. Oil on canvas. BMA 1950.302.

Félix Vallotton. *The Lie*. (1897). Oil on canvas board. BMA 1950.298.

September 5, 1927 Etta	EDGAR DEGAS. 1 pastel on paper. *Three Dancers.* (1897–1900). BMA 1950.205.	Paul Vallotton, Lausanne. 20,000 Swiss francs.
	FELIX VALLOTTON. 1 oil. *The Lie.* (1897). BMA 1950.298.	Paul Vallotton, Lausanne. 800 Swiss francs.
September 13, 1927 Claribel	HENRI MATISSE. 1 oil. *Still Life with Peaches.* 1898 (?). BMA 1950.222.	Bernheim Jeune, Paris. 32,500 francs.
January 11, 1928 Claribel	JOHN GRAHAM. 1 oil. *Landscape of Beaucaire, near Provence.* (1926–1927). BMA 1950.335.	Artist, Paris/Baltimore. $75.
March 1928 [?] Claribel or Etta	JOHN GRAHAM. 1 oil. *Still Life with Fruit and Blue and White Pitcher.* 1926. BMA 1950.334. Correspondence in the Cone Archives from John Graham to Claribel Cone (dating from January 11 and March 7, 1928) suggests that the two may have met in Paris in the summer of 1927. At that time Claribel made a cash deposit for the Graham landscape that was deliv- ered to her in January 1928, by which time the artist was residing in Baltimore. Graham's March letter to Claribel comments on objects, including two paintings, left for her approval, and this *Still Life* may have been among the group. Both Cone sisters bought Graham's work, as is noted in Graham's January letter: "I was very pleased to know that Miss Etta Cone has bought from Mr Skutch St. Barbara, the figure, I brought the summer before last, from France and sold to Mr Skutch . . ." [letter from John Graham to Claribel Cone, January 11, 1928, Baltimore]. Only the two Graham paintings noted here came to the Museum with the Cone bequest. Twenty-two Graham drawings went to the Weatherspoon Art Gallery in Greensboro, in keeping with the terms of Etta Cone's bequest (see Chronology introduction, under "Disposition of the Collection"). None of the Weatherspoon works are catalogued as "St. Barbara" and this subject, whether painting or drawing, may have been given to Cone family members, as were certain other Grahams either in Etta's lifetime or by her specific bequest.	Artist, Baltimore.
June 15, 1928 Claribel	HENRI MATISSE. 1 oil. *Nude with Spanish Comb, Seated in Front of a Cur- tained Window.* (1919). BMA 1950.237.	Bernheim Jeune, Paris. 63,775 francs. [Soubies sale, Hôtel Drouot, Paris, June 14, 1928].
June 27, 1928 Etta	AUGUSTE RENOIR. 1 oil. *Washerwomen.* (ca. 1888). BMA 1950.282.	Bernheim Jeune, Paris. $6,000.
June 28, 1928 Etta	OTHON COUBINE. 1 oil. Probably *Garden in the Village.* BMA 1950.319. ALBERT MARQUET. 1 oil. *Norwegian Landscape near Grimsted.* (1925). BMA 1950.221.	Bernheim Jeune, Paris. 16,000 francs (inclusive with Marquet).
June 1928 Claribel	LOUIS FAVRE. 1 oil. *Interior with Vase of Flowers on Table.* 1928. BMA 1950.326.	Artist, Paris.

August 23, 1928 Claribel	HENRI-EDMOND CROSS. 1 watercolor. Probably *Seascape*. BMA 1950.203.	Paul Vallotton, Lausanne. 140 Swiss francs.
	AIME-JULES DALOU. 1 bronze. *Seated Nude*. (cast after 1907). BMA 1950.412. ALPHONSE LEON QUIZET. 1 oil. *Outskirts of Paris*. BMA 1950.356. AUGUSTE RENOIR. 1 oil. *Mlle. Estable*. (1912). BMA 1950.287.	Paul Vallotton, Lausanne. 16,000 Swiss francs (inclusive with Quizet and Renoir).
	FELIX VALLOTTON. 1 oil. *Still Life with Pitcher and Plate*. (1895). BMA 1950.375.	Paul Vallotton, Lausanne. 3,000 Swiss francs.
August 23, 1928 Etta	ANDRE DERAIN. 1 oil. *In the Studio*. (1919). BMA 1950.208.	Paul Vallotton, Lausanne. 2,000 Swiss francs.
October 17, 1928 Claribel	HENRI MATISSE. 1 oil. *Festival of Flowers*. (1922). BMA 1950.240.	Artist, Paris. 100,000 francs.
October 19, 1928 Etta	MOISE KISLING. 3 oils. *Vase of Peonies with Abstract Background*. 1917. BMA 1950.338. *Vase of Peonies in Interior Setting*. (1917). BMA 1950.339. *Bouquet of Tulips with a Deep Blue Background*. BMA 1950.340.	Charles Girard, Paris. 3,000 francs each.
	CONSTANTIN TERECHKOVITCH. 1 oil. *Landscape at Montreux*. BMA 1950.371.	Charles Girard, Paris. 2,000 francs.
October 22, 1928 Claribel or Etta	AFRICAN. 3 wood objects. Two goblets, probably BMA 1950.388 and BMA 1950.389; and one hen, BMA 1950.85.4.	Au Palais de l'Orient, Paris. 250 francs for three.

1928 [additional items cited on Rancheraye packing lists]:

Claribel	ANDRE BAUCHANT. 3 oils. *Cyclamen*. 1925. BMA 1950.311. *Small Bouquet*. 1927. BMA 1950.313. *Small Bouquet*. 1927. BMA 1950.187.	Galerie Jeanne Bucher, Paris. 1,200, 600, & 750 francs.
Etta	ANDRE BAUCHANT. 3 oils. *Grandfather*. 1927. BMA 1950.312. *Little Landscape*. 1927. BMA 1950.186. *Apollo*. 1928. BMA 1950.188.	Galerie Jeanne Bucher, Paris. 450, 1,300, & 1,800 francs.
Claribel (2 oils & 2 pastels) Etta (3 oils & 1 pastel)	LOUIS FAVRE. 5 oils and 3 pastels. See entry for June 16, 1925, above.	Artist, Paris. 2,850 francs for eight.
Etta	MARIE LAURENCIN. 1 oil and 1 watercolor. Either *Portrait of a Girl*, BMA 1950.216, or *Portrait of a Girl*, BMA 1950.344. *Two Girls*, BMA 1950.345.	Le Portique, Paris. 4,400 francs for two.
Claribel (2 oils & 4 watercolors) Etta (4 watercolors)	BEN SILBERT. 2 oils and 8 watercolors. The Cones befriended the artist in Paris, and Silbert purchases appear with frequency in Cone documentation. Silbert was an active correspondent as he traveled around the world. Among the Silberts accessioned with the Cone bequest are six watercolors and eighteen draw- ings, but no oils.	Artist, Paris. $250 each for the oils; $75 each for watercolors.

Gustave Courbet. *The Shaded Stream at Le Puits Noir*. (ca. 1860–1865).
Oil on canvas. BMA 1950.202.

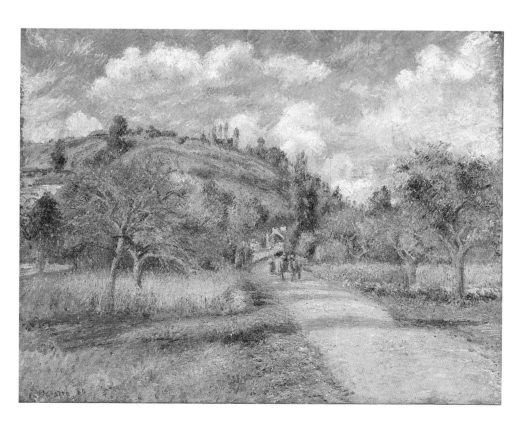

Camille Pissarro. *The Highway ("La Côte de Valhermeil")*. 1880.
Oil on canvas. BMA 1950.280.

February 27, 1929 Etta	ANDRE DERAIN. 1 oil. *Head of a Woman.* (1920). BMA 1950.209. Young Richard Moses was a Cone cousin who spent time with the sisters in Paris. Partly under their influence, he took up private picture dealing. Etta was anxious to lend her support to his fledgling endeavor.	Richard G. Moses, Paris. 36,250 francs ($1,416.47).
August 3, 1929 Claribel	ALBERT MARQUET. 1 oil. *Entrance of the Canal at Hesnes.* (1925). BMA 1950.219. CAMILLE PISSARRO. 1 oil. *The Highway ("La Côte de Valhermeil").* 1880. BMA 1950.280. ALFRED SISLEY. 1 oil. *Poplars on a River Bank.* (1882). BMA 1950.296.	Paul Vallotton, Lausanne. $9,500 (inclusive with Pissarro and Sisley.
September 20, 1929 Claribel	GUSTAVE COURBET. 1 oil. *The Shaded Stream at Le Puits Noir.* (ca. 1860–1865). BMA 1950.202.	Paul Vallotton, Lausanne. 12,000 Swiss francs.
October 25, 1929 Frederic Cone	MAURICE DE VLAMINCK. 1 oil. *Vase with Flowers.* BMA 1950.304. This painting is among a group of several that came to the BMA designated as being from the collection of Fred Cone. During Etta's lifetime there was not always a clear distinction drawn between those objects that belonged to her and those that belonged to younger brother Fred. After Fred's death in 1944, his collection joined those of Claribel and Etta under Etta's custodianship. Etta provided an itemization of which objects in the collections she wished to be cited under Fred's name, without regard, necessarily, for which sibling actually purchased the object in the first place. The Vlaminck is one of the rare instances in which the bill of sale actually carries Fred Cone's name (in most cases, bills were paid by Etta for those items specified by her as being Fred's).	Le Portique, Paris. 17,000 francs.
October 30, 1929 Etta	HENRI MATISSE. 1 bronze. *Head of a Young Girl.* (1906). BMA 1950.426. An envelope annotated in Etta's hand reports "Pd Mme Duthuit 18000 for 2 bronzes of Margot on Wed Oct 30/29 . . . one sent home other to Sally." The *Head of a Young Girl* has been traditionally held to be a portrait of Marguerite (called Margot) Matisse. The odd notation that Etta bought two casts of the sculpture and sent one to "Sally" must indicate that she bought the second cast as a gift for Michael and Sarah Stein.	Artist, Paris. 9,000 francs.
Autumn [?] 1929 Etta [?] or Claribel and Etta	HENRI MATISSE. 2 bronzes. *Head of a Child (Pierre Matisse).* (1905). BMA 1950.425. *Reclining Nude III.* (1929). BMA 1950.437. The Cone sisters often bought duplicates of Matisse sculpture, one for each. Correspondence between Marguerite Duthuit (who handled these sales for her father) and Etta Cone sometimes cites billing for two casts of a given sculpture, occasionally identifying the two numbers in the edition. Oddly, Etta apparently continued this practice of buying duplicate casts even after Claribel's death.	Artist, Paris. 9,000 francs. 30,000 francs.

182

	Only six duplicate Matisse sculptures went to the Weatherspoon; other duplicates suggested in Duthuit correspondence are unaccounted for.	
Autumn [?] 1929 Claribel and Etta [?]	LOUIS FAVRE. 3 oils and 1 pastel. See entry for June 16, 1925, above.	Artist, Paris.
November 4, 1929 Etta	EDGAR DEGAS. 1 bronze. *Fourth Position Front, on the Left Leg.* BMA 1950.413.	Paul Vallotton, Lausanne.
1929–1930 [?] Etta	PABLO PICASSO. 1 oil. *Woman with Bangs.* (1902). BMA 1950.268.	Gertrude Stein, Paris.
March 5, 1930 Etta	ARISTIDE MAILLOL. 1 bronze. *Bather Fixing her Hair.* (1930). BMA 1950.420.	Paul Vallotton, Lausanne. 16,000 Swiss francs.
August 22, 1930 Etta	ARISTIDE MAILLOL. 1 ink/graphite drawing. *Female Nude Standing.* BMA 1950.12.423.	Galerien Thannhauser, Berlin/Lucerne. 569 "R.M."
September 18, 1930 Etta	HENRI MATISSE. 4 bronzes. *Seated Nude with Arms on Head.* (1904). BMA 1950.431. *Head with Necklace.* (1907). BMA 1950.428. *Crouching Venus.* (1918). BMA 1950.435. *Large Seated Nude.* (1923–1925). BMA 1950.436. The Rancheraye packing list for 1930 notes only one of each of the above. But the September billing from Marguerite Duthuit is for two of *Head with Necklace,* at 7,000 francs, and two of *Large Seated Nude,* at 60,000 francs. Neither of these was among the Weatherspoon duplicates.	Artist, Paris. 6,000 francs. 3,500 francs. 6,000 francs. 30,000 francs.
September 22, 1930 Etta	CHARLES DESPIAU. 1 bronze and 1 chalk drawing. *La Bacchante.* (1929). BMA 1950.416. *Seated Nude in Profile.* (1928?). BMA 1950.12.665.	Charles Girard, Paris. 30,000 francs. 2,480 francs.
September 24, 1930 Etta	FELIX VALLOTTON. 4 bronzes. *Nude with Drapery.* BMA 1950.454. *Mother and Child.* BMA 1950.455. *Walking Nude.* BMA 1950.456. *Nude with Vase.* BMA 1950.457.	Paul Vallotton, Lausanne.
December 3, 1930 Etta	EDOUARD MANET. 1 pastel on canvas. *Lady in a Bonnet.* (1881). BMA 1950.217.	Galerien Thannhauser, Berlin/Lucerne. $17,500.
December 14, 1930 Etta	LEON KROLL. 1 oil. *Frenchwoman: Portrait of a Lady from Honfleur.* 1923. BMA 1950.341. Leon Kroll was one of Etta Cone's most sustained correspondents. They wrote and visited with regularity throughout the 1930's, and Etta bought three major canvases by the artist as well as numerous works on paper.	Artist, New York. $1,500.

1930 [additional items cited on Rancheraye packing lists]:

Etta	LOUIS FAVRE. 3 oils and 3 pastels, "fleurs, Paysage, & Femme en rouge; tête, nu, & nu couché."	Artist, Paris. 5,200 francs for three paintings & 1,000 francs for three pastels.
	JEAN GERARD MATISSE. 1 bronze. *Woman Enchained.* (ca. 1930). BMA 1950.442.	Madame Duthuit, Paris. 3,000 francs.

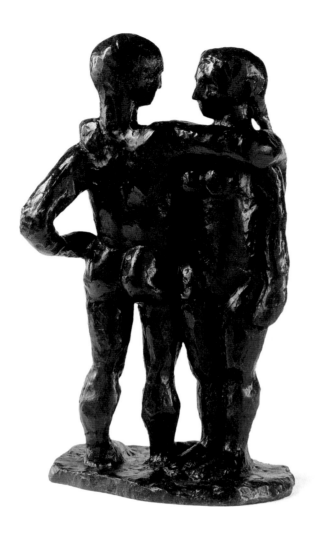

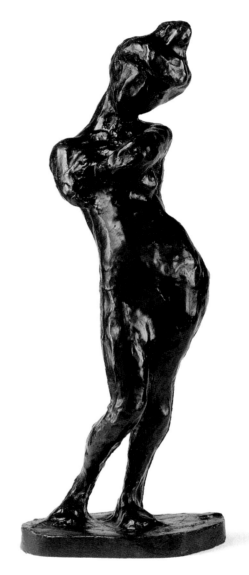

Henri Matisse. *Two Negresses*. (1908).
Bronze. BMA 1950.430.

Henri Matisse. *Madeleine I*. (1901).
Bronze. BMA 1950.423.

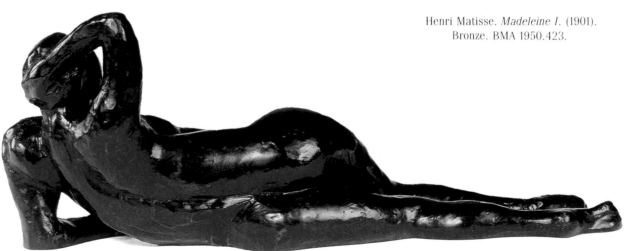

Henri Matisse. *Reclining Nude III*. (1929). Bronze. BMA 1950.437.

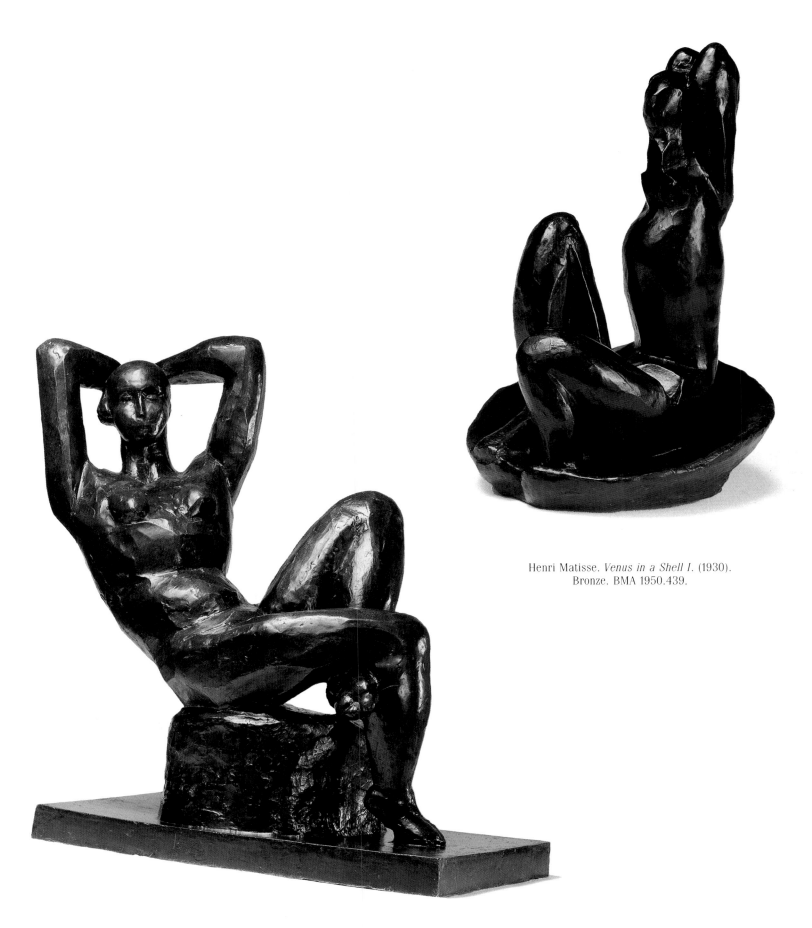

Henri Matisse. *Venus in a Shell I*. (1930).
Bronze. BMA 1950.439.

Henri Matisse. *Large Seated Nude*. (1923–1925). Bronze. BMA 1950.436.

	Pablo Picasso. "14 drawings." It is not known which Picasso drawings were included in this group, nor whether the drawings in fact came from the collection of Michael Stein or, more likely, from Gertrude Stein.	Michael Stein, Vaucresson, Seine-et-Oise, France. 50,000 francs.
February 19, 1931 Etta	Edouard Edy-Legrand. 1 gouache and 2 ink drawings.	Marie Sterner, New York.
	The Thinker. BMA 1950.12.410.	$350.
	Two Reclining Women. BMA 1950.12.409.	$ 35.
	"Laghaout Spahis." BMA 1950. [?].	$ 35.
July 22, 1931 Etta	Louis Favre. 1 oil. *Still Life with Anemones and Art Books.* 1926. BMA 1950.324.	Artist, Paris. 2,300 francs.
July 27, 1931 Etta	Othon Coubine. 2 oils. *Vase of Flowers.* BMA 1950.201. Probably *Landscape with Larkspur.* BMA 1950.320.	Galerie Sèvres, Paris. 4,000 francs each.
	Berthe Morisot. 1 pastel on paper. *Portrait of a Child in a Hat.* (1883). BMA 1950.266.	Galerie Dru, Paris. 13,250 francs.
	Walter Pach. 1 watercolor. *Fox.* 1931. BMA 1950.355.	Galerie Dru, Paris. 6,750 francs.
1931 [?] Etta	Mary Cassatt. 1 watercolor and 1 crayon/pencil drawing. *Augusta's Daughter and a Friend Seated near a River Bank.* (1910). BMA 1950.194. *Portrait Head of a Lady.* BMA 1950.12.669.	"Mathilde X Sale," Paris.
1931 [additional items cited on Rancheraye packing lists]:		
Etta	Jean Gerard Matisse. 2 bronzes. *Reclining Ballet Dancer.* (ca. 1930). BMA 1950.441.	Madame Duthuit, Paris. 1,200 francs.
	Small Crouching Nude. (ca. 1930). BMA 1950.440.	1,200 francs.
	Henri Matisse. 3 bronzes. *Two Negresses.* (1908). BMA 1950.430. *Tiari (with Necklace).* (1930). BMA 1950.438. *Venus in a Shell I.* (1930). BMA 1950.439. See entry for September 18, 1930, above. Again, the Rancheraye packing list cites only one of each of the above Matisse bronzes; but an undated billing from Marguerite Matisse, in the Cone Archives, specifies two of each of these three sculptures, at double the single object value. Since the *Tiari (with Necklace)* is unique, if Etta in fact bought two of this sculpture, her second cast was the version without a necklace.	Artist, Paris. 12,000 francs. 10,000 francs. 6,000 francs.
July 2, 1932 Etta	Emile Othon Friesz. 1 oil. *Honfleur.* 1930. BMA 1950.211.	Artist, Paris.
September 1, 1932 Etta	Edgar Degas. 1 pastel on paper. *After the Bath.* (1899). BMA 1950.206. Auguste Renoir and Richard Guino. 1 bronze. *Small Stooping Washerwoman.* (1916). BMA 1950.445.	Galerien Thannhauser, Lucerne. [ex-coll. Ambroise Vollard]. 5,000 Swiss francs (inclusive with Renoir).
September 14, 1932 Etta	Pablo Picasso. 1 gouache. *Leo Stein.* (1906). BMA 1950.276.	Gertrude Stein, Paris. [Gift from Picasso to Leo Stein, ca. 1906].
Summer–Fall 1932 Etta	Henri Matisse. 1 oil. *The Yellow Dress.* 1929–1931. BMA 1950.256.	Madame Duthuit, Paris. 200,000 francs [?].

Edgar Degas. *After the Bath*. (1899). Charcoal and pastel on paper. BMA 1950.206.

March 1933 Etta	HENRI MATISSE. Ensemble of drawings, prints, and copper plates for the illustrated book, *Poésies de Stéphane Mallarmé,* comprising 250 items.	Madame Duthuit, Paris. 140,000 francs.
September 13, 1933 Etta	HENRI MATISSE. 1 pencil drawing. *The Plumed Hat.* (1919). BMA 1950.12.58.	Pierre Matisse, New York. 12,500 francs.
May 5, 1934 Etta	LEON KROLL. 1 oil. *Landscape—Two Rivers.* (1917). BMA 1950.343.	Artist, New York. $2,000.
May 12, 1934 Etta	WILLIAM ZORACH. 1 marble. *Hilda.* 1932. BMA 1950.404.	Artist, New York. $1,200.
July 5, 1934 Etta	OTHON COUBINE. 1 bronze, 1 watercolor, and 1 pencil drawing. *Woman with Mirror.* (1933). BMA 1950.411. *Portrait of a Woman.* BMA 1950.12.394. *Nude Female.* BMA 1950.12.411.	Galerie Sèvres, Paris. 2,500 francs for three.
July 1934 Etta	HENRI MATISSE. 10 drawings, all dating between 1931 and 1934, in pencil, crayon, or charcoal. *Dr. Claribel Cone.* 4 drawings, BMA 1950.12.65, BMA 1950.12.66, BMA 1950.12.72, and BMA 1950.12.71. *Etta Cone.* 6 drawings, BMA 1950.12.63, BMA 1950.12.64, BMA 1950.12.67, BMA 1950.12.68, BMA 1950.12.69, and BMA 1950.12.70. See present text for discussion of Etta Cone's commission of Matisse to do a memorial portrait drawing of Claribel. The finished drawings of both sisters appeared in the Cone memorial volume published in 1934, along with reproduction of all of the studies. Correspondence from Marguerite Duthuit to Etta Cone seems to suggest that the artist wanted Etta to have all ten drawings (four of Claribel and six of Etta) as a gift.	Artist, Paris. Gift [?]. Shipped at valuation of 40,000 francs for ten.
August 10, 1934 Etta	EDGAR DEGAS. 1 bronze. *Draught Horse.* BMA 1950.414.	Galerie Rosengart, Lucerne. $100.
	HENRI MATISSE. 1 crayon drawing. *Nude Male Model Seated on a Stool.* (ca. 1898?). BMA 1950.12.53.	Galerie Rosengart, Lucerne. $100.
	VINCENT VAN GOGH. 1 oil. *Landscape with Figures.* (1889). BMA 1950.303.	Galerie Rosengart, Lucerne. $9,900.
Summer–Fall 1934 Etta	HENRI MATISSE. 1 oil. *Interior with Dog.* 1934. BMA 1950.257.	Artist, Paris. 75,000 francs [?].
October 2, 1934 Etta	GIORGIO DE CHIRICO. 1 crayon drawing. *Horses.* BMA 1950.12.660.	Quatre Chemins, Paris. 600 francs.
	ANDRE DERAIN. 1 pencil drawing. *Reclining Nude.* BMA 1950.12.662.	Quatre Chemins, Paris. 1,500 francs.
	PABLO PICASSO. 2 drawings. "Tête," possibly *Head of a Young Man (Self-Portrait).* (1906). BMA 1950.12.485. "Personnage." BMA 1950.12.[?].	Quatre Chemins, Paris. 1,500 francs. 2,000 francs.
October 4, 1934 Etta	EMILE OTHON FRIESZ. 1 oil. *St. Mâlo.* 1934. BMA 1950.212. Although Etta Cone paid the bill for this painting, it was among the group later designated by Etta as being from the collection of Fred Cone.	Artist, Paris. 6,000 francs.

Date / Buyer	Artwork	Source / Price
July 25, 1935 Etta	HENRI MATISSE. 1 oil. *The Blue Eyes.* 1935. BMA 1950.259.	Madame Duthuit, Paris. 25,000 francs.
April 3, 1936 Etta	HENRI MATISSE. 1 pencil drawing. *Veiled Head.* 1932. BMA 1950.12.40.	Pierre Matisse, New York. $350.
August 5, 1936 Etta	GEORGES BRAQUE. 1 oil. *Still Life with Lemons.* 1928. BMA 1950.192.	Galerie Rosengart, Lucerne.
	EDOUARD MANET. 1 ink drawing. *Henri Vigneau.* BMA 1950.12.654.	Galerie Rosengart, Lucerne. [ex-coll. Edgar Degas].
	AUGUSTE RENOIR and RICHARD GUINO. 1 bronze. *Mother and Child.* (1916). BMA 1950.446.	Galerien Thannhauser, Lucerne. $1,000.
	HENRI ROUSSEAU. 1 oil. *View of the Quai d'Ivry, near the Port à l'Anglais, Seine (Family Fishing).* 1900. BMA 1950.294.	Galerie Rosengart, Lucerne.
	PABLO PICASSO. 1 ink drawing. *Three Dancers.* 1925. BMA 1950.12.493.	Galerie Rosengart, Lucerne.
	THEOPHILE STEINLEN. 1 crayon drawing. *Figure Study ("J'ai fait sauter la banque").* (1893). BMA 1950.12.420.	Galerie Rosengart, Lucerne.
	HENRI DE TOULOUSE-LAUTREC. 1 ink drawing. *Musketeer.* 1881. BMA 1950.12.656.	Galerie Rosengart, Lucerne.
	VINCENT VAN GOGH. 1 watercolor/gouache. *Beach at Scheveningen.* (1883). BMA 1950.301.	Galerie Rosengart, Lucerne.
August 10, 1936 Etta	HENRI MATISSE. 1 pencil drawing. *Mlle. Vignier.* BMA 1950.12.39.	Paul Vallotton, Lausanne. 325 Swiss francs.
August 24, 1936 Etta	GIORGIO DE CHIRICO. 3 gouaches. *Horse and Bather.* BMA 1950.198. *Horses by the Sea.* BMA 1950.199. A third gouache, titled "Two Horses and Bathers" on the bill of sale, was not among the Cone bequest materials.	Paul Rosenberg, Paris. 500 francs each.
	PABLO PICASSO. 1 gouache, "Nu." Possibly *Study for Nude with Drapery.* (1907). BMA 1950.278.	Paul Rosenberg, Paris. 9,000 francs. [ex-coll. Gertrude Stein].
Summer–Fall 1936 Etta	HENRI MATISSE. 1 oil. *Large Reclining Nude* ("The Pink Nude"). 1935. BMA 1950.258.	Artist, Paris. 90,000 francs.
	HENRI MATISSE. 6 drawings and 2 etchings. *Portrait of a Young Girl.* (1919). Pencil. BMA 1950.12.41. *Study for Interior with Dog.* (1934); inscribed with dedi- cation to Etta Cone, 1936. Pencil. BMA 1950.12.42. *Study for Large Reclining Nude.* 1935. Charcoal. BMA 1950.12.47. *Study for The Blue Eyes.* (1935)/1936. Pencil. BMA 1950.12.49. *Resting Woman in Tiara.* 1936. Ink. BMA 1950.12.130. "Icone." Ink. BMA 1950.12.[?]. *Dancing Figures.* (1935). Color etching. BMA 1950.12.940. "Gold Hair." Etching. BMA 1950.12.[?].	Artist, Paris. 1,600 francs. 1,600 francs. 3,000 francs. 5,000 francs. 2,500 francs. 4,000 francs. 1,200 francs. 1,200 francs.

	Jean Gerard Matisse. 1 marble relief. *Seated Nude.* (ca. 1935). BMA 1950.443.	Artist, Paris. 1,500 francs.
April 2, 1937 Etta	Eugene Delacroix. 1 oil. *Perseus and Andromeda.* (1847). BMA 1950.207.	Howard S. Gans, New York. [ex-coll. Leo Stein].
June 29, 1937 Etta	Andre Derain. 1 oil. *Landscape, Southern France.* (ca. 1930–1932). BMA 1950.210.	Galerie Rosengart, Lucerne. 26,000 Swiss francs.
	J-A-D. Ingres. 1 pencil drawing. *Study for Vénus à Paphos.* (ca. 1852). BMA 1950.12.661.	Galerie Rosengart, Lucerne. 20,000 Swiss francs.
June 1937 [?] Etta	Georges Seurat. 1 conté crayon drawing. *Two Men Walking in a Field.* (ca. 1882–1884). BMA 1950.12.664.	Unknown.
July 22, 1937 Etta	Henri Matisse. 1 drawing. Unidentified, BMA 1950.12.[?].	Paul Rosenberg, Paris. 3,000 francs.
August 6, 1937 Etta	Henri Matisse. 1 oil. *Purple Robe and Anemones.* 1937. BMA 1950.261.	Paul Rosenberg, Paris. $4,500.
August 19, 1937 Etta	Edgar Degas. 1 bronze. *Dancer Looking at the Sole of her Right Foot.* BMA 1950.415.	Galerie Rosengart, Lucerne. $1,080.
	Paul Gauguin. 1 oil. *Vahine no te Vi (Woman with Mango).* 1892. BMA 1950.213.	Galerie Rosengart, Lucerne. $15,000. [ex-coll. Edgar Degas].
	Henri Matisse. 1 oil. *Odalisque with Green Sash.* (1927). BMA 1950.253.	Galerie Rosengart, Lucerne. $2,000.
	Henri Matisse. 5 drawings.	Galerie Rosengart, Lucerne.
	Reclining Woman. (1926). Charcoal. BMA 1950.12.52. *Odalisque with Checkerboard.* (1928). Ink. BMA 1950.12.46. *Girl with Aquarium.* (1931). Pencil. BMA 1950.12.38. *Seated Odalisque and Sketch.* (1931). Pencil. BMA 1950.12.44. *The Rumanian Blouse.* 1937. Ink. BMA 1950.12.57.	900 Swiss francs. 600 Swiss francs. 400 Swiss francs. 400 Swiss francs. 900 Swiss francs.
	Pablo Picasso. 1 watercolor/pastel on paper. *Seated Saltimbanque with Boy (Study for Family of Saltimbanques).* (1905). BMA 1950.270.	Galerie Rosengart, Lucerne. $1,800.
August 1937 [?] Etta	Henri Matisse. 1 charcoal drawing. *Self-Portrait.* 1937. BMA 1950.12.61.	Artist, Paris.
November [?] 1937 Etta	Ernest Fiene. 1 oil. *Goldenrod Flowers.* (1937). BMA 1950.330.	Artist, New York.
August 18, 1938 Etta	Amedeo Modigliani. 1 pastel on paper. *Seated Nude.* (ca. 1909–1914). BMA 1950.12.43.	Galerie Rosengart, Lucerne. 1,450 Swiss francs.
August 31, 1938 Etta	Henri Matisse. 1 oil. *Small Rumanian Blouse with Foliage.* (1937; incorrectly dated 1938). BMA 1950.262.	Paul Rosenberg, Paris. $1,800.
September 8, 1938 Etta	Paul Cezanne. 1 pencil drawing. *The Poplar.* (ca. 1879–1882). BMA 1950.12.667.	Quatre Chemins, Paris. 4,000 francs.

Georges Seurat. *Two Men Walking in a Field*. (ca. 1882–1884). Black conté crayon on paper. BMA 1950.12.664.

Pablo Picasso. *Mother and Child*. 1922. Oil on canvas. BMA 1950.279.

November 4, 1938 Etta	HENRI DE TOULOUSE-LAUTREC. 1 ink drawing. *Old Woman Carrying Fagots.* (ca. 1896). BMA 1950.12.676.	Quatre Chemins, Paris. 3,500 francs.
December 15, 1938 Etta	HENRI MATISSE. 1 oil. *The Embroidered Dark Blouse (Woman in Red Chair).* 1936. BMA 1950.260.	Paul Rosenberg, Paris. $1,100.
	GEORGES ROUAULT. 1 oil. *Two Clowns.* BMA 1950.292.	Paul Rosenberg, Paris. $1,000.
August 16, 1939 Etta	PABLO PICASSO. 1 oil. *Mother and Child.* 1922. BMA 1950.279.	Galerie Rosengart, Lucerne. $8,500.
November 12, 1940 Etta	HENRI MATISSE. 1 oil. *Striped Robe, Fruit, and Anemones.* 1940. BMA 1950.263.	Pierre Matisse, New York. $3,600.
November 29, 1940 Etta	GEORGES ROUAULT. 1 oil. *Two Female Circus Riders.* (ca. 1933). BMA 1950.293.	Pierre Matisse, New York. $2,000.
December 17, 1940 Etta	PABLO PICASSO. 1 bronze, 1 pencil drawing, and 1 ink drawing. *Woman Combing her Hair.* (1905). BMA 1950.452. *Women at Seashore.* (1920). BMA 1950.12.498. *Bathers at Seashore.* (1920). BMA 1950.12.500.	Buchholz Gallery, New York. $810. [ex- coll. Ambroise Vollard]. $211.50. $234.
March 20, 1941 Etta	WILLIAM ZORACH. 1 bronze. *Ellen.* 1941. BMA 1950.403. This was a cast from a commissioned portrait of Cone niece Ellen Berney Hirschland.	Artist, New York. $250.
November 5, 1941 Etta	ANDRE MASSON. 1 ink drawing. *The Donkey and the Flower.* (1941). BMA 1950.12.433.	Buchholz Gallery, New York. $100.
November 29, 1941 Etta	AUGUSTE RENOIR and RICHARD GUINO. 1 bronze. *Small Standing Venus.* (1913). BMA 1950.444.	Buchholz Gallery, New York.
January 16, 1942 Etta	HENRI MATISSE. 1 oil. *Seated Odalisque, Left Leg Bent.* (1926). BMA 1950.251.	Pierre Matisse, New York. $5,300.
March 9, 1942 Etta	MARY CASSATT. 1 pastel on paper. *In the Garden.* (1893). BMA 1950.193.	Durand-Ruel, Paris. $3,000.
October 5, 1942 Etta	LEON KROLL. 1 oil. *Adolescence.* (1941). BMA 1950.342.	Artist, New York. $3,500.
November 25, 1942 Etta	WILLIAM ZORACH. 1 drawing. *Margaret Zorach.* (1936). BMA 1950.12.366.	Artist, New York. $100.
by December 1, 1942 Etta	ANDRE MASSON. 1 oil. *Tauromachie.* (1937). BMA 1950.349.	Unknown.
October 14, 1943 Etta	HENRI MATISSE. 1 oil. *The Pierced Rock.* (1920). BMA 1950.234.	M. Knoedler, New York. $2,000.
October 1943 Etta	WILLIAM ZORACH. 1 marble and 1 bronze. *Etta Cone.* 1943. BMA 1950.400. *Etta Cone.* 1943. BMA 1950.401. This was a portrait commission, with Etta retaining the marble and one cast from the bronze edition.	Artist, Brooklyn. $2,500 (inclusive).
November 1943 Etta	ARISTIDE MAILLOL. 1 bronze relief. *Seated Nude.* (ca. 1920). BMA 1950.421.	Buchholz Gallery, New York.
December 8, 1943 Etta	WILLIAM ZORACH. 2 bronzes. *Seated Nude.* BMA 1950.402. *Mother and Child.* 1928. BMA 1950.399.	Artist, Brooklyn. $250. $750.

September 18, 1944 Etta	JOHN MARIN. 1 watercolor. *Rocks and Sea, Maine (Deer Isle)*. 1919. BMA 1950.218.	An American Place (Alfred Stieglitz), New York.
October 26, 1944 Etta	MARC CHAGALL. 1 gouache. *Fruit Vendor*. (1942). BMA 1950.197.	Pierre Matisse, New York. $650.
May 25, 1946 Etta	AUGUSTE RENOIR. 1 watercolor. *Washerwomen*. (ca. 1888). BMA 1950.283.	Fine Arts Associates, New York. $800.
November 2, 1946 Etta	CHARLES DESPIAU. 1 bronze. *Head of a Young Girl ("Dede")*. (1923). BMA 1950.417. PABLO PICASSO. 1 pencil drawing. *Dancers*. (1925). BMA 1950.12.507.	Buchholz Gallery, New York. $1,300 (inclusive with Picasso).
December 17, 1947 Etta	CAMILLE COROT. 1 oil. *The Artist's Studio*. (1865–1870). BMA 1950.200.	Paul Rosenberg, New York. $15,000.
January 24, 1948 Etta	HENRI MATISSE. 1 illustrated book. *Jazz*. 1947. BMA 1950.12.745.	Pierre Berès, New York. $375.
April 12, 1948 Etta	JACQUES LIPCHITZ. 1 bronze. *Gertrude Stein*. (1920). BMA 1950.396.	Buchholz Gallery, New York. $1,200.
August 25, 1948 Etta	HENRI MATISSE. 1 oil. *Ballet Dancer Seated on a Stool*. (1927). BMA 1950.254.	Artist, Paris, through Pierre Matisse, New York. $15,000.
March 8, 1949 Etta	HENRI MATISSE. 1 oil. *Two Girls, Red and Green Background*. 1947. BMA 1950.264.	Pierre Matisse, New York. $6,500.
April 4, 1949 Etta	HENRI MATISSE. 1 illustrated book. *Florilège des Amours de Ronsard*. 1948. BMA 1950.12.743.	Buchholz Gallery, New York. $585.
Spring 1949 Etta	ELIE NADELMAN. 1 bronze. *Seated Female Nude*. (1908). BMA 1950.397.	Viola M. Nadelman, New York. $500.
August 1949 Etta	PABLO PICASSO. 1 gouache. *Allan Stein*. (1906). BMA 1950.275.	Allan Stein, Palo Alto, California.

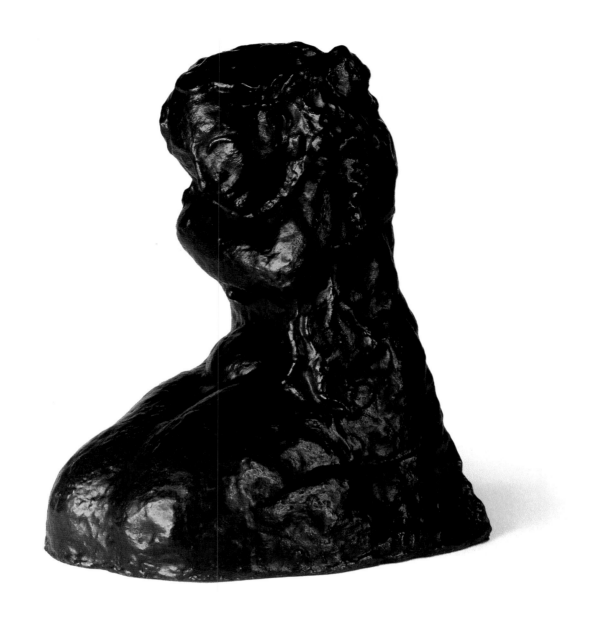

Pablo Picasso. *Woman Combing her Hair*. (1906). Bronze. BMA 1950.452.

Henri Matisse. *Self-Portrait*. 1937. Charcoal and estompe on paper. BMA 1950.12.61.

Appendix:

Matisse Painting and Sculpture in the Cone Collection

The following is a complete listing of the paintings and sculpture by Henri Matisse in The Cone Collection of The Baltimore Museum of Art. Titles of paintings are cited in English and French (see "Matisse Titles/Dates" in the introduction to the Annotated Chronology of the present volume). Sculpture titles are cited only in English. Dates which appear on works are cited without parentheses; ascribed dates, based on either documentary or stylistic evidence, appear in parentheses. Dimensions are given in inches and centimeters, height preceding width preceding depth. In the case of sculpture, the cast and edition numbers appear with the medium. The Baltimore Museum accession number is cited at the end of the entry. Pages of illustration refer to the present volume. Works are cited in chronological order and, within each year, in alphabetical order by title.

Paintings

THE DAM AT PONT NEUF
Le barrage du Pont Neuf
1896, oil on canvas
11 ½ x 14 ⅝ in. (29.2 x 37.2 cm.)
BMA 1950.223

STILL LIFE WITH PEACHES
Nature morte aux pêches
1898(?), oil on canvas
17 ¹⁵/₁₆ x 13 ¼ in. (45.6 x 33.7 cm.)
BMA 1950.222

THE SICK WOMAN
La malade
(1899), oil on canvas
18 ⁵/₁₆ x 15 ⅛ in. (46.5 x 38.4 cm.)
BMA 1950.225

STILL LIFE, COMPOTE, APPLES, AND ORANGES
Nature morte, compotier, pommes et oranges
(1899), oil on canvas
18 ¼ x 21 ⅞ in. (46.4 x 55.6 cm.)
BMA 1950.224

YELLOW POTTERY FROM PROVENCE
Poterie jaune de Provence
(1906), oil on canvas
21 ⅞ x 18 ⅜ in. (55.6 x 46.7 cm.)
BMA 1950.227
[Ill. p. 166]

BLUE NUDE ("SOUVENIR DE BISKRA")
Nu bleu ("Souvenir de Biskra")
(1907), oil on canvas
36 ¼ x 55 ¼ in. (92.1 x 140.4 cm.)
BMA 1950.228
[Ill. p. 114]

WOMAN IN TURBAN (LORETTE)
Femme au turban (Lorette)
(early 1917), oil on canvas
32 x 25 ¾ in. (81.3 x 65.4 cm.)
BMA 1950.229
[Ill. p. 105]

THE PEWTER JUG
Le pot d'étain
(1917), oil on canvas
36 ¼ x 25 ⅝ in. (92.1 x 65.1 cm.)
BMA 1950.230
[Ill. p. 162]

EUCALYPTUS, MONTALBAN
Les eucalyptus, Montalban
(1918), oil on canvas board
12 ⅞ x 16 ¹/₁₆ in. (32.7 x 40.8 cm.)
BMA 1950.231

THE MAINTENON VIADUCT
Le viaduc de Maintenon
(1918), oil on canvas board
13 x 16 ¹/₁₆ in. (33 x 40.8 cm.)
BMA 1950.232

NUDE WITH SPANISH COMB, SEATED IN FRONT OF A CURTAINED WINDOW
Nu au peigne espagnol, assis devant la fênetre à voilages
(1919), oil on canvas
28 ¹³/₁₆ x 23 ¾ in. (73.2 x 60.4 cm.)
BMA 1950.237

ETRETAT, THE BEACH
Etretat, La plage
(1920), oil on canvas board
14 ¹⁵/₁₆ x 18 in. (38 x 45.7 cm.)
BMA 1950.235

LARGE CLIFF—FISH
Grand falaise—Les poissons
(1920), oil on canvas
36 ⅝ x 29 in. (93.1 x 73.7 cm.)
BMA 1950.233
[Ill. p. 174]

THE PIERCED ROCK
La roche percée
(1920), oil on canvas board
14 ¹⁵/₁₆ x 18 in. (38 x 45.7 cm.)
BMA 1950.234

THE MUSIC LESSON, TWO WOMEN SEATED ON A DIVAN
La leçon de musique, deux femmes assises sur un divan
(1921), oil on canvas
21 ⁹/₁₆ x 25 ¾ in. (54.8 x 65.4 cm.)
BMA 1950.242

STANDING GIRL, GREEN DRESS, WHITE SHAWL
Jeune fille debout, robe verte, châle blanc
(1921), oil on canvas
24 ¼ x 19 ¹³⁄₁₆ in. (61.6 x 50.3 cm.)
BMA 1950.236

VIOLINIST AND YOUNG GIRL ("DIVERTISSEMENT")
Violoniste et fillette ("Divertissement")
(1921), oil on canvas
20 x 25 ¾ in. (50.8 x 65.4 cm.)
BMA 1950.243

YOUNG WOMAN AT THE WINDOW, SUNSET
Jeune femme à la fenêtre, soleil couchant
(1921), oil on canvas
20 ⅝ x 23 ¾ in. (52.4 x 60.3 cm.)
BMA 1950.245

WOMAN IN STRIPED PULLOVER, VIOLIN ON THE TABLE
Femme au pull-over rayé, violon sur la table
(late 1921–early 1922), oil on canvas
28 ⅞ x 23 ⅞ in. (73.4 x 60.7 cm.)
BMA 1950.241

ANEMONES AND CHINESE VASE
Anémones et vase chinois
(1922), oil on canvas
24 x 36 ⅜ in. (61 x 92.4 cm.)
BMA 1950.248
[Ill. p. 172]

THE BROWN DRESS
La robe tête de nègre
(1922), oil on canvas
18 ⅛ x 15 ⅜ in. (46.1 x 39.1 cm.)
BMA 1950.244

FESTIVAL OF FLOWERS
Fête des Fleurs
(1922), oil on canvas
25 ⅞ x 36 ⅝ in. (65.8 x 93.1 cm.)
BMA 1950.240
[Ill. p. 20]

GIRL READING, VASE OF FLOWERS
La liseuse, vase de fleurs
(1922), oil on canvas
15 ⅛ x 18 ¼ in. (38.4 x 46.4 cm.)
BMA 1950.246

STANDING ODALISQUE, TAMBOURINE IN HER RIGHT HAND
Odalisque debout, tambourin dans la main droite
(1922), oil on canvas
22 x 15 ⅛ in. (55.9 x 38.4 cm.)
BMA 1950.247

TWO WOMEN IN A LANDSCAPE, VALLÉE DU LOUP
Deux femmes dans un paysage, Vallée du Loup
Formerly called "Rest in the Country"
(1922), oil on canvas
15 ⅛ x 18 ³⁄₁₆ in. (38.4 x 46.2 cm.)
BMA 1950.238

STANDING ODALISQUE REFLECTED IN A MIRROR
Odalisque debout reflétée dans la glace
(1923), oil on canvas
31 ⅞ x 21 ⅜ in. (81 x 54.3 cm.)
BMA 1950.250
[Ill. p. 154]

STILL LIFE, BOUQUET OF DAHLIAS AND WHITE BOOK
Nature morte, bouquet de dahlias et livre blanc
(1923), oil on canvas
19 ¾ x 24 in. (50.2 x 61 cm.)
BMA 1950.249
[Ill. p. 172]

PAINTER IN THE OLIVE GROVE
Peintre dans les oliviers
(1923–early 1924), oil on canvas
23 ¾ x 28 ⅞ in. (60.3 x 73.4 cm.)
BMA 1950.239
[Ill. p. 113]

INTERIOR, FLOWERS AND PARAKEETS
Intérieur, fleurs et perruches
(1924), oil on canvas
46 x 28 ⅝ in. (116.9 x 72.7 cm.)
BMA 1950.252
[Ill. p. 44]

SEATED ODALISQUE, LEFT LEG BENT
Odalisque assise, jambe gauche repliée
(1926), oil on canvas
25 ¾ x 18 ⅛ in. (65.4 x 46.1 cm.)
BMA 1950.251

BALLET DANCER SEATED ON A STOOL
Danseuse assise sur un tabouret
(1927), oil on canvas
32 ⅛ x 23 ⅞ in. (81.6 x 60.7 cm.)
BMA 1950.254

ODALISQUE WITH GREEN SASH
Odalisque à la ceinture verte
(1927), oil on canvas
20 x 25 ½ in. (50.8 x 64.8 cm.)
BMA 1950.253

SEATED ODALISQUE, LEFT KNEE BENT,
ORNAMENTAL BACKGROUND AND CHECKERBOARD
Odalisque assise, genou gauche replié, fond ornamental et damier
(1928), oil on canvas
21 ⅝ x 14 ⅞ in. (55 x 37.8 cm.)
BMA 1950.255
[Ill. p. 4]

THE YELLOW DRESS
La robe tilleul
1929–1931, oil on canvas
39 ¼ x 31 ¾ in. (99.7 x 80.7 cm.)
BMA 1950.256
[Ill. p. 141]

INTERIOR WITH DOG
L'intérieur au chien
Formerly called "The Magnolia Branch"
1934, oil on canvas
61 x 65 ¾ in. (155 x 167 cm.)
BMA 1950.257
[Ill. p. 128 and detail on cover]

THE BLUE EYES
Les yeux bleus
1935, oil on canvas
15 x 18 in. (38.1 x 45.7 cm.)
BMA 1950.259
[Ill. p. 132]

LARGE RECLINING NUDE
Grand nu couché
Formerly called "The Pink Nude"
1935, oil on canvas
26 x 36 ½ in. (66 x 92.7 cm.)
BMA 1950.258
[Ill. p. 135]

THE EMBROIDERED DARK BLOUSE (WOMAN IN RED CHAIR)
La blouse noire brodée (La femme à la chaise rouge)
1936, oil on canvas
13 ⅞ x 9 ½ in. (35.3 x 24.1 cm.)
BMA 1950.260

PURPLE ROBE AND ANEMONES
Robe violette et anémones
1937, oil on canvas
28 ¾ x 23 ¾ in. (73.1 x 60.3 cm.)
BMA 1950.261
[Ill. p. 95]

SMALL RUMANIAN BLOUSE WITH FOLIAGE
Petite blouse roumaine au feuillage
Formerly called "Woman with Philodendron"
(1937); incorrectly dated 1938, oil on canvas
18 ⅛ x 15 in. (46.1 x 38.1 cm.)
BMA 1950.262
[Ill. p. 148]

STRIPED ROBE, FRUIT, AND ANEMONES
Robe rayée, fruit et anémones
1940, oil on canvas
21 ⅜ x 25 ½ in. (54.3 x 64.8 cm.)
BMA 1950.263
[Ill. p. 146]

TWO GIRLS, RED AND GREEN BACKGROUND
Deux fillettes, fond rouge et vert
1947, oil on canvas
22 ⅛ x 18 ¼ in. (56.2 x 46.4 cm.)
BMA 1950.264

Sculpture

THE SERF
(1900–1903), bronze; cast 2/10
36 ⅛ x 11 ¼ x 13 ¹⁄₁₆ in. (91.8 x 28.6 x 33.2 cm.)
BMA 1950.422

MADELEINE I
(1901), bronze; cast 3/10
23 ¼ x 8 ¾ x 7 ⅛ in. (59.1 x 22.2 x 18.1 cm.)
BMA 1950.423
[Ill. p. 184]

SEATED NUDE WITH ARMS ON HEAD
(1904), bronze; cast 2/10
13 ¾ x 6 ⅜ x 7 ⅛ in. (34.9 x 16.2 x 18.1 cm.)
BMA 1950.431

HEAD OF A CHILD (PIERRE MATISSE)
(1905), bronze; cast 6/10
6 ⁷⁄₁₆ x 4 ⁵⁄₁₆ x 4 ⅝ in. (16.4 x 11 x 11.8 cm.)
BMA 1950.425

WOMAN LEANING ON HER HANDS
(1905), bronze; cast 5/10
4 ⅞ x 9 ⅜ x 6 ⅜ in. (12.4 x 23.8 x 16.2 cm.)
BMA 1950.424

HEAD OF A YOUNG GIRL
(1906), bronze; cast 5/10
6 ⁵⁄₁₆ x 6 ¾ x 5 ¾ in. (16 x 17.2 x 14.6 cm.)
BMA 1950.426

HEAD WITH NECKLACE
(1907), bronze; cast 8/10
5 ¹⁵⁄₁₆ x 5 ⅛ x 4 ⅜ in. (15.1 x 13 x 11.1 cm.)
BMA 1950.428

RECLINING NUDE I (AURORE)
(1907), bronze; cast 6/10
13 ⁹⁄₁₆ x 19 ⅝ x 11 in. (34.5 x 49.9 x 28 cm.)
BMA 1950.429
[Ill. p. 116]

SMALL HEAD WITH COMB
(1907), bronze; cast 6/10
3 ¹⁄₁₆ x 2 ³⁄₁₆ x 2 ½ in. (7.8 x 5.6 x 6.4 cm.)
BMA 1950.427

SMALL CROUCHING NUDE WITHOUT AN ARM
(1908), bronze; cast 6/10
5 x 2 ⅝ x 3 ⅝ in. (12.7 x 6.7 x 9.2 cm.)
BMA 1950.432

TWO NEGRESSES
(1908), bronze; cast 4/10
18 ⅜ x 9 ¾ x 8 in. (46.7 x 24.8 x 20.3 cm.)
BMA 1950.430
[Ill. p. 184]

CROUCHING VENUS
(1918), bronze; cast 6/10
10 ⅜ x 9 ⁷⁄₁₆ x 5 ⅝ in. (26.4 x 24 x 14.3 cm.)
BMA 1950.435

FIGURE WITH CUSHION
(1918), bronze; cast 2/10
5 ¼ x 10 ½ x 4 ⅛ in. (13.3 x 26.7 x 10.5 cm.)
BMA 1950.433

SEATED NUDE CLASPING HER RIGHT LEG
(1918), bronze; cast 6/10
9 x 8 ⅝ x 6 in. (22.9 x 21.9 x 15.2 cm.)
BMA 1950.434

LARGE SEATED NUDE
(1923–1925), bronze; cast 7/10
30 ¹³⁄₁₆ x 31 ⅝ x 14 in. (78.3 x 80.4 x 35.6 cm.)
BMA 1950.436
[Ill. p. 185]

RECLINING NUDE III
(1929), bronze; cast 5/10
7 ⅜ x 18 ½ x 5 ¹³⁄₁₆ in. (18.7 x 47 x 14.8 cm.)
BMA 1950.437
[Ill. pp. 116 and 184]

TIARI (WITH NECKLACE)
(1930), bronze, with gold chain; cast 1/10
8 x 5 ⅝ x 7 ⅝ in. (20.3 x 14.3 x 19.4 cm.)
BMA 1950.438
[Ill. p. 118]

VENUS IN A SHELL I
(1930), bronze; cast 3/10
12 ¹⁄₁₆ x 7 x 8 in. (30.7 x 17.8 x 20.3 cm.)
BMA 1950.439
[Ill. p. 185]

List of Illustrations

All works are from The Cone Collection or the Cone Archives of The Baltimore Museum of Art unless otherwise noted.

Archival

Works of Art

AFRICAN, ZAIRE, KONGO
Cup, (late 19th century)
Wood
7 3/8 x 3 1/2 in. (18.7 x 9 cm.)
BMA 1950.388
[Ill. p. 11]

PAUL CÉZANNE
French, 1839–1906
Mont Sainte-Victoire Seen from the Bibémus Quarry, (ca. 1897)
Oil on canvas
25 1/8 x 31 1/2 in. (65.1 x 80 cm.)
BMA 1950.196
[Ill. p. 111]

GUSTAVE COURBET
French, 1819–1877
The Shaded Stream at Le Puits Noir, (ca. 1860–1865)
Oil on canvas
25 1/4 x 31 1/8 in. (64.2 x 79.1 cm.)
BMA 1950.202
[Ill. p. 181]

EDGAR DEGAS
French, 1834–1917
After the Bath, (1899)
Charcoal and pastel on paper
12 7/8 x 10 11/16 in. (327 x 272 mm.)
BMA 1950.206
[Ill. p. 187]

EGYPTIAN
Seated Cat, Saitic Period (7th–4th century B.C.)
Bronze
6 1/2 in. high (16.5 cm.)
BMA 1950.405
[Ill. p. 12]

FRENCH
Center part of a *Necklace*, (ca. 1750)
Silver set with green and red stones and brilliants
3 1/4 x 5 3/8 in. (8.3 x 13.7 cm.)
BMA 1950.552.12
[Ill. p. 11]

PAUL GAUGUIN
French, 1848–1903
Vahine no te Vi (Woman with Mango), 1892
Oil on canvas
28 5/8 x 17 1/2 in. (72.7 x 44.5 cm.)
BMA 1950.213
[Ill. p. 152]

JOHN D. GRAHAM
American, born in Russia, 1890–1961
Still Life with Fruit and Blue and White Pitcher, 1926
Oil on canvas
23 x 17 in. (58.4 x 43.2 cm.)
BMA 1950.334
[Ill. p. 151]

INDIAN
Delhi Shawl (detail), (19th century)
Cotton
68 x 70 in. (172.8 x 177.9 cm.)
Cone, T-NE 3.49
[Ill. p. 11]

MARIE LAURENCIN
French, 1885–1956
Group of Artists, 1908
Oil on canvas
25 1/2 x 31 7/8 in. (64.8 x 81 cm.)
BMA 1950.215
[Ill. p. 100]

JACQUES LIPCHITZ
American, born Lithuania, 1891–1973
Gertrude Stein, (1920)
Bronze
13 7/16 x 8 1/4 x 10 5/8 in. (34.1 x 21 x 27 cm.)
BMA 1950.396
[Ill. p. 78]

GEORGE PLATT LYNES
American, 1907–1955
Gertrude Stein, (late 1920's)
Toned gelatin silver print
9 13/16 x 7 11/16 in. (250 x 195 mm.)
The Baltimore Museum of Art: Gift of Adelyn D. Breeskin to the Cone Archives
BMA 1950/85.4
[Ill. p. 144]

HENRI MATISSE
French, 1869–1954
Madeleine I, (1901)
Bronze; cast 3/10
23 1/4 x 8 3/4 x 7 1/8 in. (59.1 x 22.2 x 18.1 cm.)
BMA 1950.423
[Ill. p. 184]

The Harbor of Collioure, (1905)
Watercolor on paper
14 5/16 x 12 1/4 in. (363 x 311 mm.)
BMA 1950.226
[Ill. p. 97]

Yellow Pottery from Provence, (1906)
Oil on canvas
21 7/8 x 18 3/8 in. (55.6 x 46.7 cm.)
BMA 1950.227
[Ill. p. 166]

Blue Nude ("Souvenir de Biskra"), (1907)
Oil on canvas
36 1/4 x 55 1/4 in. (92.1 x 140.4 cm.)
BMA 1950.228
[Ill. p. 114]

Reclining Nude I (Aurore), (1907)
Bronze; cast 6/10
13 9/16 x 19 5/8 x 11 in. (34.5 x 49.9 x 28 cm.)
BMA 1950.429
[Ill. p. 116]

Two Negresses, (1908)
Bronze; cast 4/10
18 3/8 x 9 3/4 x 8 in. (46.7 x 24.8 x 20.3 cm.)
BMA 1950.430
[Ill. p. 184]

Woman in Turban (Lorette), (early 1917)
Oil on canvas
32 x 25 3/4 in. (81.3 x 65.4 cm.)
BMA 1950.229
[Ill. p. 105]

The Pewter Jug, (1917)
Oil on canvas
36 1/4 x 25 5/8 in. (92.1 x 65.1 cm.)
BMA 1950.230
[Ill. p. 162]

Large Cliff—Fish, (1920)
Oil on canvas
36 5/8 x 29 in. (93.1 x 73.7 cm.)
BMA 1950.233
[Ill. p. 174]

Anemones and Chinese Vase, (1922)
Oil on canvas
24 x 36 3/8 in. (61 x 92.4 cm.)
BMA 1950.248
[Ill. p. 172]

Festival of Flowers, (1922)
Oil on canvas
25 ⅞ x 36 ⅝ in. (65.8 x 93.1 cm.)
BMA 1950.240
[Ill. p. 20]

Standing Odalisque Reflected in a Mirror,
(1923)
Oil on canvas
31 ⅞ x 21 ⅜ in. (81 x 54.3 cm.)
BMA 1950.250
[Ill. p. 154]

*Still Life, Bouquet of Dahlias and White
Book*, (1923)
Oil on canvas
19 ¾ x 24 in. (50.2 x 61 cm.)
BMA 1950.249
[Ill. p. 172]

Painter in the Olive Grove, (1923–early
1924)
Oil on canvas
23 ¾ x 28 ⅞ in. (60.3 x 73.4 cm.)
BMA 1950.239
[Ill. p. 113]

Large Seated Nude, (1923–1925)
Bronze; cast 7/10
30 ¹³⁄₁₆ x 31 ⅝ x 14 in.
(78.3 x 80.4 x 35.6 cm.)
BMA 1950.436
[Ill. p. 185]

Interior, Flowers and Parakeets, (1924)
Oil on canvas
46 x 28 ⅝ in. (116.9 x 72.7 cm.)
BMA 1950.252
[Ill. p. 44]

*Seated Odalisque, Left Knee Bent,
Ornamental Background and Checkerboard*,
(1928)
Oil on canvas
21 ⅝ x 14 ⅞ in. (55 x 37.8 cm.)
BMA 1950.255
[Ill. p. 4]

Reclining Nude III, (1929)
Bronze; cast 5/10
7 ⅜ x 18 ½ x 5 ¹³⁄₁₆ in.
(18.7 x 47 x 14.8 cm.)
BMA 1950.437
[Ill. pp. 116 and 184]

The Yellow Dress, 1929–1931
Oil on canvas
39 ¼ x 31 ¾ in. (99.7 x 80.7 cm.)
BMA 1950.256
[Ill. p. 141]

Tiari (with Necklace), (1930)
Bronze, with gold chain; cast 1/10
8 x 5 ⅝ x 7 ⅝ in. (20.3 x 14.3 x 19.4 cm.)
BMA 1950.438
[Ill. p. 118]

Venus in a Shell I, (1930)
Bronze; cast 3/10
12 ¹⁄₁₆ x 7 x 8 in. (30.7 x 17.8 x 20.3 cm.)
BMA 1950.439
[Ill. p. 185]

Dr. Claribel Cone, (1931–1934)
Pencil on Arches paper
16 ⁵⁄₁₆ x 9 ¹⁵⁄₁₆ in. (415 x 253 mm.)
BMA 1950.12.65
[Ill. p. 122]

Dr. Claribel Cone, (1931–1934)
Pencil on Arches paper
12 ⅜ x 9 ¹⁵⁄₁₆ in. (315 x 252 mm.)
BMA 1950.12.72
[Ill. p. 122]

Dr. Claribel Cone, (1931–1934)
Pencil on wove paper
12 ⅜ x 9 ¾ in. (314 x 248 mm.)
BMA 1950.12.66
[Ill. p. 122]

Dr. Claribel Cone, (1931–1934)
Charcoal and estompe on wove paper
23 ¼ x 16 in. (591 x 406 mm.)
BMA 1950.12.71
[Ill. p. 122]

Etta Cone, (1931–1934)
Crayon on wove paper
20 ¾ x 16 in. (527 x 406 mm.)
BMA 1950.12.63
[Ill. p. 123]

Etta Cone, (1931–1934)
Charcoal on wove paper
20 ¾ x 16 ¹⁄₁₆ in. (527 x 408 mm.)
BMA 1950.12.64
[Ill. p. 123]

Etta Cone, (1931–1934)
Charcoal on wove paper
22 ⁹⁄₁₆ x 16 ¹⁄₁₆ in. (573 x 408 mm.)
BMA 1950.12.67
[Ill. p. 123]

Etta Cone, (1931–1934)
Charcoal on wove paper
24 ⅝ x 16 ⅛ in. (625 x 410 mm.)
BMA 1950.12.68
[Ill. p. 123]

Etta Cone, (1931–1934)
Charcoal on wove paper
27 ¾ x 16 in. (705 x 406 mm.)
BMA 1950.12.69
[Ill. p. 123]

Etta Cone, (1931–1934)
Charcoal on wove paper
28 x 16 ¹⁄₁₆ in. (711 x 409 mm.)
BMA 1950.12.70
[Ill. p. 123]

Poésies de Stéphane Mallarmé, 1932
Illustrated book
BMA 1950.12.691

Le Pitre Châtié
pages 18–19
[Ill. p. 125]

Les Fleurs
pages 28–29
[Ill. p. 125]

Les glaïeuls
Study for page 29, illustration to "Les
Fleurs"
Pen and black ink; sheet, 324 x 250 mm.
BMA 1950.12.705
[Ill. p. 126]

Nymph and Faun III
Study for page 81, illustration to
"L'Après-Midi d'un Faune"
Pencil; sheet, 329 x 260 mm.
BMA 1950.12.726
[Ill. p. 126]

Triste fleur qui croît seule
Refused plate for page 63 (or additional
plate?), illustration to "Hérodiade"
Etching; sheet, 333 x 252 mm.
BMA 1950.12.694x
[Ill. p. 126]

Le concert
Refused plate for page 77(?), illustration
to "L'Après-Midi d'un Faune"
Etching; sheet, 332 x 250 mm.
BMA 1950.12.694xvii
[Ill. p. 126]

Interior with Dog (formerly called
"The Magnolia Branch"), 1934
Oil on canvas
61 x 65 ¾ in. (155 x 167 cm.)
BMA 1950.257
[Ill. p. 128 and detail on cover]

The Blue Eyes, 1935
Oil on canvas
15 x 18 in. (38.1 x 45.7 cm.)
BMA 1950.259
[Ill. p. 132]

Study for The Blue Eyes, 1935
Photograph sent by Henri Matisse to Etta
Cone, with letter of February 22, 1936
Cone Archives
[Ill. p. 133]

Study for The Blue Eyes, (1935)/1936
Pencil on white paper
17 ¼ x 20 in. (438 x 508 mm.)
BMA 1950.12.49
[Ill. p. 133]

Large Reclining Nude (formerly called
"The Pink Nude"), 1935
Oil on canvas
26 x 36 ½ in. (66 x 92.7 cm.)
BMA 1950.258
[Ill. p. 135]

Large Reclining Nude, 1935
Photographic documentation of 22
progressive states, May 3, 1935 through
October 30, 1935
Original photographs sent by Henri Matisse
to Etta Cone, with letters of September 19,
1935, and November 16, 1935
Cone Archives
[Ill. pp. 136–137]

Seated Nude, Head on Arms, 1935
Photographic documentation of 6
progressive states of a drawing
Original photographs sent by Henri Matisse
to Etta Cone, with letter of September 19,
1935
Cone Archives
[Ill. p. 130]

*Sleeping Nymph Awakened by a Faun
Playing the Flute*, 1935
Original photograph, marked on the reverse
"Nouveau panneau / 1.70 x 2 m," sent by
Henri Matisse to Etta Cone, with letter of
September 19, 1935
Cone Archives
[Ill. p. 131]

Oil on canvas
36 ¼ x 28 ¾ in. (92 x 73 cm.)
Private Collection
[Ill. p. 139]

201

Artist and Model Reflected in a Mirror,
1937
Pen and ink on paper
24 ⅛6 x 16 in. (612 x 407 mm.)
BMA 1950.12.51
[Ill. p. 149]

Purple Robe and Anemones, 1937
Oil on canvas
28 ¾ x 23 ¾ in. (73.1 x 60.3 cm.)
BMA 1950.261
[Ill. p. 95]

The Rumanian Blouse, 1937
Pen and ink on paper
24 ¹³⁄₁₆ x 19 ¹¹⁄₁₆ in. (630 x 500 mm.)
BMA 1950.12.57
[Ill. p. 149]

Small Rumanian Blouse with Foliage
(formerly called "Woman with
Philodendron"), (1937); incorrectly dated
1938
Oil on canvas
18 ⅛ x 15 in. (46.1 x 38.1 cm.)
BMA 1950.262
[Ill. p. 148]

Self-Portrait, 1937
Charcoal and estompe on paper
18 ⅝ x 15 ⅜ in. (473 x 391 mm.)
BMA 1950.12.61
[Ill. p. 196]

Striped Robe, Fruit, and Anemones, 1940
Oil on canvas
21 ⅜ x 25 ½ in. (54.3 x 64.8 cm.)
BMA 1950.263
[Ill. p. 146]

PABLO PICASSO
Spanish, 1881–1973
Woman with Bangs, (1902)
Oil on canvas
24 ⅛ x 20 ¼ in. (61.3 x 51.3 cm.)
BMA 1950.268
[Ill. p. 106]

La Coiffure, (1905)
Oil and charcoal on canvas
31 ⅞ x 25 ⅝ in. (81 x 65.1 cm.)
BMA 1950.269
[Ill. p. 108]

Head of a Young Man (Self-Portrait),
(1906)
Pen and ink on paper
12 ½ x 9 ⅜ in. (318 x 239 mm.)
BMA 1950.12.485
[Ill. p. 169]

Two Nudes, (1906)
Gouache and black crayon on paper
24 ¹³⁄₁₆ x 18 ⅞ in. (631 x 480 mm.)
BMA 1950.277
[Ill. p. 88]

Woman Combing her Hair, (1906)
Bronze; cast ?/7
16 ⅜ x 10 ¼ x 12 ⁵⁄₁₆ in.
(41.6 x 26 x 31.3 cm.)
BMA 1950.452
[Ill. p. 195]

Self-Portrait (Bonjour Mlle Cone), (1907)
Pen and black ink on paper
8 ⁵⁄₁₆ x 5 ⁷⁄₁₆ in. (211 x 139 mm.)
BMA 1950.12.481
[Ill. p. 169]

Study for Nude with Drapery, (1907)
Watercolor on paper
12 ⅛ x 9 ⁹⁄₁₆ in. (309 x 243 mm.)
BMA 1950.278
[Ill. p. 92]

Dr. Claribel Cone, 1922
Pencil on paper
25 ³⁄₁₆ x 19 ⁷⁄₁₆ in. (640 x 493 mm.)
BMA 1950.12.499
[Ill. p. 171]

Mother and Child, 1922
Oil on canvas
39 ⅜ x 31 ⅞ in. (100 x 81 cm.)
BMA 1950.279
[Ill. p. 192]

CAMILLE PISSARRO
French, 1830–1903
The Highway ("La Côte de Valhermeil"),
1880
Oil on canvas
25 ¼ x 31 ½ in. (64.2 x 80 cm.)
BMA 1950.280
[Ill. p. 181]

MAN RAY
American, 1890–1976
*Alice B. Toklas and Gertrude Stein, rue de
Fleurus, Paris, 1922*
Gelatin silver print
3 ³⁄₁₆ x 4 ¾ in. (96 x 121 mm.)
Cone Archives, Bequest of Etta Cone
BMA 1950/85.1
[Ill. p. 86]

ODILON REDON
French, 1840–1916
Peonies, (ca. 1900–1905)
Oil on canvas
20 x 17 ¾ in. (50.8 x 45.1 cm.)
BMA 1950.281
[Ill. p. 142]

THEODORE ROBINSON
American, 1852–1896
The Young Violinist, (late 1880's)
Oil on canvas
32 ⅛6 x 26 ⅛6 in. (81.5 x 66.2 cm.)
BMA 1950.290
[Ill. p. 54]

GEORGES SEURAT
French, 1859–1891
Two Men Walking in a Field, (ca. 1882–
1884)
Black conté crayon on paper
12 ½ x 9 ⁹⁄₁₆ in. (318 x 243 mm.)
BMA 1950.12.664
[Ill. p. 191]

KITAGAWA UTAMARO
Japanese, 1753–1806
Courtesan and Attendant, (n.d.)
Color woodblock print
15 x 10 ⅛ in. (381 x 257 mm.)
BMA 1950.12.729B
[Ill. p. 61]

FÉLIX VALLOTTON
Swiss, 1865–1925
The Lie, (1897)
Oil on canvas board
9 ⁷⁄₁₆ x 13 ⅛ in. (24 x 33.4 cm.)
BMA 1950.298
[Ill. p. 178]

VINCENT VAN GOGH
Dutch, 1853–1890
A Pair of Boots, 1887
Oil on canvas
13 x 16 ⅛ in. (33 x 41 cm.)
BMA 1950.302
[Ill. p. 177]